W9-CEN-701

ITALIAN DRAWINGS

DRAWINGS

IN THE

ART INSTITUTE

OF CHICAGO

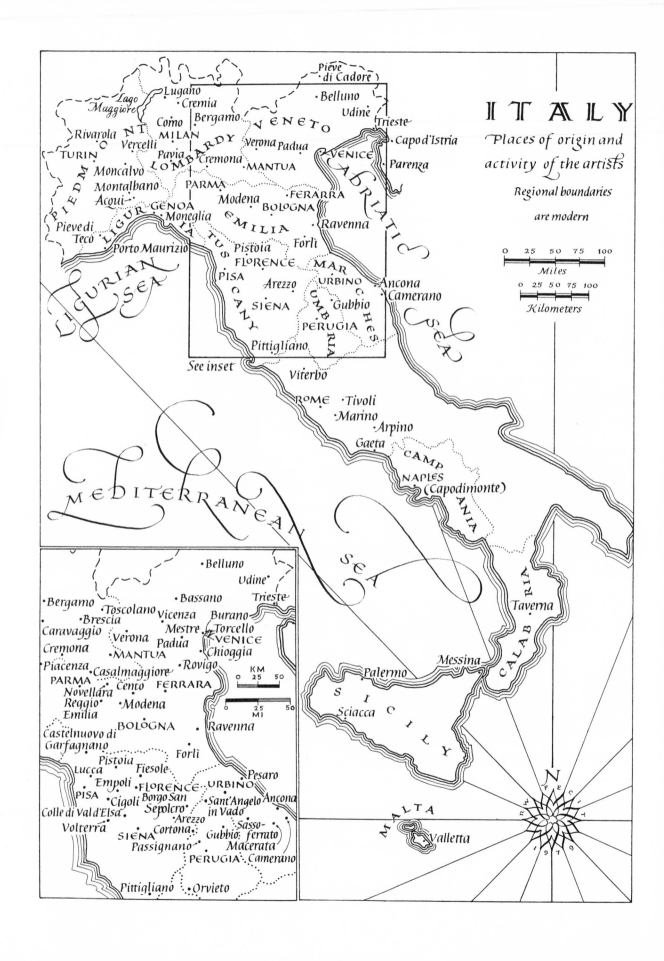

ITALY

Places of origin and
activity of the artists

Regional boundaries
are modern

0 25 50 75 100
Miles

0 25 50 75 100
Kilometers

Main map labels:

Pieve di Cadore · Belluno · Udine · Trieste · Capo d'Istria · Parenza

Lugano · Cremia · Bergamo · VENETO

Lago Maggiore · Como · Verona · Padua · VENICE · ADRIATIC SEA

Rivarola · MILAN · LOMBARDY · Mantua

Vercelli · Pavia · Cremona · MANTUA

TURIN · PIEDMONT · Moncalvo · Montalbano · Acqui · PARMA · Modena · FERRARA · BOLOGNA · Ravenna

Pieve di Teco · LIGURIA · GENOA · Moneglia · EMILIA · Pistoia · Forlì

Porto Maurizio · TUSCANY · FLORENCE · PISA · Arezzo · MARCHES · URBINO · Ancona · Camerano

LIGURIAN SEA · SIENA · Gubbio · UMBRIA · PERUGIA

Pittigliano · Viterbo

See inset

MEDITERRANEAN SEA

ROME · Tivoli · Marino · Arpino · Gaeta · CAMPANIA · NAPLES (Capodimonte)

Taverna · CALABRIA

Messina · Palermo · SICILY · Sciacca

MALTA · Valletta

N · 1979

Inset map labels:

Belluno · Udine · Trieste · Bassano · Bergamo · Toscolano · Vicenza · Burano · Brescia · Mestre · Torcello · Caravaggio · Verona · Padua · VENICE · Cremona · MANTUA · Chioggia · Piacenza · Casalmaggiore · Rovigo · PARMA · Cento · FERRARA · Novellara · Reggio Emilia · Modena · Castelnuovo di Garfagnano · BOLOGNA · Ravenna · Pistoia · Forlì · Lucca · Fiesole · Empoli · FLORENCE · Pesaro · PISA · Cigoli · Borgo San Sepolcro · URBINO · Colle di Val d'Elsa · Arezzo · Sant'Angelo in Vado · Ancona · Volterra · Cortona · Gubbio · Sasso-ferrato · SIENA · Passignano · Macerata · PERUGIA · Camerano · Pittigliano · Orvieto

KM 0 25 50

MI 0 25 50

ITALIAN DRAWINGS

IN THE

ART INSTITUTE

OF CHICAGO

Harold Joachim

and

Suzanne Folds McCullagh

The University of Chicago Press

Chicago and London

*This project is supported by a grant from the
National Endowment for the Arts in Washington, D.C.
a federal agency.*

The University of Chicago Press, Chicago 60637
The University of Chicago Press, Ltd., London

©1979 by The Art Institute of Chicago
All rights reserved. Published 1979
Printed in the United States of America

83 82 81 80 79 5 4 3 2 1

Library of Congress Cataloging in Publication Data

Chicago. Art Institute.
 Italian drawings in the Art Institute of Chicago.

 Bibliography: p.
 Includes index.
 1. Drawing, Italian—Catalogs. 2. Drawing—
Illinois—Chicago—Catalogs. 3. Chicago.
Art Institute—Catalogs. I. Joachim, Harold.
II. McCullagh, Suzanne Folds. III. Title.
NC255.C46 1979 741.9'45'074017311 78-31088
ISBN 0-226-40013-1
ISBN 0-226-40015-8 pbk.

CONTENTS

PLATES

PREFACE

This is the first of four projected volumes devoted to the collection of drawings owned by the Art Institute of Chicago. It is intended as a selective catalog, highlighting the major acquisitions with thorough documentation and discussion of each piece and attempting to put them all in historical context. While this catalog numbers 151 pieces, another catalog, soon to be published with almost 600 drawings on microfiche, will offer a more comprehensive overview of the entire collection with a text reduced to the most concise factual information. The Art Institute collection lends itself to such an arrangement because of its great bulk of problematic study material of various levels of quality.

In the affection of Chicago collectors, Italian drawings have rarely competed with French drawings. One exception was William F. E. Gurley, a geologist and paleontologist who collected drawings with the same acquisitive passion that he collected specimens in his own discipline. Making no pretense of scholarship, he accepted without question the often over-optimistic attributions of the drawings he bought in London, mostly in inexpensive bundled lots at the no longer extant firm of Puttick and Simpson. In 1922, he donated his vast collection of about five thousand items to the Art Institute, which up to that time had no Italian drawings. The gift was made in memory of his mother, Leonora Hall Gurley. Every sheet in the collection bears his stamp on the face: a true circle, 9 mm. in diameter, with the letters WFE contained within a large G, printed in black; another stamp on the back reads "Leonora Hall Gurley Memorial Collection." The first exhibition of Italian drawings from his collection was held in March and April of 1922; the small catalog of forty-three items, not much more than a checklist, contains the following statement: "The attributions are mostly those borne by the drawings in former collections and catalogues. It is hoped to have them expertized when a suitable opportunity presents itself."

That opportunity arrived when Ulrich Middeldorf came to the University of Chicago in 1938 as assistant professor; eventually he served as chairman of the Art Department until he left in 1953 to assume the directorship of the German Art History Institute in Florence. He realized at once the inestimable value of the Gurley drawings as a study collection and brought order into

what had seemed chaos, by no means an easy task if one considers the paucity of publications in the field of Italian drawings at that time. He prepared a catalog of two hundred selected pieces, half of which were to be Italian. The project was shelved, however, when Carl O. Schniewind became curator of prints and drawings at the Art Institute in 1940. Schniewind was adamant that the collection would have to be considerably upgraded before a catalog could be published. Similar sentiments were expressed by the well-known Viennese scholar Hans Tietze, who wrote in 1947 in his book *European Master Drawings in America*, "The Gurley Collection, though burdened with dead weight, contains much interesting material, though little of real fascination; a case of too much and too little."

Schniewind himself issued a catalog in 1945, called *Drawings Old and New*, which was intended to represent the cream of the collection. There he published a few Italian drawings that were acquired after 1940 (a Canaletto, an Antonio Guardi, and four red and white chalk drawings by members of the Tiepolo family), but strangely enough not a single piece from the Gurley Collection was included. In subsequent years, he acquired the fine double-sided sheet of landscapes by Fra Bartolommeo and the fifteenth-century silverpoint portrait from the Moscardo album, which at that time was believed to be of Flemish origin. By training and inclination, Schniewind was far more deeply involved with French drawings, and his great achievements for the Art Institute in that field will never be forgotten.

Perhaps no area of art history has flourished quite as much in these past twenty years as the study of Italian drawings, and this could not fail to bring about a more positive appraisal of the Gurley Collection, because it has now become possible to assign names to formerly anonymous or wrongly attributed pieces. The weaknesses of the Gurley Collection are obvious, such as the lack of examples from the quattrocento or by the leading masters of the High Renaissance, or the first generation of the Florentine Mannerists. Particularly unbalanced in that collection was the representation of the eighteenth century, with five examples by Diziani and none by G. B. Tiepolo. Yet, there remains much of interest in the Gurley Collection.

The most remarkable sheet of the Florentine High Renaissance is a great rarity: a large though unfortunately poorly preserved sheet by Girolamo

Genga (cat. 6, pl. 11); another fascinating drawing is the double-sided sheet by Perino del Vaga (cat. 10, pl. 15), done during his sojourn in Genoa. The main strength of the collection, however, lies in artists of the late sixteenth and the seventeenth centuries, a field that is of particular interest to scholars and connoisseurs today. We can single out only a few examples here, such as the *Allegorical Subject* by Cambiaso (cat. 25, pl. 32), the *Head of the Virgin* by Barocci (cat. 31, pl. 34), *The Resurrection* by Santi di Tito (cat. 32, pl. 41), the portrait of a *Seated Cleric* by Cesi (cat. 45, pl. 54), *Jacob Blessing the Sons of Joseph* by Guercino (cat. 60, pl. 66), *Studies of the Madonna and Child* by Cantarini (cat. 77, pl. 89), and others.

Unfortunately, the Art Institute, not having had a specialist on drawings on the staff between 1922 and 1940, added very few old master drawings during those years. There were, however, some gifts. The Deering Collection, which contained thousands of prints and also included some Italian drawings, came in 1927, and in 1928 one of the institute's most important Italian drawings, the sheet of sketches by Taddeo Zuccaro (cat. 28, pl. 36), was given by its director at the time, Robert B. Harshe.

During the twenty years of his activity (since September 1958), the present curator has had every reason to be thankful to generous donors, such as Mrs. Joseph Regenstein and Mrs. Tiffany Blake, and to the Board of Trustees for enabling him to enrich the collection in several directions. With the fascinating sheet by Pisanello (cat. 2, pl. 4), the museum gained its most important quattrocento drawing, and the great sheets by Cortona (cat. 65, pl. 75) and Castiglione (cat. 74, pl. 79 and cat. 72, pl. 82) added much-needed splendor to the period of the High Baroque. Among the most recent acquisitions are two works from the Ellesmere Collection, a portrait by Agostino Carracci of his son Antonio (cat. 46, pl. 55) and a drawing of Christ on the road to Calvary by Antonio himself (cat. 58, pl. 65).

But it was chiefly the eighteenth century that seemed to cry out for attention, especially in view of the Art Institute's fine collection of paintings of that era (Magnasco, Ricci, Piazzetta, Tiepolo, Canaletto, Guardi, and others). Acquisitions include two large drawings by Magnasco, two by Donato Creti, the splendid Schulenburg Collection of nine portrait studies and genre subjects by Piazzetta, six major pieces by G. B. Tiepolo (represent-

ing at least five distinct periods of his career), three by Francesco Guardi, and two each by Piranesi and G. D. Tiepolo. The most important of these came as donations from the Joseph and Helen Regenstein Foundation.

In this catalog, artists are listed in chronological order according to date of birth, regardless of regional schools. It will be noted that the dates of birth cover the entire span of time from about 1500 to 1750 with hardly a pause. Thus, every generation is represented within that range, and there also is a wide variety of types and techniques of drawings, including rough compositional sketches (Taddeo Zuccaro, Pietro da Cortona, and others), studies of single figures or groups for paintings, even a rare cartoon by Barocci, finished drawings as independent works of art (mostly of the eighteenth century), various portraits, and architectural drawings.

Many noted scholars have generously shared information and opinions with us. Without their help, this catalog could not have been done, and our debt can never be repaid. The visit of Philip Pouncey in the spring of 1958 was undoubtedly the greatest single event to be recorded here because it actually marked the beginning of a new appreciation of the collection as far as the sixteenth and seventeenth centuries were concerned. He identified at that time such important sheets as those by Perino del Vaga, Taddeo Zuccaro, and many others, as indicated in the catalog itself. The number of distinguished scholars visiting the collection has increased steadily since that date. We should like to mention those who were particularly helpful: Jacob Bean, who generously responded to my request for his advice concerning the selections for this catalog, the late Anthony M. Clark, Bernice Davidson, John Gere, Denis Mahon, Mary Newcome, Konrad Oberhuber, who has graciously reviewed portions of this manuscript, Terisio Pignatti, Edmund Pillsbury, Herwarth Röttgen, Janos Scholz, Christel Thiem, the late Walter Vitzthum, the late Rudolf Wittkower, and Federico Zeri. Much valuable work was also done by members of the staff, past and present, and by students on temporary assignment. There were Diane de Grazia Bohlen, Ilse Friesen, Janet Garrell, Sandra Haller Olsen, Mary Quinlan, Bertha Wiles, and especially Rafael Fernandez who added many fresh ideas and valuable information to our knowledge of the drawings. I also wish to thank Professor Edward A. Maser, of the University of Chicago, who,

besides his contribution of the article on Ferretti, was always available for consultation. The department of paper conservation, Douglas Kenyon, David Chandler, and Rebecca Rubin, worked with great skill and patience to improve the physical condition of many pieces. The much overburdened department of photography, Howard Kraywinkel and John Mahtesian, never once departed from their high standards of excellence in photographing our drawings. Kay Weinstein typed the manuscript with patience and precision. To all those individuals involved in the project go our warmest thanks.

HAROLD JOACHIM
Curator of
Prints and Drawings

INTRODUCTION

Drawing, or *disegno*, formed the foundation of Italian artistic theory and practice from the beginning of the Renaissance through the eighteenth century. Cennino Cennini was the first to advocate formally the serious study of drawing as the basis of all artistic training in his *Libro dell'Arte*, written at the beginning of the fifteenth century. Cennini, like theoreticians to follow, included in this craftsman's handbook, along with his description of techniques and the proper training of an artist, his convictions on the nobility of drawing as an intellectual discipline. The importance of drawing as a means of scientific discovery was demonstrated at the end of the fifteenth century by Leonardo da Vinci, in his writings and drawings alike. Furthermore, as has been frequently observed, Leonardo may have been the first artist to show a cartoon in public instead of a picture, with a typically Florentine preference for design over color. By the middle of the sixteenth century, Giorgio Vasari had formulated the doctrine of *disegno* that associated drawing with invention as a direct expression of the intellect of the artistic genius. This was the beginning of the famous controversy between *disegno* and *colore* of the Central Italian and Venetian theorists. By the end of the sixteenth century, Federico Zuccaro had taken the theory of *disegno* to its ultimate extension and declared drawing to be man's direct link to divine power, elevating the art to a supernatural phenomenon. From the late sixteenth century on, the supremacy of drawing in academic artistic training was incontestably established in the schools of Rome, Bologna, Florence, and their offshoots.

The practice of drawing may, of course, be traced back to the earliest cave paintings, Egyptian hieroglyphics, and Greek vase decorations. But for the purposes of uncovering its development in Italy, one may look for its roots in medieval workshops and scriptorii. The creation of illuminated manuscripts and the practice of making model books were characterized by anonymity and conformity of copywork, occasionally alleviated by individual inspiration. These traditions lasted into the Renaissance and can be recognized in the typical training of an artist's apprentice: he would begin by making careful copies from the drawings of his master, then proceed to copy from classical antiquity, and finally be allowed to draw from

nature. Although no illuminated manuscripts or strictly defined model books are included in this selection of drawings, vestiges of the medieval craftsman's work can be discerned in the stiffly executed, anonymous mid-fifteenth-century *Papal Prophecy* (cat. 3, pls. 2–3), drawn according to mid-fourteenth-century formula rather than from nature. Executed on vellum, it is a reminder that the manufacture of paper did not become widespread in Italy until the middle of the fourteenth century. The double-sided drawing by Pisanello (ca. 1395 to ca. 1455; cat. 2, pls. 4–5) may also be considered in this tradition, for the detailed studies of the bow and quiver, carefully noted for possible use in later paintings, are characteristic of the precise draftsmanship found in pattern books; however, Pisanello's genius for observation and his audacious life sketches of the oriental retinue in this case transcend the limitations of the International Gothic era.

The mysterious precision and delicacy of silverpoint, a technique quite popular in the awakening years of drawing, can be seen in the mid-fifteenth-century North Italian portrait of a priest (cat. 1, pl. 1). More suited to the tentative and cautious line of an early Renaissance artist than the bold scribblings of subsequent draftsmen, the silverpoint technique is achieved by drawing a metal point over a specially prepared paper, coated with a thin opaque ground. The fact that the stylistic evidence of this drawing indicates Veronese origins is further testimony that this North Italian region, the home of such notable artists as Pisanello, Stefano da Zevio, and others, was a fertile source of Italian draftsmanship.

At the turn of the sixteenth century, in the hands of the greatest Renaissance draftsmen—Leonardo, Michelangelo, and especially Raphael—drawing developed more elaborate and significant functions for the artist. Artists came to rely on drawings as a scientific and inventive method of preparing a painting or sculpture commission, for exploring and developing ideas, and as expressions of their personal genius or ability. In Raphael's workshop in Rome, some fundamental stages of preparatory drawings became codified. The first thought (*primo pensiero*) for the invention of a composition meant hastily roughing out the figures and action, frequently in pen and ink with a chalk base, as seen in Vasari's study for the Palazzo Vecchio (cat. 19, pl. 24), Veronese's(?) *Studies for a Descent from the Cross* (cat. 27, pl. 28), Pietro da

Cortona's sketch for *The Martyrdom of Saint Stephen* (cat. 64, pl. 74), or Valerio Castello's two evocative compositions (cat. 82–83, pls. 92–93).

The artist would then develop his idea by means of specific studies of elements within the composition. At this point, he would frequently turn to studies from life: for example, anatomical studies such as the pieces by Tintoretto(?) (actually from a sculpted model; cat. 21, pl. 25), Casolani (cat. 43, pl. 51), and Cesari d'Arpino (cat. 51, pl. 61); facial studies, as in the Veronese *Head of a Woman* (cat. 26, pl. 27); or draped figure studies and figure groups, such as that by Cesi (cat. 45, pl. 54) and the double-sided sheet by Carpaccio (cat. 4, pls. 6–7).

A more precise drawing of the total composition (the *modello*) would then be worked up, which might be proposed to the prospective client. A late sixteenth-century drawing that was probably intended as a *modello* is the composition of *The Resurrection* by Santi di Tito (cat. 32, pl. 41). It is characteristically elaborated in pen and ink with brush and wash and white gouache to convey the painterly qualities of the finished work. Traces of a squaring grid in black chalk over a subsequent version of the drawing (in the Uffizi) suggest the usual method of enlargement and transfer of a composition to its support. The full-blown creation of *The Holy Trinity with Saint Michael Conquering the Dragon* by Pietro da Cortona (cat. 65, pl. 75) is, in all likelihood, a *modello* as well, and it demonstrates the strength of this type of finished drawing as an independent work in its own right.

Finally, artists would often make full-size cartoons of their compositions, figures, or even parts of figures, for ease of exact copying onto the support. This drawing type is represented in our collection by the cut-down *Head of the Virgin* by Barocci (cat. 31, pl. 34) for the *Deposition* in Perugia and also in the over-life-sized cartoon of *Pomona* by Guido Reni (cat. 54, pl. 62). The drawing by Barocci still shows the stylus tracing that transferred the outlines of the composition to its support.

After the painting was executed, a record, or *ricordo*, of the completed composition might then be made, by the artist or by a member of his studio. It would generally be of a highly finished technique, similar to the *modello*; however, unlike the *modello*, which might not anticipate some last-minute changes, the *ricordo* would follow the painting exactly.

Although some of the greatest sixteenth- and seventeenth-century drafts-men are not represented in the Art Institute's collection, it may be useful to attempt here a cursory survey of the history of Italian drawings, beginning with the sixteenth century, based on the present selection. This is possible thanks to a nearly continuous series of birth dates for the artists represented, from the fifteenth century to 1750, and a general distribution of works in all major schools, with a few exceptions.

As mentioned above, the greatest draftsmen of the High Renaissance—Leonardo, Michelangelo, and Raphael—are not represented here; nor, un-fortunately, are some of their Florentine followers: Andrea del Sarto, Pon-tormo, Rosso, Bronzino, or Francesco Salviati. Nevertheless, several note-worthy aspects of Tuscan and Umbrian art of these generations are included in the present selection.

The rarest among these is a drawing by Girolamo Genga (1467–1551; cat. 6, pl. 11), a native of Urbino like Raphael, who also came under the early influence of Luca Signorelli's knotty musculature, studied the antique, and showed a predominant interest in the human form. Genga's talent is, of course, not comparable to that of Raphael, but the rustic strength of the large remnant of a sheet in this collection is a forceful reminder of Raphael's environment. This is complemented by the masterly atmospheric effects of a landscape by the major representative of Raphael's legacy in Florence, the Dominican monk, Fra Bartolommeo (1472–1517; cat. 7, pls. 9–10). The double-sided sheet can be dated about 1508–10, in the years just following Raphael's departure from Florence to Rome, and reveals the impact of the Frate's own trip to Venice about 1508.

One of the finest drawings from Mr. Gurley's collection is the sheet of studies by Perino del Vaga (1501–47; cat. 10, pls. 15–16), a Florentine artist who, with Giulio Romano and others, formed Raphael's Roman workshop. After the sack of Rome in 1527, Perino spread his influence north to Genoa, as witnessed in this drawing for the Palazzo Doria. Finally, the transition from the High Renaissance to Mannerism in Florence is rep-resented by two drawings for decorations of the Palazzo Vecchio (ca. 1556–59) by Giorgio Vasari (1511–74; cat. 18–19, pls. 23–24), the noted historian and author of the *Lives of the Most Famous Italian Architects, Painters and*

Sculptors (1550, 1568), who propounded the importance of *disegno* as the expression of the artist's inventive faculties. As previously noted, Vasari was one of the key figures in the controversy over the relative merits of *disegno* and *colore* which characterized the two centers of Florence and Venice.

Examples of Venetian Renaissance draftsmanship in the Chicago collection form a significant group, but for the lack of a sure attribution to the greatest sixteenth-century Venetian artist, Titian. The earliest sheet, by Carpaccio, is executed in a characteristic Venetian technique of brush with black ink and white gouache on blue paper. This suggests, even in a detail study, the atmospheric effects sought in the Venetian school. The unfortunately rubbed chalk drawing by Jacopo Bassano (1510 or 1515 to 1592; cat. 20, pl. 26) shows the development of this tradition into yet more evocative effects approximately sixty years later. The medium of black chalk on blue paper is used for entirely different reasons by Tintoretto (1518–94) and his studio; the dramatically angled *Male Nude* (cat. 21, pl. 25) is typical of Tintoretto's exercises of drawing from small models in a Central Italian manner. Certainly Vasari's visit to Venice (ca. 1540) contributed to Tintoretto's inclination to work in this fashion. Central Italian influence was represented in Venice in another form by Giuseppe Porta Salviati (1520–75; cat. 22, pl. 31), the Venetian-born follower of Francesco Salviati in Rome who adopted his master's name and something of his style and returned with it to Venice. Brown wash and white gouache thus play on the paper not only to describe the area that surrounds the figure, but also to define the design of its muscular form. Paolo Farinati (1524–1606; cat. 23, pl. 30) and Paolo Caliari, called Veronese (1528–88; cat. 26–27, pls. 27–29), belong to a generation of Veronese artists more or less dependent on Venice who, like Porta Salviati, show a blend of Central Italian and Venetian characteristics. They were succeeded by the prolific draftsman, Jacopo Palma il Giovane (1544–1628; cat. 36–40, pls. 44–48), whose pliant line ripples and dissolves to indicate the play of light on knotty, muscular forms.

Parma was the Emilian center that flourished during the High Renaissance and Mannerist periods, and it is well represented by its most illustrious creative genius, Francesco Mazzola, called Parmigianino (1503–40). A group of five drawings testify to his Roman experience (cat. 13–16, pls. 18–20, 22),

and—on his return to the north after the sack of Rome—his ultimate drawing style before his untimely death (cat. 17, pl. 21). The impact of Parmigianino's canon of elongated forms can be seen throughout the North Italian region, not merely in the fine example by his cousin by marriage, Girolamo Mazzola Bedoli (1500–1569; cat. 9, pl. 12), but also in the bizarre strain of the Ferrarese artist Girolamo da Carpi (1501–56; cat. 11, pl. 13) and the stylized antiquarianism of the Cremonese Campi family (1502–72 and 1523–87; cat. 12, pl. 17).

Despite the dispersal and destruction resulting from the sack of 1527, Rome again emerged as the major artistic center of Italy about the middle of the sixteenth century and regained its power to attract artists from other cities. This included a number of established Florentine-born artists such as Perino del Vaga, Giorgio Vasari, and Francesco Salviati who brought with them a highly decorative and artificial style; however, the Roman tradition initiated earlier in the century by Michelangelo, Raphael, and their circles was reasserted at this same time by the forceful personality of Taddeo Zuccaro (1529–66) and his school. Like Raphael, Taddeo and his brother Federico Zuccaro came from the Marches and perhaps it was partially due to this common regional background that Taddeo perceived and described substantial human form, organic weight, and movement in space almost as persuasively as Raphael had before him, albeit within the Maniera mode. The double-sided sheet shown here (cat. 28, pls. 36–37) equally recalls his debt to Michelangelo and his highly personal, agitated notations.

Taddeo Zuccaro lived a tragically short but tremendously influential life, and in the decade before his death in 1566 a number of significant artists from all over Italy came to work with him in Rome. Foremost among these was his younger brother Federico (1540/41–1609), who was trained by and assisted his brother from an early age. By 1560, however, Federico was receiving independent commissions, and in 1563 he embarked on the first of many journeys that took him from Rome for extended periods to Venice and Lombardy (1564), Florence (1565, 1575–79), France, the Netherlands, and England (1574), Urbino (1580–83), Venice (1584–85), Spain (1586–88) and Turin (early seventeenth century). Although closely similar to his brother's style, at least initially, Federico's art shows a more reserved intellec-

tual and abstracting inclination fitting to a man whose interests went beyond mere description to include travel, aesthetics, and art education (cat. 34, pl. 42). Because of his longer life, his more accessible genius, and his ability and desire to instruct, Federico was an important continuing influence on artists initially attracted to Taddeo's work. Among the closest followers were Cesare Nebbia of Orvieto (1536–1614) and Niccolò Martinelli, called Il Trometta, from Pesaro (ca. 1540[?] to ca. 1611); both artists clearly reveal these roots in their drawing styles (cat. 33, 35, pls. 38–39). Calligraphy like Zuccaro's is also visible in the large sheet here attributed to Bartolomeo Passarotti (1529–92), one of the foremost innovators of the Bolognese school, who was a pupil of Taddeo and worked in Rome in about 1551–65 (cat. 30, pl. 40).

A fellow Umbrian, Federico Barocci (1535–1612), became a close friend and follower of Taddeo's during visits to Rome in the 1550s and 1560–63. He was to prove one of the most significant talents in Italy at mid century. Far from being a true member of the Zuccaro school, Barocci extended beyond their brand of Maniera and looked to the Parmese and Venetian artists to suffuse his experience of Roman art with effects of color and light that anticipate the sublime creations of the Baroque (cat. 31, pl. 34). In this avant-garde individualism, Barocci may be said to have a counterpart in the north in the person of Luca Cambiaso (1527–85), who, in his paintings and drawings alike, altered perceptions, prophesied the Baroque, and indeed heavily influenced all subsequent generations of Genoese artists (cat. 24–25, pls. 32–33).

It is of particular interest that Florentine artists who came to Rome just after mid century should also have fallen under the influence of the Zuccaros more than under that of the legacy of fellow Florentines in Rome. From 1558 to 1564, the young Santi di Tito (1536–1603) worked and studied in Rome, responding strongly to the example of Taddeo Zuccaro and to his inspiration in High Renaissance models. This formed the foundation for his revolutionary reformist movement, which Santi instigated in Florence, urging a return to classical ideals, naturalism, and simplicity. His highly finished drawing of *The Resurrection* (cat. 32, pl. 41) for the altarpiece in Santa Croce, 1570–74, reveals strongly Zuccaresque anatomies combined

with an attempted purification and naturalistic effect. A younger Florentine, Domenico Cresti, called Passignano (1558–1636), was to have a similar experience with Federico Zuccaro, whom he met and worked with in Florence in the mid 1570s, accompanied to Rome and then to Venice, where he resided from 1581–89. The wiry calligraphy of the Zuccaros' vocabulary combines in Cresti's work with a typically Venetian colorism in this monumental drawing on blue paper (cat. 48, pl. 43).

By the end of the sixteenth century, Tuscany had ostensibly lost the position of artistic innovation and prominence it had held in the century's opening years, but the flexibility and continual reevaluation demonstrated by artists in Tuscany during this period marks it as an intriguing blend of progressive and archaizing influences of significance for the resolution of the Maniera and the awakening of the Baroque. The reformers in Florence were led by Santi di Tito, whose ideals were to be more forcefully paralleled by the contemporary theories and teachings of the Carracci in Bologna. Jacopo Chimenti da Empoli (1551–1640) continued Santi's quest for naturalism and classicism, and his emphatic reference to Andrea del Sarto is clearly evident in the drawing here attributed to him (cat. 41, pl. 50). Alessandro Casolani (1552–1606?), trained under the Roman Mannerist Cristofano Roncalli and influenced greatly by Barocci, was to serve as the modest but foremost example of avant-garde naturalism in Siena at the same time (cat. 42–43, pls. 49, 51). Finally, adventurers such as Cresti and Ludovico Cardi, called Il Cigoli (1559–1613), in Florence became receptive to artistic currents from all parts of Italy, especially Venice. Cigoli looked to Barocci and his sources in Parmese art, to Venice, to Rome, and to Bologna to renew his art and became one of the leaders of the avant-garde in Florence. In the large compositional study of *The Marriage of the Virgin*, given to Cigoli (cat. 50, pl. 58), his keen observations of Parmigianino's interpretation of Raphael's classical *Stanze* is matched by Barocci's light and Venetian colorism; the linear flow of Ludovico Carracci's drawing style (cf. pl. 52) is noticeable in the other examples of Cigoli's draftsmanship presented here (cat. 49, pl. 59). Biliverti (1576–1644), of Flemish descent, was one of Cigoli's most significant followers who, along with the spirited Frenchman Jacques Callot, heralded the transition to seicento art in Florence (cat. 55, pl. 57). At the same time in

the provincial towns of the North, Guglielmo Caccia, called Moncalvo (ca. 1568–1625), provided an individual but curiously backward-looking vision of devotional art (cat. 52, pl. 56).

The transition to the new century was perhaps the smoothest in Bologna, which developed during the course of the sixteenth century from a provincial artistic center under Tusco-Roman influence (seen in Passarotti's early pilgrimage to Rome), to a major autonomous artistic capital of the greatest influence for subsequent centuries. The achievement of this prominence was due entirely to the innovative talent and determination of the Carracci. Ludovico Carracci (1555–1619) and his two younger cousins Annibale (1560–1609) and Agostino (1557–1602) together initiated an active campaign for the reformation of Italian painting from Mannerist artificiality to renewed study of nature, antiquity, and the classical masters of the High Renaissance. To further these ideals, in 1582, they founded the Accademia degli Incamminati, where the most significant students of the Bolognese school were taught these principles, with particular emphasis on drawing, especially drawing from life. Ludovico, who never left Bologna, became the leader of the school, and the influence of the fluid movement of line in his drawings (cat. 44, pl. 52) has already been observed. Agostino achieved fame as an engraver as well as a painter, and it is this aspect of his work that is most evident in the two drawings in Chicago: one, a calligraphic fantasy (cat. 47, pl. 53), the second, a solidly observed portrait of his son, built up of sculptural chalk strokes (cat. 46, pl. 55). Although no certain example of Annibale's superior draftsmanship is represented in the Art Institute, an unusual and rare drawing by the fourth and last major artist of the Carracci family, Antonio (ca. 1583–1618), the son of Agostino, has been recently added to the collection. As *The Portrait of Antonio* by Agostino, *The Virgin, the Holy Women, and Saints John, James, and Joseph of Arimathea with Christ on the Way to Calvary* by Antonio (cat. 58, pl. 65) comes from the famed Ellesmere Collection of Carracci drawings; in a restricted way, it suggests the landscape style as well as the dramatic narrative ability of his uncle Annibale's art.

The impact of the Carracci on fellow Bolognese artists and followers is demonstrated in figurative drawings by Bartolomeo Cesi (1556–1629; cat. 45, pl. 54), Francesco Albani (1578–1660; cat. 56, pl. 63), Domenichino

(1581–1641; cat. 57, pl. 64), and Guido Reni (1575–1642; cat. 54, pl. 62). Significant also for their work was the experience of Rome: Annibale was the first to establish himself in Rome (ca. 1595); he was soon joined by his brother Agostino and nephew Antonio, in 1600, by Reni, and, in 1602, by Domenichino and Albani. It was again in Rome, under the guiding spirit of Raphael and in the face of late Maniera artists such as Baglione (1571–1644; cat. 53, pl. 60) and Giuseppe Cesari, Il Cavaliere d'Arpino (1568–1640; cat. 51, pl. 61)—one-time instructor of their rival, Caravaggio—that the Carracci and their school achieved their greatest works of monumental classicism and left a frescoed legacy for future generations of Baroque artists.

There are no known drawings by that other leader in Rome in the opening years of the seventeenth century, Caravaggio. Nonetheless, his influence was strongly felt by Neapolitan artists, such as the Spaniard Ribera (1591–1652; cat. 59, pl. 67). It is especially evident in the drawings of the Bolognese artist Giovanni Francesco Barbieri, called Guercino (1591–1666) where the flowing linearism of Ludovico Carracci joins the heightened emotionalism and realism of Caravaggio's paintings; the dramatic coloration and chiaroscuro are expressed in subtly applied washes and pools of ink (cat. 60–63, pls. 66, 68–70). The eventual modification of this bold pictorial style under the classicizing influence of Reni, whom Guercino succeeded in 1642 as the leader of the Bolognese school, is not evident in the present selection. The Carracci landscape tradition was carried on in seventeenth-century Rome by G. F. Grimaldi (1606–80; cat. 69, pl. 72); at the same time Alessandro Algardi (1602–54; cat. 68, pl. 71) served as Bologna's classicizing counterpart in Rome to the High Baroque sculpture of Bernini.

Bernini's equivalent in painting and one of the leaders of the High Baroque in Rome was Pietro da Cortona (1596–1669). Based on study of the Roman works of Annibale Carracci, the High Renaissance and antiquity, Cortona and Bernini infused their works with passionate expression and dramatic movement, as vividly demonstrated in the forceful drawing *The Holy Trinity with Saint Michael Conquering the Dragon* (cat. 65, pl. 75). The fluid freedom of Cortona's line is more clearly seen in his first-thought sketch of *The Martyrdom of Saint Stephen* (cat. 64, pl. 74).

Another artist who demonstrated a similar calligraphic ability and ap-

proached the High Baroque splendor of Cortona was the Genoese artist, Giovanni Benedetto Castiglione (1609 to ca. 1665), who worked in Rome from 1634 to 1648. He was accepted into the most selective and intellectual circles of Nicolas Poussin and Claude Gellée, and the often enigmatic subject matter favored by that circle is seen in the monumental *Pagan Sacrifice* (cat. 72, pl. 82). The pastoral and animal subjects which were a part of Castiglione's Genoese repertory, inspired by Dutch and Flemish art, are represented in three examples (cat. 71, 73–74, pls. 79–81).

A more severely traditional current in Rome is witnessed in the staid *Head of a Cleric* by Sassoferrato (1609–85; cat. 75, pl. 84), a puzzling figure whose archaic classicism is not explained entirely by the continuing influence of Guido Reni. By contrast, Pier Francesco Mola (1612–66) shows a more liberated and receptive approach: apprenticed alternately to Cesari, Albani, and Guercino, Mola spent a period in Venice before returning to Rome, where Poussin's classical compositions and Cortona's volatile line combined in his work, as seen in the large sheet here attributed to him (cat. 78, pl. 83). At the same time the Neapolitan Mattia Preti (1613–99)—trained under the influence of Ribera, Guercino, Lanfranco, and Cortona—had a direction more clearly related to Caravaggio, evident in his highly pictorial, spontaneous red chalk sketches for the central commission of his career, the frescoes for Saint John at La Valletta (cat. 79, pl. 85). Luca Giordano (ca. 1632[?]–1705), a pupil of Preti's, inherited this impulsive manner but clothed it in a wide range of drawing styles. The sheet exhibited here (cat. 88, pl. 91) reveals his most painterly style, no doubt produced during his late Spanish period, under direct inspiration of the late Venetian *Poesie* of Titian. In fact, Giordano had spent several years actually in Venice, about 1685, and developed what has been called a neo-Venetian manner which one can recognize here.

The classical movement that dominated art of the second half of the seventeenth century in Rome was led primarily by one man, Carlo Maratta (1625–1713), and his foremost vehicle was the altarpiece. Heir to the drawings and tradition of Domenichino, Maratta himself showed a variety of drawing styles, from carefully observed chalk life studies to more energized, inventive pen and ink compositional sketches, such as the one included here

(cat. 85, pl. 94). Maratta's impact was enormous, and he had many students and followers: among the most devoted was Giuseppe Bartolomeo Chiari (1654–1727; cat. 92, pl. 95).

Finally, juxtaposition of two monumental compositions of church interiors by Francesco Allegrini (ca. 1624 to ca. 1663; cat. 84, pl. 99) and Pietro Antonio de' Pietri (1663–1716; cat. 93, pl. 100), a follower of Maratta, summarizes something of the diversity in Roman Baroque art. Allegrini's highly conservative direction looks back beyond his training under Cortona to cinquecento Mannerists, while Pietri's yet somewhat mannered figures (dated ca. 1715), in their broad movements and looser handling, mark the slow transition to the eighteenth century in Roman religious art.

If more unconventional than their Roman and Bolognese counterparts, the few examples of Florentine seventeenth-century draftsmanship of the present selection may also be said to be more visionary, more prophetic of the next century than the works already examined. This is most apparent in the work of Francesco Montelatici, called Cecco Bravo (1607–61) whose *Dream of Cecco Bravo* (cat. 70, pl. 77) presents a fantastic image of floating bodies and angelic creatures. Despite its rubbed condition, the pictorial handling of the chalks and the expressive quality of line seem to transcend the provincialism of contemporary Florentine art. Similar atmospheric effects and spirited characters are found in the evocative drawings of Stefano della Bella (1610–64), such as the *Dancer* (cat. 76, pl. 78). Like Biliverti, a follower of Callot, della Bella produced a vast graphic oeuvre and had the broadening experience of a period of work in Paris (1639–50). His significance within the mainstream of Italian draftsmanship should not be discounted; highly esteemed in his own day, della Bella can be compared with individual pictorial Baroque masters such as Castiglione and Cortona.

Of the present catalog, only Anton Domenico Gabbiani (1652–1726), a pupil of a pupil of Pietro da Cortona, shows the direct link of Florentine art to the strong Roman tradition established in Florence by Cortona's visits in 1637, 1640–42, and 1644–48, and his decorations for the Palazzo Pitti, continued by his follower Ciro Ferri. Gabbiani studied with Ciro Ferri in Rome from 1673–78, so it is not surprising to find something of Cortona's bravura and excitement in *The Apotheosis of Hercules* (cat. 91, pl. 98). Classi-

cism was continued in Florence by Giovanni Domenico Ferretti (ca. 1692 to ca. 1769) who, however, received his training in Bologna for the most part. A more restrained Maratta-styled classicism, which Gabbiani also developed, was carried late into the eighteenth century by Gabbiani's pupil G. B. Cipriani (1727–85; cat. 146, pl. 157).

Bologna itself became more insular during the course of the seventeenth century with the passing of the Carracci and their first-generation followers, particularly on the death of Guido Reni in 1642. Perhaps the most gifted draftsman of the generation to succeed Reni in Bologna was Simone Cantarini (1612–48), whose glowing sheet of studies is one of the treasures of the Gurley Collection (cat. 77, pl. 89). It may be compared with the relatively dry rendition of the *Rest on the Flight into Egypt* by Cantarini's pupil, Flaminio Torre (1621–61; cat. 81, pl. 88), who worked more strictly in Reni's mode.

A pupil of Reni, Domenico Maria Canuti (1620–84) branched out of Bologna with two journeys to Rome (1651, 1672–75), where he developed a heavily dramatic *quadratura* fresco technique for ceiling decorations. The highly emotional tenor of his figures thus viewed from oblique perspectives is evident in his study for the *Head of a Nun* for the *Ecstasy of Saint Dominic* (cat. 80, pl. 87). Albani's pupil, Carlo Cignani (1628–1719), who carried on the classical tradition of the Carracci school, shows an emotional and technical polish similar to that of Canuti which often, as in the case of this drawing, verges on the sentimental (cat. 87, pl. 86).

The evocative works of Donato Creti (1671–1749) mark the transition to the eighteenth century in Bologna (cat. 96–97, pls. 104–5). Although revealing the classical foundations and lyrical poignance of Reni's heritage, it is difficult to place Creti's genius strictly within his native school. The divergent styles of the two drawings listed here show his simultaneously archaistic and progressive, Rococo tendencies. The last artists to fall properly within the academic Bolognese tradition were the brothers Gandolfi (cat. 147–48, pls. 153–54) and their school in the eighteenth century, who enriched their native classicism with Rococo elements gleaned from the Venetian environment where they worked from about 1760 on.

Finally, within the tradition of *quadratura* painters in Bologna, a distin-

guished member of the Galli-Bibiena school, Mauro Tesi (1730–66), is represented by a dazzling *Architectural Fantasy* (cat. 150, pls. 158–59). It was in this area, which developed alongside the academic tradition, that the Bolognese school made its greatest contribution to the art of the eighteenth century.

Few strictly architectural drawings can be found in this collection, but one superb example is a drawing by Filippo Juvarra (1676–1736; cat. 98, pl. 103) for an altar in Santissima Trinità in Turin. Trained in Rome (1703–14), Juvarra was enlisted for commissions all over Europe but ultimately he settled in Turin for the rest of his short career. Although his base was in the Roman architecture of Cortona and Borromini, Juvarra's synthesis and innovations transcend all categories and schools. While he revitalized artistic and architectural programs in the Piedmont, it must be said that—in terms of the development of Italian draftsmanship—his contribution was an isolated, individual one.

Genoa was the provincial center that developed the most significant local school during the course of the seventeenth century, with resonances that carried well into the Rococo art of the eighteenth. Although, of its greatest artists, Castiglione and Gaulli left Genoa for Rome and Strozzi settled in Venice, a strong native decorative tradition that grew out of Cambiaso and his followers continued to strengthen from within and came to be widely influential in its own right.

Of the string of Genoese draftsmen represented in Chicago, Giulio Benso (ca. 1601–68; cat. 67, pl. 76) is surely the most idiosyncratic, working with an easily identifiable, nervous line in the narrative Genoese mode. The more famous artist, Valerio Castello (1624–59; cat. 82–83, pls. 92–93), also worked with a cursive pen stroke, but for more fully Baroque, less mannered effects. Drawings of his are extremely rare because of his tragically short career, and the Art Institute is fortunate to have two telling examples of his work.

It was primarily Domenico Piola (1627–1703) and his son-in-law Gregorio de Ferrari (1647–1726) who brought Genoese decorative art to its culmination—a combination of Roman theatricality, Parmese color and light, and native Genoese animation that rivalled the High Roman Baroque and prophesied the Rococo. The absorption of Central Italian influences is most clearly

seen in the *Descent from the Cross* by Piola (cat. 86, pl. 90); the creative leap made by Ferrari is visible in *Female Figures with Putti in Clouds* (cat. 90, pl. 97). Ultimately, however, the most fantastic artistic talent native to Genoa was the bizarre and visionary Alessandro Magnasco (ca. 1667–1749), represented here by two superb examples of his agitated draftsmanship (cat. 94–95, pls. 101–2). Trained in Milan, where he remained until 1735, Magnasco, like Creti, is more difficult to locate within the Genoese school, for he seems to have absorbed many divergent influences into his own highly personal style. Magnasco may be seen as a truly transitional figure: rooted in seventeenth-century sources, he had a lasting impact on the art of the eighteenth century, particularly in Venice.

Among the rarest pieces in this collection is a large study sheet by the seventeenth-century Venetian artist Andrea Celesti (1637–1712[?]; cat. 89, pl. 96), whose roots in Palma Giovane are clearly apparent. The other trend present in Venice in the late seventeenth century has already been mentioned—the neo-Venetian manner of Luca Giordano's decorations there. But it was not until the eighteenth century that Venice once again dominated the Italian artistic scene.

Although the present selection does not include examples by either Sebastiano or Marco Ricci, two extraordinary draftsmen who initiated the Rococo explorations of the new century, it does include two characteristic works by Sebastiano Ricci's pupil and closely similar follower, Gaspare Diziani (1689–1767; cat. 109–10, pls. 117–18). At the same time that Diziani was studying with the virtuoso Ricci, another Venetian artist, of quite different personality, Giovanni Battista Piazzetta (1682–1754), was developing a more careful, painterly, and expressive style under the direction of Giuseppe Maria Crespi in Bologna (until ca. 1711). Piazzetta's masterly character studies visualized with powerful effects of atmosphere and luminosity are presented in the unsurpassed examples of the Regenstein collection (cat. 99–107, pls. 106–14). In these various head studies, it may be said that the noble Bolognese tradition of drawing from life and the sensuous Venetian emphasis on coloration and rich effects of chiaroscuro meet in perfect synthesis. Beside this array of nine portraits from the Schulenburg collection

can be seen a double-sided sheet of rapid compositional sketches belonging to a limited group of such private, preparatory drawings attributed to Piazzetta (cat. 108, pls. 115–16).

Undoubtedly the greatest artistic genius in Venice in the eighteenth century was Giovanni Battista Tiepolo (1696–1770) and the drawings presented here may be seen to represent each of the various aspects of his rich and productive career. One of the earliest drawings known by Giambattista is the monumental *Meeting of Abraham and Melchizedek* (cat. 112, pl. 120), which may be related to his early fresco style in Udine (ca. 1725). The *Three Angels Appearing to Abraham* (cat. 113, pl. 121) shows the artist's subsequent development and the beginning of his use of white paper to accentuate his compositional groups. Tiepolo's work as an illustrator is demonstrated in the *Temptation of Saint Anthony* (cat. 114, pl. 122), later engraved by Pietro Monaco. The artist's full maturity is stunningly represented by two works drenched in luminosity and of the sparest description: *Two Monks Contemplating a Skull* (cat. 115, pl. 124) and *Fantasy on the Death of Seneca* (cat. 116, pl. 123). His sense of humor can be seen in his vaguely sinister drawing, *Punchinellos' Repast* (cat. 117, pl. 125) and the more satiric caricatures (cat. 118–19, pls. 126–27). The ultimate tenderness and dissolution of line in light of Tiepolo's last years is testified in the *Rest on the Flight into Egypt* (cat. 120, pl. 128).

Two of Giambattista's sons, Giovanni Domenico and Lorenzo, were trained by their father and became valued members of his studio. The confusion that has arisen, however, concerning the precise authorship of the red chalk drawings on blue paper that were a product of the studio is demonstrated in the four examples presented here: two may be rather securely given to Giambattista (cat. 121–122, pls. 129–30), but the other two are more reasonably given to Giandomenico (1727–1804; cat. 123–24, pls. 131–32), whose more dry, descriptive line never equalled the sublime creations of his father.

The *vedute*, or view paintings, were a unique product of Venice in the eighteenth century, and it is significant that the best artists created finished works on paper as often as on canvas. The earliest artist in this category is Antonio Canal, called Canaletto (1697–1768), with one unusual rapid sketch

(cat. 125, pl. 135) and two more characteristic *vedute* in pen and brown ink with variations of gray wash (cat. 126–27, pls. 133, 136). One of these evokes his native Venetian environment, and the other has such strong suggestions of Rome that it supports the theory that Canaletto must have travelled there at one or more points in his life.

Among the most controversial drawings in the present group is the large composition of the *Ridotto* (cat. 128, pl. 134), a rare specimen by Giovanni Antonio Guardi (1699–1760). The inclination of some scholars to attribute it to his more famous brother and pupil, Francesco (1712–93), may be overcome when it is compared with four prime examples of Francesco's drawing style, in both rare figurative works (the *Adoration of the Shepherds*, cat. 133, pl. 139) and the more characteristic *vedute* (cat. 133–35, pls. 140–42), of unparalleled quality. One can easily read the impact of Magnasco's art in the spirited figures and agitated pen stroke of Francesco.

One other artist known primarily for his Venetian landscapes was neither Venetian nor is he to be seen here as a landscape artist. Francesco Zuccarelli (1702–88) was more correctly Florentine, but he settled in Venice in 1730 as a disciple of Marco Ricci and adopted not only the vocabulary but the stylistic characteristics of Venetian artists. Even in this rare *Portrait of an Old Man* (cat. 130, pl. 138), the atmospheric qualities of Venetian drawings on blue paper characteristic since the time of Carpaccio can be seen.

The last great Venetian artist of the eighteenth century was Giandomenico Tiepolo, whose style, though of a different nature from that of his father, exhibited extraordinary consistency throughout his long career and can be considered a natural transition to the nineteenth century. Each of his major series of drawings contained 102 numbered works; four of them are represented here by two drawings apiece: the majestic drama of *God the Father Supported by Angels in the Clouds* (cat. 138–39, pls. 145–46); animals looking rather unnatural but lively (cat. 141, pl. 150) and the sensuous wit of the satyr series (cat. 140, pl. 152); the dramatic power of the large biblical series (cat. 142–43, pls. 147–48); and finally, the poignant spoofs of the drawings of the life of Punchinello (cat. 144–45, pls. 149, 151). Many of these drawings relate to his own or his father's decorative cycles, yet the drawings maintain an autonomous individuality as works of art in their own right. This is less true

of the spectacular ceiling decoration created by Pietro Novelli (1729–1804; cat. 149, pl. 160) in a dry and linear but splendidly colorful Rococo design.

Giovanni Battista Piranesi (1720–78) found his roots and later his rejuvenation in Venetian art, the *vedute*, and the fantastic decorations of the Tiepolo family; but it was in Rome that he established his monumental theatrical style based on architecture and antiquity. His Venetian heritage is strongly felt in the atmospheric rendering of the *Palatial Courtyard* (cat. 136, pl. 143) while the spirited *Sheet of Six Figure Studies* (cat. 137, pl. 144) relates more directly to creations by the Guardi and Giandomenico Tiepolo than to anything produced in Rome at that time.

It must be said that Roman draftsmanship closed in the eighteenth century with less *éclat* than in any previous century. Here the late Rococo sculptural style was represented by Pietro Bracci (1700–1773; cat. 129, pl. 137); Maratta's classicism was perpetuated and diluted by Stefano Pozzi (1708–68; cat. 131–32, pls. 155–56), who worked on blue paper in an attempt to infuse his work with contradictory Venetian atmospheric effects and Rococo lightness; and Giuseppe Cades (1750–99; cat. 151, pl. 161), who culminated the longstanding tradition of *disegno* in the last years of the eighteenth century with a prominent forecast of Neoclassical art of the nineteenth century to come.

SUZANNE FOLDS MCCULLAGH
Assistant Curator of
Prints and Drawings

CATALOG

Anonymous North Italian
mid-fifteenth century

I *Bust of a Young Priest in Profile* (pl. 1)

Inscribed recto, upper center, in pen and brown ink: *joane badille²[?] prete;* inscribed recto, upper right, in pen and brown ink: *10;* inscribed recto, left margin, in graphite: *38;* inscribed verso, at left edge, in graphite: *39, 40.*

Silverpoint, on prepared gray-white ground, on salmon-tinted paper; 241 x 174 mm.

COLLECTIONS: Moscardo, Verona, script (Lugt Suppl. *2990b–g?*); recto, upper center, in pen and brown ink; acquired from Richard Zinser, New York.

LITERATURE: Frankfurter, " 'Il bon disegno' from Chicago," *Art News* 62:29, reproduced; Sonkes, *Dessins du XVᵉ siècle,* pp. 252–54, 275, pl. 68, no. E21.

EXHIBITIONS: *Master Drawings from the Art Institute of Chicago,* no. 1, reproduced; *Catalogue of the Carl O. Schniewind Memorial Exhibition,* no. 1, reproduced; Joachim, *A Quarter Century of Collecting,* no. 2, reproduced; Pignatti, *Venetian Drawings,* p. 5, no. 1, reproduced.

Margaret Day Blake Collection, 1957.79

On the basis of hair style and clothing, this drawing should be dated to the middle of the fifteenth century, but its place of origin is more problematic. When the drawing came to the Art Institute, it was considered Flemish (circle of Rogier van der Weyden). Philip Pouncey suggested that the work might be Veronese, and this idea has been generally accepted because of its resemblance to the refined portraiture of Pisanello.

Recently, Terisio Pignatti has proposed Michele Giambono as the artist; he was active primarily in Venice about 1420–62, but was in Verona around 1430.

Whether the name "Joane [Giovanni] Badille" refers to the artist, the subject, or the owner of the drawing is hard to determine. The Badiles were a prolific clan of artists in fifteenth-century Verona, and one Giovanni Badile, who lived between 1379 and 1478, was a follower of Stefano da Zevio. Comparison with drawings by Giovanni Badile, such as those sold at Sotheby's, London, on October 21, 1963, is not entirely conclusive because of differences in technique.

But, the inscriptions that appear on this sheet and on those sold at Sotheby's seem to be by the same early hand, which is a characteristic feature of drawings from the Moscardo Collection (Lugt Suppl. 2990b–g) in Verona. Recently these inscriptions have been identified by Bernhard Degenhart as the hand of Antonio II Badile (d. 1507) who, in about 1500, gathered a group of his family's drawings into a notebook and inscribed each with the particular artist's name (see Degenhart and Schmitt, *Italienische Zeichnungen,* p. 50, nos. 3–4, pls. 2–3).

Micheline Sonkes has tentatively attributed our sheet to Giovanni II Badile—a little-known son of Giovanni I (mentioned above)—who was identified as an artist of profile portraits in the notebook of Antonio II. As Bertha Wiles has suggested, the number "2" in the inscription may support this hypothesis, that the drawing is the work of Giovanni *secondo,* while the word *prete,* "priest," undoubtedly refers to the sitter.

NOTE: Measurements are given in millimeters, height before width; in the case of an irregular shaped sheet, the maximum dimensions are noted.

Antonio Pisano (Pisanello)

Pisa ca. 1395–ca. 1455 Rome(?)

2 *Studies of the Emperor John VIII Palaeologus, a Monk, and a Scabbard*, recto (pl. 4)
Bowcase and Quiver of Arrows, verso, 1438 (pl. 5)

Inscribed recto, center, in pen and brown ink: *chaloire*[?].
Pen and brown ink, on ivory laid paper; 190 x 266 mm.
WATERMARK: Oxhead (Briquet 14.811, Vicenza, 1423).
COLLECTIONS: Private collection; acquired from Wildenstein & Co., New York.
LITERATURE: Venturi, *Pisanello*, p. 37, n. 1, pl. 32 (verso), pl. 33 (recto); Degenhart, *Pisanello*, pp. 44, 65, n. 26; Brenzoni, *Pisanello pittore*, p. 210, pl. 84 (recto, mistakenly cited as belonging to the Louvre); Degenhart, "Di una publicazione su Pisanello e di altri fatti (I)," *Arte Veneta* 7:182, n. 2; Fasanelli, "Some Notes on Pisanello and the Council of Florence," *Master Drawings* 3:36–47, pl. 30 (verso), pl. 31 (recto); Fossi Todorow, *I Disegni del Pisanello*, pp. 30–31, 81, no. 58, pls. 69 (recto), 71 (verso); Fossi Todorow, *L'Italia dalle origini a Pisanello*, p. 92, fig. 39 (verso); Vickers, "Some Preparatory Drawings for Pisanello's Medallion of John VIII Palaeologus," *Art Bulletin* 60:417–24, figs. 7 (recto), 8 (verso).
EXHIBITIONS: *Master Drawings from the Art Institute of Chicago*, no. 2, pl. 3 (recto); Joachim, *A Quarter Century of Collecting*, no. 1, reproduced (recto).
Margaret Day Blake Collection, 1961.331

This sheet and a similar one in the Louvre (M.I. 1062; see Fossi Todorow, *I Disegni del Pisanello*, pp. 80–81, pls. 68, 70) are visual records of the visit of John VIII Palaeologus, Emperor of Constantinople, and Joseph II, Patriarch of the Eastern Orthodox Church, to Ferrara for the convening of the Council of Florence in 1438. These meetings lasted for over a year, and it probably was not until 1439 that Pisanello finished his famous medallion in commemoration of the event, with the profile portrait of the emperor on the obverse and a scene of the emperor on horseback in a landscape on the reverse (see Weiss, *Pisanello's Medallion of the Emperor John VIII Palaeologus*, frontispiece and pl. 1). Recently, however, Michael Vickers has suggested ("Some Preparatory Drawings for Pisanello's Medallion of John VIII Palaeologus," *Art Bulletin* 60:417–24) that the Louvre and Chicago sheets are almost entirely dedicated to depictions of the emperor and thus may represent the earliest known preparatory stages for the medallion, dating from 1438.

A close connection between the Louvre and Chicago sheets has always been assumed. Not only are they similar in subject matter and drawing style, but an inscription on the Louvre drawing precisely describes the quiver, bow, and scimitar of Turkish type which are delineated on the Chicago sheet. Furthermore, the pages were probably once of similar size (the page in Chicago seems to have been trimmed) and may have been part of the same sketchbook.

Concerning the identification of figures on these two sheets, Fasanelli has suggested that the figures represent various members of the Greek retinue as observed by Pisanello during a certain procession on a particular day and that none of the major protagonists of the council can be found on the drawing in Chicago. The horseman is considered by some to be the aged Patriarch Joseph II, though unlikely to be found armed, and by Fasanelli to be "a mounted archer or squire-dwarf," but he has been identified by Vickers as the short, "stoop-shouldered" emperor. Except for the pointed hat, he is equipped with the very quiver, bow, and scimitar that are shown on the reverse of the medallion.

Other portraits of the emperor in various costumes and postures can be recognized on the Louvre and Chicago sheets on the basis of his physical traits and from the inscriptions on the drawing in the Louvre. Vickers identifies the two figures at the right of the recto of the Chicago sheet as the emperor, dressed in the ceremonial robes he received as a present from the Sultan of Egypt; when he is seen full-face, his short forked beard appears just as it did when Piero della Francesca represented him as Constantine the Great in the Arezzo frescoes. Thus the artist tried out many different possibilities in preparation for his planned portrait or medallion of the emperor. Pisanello experimented equally with formal attire and hunting costume, but he eventually settled on the latter; it seems an appropriate choice, for the emperor apparently spent most of his time during the council hunting in the region around Ferrara. In fact, it is likely that these sheets were drawn while the emperor was a guest at a convent near Ferrara from summer through winter, 1438, where he freely indulged his passion for the hunt.

Only one image on the page in Chicago does not fit the emperor's description: the central figure, seen from the back, with an inscription above it. The inscription has been read by some as *chalone* (cardinal's hat), but Middeldorf has suggested that it might be read *chaloire*, a phonetic interpretation of the vocative of the Greek word *kalogeros* or "monk."

This drawing may be regarded as a critical moment in Pisanello's stylistic development. On the one hand, the carefully executed ornamental details of the bowcase, quiver, and scabbard are characteristic of his works of the fourth decade, such as the studies for *Saint Anastasius*. On the other hand, a new direction—exploring the effects of light, greater modelling, and the description of movement—can be seen in the rapid life-

sketches of the emperor and the monk on both the Louvre and Chicago pages. It is the Chicago sheet which, according to Fossi Todorow, in its stylistic combination of the old and the new, further secures the date and attribution of both drawings within Pisanello's oeuvre.

Anonymous North Italian
fifteenth century

3 *Papal Prophecy*, folios 2 recto and 6 verso (pls. 2 and 3)

Gloss on folio 6 verso inscribed, upper center, in pen and brown ink: *1462 | Pius Secundus de Senis;* inscribed at upper right, in pen and brown ink: *Defert lunam in capite | quia eius arma lunis | quinque descripta;* inscribed at left, in pen and brown ink: *Nota quod nepotes Pii deferebant | in eorum scutis agnum. Unde in hoc | quod tenet mitram super agnos quia | multum studuit suos magnificare | nepotes ut clare patuit;* inscribed lower center, in pen and brown ink: *Nota quod ubi prophetia dicit iste habebit septicolis imperium intelligi potest de | civitate Senarum que iste est super septem coles, quia ante creationem istius ad | summum pontificium eius progenies fuerat primata regimine dominii | civitatis expulsi a dominio eorum (ab his) qui modo regnant. Tunc eo sancto | summo pontifice eius intuitu reversi sunt una cum istis qui regnant | in dominium et hoc modo dici potest iterum habuisse imperium septicolis | quia eius progenitores fuerunt dominatores Senarum et postea fuerunt ex- | pulsi et tempore istius eius cognatio redierunt ad dominum civitatis.*

Pen and brown ink; text in pen and brown, red, and black inks; gloss in pen and brown ink; on vellum; maximum 238 x 170 mm. per page.

COLLECTIONS: Acquired from Richard Zinser, New York.
LITERATURE: See Degenhart and Schmitt, *Corpus der italienischen Zeichnungen* (forthcoming).

Clarence Buckingham Collection, 1944.165

This manuscript contains a group of prophecies predicting the fall of a corrupt papacy and the subsequent rise of a new order of angelic popes. The text is a characteristic Latin adaptation of fifteen Byzantine prophecies brought to the West in 1304 by a small group of spiritual Franciscans returning from political exile in Constantinople. The fifteen oracles they brought back predicted the fall of the Comnenian dynasty and the mystical resurrection of a new, pure ruler appointed directly by God. In adapting these to the Roman papacy, very little adjustment was necessary; frequently, however, commentaries or glosses were appended to clarify the text and identify the prophecies with contemporary popes.

In this case, the gloss (dated 1462 on folio 6 verso) helps to place the manuscript in or right after the middle of the fifteenth century. The illustrations of the text follow closely the iconography of a mid-fourteenth-century Venetian model (Vat. lat. 3819; Rome, Biblioteca Vaticana), and the drawing style further supports a north Italian origin for the manuscript. It compares with drawings of Stefano da Zevio, Gentile da Fabriano, and Pisanello in its delicate line work, broad physiognomies, airy parallel hatching, and hooked pockets of shading (see Fossi Todorow, *L'Italia dalle origini a Pisanello*, pls. 25–30).

The gloss identifies the protagonists of the prophecies with popes of the recent past, from Pope Gregory XII (1406–15) through Pius II (1458–68). Certain features that emerge from the commentary help to characterize the glossator as someone who was familiar with the Venetian and Sienese personalities, less so with the one Spanish pope, Callistus III (1455–58), and who had a particular dislike for Pius II. Since he is the last pope mentioned in the manuscript, and the gloss is mostly written in the present tense, it seems likely that the date 1462 (written above Pius) is the year in which the commentary was appended and that the illustrations were done earlier. Mary Quinlan has pointed out that the glossator, writing during Pius's reign, has, in fact, gone to extreme lengths to condemn him and his family.

Although meticulously faithful to details of iconography of the mid-fourteenth-century Venetian model, evident in such minutiae as the position of the bird on the Pope's tiara on folio 2 recto, there is one illustration that varies considerably from the norm. On folio 6 verso, the page condemning Pius II, Enea Silvio Piccolomini, there are only two lambs, whereas four are traditionally shown. Close examination indicates that two of the four have been scraped away, no doubt by the glossator himself, who interprets these two remaining lambs as Pius's nephews, each of whom bore a lamb on his coat-of-arms. In the gloss, it is made quite clear that Pius "holds the mitre over the lambs because he was very eager to glorify his nephews"! Quinlan has questioned the glossator's animosity in this case (history has shown that the nephews of Pius II were scholarly and worthy men); furthermore, nepotism is more appropriately alleged against Pius's predecessor, Callistus III, or Eugene IV. Finally, in the last lengthy paragraph, the glossator includes a diatribe against Pius II's family and ancestors—an unintentionally illuminating commentary on the character of the glossator himself. What grudge did he bear against the pontiff?

From such interpretive evidence, it may be possible one day to locate the origin of the manuscript more precisely. However, from the remark on folio 5 recto, that "the painter has erred," it may be concluded that

the glossator received the codex fully finished and that there was no collaboration on his part with the artist.

Vittore Carpaccio
Venice ca. 1460 or 1465 to 1523 or 1526

4 *Two Kneeling Clerics*, recto (pl. 7) *Standing Youth*, verso, 1507–8 (pl. 6)

Brush with gray and black wash and white gouache, over traces of black chalk, on blue laid paper (recto and verso); 195 x 253 mm.

COLLECTIONS: Lt. Col. Norman R. Colville; Dr. Francis Springell, sale: London, Sotheby's, June 28, 1962, lot 13, reproduced; acquired from Richard Zinser, New York.

LITERATURE: Popham, "The Drawings at the Burlington Fine Arts Club," *Burlington Magazine* 70:87–88; Tietze and Tietze-Conrat, *Drawings of the Venetian Painters*, p. 153, no. 618, pl. 16, fig. 3 (recto) and pl. 22, fig. 2 (verso); Fiocco, *Carpaccio*, p. 29, no. 3; Pallucchini, *I Teleri del Carpaccio*, p. 49; Lauts, *Carpaccio*, pp. 37, 257, 272, and 277, no. 31, pl. 120 (verso) and pl. 139 (recto); Maxon, "A Sheet of Drawings by Carpaccio," *Art Institute of Chicago Quarterly* 56:62–64, reproduced (recto and verso); Pignatti, Review of *Carpaccio: Paintings and Drawings* by Jan Lauts, *Master Drawings* 1:53; Perocco, *Carpaccio nella Scuola di San Giorgio degli Schiavoni*, p. 79, fig. 53 (verso); Muraro, *Carpaccio*, p. 109; Joachim, *Helen Regenstein Collection*, pp. 8–9, no. 1, reproduced (recto and verso).

EXHIBITIONS: Zampetti, *Vittore Carpaccio*, p. 298, no. 24, reproduced (recto and verso); *Master Drawings from the Art Institute of Chicago*, no. 4, pl. 2 (verso).

Helen Regenstein Collection, 1962.577

Drawings done with a fine-pointed brush in black and white on blue paper are a Venetian specialty developed in the fifteenth century. Such drawings are not the first ideas for paintings, but rather preliminary studies for individual figures whose roles in the paintings had already been determined. In particular, Vittore Carpaccio —the Venetian master of narrative painting under the influence of the Bellinis in the early cinquecento—relied on such drawings in refining the individual elements of his often complicated cycles.

This sheet demonstrates Carpaccio's involvement in two distinct but simultaneous commissions. The elegant *Standing Youth* can be found with slight variations in the center of *Saint Tryphon and the Basilisk*, the last of the cycle in the Scuola di San Giorgio degli Schiavone, executed in 1507–8. *The Two Kneeling Clerics* was destined for *The Pope Presenting a Ceremonial Parasol to Doge Sebastiano Ziano* in the History of Ancona cycle in the Sala del Gran Consiglio of the Doge's Palace in Venice.

An approximate date for Carpaccio's involvement in the latter project is suggested by a document of Sep-

tember, 1507, mentioning his role as an assistant to Giovanni Bellini in the completion of the decoration in the Great Council Hall. The painting was destroyed by fire in 1577, but the E. B. Crocker Art Gallery in Sacramento, California, owns a preliminary pen drawing for the central part of the composition which indicates the placement of the two kneeling figures with a few precise strokes (see Tietze and Tietze-Conrat, *Drawings of the Venetian Painters*, p. 155, no. 635, pl. 17, fig. 1).

In 1963, Terisio Pignatti suggested that the drawings on the Chicago sheet are the work of an assistant of Benedetto Carpaccio ("Amico di Benedetto"), but this hypothesis has found no support.

Vittore Carpaccio (Studio)
early sixteenth century

5 *Madonna and Child with Saint John the Baptist and Saint Roch* (pl. 8)

Inscribed recto, upper right, in pen and brown ink: *del Vivarino*; inscribed recto, upper right, in graphite: *lira*(?).

Pen and brown ink with brush and brown wash, over traces of black chalk, on buff laid paper; 138 x 215 mm.

COLLECTIONS: Puttick & Simpson, London, May 15, 1914 (stamp on former mount); William F. E. Gurley, Chicago, stamp (not in Lugt) recto, lower right, in black; Leonora Hall Gurley Memorial Collection, stamp (Lugt Suppl. 1230*b*) verso, center on mount, in black.

LITERATURE: Tietze and Tietze-Conrat, *Drawings of the Venetian Painters*, p. 157, no. 643, pl. 24, fig. 1; Lauts, *Carpaccio*, p. 278, no. 54; Pignatti, Review of *Carpaccio: Paintings and Drawings* by Jan Lauts, *Master Drawings* 1:52; Muraro, *Carpaccio*, p. 111.

Leonora Hall Gurley Memorial Collection, 1922.1042

The theme of the Sacra Conversazione, the Virgin adored by surrounding saints, is very common to the Bellini-Carpaccio circle. Our sheet would closely resemble Carpaccio's drawing style were it not for certain weaknesses, such as the tentative character of the line, the confusion in the lower garment of Mary, and the vague connection among the figures.

Only Michelangelo Muraro lists this among the master's works; otherwise, there is general agreement that the drawing is not by Vittore himself, but by a follower. Ulrich Middeldorf suggested that it might be by Benedetto Carpaccio, the artist's son, grandson, or nephew, about whom little is known. The Tietzes were hesitant, however, to attribute this or any drawing to Benedetto, preferring the designation "Carpaccio School." A drawing in Copenhagen (see Hadeln, *Venezianische Zeichnungen des Quattrocento*, pp. 52–53, pl. 51; see also Tietze and

Tietze-Conrat, *Drawings of the Venetian Painters*, p. 157, no. 644) has been connected with Benedetto's *Coronation of the Virgin* of 1533 in Capo d'Istria, but it is disputed whether it is the *modello* by Benedetto or a copy of it by a member of the studio. It may be compared with our drawing in the broad faces and stubby noses of the figures and the angular, flat treatment of the folds.

The composition of this drawing compares more closely, however, with a sheet containing full-length figures in the Koenigs Collection, Rotterdam (see Tietze and Tietze-Conrat, *Drawings of the Venetian Painters*, p. 158, no. 646), which J. Byam Shaw assigned to Benedetto Carpaccio "with due reserve" (see Byam Shaw, "Benedetto Carpaccio," *Old Master Drawings* 14:5, figs. 4–5). A third drawing of a *Sacra Conversazione* in the Uffizi (1767; see Tietze and Tietze-Conrat, *Drawings of the Venetian Painters*, pp. 157–58, no. 645), similar in composition to those in Rotterdam and Chicago but different from them in hand, demonstrates the interchange within a workshop such as Carpaccio's. Lauts assigns these three pieces to a group of drawings he attributed to an immediate follower of Carpaccio who worked in his studio.

Girolamo Genga
Urbino 1467–1551

6 *Mythological Pageant* (pl. 11)

Pen and brown ink, over black chalk, on ivory laid paper; 505 x 360 mm.; verso: anatomical studies of a head, illegible inscriptions, in pen and brown ink and graphite.

COLLECTIONS: Parsons & Sons, stamp (Lugt 2881) verso, lower right, in black; Bought Jan. 29, 1915 / Puttick & Simpson, stamp (not in Lugt) verso, center, in purple; William F. E. Gurley, Chicago, stamp (not in Lugt) recto, lower left, in black; Leonora Hall Gurley Memorial Collection, stamp (Lugt Suppl. 1230b) verso, center, in black.

EXHIBITIONS: Neilson, *Italian Drawings*, no. 3, reproduced.

Leonora Hall Gurley Memorial Collection, 1922.825

This still impressive ruin of a large-scale drawing which entered the collection in 1922 as the work of Andrea Mantegna was identified as that of Girolamo Genga by Philip Pouncey in 1958. Genga, like Raphael a native of Urbino, was praised by Vasari for his skill in painting, perspective, and architecture. Trained initially in the studio of Luca Signorelli, Genga entered Perugino's workshop around 1500 and so was for a time a fellow student of Raphael.

This sheet was probably part of a larger composition, and one can no longer be completely certain of its sub-

ject. It has been suggested that it might represent some athletic pageant in honor of Cybele, the Phrygian mother of the gods, seen in the mythological figure at right who is enthroned and bears the attributes of sceptre and *kalanthos* (or mural crown). The ceremony of this scene and character of its setting may reflect Genga's activity as a stage designer or coordinator of a triumphal or theatrical pageant in the court of Urbino.

Genga's drawings are relatively rare, but in subject matter and handling this drawing compares with the others of his that are known. Another sheet, *Mythological Subject*, at Windsor Castle may be related, for it depicts Cybele's companion, the river god Sangarios (0473; see Popham and Wilde, *Italian Drawings*, pp. 233–34, no. 341, fig. 76). In its tightly packed group of male nudes, some on horseback, it is similar to drawings in the Albertina (inv. nos. 136, 233; see Stix and Fröhlich-Bum, *Beschreibender der Katalog der Handzeichnungen*, vol. 3, p. 27, nos. 199–200, reproduced), the British Museum (1897-4-10-2; see Pouncey and Gere, *Raphael and His Circle*, p. 160, no. 271, pl. 253), the Uffizi (10900; see Fischel, "Die Zeichnungen der Umbrer," *Jahrbuch der Königlich preussischen Kunstsammlungen* 38:184, no. 203, pl. 333), and the Horne Collection (5951; see Ragghianti Collobi, *Disegni della Fondazione Horne in Firenze*, p. 20, no. 50, pl. 28).

The delineation of horses' heads in the drawing in Chicago particularly compare with details of drawings in the Louvre (nos. 10469 and 10514) and in the National Gallery of Scotland (D1569; see Andrews, *Catalogue of Italian Drawings*, p. 54, fig. 389). The verso of the drawing in Scotland is connected with Genga's *Resurrection* altar in the Oratory of Saint Catherine of Siena, in the Villa Giulia, Rome, which was commissioned in 1519. But too little is known of Genga's development as a draftsman to give even an approximate date to this drawing.

Baccio della Porta (Fra Bartolommeo)
Florence 1472–1517

7 *Monastery on the Slope of a Rocky Hill*, recto (pl. 9)
Watermill with Figures on an Arched Bridge, verso, ca. 1508–10 (pl. 10)

Pen and brown ink, on ivory laid paper (recto and verso); 293 x 216 mm.

WATERMARK: Tulip (cf. Briquet 6664, Florence, 1508).

COLLECTIONS: Fra Paolino da Pistoia (heir to artist's studio);

Suor Plautilla Nelli; Convent of Saint Catherine, Piazza San Marco, Florence; Cavaliere Francesco Maria Nicolò Gabburri; William Kent; private collection, southern Ireland; private collection, England, sale: London, Sotheby's, November 20, 1957, lot 13, reproduced (recto and verso); acquired from F. Kleinberger, New York.

LITERATURE: See Knapp, *Fra Bartolommeo*, pp. 46, 92; see Jeudwine, "A Volume of Landscape Drawings by Fra Bartolommeo," *Apollo* 66:132–35; see Fleming, "Mr. Kent, Art Dealer, and the Fra Bartolommeo Drawings," *Connoisseur* 141:227; see Wick, "Farm Building and Pollarded Mulberry Tree (recto); Farmhouse and Watermill (verso)," *Boston Museum of Fine Arts Bulletin* 56:106–8; see Kennedy, "A Landscape Drawing by Fra Bartolommeo," *Smith College Museum of Art Bulletin* 39:1–12; see Härth, "Zu Landschaftszeichnungen Fra Bartolommeos und seines Kreises," *Mitteilungen des Kunsthistorischen Institutes in Florenz* 9:125–30; see Richards, "Three Early Italian Drawings," *Bulletin of the Cleveland Museum of Art* 49:167–74.

EXHIBITIONS: *Master Drawings from the Art Institute of Chicago*, no. 3.

Clarence Buckingham Collection, 1957.530

After about 1508 and the departure for Rome of Leonardo, Michelangelo, and Raphael, the leading exponents of the classical High Renaissance style in Florence were Andrea del Sarto and the Dominican Friar Baccio della Porta, called Fra Bartolommeo. This sheet belongs to the renowned album of forty-one landscape drawings by the Frate which was divided up and sold at auction in London in 1957 and now is distributed among major public and private collections throughout the world. Prior to the discovery and sale of this group, only a few drawings (in the Louvre and Albertina) testified to this aspect of the artist's activity, although it was known that Lorenzo di Credi listed approximately 150 such drawings in his inventory of Fra Bartolommeo's studio at the time of his death. Our sheet certainly was among these, for along with the other drawings in the album, its provenance can be traced back to the artist's heir, his assistant Fra Paolino da Pistoia, who in turn left the group to a Dominican nun, Suor Plautilla Nelli of the Convent of Saint Catherine in Florence. There the drawings remained for almost two centuries, purportedly serving on occasion as kindling for fires or wrapping for parcels. In 1725, the Florentine art historian and *marchand-amateur* Cavaliere Francesco Gabburri (1675–1742) purchased what was left of these drawings from the convent. He bound all of the landscapes into an album in 1730, attributing them to Andrea del Sarto. Thus the drawings remained in obscurity for two more centuries, passing through numerous private collections and eventually travelling to Great Britain.

A few of the drawings have been related to paintings (e.g., Seilern Collection, London, and the Cleveland Museum of Art) and several locations have been identified (e.g., the Monastery of Saint Mary Magdalen in Pian di Mugnone, and Fiesole seen from the Mugnone valley). But for the most part, these sketches seem to have been drawn randomly from nature, apparently for the artist's own pleasure and not necessarily in preparation for paintings. Stylistically, they seem to represent a range of a number of years. Although most are characteristic scenes of his native Tuscany, others seem to reflect Fra Bartolommeo's trip to Venice in 1508. The watermarks found on a number of sheets provide a date *post quem* of 1507–8. This is the case for the drawing in Chicago. In its saturated atmosphere and effects of light, it suggests a prior exposure to the Venetian environment, but the terrain is certainly that of Tuscany (although it has not been identified specifically). In the arid spaciousness of the landscape and the lightness of pen stroke, it compares most closely with the drawing in Cleveland that has been linked to the painting *God the Father with Saints Mary Magdalen and Catherine*, in Lucca, dated 1509 (57.498; see Neilson, *Italian Drawings*, no. 2, reproduced). Thus, based on stylistic connections and the evidence provided by the watermark, we propose to date this sheet about 1508–10.

Domenico Campagnola
Venice 1500–1564 Padua

8 *Battle Scene with Horses and Men* (pl. 14)

Inscribed recto, lower center, in pen and brown ink: *Campagnola*.
Pen and brown ink, on buff laid paper; laid down; 211 x 317 mm.

COLLECTIONS: Peter Lely, stamp (Lugt 2092) recto, lower right, in black; F. Abbott, embossed stamp (Lugt 970) recto, lower right, on mount; Bought Aug. 6–7, 1914 | Puttick & Simpson, stamp (not in Lugt) verso, lower center on mount, in violet; William F. E. Gurley, Chicago, stamp (not in Lugt) recto, lower right and verso, center on mount, in black; Leonora Hall Gurley Memorial Collection, stamp (Lugt Suppl. 1230b) verso, center on mount, in black.

LITERATURE: Tietze and Tietze-Conrat, *Drawings of the Venetian Painters*, p. 126, no. 451; see Levenson, Oberhuber, and Sheehan, *Early Italian Engravings*, pp. 428–31.

EXHIBITIONS: *Catalogue of the Gurley Collection*, no. 4; Sheard, *Antiquity in the Renaissance*, no. 46.

Leonora Hall Gurley Memorial Collection, 1922.16

The adoptive son and pupil of Giulio Campagnola, Domenico received a strong, early stylistic influence from Titian, with whom he may have studied. Recent scholarship on the prints and drawings by Titian and his circle has brought the individual character of Dome-

nico Campagnola's drawing style into clear definition, particularly during the years of his greatest engraving activity, about 1517 and 1518 (see Oberhuber, *Disegni di Tiziano*). Unlike Titian, whose fidelity to form and to nature was unerring, Domenico abstracted and distorted figures in his rapid pen sketches, as well as in his engravings, to increase the expression of movement and emotional drama.

Nowhere is this tendency more evident than in his drawing of a *Battle Scene with Horses and Men* and the engraving of the same subject, signed and dated 1517 (Hind, *Early Italian Engraving*, vol. 5, p. 211, no. 4; vol. 7, pl. 790). There is a certain association between the print and our drawing, but in the drawing the action is more strictly confined to the foreground, as in a classical relief. Based on a thorough knowledge of antique sarcophagi and certainly influenced by the famous battle compositions of Pollaiuolo, Michelangelo, and Leonardo, this sheet, like that by Genga (cat. 6), is a tightly woven network of nude bodies and horses. A drawing similar in style, also from the Peter Lely collection, is now at the University of Uppsala (see Tietze and Tietze-Conrat, *Drawings of the Venetian Painters*, p. 131, no. 557, pl. 77, fig. 1).

Girolamo Mazzola Bedoli
Parma ca. 1500–1569

9 *The Meeting of Joachim and Anna at the Golden Gate* (pl. 12)

Pen and brown ink with brush and gray wash, heightened with white gouache (partly discolored), on buff laid paper; laid down; 188 x 120 mm.

COLLECTIONS: J. Richardson, Sr., stamp (Lugt 2183) recto, lower right, in black; A. M. Champernowne, script (Lugt 153) recto, lower right, in pen and black ink; William F. E. Gurley, Chicago, stamp (not in Lugt) recto, lower center, in black; Leonora Hall Gurley Memorial Collection, stamp (Lugt Suppl. 1230b) verso, center on mount, in black.

LITERATURE: Cf. Popham, "The Drawings of Girolamo Bedoli," *Master Drawings* 2:243–67; Oberhuber, "Drawings by Artists Working in Parma in the Sixteenth Century," *Master Drawings* 8:284, 287, n. 41, pl. 45; Popham, *Disegni di Girolamo Bedoli*, pp. 70–71, no. 64, reproduced.

EXHIBITIONS: Vitzthum, *A Selection of Italian Drawings*, pp. 18–19, 112, no. 8, reproduced.

Leonora Hall Gurley Memorial Collection, 1922.2987

In 1965, Konrad Oberhuber recognized this drawing as a characteristic work of the Parmesan artist Girolamo Mazzola Bedoli. Until that time, it had been considered the work of an unknown north Italian mannerist, possibly of Cremonese origin. Such confusion is understandable, for the drawing is characterized by an interest in the effects of surface light and texture, as well as details of contour and modelling common to both the Cremonese and Parmesan schools. However, the distinctive influence of Bedoli's cousin by marriage, Francesco Mazzola, called Parmigianino, is directly felt in this drawing, in the graceful proportions and typology of the figures and the sinuous character of the pen line.

As Oberhuber has pointed out, Bedoli's outline is more deliberate than Parmigianino's, his modelling broader and heavier. Vitzthum and Popham have concurred with his attribution and with his suggestion that this drawing shows the influence of Parmigianino after that artist's return to Parma from Rome in the early 1530s.

Pietro Buonaccorsi (Perino del Vaga)
Florence 1501–47 Rome

10 *Studies of Warriors, Horsemen, and Lions,* recto (pl. 15)
Studies of Heads, Plan of a Ceiling, and Inscriptions, verso (pl. 16)

Inscribed recto, lower center, in pen and brown ink (in a nineteenth- or twentieth-century hand): *Andrea del Sarto;* inscribed verso, upper left, in pen and brown ink: *Ventti | 34 | 37; ricomincia la bissia afanni e stenti | danno rovina di turco scacho | lo scetro christian di vita se dismette;* [inverted] *venti 32 | grotesc[h]e | le figure; are | arme arar | venti | di so' grazia pasato ò tante fortune | e vi fo intendere come io son vivo;* inscribed verso, lower right, in pen and brown ink (in a nineteenth- or twentieth-century hand): *("Del Sarto") Andrea D'Agnolo 1487–1531.*

Pen and brown ink, on red-tinted ivory laid paper; verso: pen and brown and black inks, on red-tinted ivory laid paper; maximum 198 x 384 mm.

WATERMARK: Fleur-de-lis with letter *S* below (cf. Briquet 7275–7298).

COLLECTIONS: J. J. Lindman, stamp (Lugt Suppl. 1479a) recto, lower center, in black; William F. E. Gurley, Chicago, stamp (not in Lugt) recto, lower right, in black; Leonora Hall Gurley Memorial Collection, stamp (Lugt Suppl. 1230b) recto, lower right and verso, lower center, in black.

LITERATURE: Cf. Askew, "Perino del Vaga's Decorations for the Palazzo Doria, Genoa," *Burlington Magazine* 98:46–53; cf. Davidson, "Drawings by Perino del Vaga for the Palazzo Doria, Genoa," *Art Bulletin* 41:315–26; see Davidson, *Mostra di Perino del Vaga*, p. 36, no. 31, figs. 31–32 (mentioned in connection with Louvre no. 627); Gibbons, "Notes on Princeton Drawings I: A Sheet of Figures by Perino del Vaga," *Record of the Art Museum, Princeton University* 26:13–18, figs. 4–5; see Gibbons, *Catalogue of Italian Drawings*, vol. 1, pp. 211–12, no. 692 and vol. 2, reproduced.

EXHIBITIONS: Vitzthum, *A Selection of Italian Drawings*, pp. 14–15, 107, no. 3, reproduced; Neilson, *Italian Drawings*, no. 4, reproduced; Gorse in *Drawings and Prints of the First Maniera*, pp. 58–60, no. 65, reproduced (recto and verso).

Leonora Hall Gurley Memorial Collection, 1922.477

This sheet of figure studies and a ceiling plan, which was first identified by Philip Pouncey, belongs to the relatively large group of surviving preliminary drawings by Perino del Vaga for his decoration of the Palazzo Doria, Genoa, in the years following the sack of Rome in 1527. A shallow frieze of striding male nudes and studies of equestrians and lions extend across the recto of the red-tinted sheet, which seems to have been removed from a sketchbook. Certain of these figures can be linked to the background staffage in Perino's most monumental ceiling decoration, the *Fall of the Giants*, in the palace, while the sketches of a ceiling plan on the verso correspond in number of bays and general proportions to the architecture of that hall. The lengthy inscription in Perino's hand, which also appears on the verso, unfortunately is not entirely legible, for it may offer the key to the dating of the decoration.

Soon after 1527 Prince Andrea Doria, admiral of the Pope's fleet, abruptly changed his allegiance from Francis I to the conquering Charles V of Spain and, with the emperor's assistance, freed his native Genoa from French rule. Triumphant, recently wed, eager to serve and impress the emperor, Doria subsequently embarked on an ambitious campaign to reconstruct and decorate his humble palace in Genoa in the grand Roman manner. For this, he called on the last available member of Raphael's Roman school, Pietro Buonaccorsi, called Perino del Vaga.

But for a brief period, from July 1534 to early 1536, spent in Pisa, Perino is said to have devoted most of his energy in Genoa from 1528 to 1538 to the decoration of the Palazzo Doria. There has been controversy about the dating and chronology of Perino's decorations in the palace, but generally the project is characterized by a gradual transformation of High Renaissance motifs and an increasing subordination of all figurative elements to decorative surface effect. The strong influence of Parmigianino, in the small heads and slim proportions of the figures in this drawing, mediates between the forceful origins of Perino's monumental vision in the works of Raphael and Michelangelo, and the eventual ornamentalism of his brand of Mannerism.

The individual characters of the various rooms of the Palazzo Doria have been clearly defined by Askew and Davidson, but as Davidson has pointed out, it is likely that Perino worked on more than one room—even more than one project—at a time. The evidence of this sheet, as well as others in the Louvre, Albertina, and Uffizi, supports just such a conclusion: while some of the individual figures quickly jotted on our sheet accord with those in the background of the *Fall of the Giants*, certain others (as well as the overall flow of forms) compare more closely with the friezes of the Sala dei Trionfi than to the stylized, artificial arrangement of figures in the Sala dei Giganti. Moreover, other figures equally relate to elements of the loggia, the façade, and possibly even to the decoration of the chapel of San Giorgio e San Giovanni Battista in the Duomo at Pisa (e.g. the figure of San Giorgio on the Albertina sheet).

It has been suggested that the partial transcription of Perino's writing on the verso, "danno rovina di turco," might support Askew's contention that the *Fall of the Giants* was painted in about 1536, after Doria's greatest victory, his defeat of the Turks and the restoration of Tunis. However, Davidson's argument that the decoration must have been completed for the important visit of Charles V in 1533 bears serious consideration both on the basis of the central location of the hall, and on the reasonable assumption that this was the very audience for whom Doria and Perino undertook their program. If the *Fall of the Giants* is an allegorical representation of their victory over the Turks, it could reflect their minor success at a battle in 1533 (mentioned by Askew), or it could have served as propaganda of a promise made to the emperor as early as 1528, when he helped Doria free Genoa of French rule. As Davidson pointed out, it may well reflect his competition for the emperor's favor against Federigo Gonzaga and Giulio Romano of Mantua, who undertook a similar program at about the same time.

Gino Corti has kindly provided a tentative translation of the major part of the problematic inscription: *The snake starts again (to give) troubles and difficulties / damage, ruin, setback of the Turk / the Christian sceptre removes himself from life / of His grace I have passed so many storms / and I let you know how I am alive.* On the basis of this interpretation, it may be assumed that the inscription, and therefore the decoration, does relate to Doria's plans to defeat the Turks and seems to reflect Perino's own recent escape from jeopardy—perhaps the sack of Rome. A more precise date cannot be determined at this time.

Another drawing that may be connected with the *Fall of the Giants*—one that bears similar handwriting on the verso—is in the collection of Dr. and Mrs. Malcolm W. Bick, Longmeadow, Massachusetts (see Pillsbury and Caldwell, *Sixteenth Century Italian Drawings*, no. 11, reproduced).

Girolamo da Carpi
Ferrara 1501–56

11 *Temperance* (pl. 13)

Graphite, on ivory laid paper; 237 x 157 mm.

COLLECTIONS: N. Lanier or Lanière, stamp (Lugt 2885) recto, lower left, in black; Robert Low, stamp (Lugt 2222) recto, lower center, in purple; Collection of Dr. Ridley of / Croydon, Eng. Sotheby's / Sale, April 2, 1912, stamp (not in Lugt) verso, lower right, in gray; William F. E. Gurley, Chicago, stamp (not in Lugt) recto, lower right, in black; Leonora Hall Gurley Memorial Collection, stamp (Lugt Suppl. 1230b) verso, center, in black.

LITERATURE: Canedy, "Some Preparatory Drawings by Giro-lamo da Carpi," *Burlington Magazine* 112:90, fig. 28.

Leonora Hall Gurley Memorial Collection, 1922.3036

This drawing was without an attribution when Norman Canedy identified it in 1965 as the work of the Ferrarese painter and architect Girolamo da Carpi. In writing about it, Canedy demonstrated that this sheet is among the earliest known studies by the artist.

The majority of the da Carpi drawings that remain to us are copies after antiquity or after Renaissance works primarily of Roman origin. Such an interest, typical of the antiquarianism of the Ferrarese school, is reflected in this drawing of a running allegorical female figure (whom Canedy tentatively identifies as Temper-ance). The stiff lines, emphatic contours, and shallow modelling of this figure seem a reflection of a Hellenistic sarcophagus relief. The drawing compares with known works by Girolamo da Carpi, such as a sheet from his Roman sketchbook titled *Striding Diana* after a statue formerly in the Soderini Collection, Rome (Biblioteca Reale, Turin; see Canedy, *Burlington Magazine* 112:86–94, fig. 25). Although the Turin drawing is executed in pen and brown ink and describes the amplitude of a three-dimensional subject, unlike the figure of Temper-ance, there is a similar concern with a rather dry delinea-tion of every fold, an elegance of contour and a subtlety of shading. Further, Canedy compares *Temperance* with the draftsmanship and effect of da Carpi's *Adoration of the Magi* in the Albertina.

While unable to cite a painting that corresponds pre-cisely with this drawing, Canedy has linked it con-vincingly with the panel *Saint Lucy and Saint Agatha* in the Pinacoteca dei Concordi, Rovigo. Although Saint Agatha is depicted in a serene stance, bearing her own attributes rather than a mirror and jar, she is almost identical in pose and in costume to the drawing of Temperance, especially in details of the knots and swags of the drapery. The correspondence is sufficiently close to confirm an attribution of the drawing to the same

artist, and it reveals Girolamo da Carpi's imaginative use of drawn antique motifs in his religious paintings.

Until recently, the Rovigo panels were attributed to the Dossi, so strongly do they reflect their influence in Girolamo's early work. Based on this relationship, then, Canedy dates this drawing and that in the Albertina, along with corresponding paintings, early in Girolamo's career, before 1530.

Giulio Campi
Cremona ca. 1502–72

or Antonio Campi
Cremona 1523–87

12 *Project for a Tomb* (pl. 17)

Inscribed recto, lower center, in pen and brown ink: *Titian*.

Pen and brown ink, over traces of black chalk, on ivory laid paper; laid down; maximum 307 x 210 mm.

COLLECTIONS: Sir Joshua Reynolds, stamp (Lugt 2364) recto, lower right, in black; W. Esdaile, script (Lugt 2617) recto, lower right, in pen and brown ink; Dr. C. D. Ginsburg, stamp (Lugt 1145) recto, lower left, and verso, lower left on mount, in black ink; Dr. C. D. Ginsburg, LL.D. / collection sold July / 20, 1915, Sotheby, London, stamp (not in Lugt) verso, lower left on mount, in purple; William F. E. Gurley, Chicago, stamp (not in Lugt) recto, lower left and verso, center on mount, in black; Leonora Hall Gurley Memorial Collection, stamp (Lugt Suppl. 1230b) verso, center on mount, in black.

Leonora Hall Gurley Memorial Collection, 1922.73

Bearing an old, optimistic attribution to Titian, this drawing passed through numerous distinguished col-lections and entered the Art Institute in 1922 under that name. Middeldorf, Pouncey, and others recognized that the style of this drawing was not far from the work of the leading Cremonese artist, Giulio Campi, and, in particular, that it compares with the preparatory study of the *Obsequies of Saint Agatha* (Ashmolean Museum, Oxford; see Parker, *Drawings in the Ashmolean*, vol. 2, pp. 73–74, no. 140, pl. 39) for the fresco painted by Giulio in 1537 in the Church of Saint Agatha, Cremona. Other drawings related to Giulio's work for San Sigis-mondo, Cremona, in about 1540 (in the Albertina, the Uffizi, and other collections; see Bora, "Note cre-monese,1: Camillo Boccaccino, le proposte," *Paragone* 25:57–58) share similar idiosyncracies of draftsmanship and help to create a definition of Giulio's style in about 1537–40.

An attribution problem remains, however, if the date on the unspecified Sansovinesque tomb in the drawing is taken seriously (MDLXXXIII), for Giulio Campi died in 1572. It has been suggested that the drawing

might be the work of Giulio's younger brother Antonio, the painter, architect, sculptor, and scholar, who died in 1587. This possibility gains credence when the *Project for a Tomb* is compared with drawings such as *Moses Receiving the Tablets of Law* in the British Museum, recently reattributed from Giulio to Antonio by Giulio Bora (n. 1962-7-14-70; see Bora, *Paragone* 25:60–61, pl. 65), or *Susannah and the Elders* in the Worcester Art Museum for the series on justice painted by Antonio in the Palazzo Municipale of Brescia in about 1570 (1956.32; see Vey, "Some European Drawings at Worcester," *Worcester Art Museum Annual* 6:18, fig. 7). Regarding the Worcester drawing and several in the Uffizi, Pouncey has raised the possibility that all the sheets may have been designed by Giulio for his brother Antonio to carry out. Until more is understood about the individual drawing styles of each of the Campis, a precise attribution cannot be made.

Francesco Mazzola (Parmigianino)
Parma 1503–40 Casalmaggiore

13 *Crucifixion* (pl. 18)

Inscribed recto, lower center on mount, in pen and brown ink: *Parmeggiano;* inscribed recto, lower right, in pen and brown ink: *k. 242;* inscribed verso, upper center on mount, in pen and brown ink: *D. 28.*

Pen and brown ink, on orange-tinted paper; laid down; maximum 140 x 65 mm.

COLLECTIONS: Padre Sebastiano Resta, script (Lugt 2992–93) recto, lower center on mount, in pen and brown ink; Giovanni Matteo Marchetti, Bishop of Arezzo; Cavaliere Marchetti, Pistoia; John, Lord Somers, script (Lugt 2981) recto, lower right, in pen and brown ink; J. Richardson, Sr., script (Lugt 2984) verso, upper center on mount, in pen and brown ink; sale: London, Motteux, 16 May 1717; William F. E. Gurley, Chicago, stamp (not in Lugt) recto, lower right, in black; Leonora Hall Gurley Memorial Collection, stamp (Lugt Suppl. 1230b) verso, lower center on mount, in black.

LITERATURE: Cf. Popham, "Sebastiano Resta and His Collections," *Old Master Drawings* 11:1–19; Freedberg, Review of A. E. Popham, *Catalogue of Drawings by Parmigianino;* A. E. Popham, *Disegni di Girolamo Bedoli, Art Bulletin* 55:148–50.

EXHIBITIONS: Neilson, *Italian Drawings,* no. 5, reproduced.

Leonora Hall Gurley Memorial Collection, 1922.857

Nancy Ward Neilson was the first scholar to publish this small drawing as the work of the most illustrious Parmesan Mannerist draftsman, Francesco Mazzola, called Il Parmigianino—an attribution it has borne continuously from the late seventeenth century to the present day. According to John Gere, it was listed by the Richardsons in their early eighteenth-century re-

mounting and transcription of Padre Sebastiano Resta's collection and remarks to Lord Somers's Lansdowne manuscript 802 (British Museum) as "Parmeggiano, k242."

Apparently unknown to Popham or excluded by him from his *Catalogue of the Drawings of Parmigianino,* this drawing has recently been confirmed by Sydney Freedberg as an autograph Parmigianino. Freedberg further supports Neilson's suggestion that the sheet dates from the artist's years in Rome, 1524–27. Although no other compositions of the *Crucifixion* by Parmigianino are known, Neilson has compared it in style with other rapid, loose pen drawings such as *The Marriage of the Virgin* in the Pierpont Morgan Library (Inv. no. 146b) and *A Study for a Chapel* in the Victoria and Albert Museum (Inv. no. E. 2693-1920) of those years (see Popham, *Catalogue of the Drawings of Parmigianino,* vol. 1, pp. 112–13, 121, nos. 273 and 305; vol. 2, pls. 143 and 193). The extremely free handling and physiognomy of the figures might also be compared with *The Marriage of the Virgin* in the Ecole des Beaux-Arts, Paris, of the same period (Inv. no. 223; see Popham, *Catalogue of the Drawings of Parmigianino,* vol. 1, p. 166, no. 521; vol. 2, pl. 195).

Francesco Mazzola (Parmigianino)
Parma 1503–40 Casalmaggiore

14 *Study of a Woman and Child* (pl. 19)

Inscribed recto, lower center on mount, in pen and brown ink: *Parmeggiano;* inscribed recto, lower right, in pen and brown ink: *k. 241.*

Pen and brown ink, on buff paper; laid down; 98 x 73 mm.

COLLECTIONS: Padre Sebastiano Resta, script (Lugt 2992–93) recto, lower center on mount, in pen and brown ink; Giovanni Matteo Marchetti, Bishop of Arezzo; Cavaliere Marchetti, Pistoia; John, Lord Somers, script (Lugt 2981) recto, lower right, in pen and brown ink; J. Richardson, Sr., script (Lugt 2984) verso, upper center on mount, in pen and brown ink; sale: London, Motteux, 16 May 1717; Earl Spencer, stamp (Lugt 1531) recto, lower right, in black; Bought August 6–7, 1914 / Puttick & Simpson, stamp (not in Lugt) verso, lower center on mount, in purple; William F. E. Gurley, Chicago, stamp (not in Lugt) recto, lower left, in black; Leonora Hall Gurley Memorial Collection, stamp (Lugt Suppl. 1230b) verso, center on mount, in black.

Leonora Hall Gurley Memorial Collection, 1922.851

This hitherto unpublished *Study of a Woman and Child* is another drawing in the Art Institute's collection to have come from the Resta and Somers collections and to be listed in the Lansdowne manuscript as by "Par-

meggianino." Although not included in Popham's corpus of the artist's work, this sheet shows the sinuous, rounded pen strokes characteristic of Parmigianino's Roman period and reminiscent of his Raphaelesque morphology. It may be compared with the many varied studies connected with the *Vision of Saint Jerome* (1527), especially one in the British Museum (Inv. no. Ff. 1-94; see Popham, *Catalogue of the Drawings of Parmigianino*, vol. 1, p. 91, no. 182; vol. 2, pls. 95 and 99) and one in Naples (Museo di Capodimonte Inv. no. 707; see Popham, *Catalogue of the Drawings of Parmigianino*, vol. 1, pp. 117–18, no. 291; vol. 2, pl. 99). Sydney Freedberg, who suggested this comparison, has dated the drawing about 1526 or 1527.

Francesco Mazzola (Parmigianino)
Parma 1503–40 Casalmaggiore

15 *The Old Shepherd* (pl. 20)

Indecipherable inscription recto, upper left, in pen and brown ink (according to Popham: *uom si vive*).

Pen and brown ink with brush and brown wash, over black chalk, on ivory laid paper; 141 x 118 mm.

COLLECTIONS: Cavaliere Francesco Baiardo(?); Marcantonio Cavalca; Thomas Howard, Earl of Arundel; Count Antonio Maria Zanetti; Signor Giovanni Antonio Armano; E. Bouverie, stamp (Lugt 325) recto, lower right, in black; Charles Deering, Chicago.

LITERATURE: Zanetti, *Raccolta di varie stampe*, reproduced; Bartsch, *Le Peintre graveur*, vol. 12, p. 169, no. 22; Inig, *Disegni originali*, reproduced, cited in Weigel, *Die Werke der Maler*, p. 485, no. 5782; Popham, "Parmigianino as a Landscape Draughtsman," *Art Quarterly* 20:275–86; Wiles, "Two Parmigianino Drawings from the Aeneid," *Museum Studies* 1:96–111, fig. 6; Popham, "The Baiardo Inventory," in *Studies in Renaissance and Baroque Art Presented to Anthony Blunt*, pp. 26–29; Popham, *Catalogue of the Drawings of Parmigianino*, vol. 1, pp. 60, 269, nos. 59, 310; vol. 2, pl. 302; Karpinski, *Le Peintre graveur illustré*, vol. 1, 169.22.

Charles Deering Collection, 1927.7752

Although this drawing was without an attribution when it came to the Art Institute in 1927, it is a drawing whose significance was recognized as far back as 1722. At that time, it was freely copied in a chiaroscuro woodcut by Count Antonio Maria Zanetti (see Bartsch, *Le Peintre graveur*, vol. 12, p. 169, no. 22; or Karpinski, *Le Peintre graveur illustré*, vol. 1, 169.22), who probably had acquired the drawing a year or so earlier in a lot of 130 sheets by Parmigianino from the Arundel Collection. There is also an etching with aquatint of the composition made in the 1780s by Francesco Rosaspino for Giovanni Antonio Armano, who owned the drawing

then. (We owe the identification of this drawing to Bertha Wiles, who first published the sheet.)

The extraordinary delicacy of touch, with pen and brush, are convincing testimony that this is an autograph drawing by Parmigianino, not a copy. Popham places this drawing in Parmigianino's Roman or Bolognese period, about 1524–31. Wiles's attempt to identify this figure as the blind Polyphemus failed to convince Popham.

Francesco Mazzola (Parmigianino)
Parma 1503–40 Casalmaggiore

16 *A Group of Nine Standing Figures* (pl. 22)

Inscribed verso on mount, at left, in pen and brown ink: *e La stampa intagliata all'acqua / forte in Londra da Enrico Vander / Borcht da questo disegno, che era di / quelli dello studio famoso del S. Conte / d'Arundell Inglese.*

Pen and brown ink with brush and brown wash, on tan paper; laid down; 124 x 131 mm.

COLLECTIONS: Thomas Howard, Earl of Arundel; A. M. Zanetti, script (Lugt Suppl. 2992*g*?) verso, on mount at left, in pen and brown ink; Baron D. Vivant Denon, stamp (Lugt 779) recto, lower right, in black; Samuel Woodburn, according to inscription verso, lower left on mount, in graphite; Ch. S. Bale, stamp (Lugt 640) verso, lower center on mount, in black; sale: Amsterdam, Frederick Müller, June 26, 1946, lot 862; acquired from P. & D. Colnaghi & Co., London.

LITERATURE: Zanetti, *Raccolta di varie stampe*, reproduced; Bartsch, *Le Peintre graveur*, vol. 12, p. 173, no. 32; Inig, *Disegni originali* (cited by Weigel); Vivant Denon, *Monument des arts du dessin*, vol. 3, p. 4, pl. 161*b*; Weigel, *Die Werke der Maler*, p. 469, nos. 5575–77; Popham, *Catalogue of the Drawings of Parmigianino*, vol. 1, p. 257, no. 94; vol. 2, pl. 202 (Denon lithograph reproduced); Karpinski, *Le Peintre graveur illustré*, vol. 1, 173.32.

Margaret Day Blake Collection, 1978.275

Only very recently did this evocative small drawing actually come to light again, although its mysterious composition has been known and admired for centuries through no less than four reproductive prints in as many different techniques. On the basis of these prints alone, A. E. Popham included the drawing (which he assumed to be lost) in his corpus of authentic drawings by Parmigianino.

This sheet, *A Group of Nine Standing Figures*, has enjoyed a prestigious history, passing through the most distinguished private collections of Parmigianino drawings, as outlined by Popham (*Catalogue of the Drawings of Parmigianino*, vol. 1, pp. 32–33).

Although its earliest history is obscure, there are two reasons to believe that this drawing was among the 130

or more sheets by Parmigianino that formed the famous Earl of Arundel collection (1586–1646). First, the composition was etched by Hendrik van der Borcht the younger (b. 1614, d. ca. 1690), who was in the Earl's service from 1636 to 46 and was the keeper of his collection from 1637 on. The forty-eight drawings that were etched by van der Borcht and Vorsterman are presumed by Popham to have come from Arundel's collection, which seems to be confirmed by the Italian inscription on the verso (by Zanetti?). This brings the total to thirty-five drawings now known of the forty-eight that were etched for Arundel. Second, this drawing was among those 130 sheets by Parmigianino acquired by Count Antonio Maria Zanetti from the Arundel collection in about 1720, as testified by his chiaroscuro woodcut made of the composition in reverse, dated 1723 on the plate (see Bartsch, *Le Peintre graveur*, vol. 12, p. 173, no. 32; see Karpinski, *Le Peintre graveur illustré*, vol. 1, 173.32; see Weigel, *Die Werke der Maler*, p. 469, no. 5575). Popham considers it virtually certain that all of Zanetti's Parmigianino drawings came from the Arundel collection. It is interesting to observe that *The Old Shepherd* (cat. 15) passed through these same two collections, only to be sold by the dealer Giovanni Antonio Armano.

Zanetti died in 1767, but it was not until 1787 that his collection began to appear on the market. In 1789, the first director of the Louvre, the Baron Dominique Vivant Denon, selected and acquired forty of Zanetti's best Parmigianino drawings, leaving the rest for Armano. A pioneer and enthusiast of the new technique of lithography, Denon went on to reproduce twenty of these drawings to be used in his four-volume work, the *Monument des arts du dessin*, published posthumously in 1829 (see Weigel, *Die Werke der Maler*, p. 469, no. 5577). As in the case of the Zanetti woodcut, this lithograph by Mlle Louise Bouteiller (1783–1828) is in reverse to the actual composition.

While the drawing was in Vivant Denon's collection, one Lodovico Inig published a series of fourteen facsimiles of Parmigianino drawings "della famosa Raccolta del Sig. Co. d'Arondell ora press M. de Non," engraved by Francesco Rosaspino (ca. 1762–1841), perhaps sponsored by Armano. Once again the *Group of Nine Standing Figures* was reproduced, but this time in the same direction as the drawing (see Weigel, *Die Werke der Maler*, p. 469, no. 5576).

Although noteworthy collectors such as Samuel Woodburn and Charles Sackville Bale also enjoyed this sheet in their collections, the more recent history of the drawing is curiously less well known.

Popham cited our sheet as a representative example of a drawing for a religious composition created by Parmigianino during his stay in Rome (from 1524–27) and he related it to the compositional sketch for the *Marriage of the Virgin* in the Ecole des Beaux-Arts, Paris (see Popham, *Catalogue of the Drawings of Parmigianino*, vol. 1, p. 166, no. 521; vol. 2, pl. 195). This connection is easily seen even in Cigoli's free adaptation of Parmigianino's composition (cat. 50). In particular, the two figures at the far right of Parmigianino's sketch, tightly swathed in classical garments and walking out of the scene, compare with those at the center right of the larger composition; the background group seems to represent a stage between the *Marriage of the Virgin* and the related *Presentation of Christ* in the British Museum (see Popham, *Catalogue of the Drawings of Parmigianino*, vol. 1, p. 99, no. 218; vol. 2, pl. 194). All three works clearly reveal the impact of Raphael's *Stanze*, particularly the *Disputà* and the *School of Athens*, on the young Parmigianino. His elaborate copy of the *School of Athens*, at Windsor, is further testimony of this influence and the monumental drawings it inspired in Parmigianino (see Popham, *Catalogue of the Drawings of Parmigianino*, vol. 1, p. 199, no. 666; vol. 2, pl. 205).

Popham links two other drawings and one other reproduction of a lost drawing with the *Marriage of the Virgin* in the Ecole des Beaux-Arts (see *Catalogue of the Drawings of Parmigianino*, vol. 1, pp. 52, 191, 257, nos. 29, 629, O.R. 93; vol. 2, pl. 202; vol. 3, pl. 287). All of these compositions are made up of elegant, slightly androgynous, anonymous figures. The actual purpose of these studies and identification of their subjects remain, however, elusive: in the case of our drawing, Bartsch labelled Zanetti's copy *Six Apostles* while Denon proposed that it might represent the conversion of several women.

Perhaps it is significant to note that, of the drawings mentioned for comparison above, two share similar histories with our drawing. The *Marriage of the Virgin* in Paris was in the Vivant Denon collection and is reproduced (reversed) in his *Monument des arts du dessin* (vol. 3, p. 7, pl. 168; see Weigel, *Die Werke der Maler*, p. 463, no. 5504). The *Presentation of Christ*, in the British Museum, was in the Arundel, Zanetti, and Vivant Denon collections and was also reproduced (in reverse) by Vorsterman, Zanetti, and Vivant Denon (see Bartsch, *Le Peintre graveur*, vol. 12, p. 186, no. 64; see Karpinski, *Le Peintre graveur illustré*, vol. 1, 186.64 [erroneously attributed to Bertoja]; see Vivant Denon, *Monument des arts du dessin*, vol. 3, p. 7, pl. 175; see Weigel, *Die Werke der Maler*, p. 463, no. 5503).

Francesco Mazzola (Parmigianino)
Parma 1503–40 Casalmaggiore

17 *Painter's Apprentice*, or *Valet Serving Wine* (pl. 21)

Pen and brown ink, on ivory laid paper; laid down; 173 x 115 mm.

COLLECTIONS: Comte Moriz von Fries, embossed stamp (Lugt 2903) recto, lower left; Collection of Dr. Ridley of / Croydon, Eng., Sotheby's / Sale April 2, 1912, stamp (not in Lugt) verso, lower right on mount, in purple; William F. E. Gurley, Chicago, stamp (not in Lugt) recto, lower right, in black; Leonora Hall Gurley Memorial Collection, stamp (Lugt Suppl. 1230b) verso, center on mount, in black.

LITERATURE: Popham, *Catalogue of the Drawings of Parmigianino*, vol. 1, p. 60, no. 58; vol. 3, pl. 441.

Leonora Hall Gurley Memorial Collection, 1922.1054

This drawing of a young man standing at a work table is another instance of a composition that was known and admired in the eighteenth century, for an exact copy of it was made in red chalk by no less an artist than Antoine Watteau (see Parker and Mathey, *Antoine Watteau*, vol. 2, p. 383, no. 935, reproduced).

Although our sheet, when it entered the museum, bore a traditional attribution to Federico Zuccaro, Parker and Mathey (who did not know our drawing) suspected that the copy by Watteau was after Parmigianino. This attribution has been confirmed for our sheet by Konrad Oberhuber and by A. E. Popham, who published it in his corpus of Parmigianino drawings as an original drawing dating from the end of the artist's life.

Popham, however, did not accept the identification of the figure as a painter's apprentice, indicating that the ewers and glass on the pedestal and the youth's elaborate costume rather suggest a page serving wine. This theory seems plausible when the drawing is compared with similar late genre compositions of artists at work in their studios by Parmigianino in the collections of Besançon (Inv. no. 2346), the Pierpont Morgan Library (Inv. no. IV 46), and the Victoria and Albert Museum (Inv. no. D. 989-1900; see Popham, *Catalogue of the Drawings of Parmigianino*, vol. 1, pp. 49, 125, 112, nos. 22, 321, and 272; vol. 3, pls. 439–40). Comparison may also be made with the large drawing *Portrait of a Man Holding up a Large Bitch*, perhaps a self-portrait (British Museum; Inv. no. 1858-7-24-6; see Popham, *Catalogue of the Drawings of Parmigianino*, vol. 1, pp. 108–9, no. 256; vol. 3, pl. 429), where similar brittle and meticulous pen work is characterized by Popham as typical of the last phase of Parmigianino's activity (ca. 1535–40).

Giorgio Vasari
Arezzo 1511–74 Florence

18 *Study for a Ceiling Decoration* (pl. 23)

Inscribed recto, upper left, in pen and brown ink: *Fontana Prospero*.

Pen and brown ink with brush and brown wash, over ruled lines in graphite and red chalk, on ivory laid paper; 362 x 237 mm.; verso: slight sketch for a ceiling in pen and brown ink and graphite.

WATERMARK: Indistinguisable.

COLLECTIONS: G. Vallardi, stamp (Lugt 1223) recto, upper left, in blue: J. J. Lindman, stamp (Lugt Suppl. 1479a) recto, lower right, and verso, lower left, in black; William F. E. Gurley, Chicago, stamp (not in Lugt) recto, lower right and verso, lower left, in black; Leonora Hall Gurley Memorial Collection, stamp (Lugt Suppl. 1230b) verso, lower left, in black.

LITERATURE: Monbeig-Goguel, "Giorgio Vasari et son temps," *Revue de l'Art* 14:106, 108, fig. 2.

EXHIBITIONS: *Catalogue of Early Italian Drawings*, no. 16 (as Prospero Fontana); *The Age of Vasari*, pp. 75, 100, D9, reproduced.

Leonora Hall Gurley Memorial Collection, 1922.42

This drawing bears an old attribution to the eclectic Bolognese mannerist, Prospero Fontana, which was maintained when the sheet entered the Art Institute's collection in 1922. Middeldorf supported this attribution, suggesting that this design was a study for a ceiling decoration and top of a wall frieze by Prospero in the Palazzo Parillo, Bologna. However, Pouncey, Shearman, Davidson, Pillsbury, and Thiem agree that the drawing is by Giorgio Vasari for his decoration of the Sala of Clement VII in the Palazzo Vecchio. Shearman remarked (letter of 24 November 1961) that there is another study for the central panel of *Rebecca and Eliezer* at Windsor Castle (6005; see Popham and Wilde, *Italian Drawings*, p. 345, no. 999; or see Antal, "Drawings by Salviati and Vasari after a Lost Picture by Rosso," *Old Master Drawings* 14:47–49, pl. 45). Weiner has pointed out that the *Candor Illaeus* of Clement VII appears above the profile of a bearded man at bottom center.

Although the drawing has been published again in recent years as by Prospero Fontana, Catherine Monbeig-Goguel has substantially refuted that attribution, citing the drawing as a characteristic example of a first draft for a composition by Vasari.

Giorgio Vasari
Arezzo 1511–74 Florence

19 *Allegory of Two Quarters of Florence* (pl. 24)

Inscribed recto, lower center on mount, in pen and black ink: *Cherubino Alberti*.

Pen and brown ink, on ivory laid paper; laid down; maximum 215 x 261 mm.

COLLECTIONS: Dr. Wm. Ogle, London / collection sold by / Sotheby, Feb. 6, 1913, stamp (not in Lugt) verso, lower right on mount, in purple; William F. E. Gurley, Chicago, stamp (not in Lugt) recto, lower right, in black; Leonora Hall Gurley Memorial Collection, stamp (Lugt Suppl. 1230b) verso, lower center on mount, in black.

LITERATURE: Cf. Monbeig-Goguel, "Giorgio Vasari et son temps," *Revue de l'Art* 14:110, fig. 9; Pillsbury, "The Sala Grande Drawings by Vasari and His Workshop: Some Documents and New Attributions," *Master Drawings* 14:135, 142, no. 51, pl. 10b.

EXHIBITIONS: *The Age of Vasari*, pp. 86–87, 134, D43, reproduced.

Leonora Hall Gurley Memorial Collection, 1922.468

This light and spontaneous drawing (traditionally attributed to Cherubino Alberti) has been recognized as the work of Giorgio Vasari by Davidson and Shearman, and was published recently by Pillsbury as an early study for one of the tondos of the Quarters of Florence in the Sala Grande in the Palazzo Vecchio. It shows the heraldic figure of Florence flying above cherubs on a balustrade and two shield-bearing *caporioni*. Although it differs significantly from the final fresco, the basic arrangement of these elements is the same.

As a relatively small study for the monumental project that dominated Vasari's career as an artist from 1555 to 1572, this sheet clearly illustrates the extraordinary complexity and controversy regarding the collaboration between Vasari and the assistants in his shop.

Pillsbury places it at a secondary stage in the development of Vasari's idea, between the early sketches in the Uffizi by Vasari and a more detailed drawing by Jacopo Zucchi in Oxford. Monbeig-Goguel has published yet another artist's version of the tondos, Giovanni Battista Naldini's *Allegory of the Quarters of Santa Croce and Santo Spirito* (in Siena), which is even closer to the final painting; Pillsbury believes that to be a copy from the completed *modello* or after the finished painting.

Jacopo da Ponte (Bassano)
Bassano 1510 or 1515 to 1592

20 Road to Calvary (pl. 26)

Inscribed verso, center on mount, in pen and brown ink: *This Picture is in the Gallery of the Arch Duke Leopold* / *as may be seen*

in the Book of Prints of that Gallery, published / *by David Teniers. I have the small picture. J.B.*

Black chalk and charcoal heightened with white chalk, on tan laid paper; laid down; maximum 421 x 309 mm.

COLLECTIONS: P. Crozat?, stamp (Lugt 474) recto, lower left, in black; J. Richardson, Sr., stamp (Lugt 2184) recto, lower right, in black; John Barnard, script (Lugt 1419) recto, lower right on mount and verso, center on mount, in pen and brown ink, and script (Lugt 1420) verso, upper center and right center on mount, in pen and brown ink; Bought Feb. 12, 1915 / Puttick & Simpson, stamp (not in Lugt) verso, lower center on mount, in purple; William F. E. Gurley, Chicago, stamp (not in Lugt) recto, lower left and verso, center on mount, in black; Leonora Hall Gurley Memorial Collection, stamp (Lugt Suppl. 1230b) verso, center on mount, in black.

LITERATURE: Tietze and Tietze-Conrat, *Drawings of the Venetian Painters*, p. 50, no. 124; Arslan, *I Bassano*, vol. 1, p. 165.

EXHIBITIONS: Neilson, *Italian Drawings*, no. 9, reproduced.

Leonora Hall Gurley Memorial Collection, 1922.5387

In the relatively long span of time during which Jacopo Bassano and his workshop were active, at least six painted versions of *Christ on the Road to Calvary* were produced, including one now in the Kunsthistorisches Museum, Vienna (no. 319 or 7 on slate), which corresponds exactly to the composition of this drawing. This connection was observed even in the eighteenth century, when the painting was in the collection of Archduke Leopold Wilhelm, as noted by John Barnard's inscription on the back of the drawing.

Some scholars have attributed the painting in Vienna to the master Jacopo himself (see von Engerth, *Gemälde: Beschreibendes Verzeichnis*, vol. 1, p. 38, no. 43; and see Berenson, *Italian Pictures of the Renaissance: Venetian School*, vol. 1, p. 21, as Jacopo with an assistant). Arslan believes it was executed entirely by Jacopo's eldest son, Francesco, during his years in his father's shop (ca. 1565–79), but this does not necessarily mean that the drawing was also by Francesco. As in other Venetian shops, Jacopo often provided his sons with drawings to serve as compositional models for their paintings; as W. R. Rearick has pointed out, this practice was particularly common in the Bassano shop in about 1570 (see Rearick, "Jacopo Bassano: 1568-9," *Burlington Magazine* 104:524–33).

The stylistic affinity of this drawing with known and dated works by Jacopo supports such a date and system of collaboration. Despite its badly rubbed condition, the *Road to Calvary* compares with the typically Venetian soft contours seen in the *Scourging of Christ*, dated 1 August 1568 (Calmann Collection, London) and the *Presentation of the Virgin* of 1569 (National Gallery of Canada, Ottawa; see Rearick, "Jacopo Bassano: 1568-9," *Burlington Magazine* 104:524–33, figs. 11 and 12).

Jacopo Robusti (Tintoretto) or Studio
Venice 1518–94

21 *Male Nude* (pl. 25)

Charcoal and white chalk, on blue laid paper (faded); 180 x 276 mm.

COLLECTIONS: The Property of a Gentleman, sale: London, Sotheby's, November 11, 1965, 26, lot 41, reproduced; Patch; acquired from Richard Zinser, New York.

EXHIBITIONS: Joachim, *A Quarter Century of Collecting*, no. 3, reproduced.

Margaret Day Blake Collection, 1966.23

One of the most fascinating artists of the Venetian cinquecento was Jacopo Robusti, called Tintoretto, who attempted a synthesis of Michelangelo's draftsmanship with Titian's color. His method of drawing from small wax statuettes to create a composition was highly individual, and it helped him to infuse his figures with a sense of vitality and drama.

This drawing is loosely connected with the *Finding of the Body of Saint Mark* (Brera, Milan), one of a series of paintings executed by Tintoretto after 1562 for the Scuola di San Marco. The question remains whether it might not be a derivation from, rather than a study for, the prostrate figure of the saint. It seems to be by the same hand as a similar study in the Städelsches Kunstinstitut, Frankfurt am Main (Inv. 4420), which was accepted as the work of Jacopo Tintoretto by Corrado Ricci and Detlev von Hadeln (see Ricci, *Pinacoteca di Brera*, p. 76; see Hadeln, *Zeichnungen des Giacomo Tintoretto*, pp. 44, 57, pl. 50). The Tietzes, however, considered it to be by a member of the studio (see Tietze and Tietze-Conrat, *Drawings of the Venetian Painters*, pp. 300–301, no. 1819, pl. 128, fig. 4).

Giuseppe Porta (Salviati)
Castelnuove di Garfagnano ca. 1520–ca. 1575 Venice

22 *Seated Figure: Study for a Pendentive* (pl. 31)

Pen and brown ink with brush and brown wash, heightened with white gouache, over black chalk, on blue-gray paper; laid down; 142 x 124 mm.

COLLECTIONS: William F. E. Gurley, Chicago, stamp (not in Lugt) recto, lower right, in black.

LITERATURE: Tietze and Tietze-Conrat, *Drawings of the Venetian Painters*, p. 244, no. 1377.

Leonora Hall Gurley Memorial Collection 1922.920

Giuseppe Porta began his career in Rome, where he was trained by Francesco Salviati, one of the leaders of the Mannerist school, whose style and name he adopted. In 1539 Porta Salviati moved to Venice, where he served as one of the strongest representatives of Central Italian ideals and provided a critical influence for artists such as Tintoretto and Veronese. He was not, however, immune to the impact of his surroundings. Drawings such as this small but powerful study of a figure for a pendentive reveal not only his Roman roots in the sculptural style of Michelangelo and his followers, but the typically Venetian interest in effects of atmosphere and use of dark and light wash on blue paper.

The traditional attribution of this drawing to Porta Salviati has been confirmed by Middeldorf, the Tietzes, and Bean. It may be compared with drawings reproduced by Hadeln (*Venezianische Zeichnungen der Spätrenaissance*, pls. 1–3). Neither the identity of the subject nor the decoration it was intended for is known at this time.

Paolo Farinati
Verona 1524–1606

23 *Spandrel Design: Two Satyrs and a Satyress with Putti* (pl. 30)

Pen and brown ink with brush and brown wash, heightened with white gouache (partly discolored), on blue laid paper; 265 x 420 mm.; verso: cherub's head in black chalk.

COLLECTIONS: R. Houlditch, stamp (Lugt 2214) recto, lower left, in black; John Thane, script (Lugt 1544) recto, lower left, in pen and black ink; J. J. Lindman, stamp (Lugt Suppl. 1479a) recto, lower left, in black; William F. E. Gurley, Chicago, stamp (not in Lugt) recto, lower left, in black; Leonora Hall Gurley Memorial Collection, stamp (Lugt Suppl. 1230b) verso, lower center, in black.

LITERATURE: Cf. Zannandreis, *Le Vite*, p. 155; cf. Puppi, *Paolo Farinati: Giornale*, pp. 87–90; cf. Puppi, "Paolo Farinati Architetto," *Studi di Storia dell'Arte in onore di Antonio Morassi*, pp. 162–71.

Leonora Hall Gurley Memorial Collection, 1922.766

Designs for spandrels in a rather coarse but vigorous, voluminous manner are not infrequent in the work of Paolo Farinati, the Veronese painter, etcher, and architect. This drawing seems to belong to a group of studies for decorations in the Palazzo Murari, Verona, which were completed around 1 April 1588. Unfortunately, most of Farinati's frescoes in the loggia and on the façade of this Sanmichelian edifice have deteriorated

completely, but on the basis of old descriptions, elements of the decorative scheme can be reconstructed. There were sixteen satyrs and satyresses along the wings of the long sides of the barrel vault, with cupids in the spandrels and four allegorical figures (representing agriculture, navigation, peace, and war) paired on the two short sides of the barrel vault, and *ignudi* and stories of Venus and Adonis around the door (see Puppi, *Paolo Farinati: Giornale*, pp. 87–90).

Related drawings may be found in the Albertina (Inv. no. 1609; see Stix and Fröhlich-Bum, *Beschreibender Katalog der Handzeichnungen*, vol. 1, pp. 85–86, no. 157, reproduced); the Metropolitan Museum (62.119.9; see Bean, "Form and Function in Italian Drawings," *Metropolitan Museum of Art Bulletin* 21:225–39); the National Gallery of Scotland (D1577; see Andrews, *Catalogue of Italian Drawings*, vol. 1, p. 49; vol. 2, p. 63, figs. 352–53); the Hermitage (Inv. 3064), the British Museum (Inv. 1874-8-8-29v), and Stockholm Museum (Inv. 1428; see Puppi, *Paolo Farinati: Giornale*, pp. 89–90, n. 1); the Heseltine Collection (see *Original Drawings by Old Masters*, no. 11, reproduced); the Horne Collection (Inv. 5669; see Ragghianti Collobi, *Disegni della Fondazione Horne in Firenze*, p. 36, no. 111); and the Scholz Collection (see Muraro, *Catalogo della Mostra di Disegni veneti*, p. 27, no. 29, reproduced).

However, closest of all are two sheets with garlanded figures and putti in Stuttgart and Weimar (see *Unbekannte Handzeichnungen*, p. 80, no. 77, reproduced). The relatively similar dimensions of these sheets and the Chicago sheet strongly suggest that they were drawn at approximately the same time and probably come from the same sketchbook.

Luca Cambiaso
Moneglia 1527–85 Madrid

24 *The Visitation* (pl. 33)

Inscribed recto, lower right, in pen and black ink: *L. Cangiasio*
Pen and brown ink with brush and brown wash, on buff laid paper (missing corner and strip at upper left and left); laid down; maximum 242 x 174 mm.
COLLECTIONS: W. Young Ottley, script (Lugt 2663) recto, lower left, in pen and black ink; Ottley and Sir Thomas Lawrence collections, according to inscription, verso on mount, in graphite; Dr. C. D. Ginsburg, stamp (Lugt 1145) recto, lower left and verso, lower left on mount, in black; Dr. C. D. Ginsburg, LL.D. / collection sold July / 20, 1915, Sotheby, London, stamp (not in Lugt) verso, lower left on mount, in purple; William F. E. Gurley, Chicago, stamp (not in Lugt) recto, lower

right, in black; Leonora Hall Gurley Memorial Collection, stamp (Lugt Suppl. 1230b) verso, center on mount, in black.
LITERATURE: Suida Manning and Suida, *Luca Cambiaso*, p. 189, pl. 15, fig. 21.
Leonora Hall Gurley Memorial Collection, 1922.566

The cursive, ornamental lines of Perino del Vaga's work for the Palazzo Doria in Genoa and the graceful elegance of the Parmesan school must have had an early and profound effect on the most significant artist of the cinquecento in Genoa, Luca Cambiaso. In turn, the dramatic technique and abstract schematization developed by Cambiaso were tremendously influential for generations of Genoese artists to follow.

Bertina Suida Manning and Wilhelm Suida published this sheet in their catalog of Cambiaso's work as a fine example of a rather youthful drawing by the master, probably before 1558. It reveals a compassionate sensitivity and freedom from formula unlike his later drawings. Although there is no known corresponding fresco or painting of this composition, the drawing is characteristic of Cambiaso's early work in its fluent line and loose, broad, simple handling.

Luca Cambiaso
Moneglia 1527–85 Madrid

25 *Allegorical Subject* (pl. 32)

Pen and iron gall ink with brush and brown wash, on buff laid paper; laid down; 275 x 254 mm.
COLLECTIONS: Paul Sandby, stamp (Lugt 2112) recto, lower left, in black; Frederick R. Aikman, / coll. sold Mch. 14, 1913 / by Puttick & Simpson, stamp (not in Lugt) verso, lower center on mount in purple; William F. E. Gurley, Chicago, stamp (not in Lugt) recto, lower right and verso, center on mount, in black; Leonora Hall Gurley Memorial Collection, stamp (Lugt Suppl. 1230b) verso, center on mount, in black.
LITERATURE: McKee, "The Gurley Collection of Drawings," *Bulletin of the Art Institute of Chicago* 16:25–27, reproduced; Watrous, *The Craft of Old-Master Drawings*, pp. 74–75, reproduced.
EXHIBITIONS: *Catalogue of a Century of Progress*, p. 86, no. 799.
Leonora Hall Gurley Memorial Collection, 1922.15

Of the twenty drawings in the Art Institute's collection that are more or less connected with Cambiaso, this drawing is an example of exceptional vigor in concept and execution. The subject is not far from the sybils painted by Cambiaso in numerous works around 1560–65, such as the frescoes in San Matteo in Genoa and those in the Villa Imperiale, Genoa-Terralba (see Suida Manning and Suida, *Luca Cambiaso*, p. 58, pl. 80, fig. 131; p. 73, pls. 94–98, figs. 150–55). Suida and Suida

Manning also reproduced three drawings of sybils, one in the Pinacoteca, Naples, one in the Uffizi (Inv. 13670), and the other in their own collection in New York (see Suida Manning and Suida, *Luca Cambiaso*, p. 189, pl. 55, fig. 90; p. 183, pl. 25, fig. 38; and p. 190, pl. 152, fig. 245).

As is the case so often with Cambiaso drawings, the acidity of the iron gall ink has eaten away the paper in many places in this drawing, adding to, rather than detracting from, the dramatic impact of the composition.

Paolo Caliari (Veronese)
Verona ca. 1528–88 Venice

26 *Head of a Woman* (pl. 27)

Black and white chalks, on blue-gray laid paper; maximum 266 x 187 mm.

COLLECTIONS: Sir Thomas Barlow, sale: London, P. & D. Colnaghi & Co., November–December, 1936, lot 64, reproduced; Dr. Francis Springell, sale: London, Sotheby's, June 28, 1962, lot 21, reproduced; acquired from Richard Zinser, New York.

LITERATURE: Tietze and Tietze-Conrat, *Drawings of the Venetian Painters*, p. 345, no. 2097, pl. 158, fig. 1; Fröhlich-Bum, "Ausstellung der Sammlung Springell bei Colnaghi, London," *Die Weltkunst* 29:10, reproduced; Pignatti, *Veronese*, vol. 1, p. 176, A55; vol. 2, fig. 769.

EXHIBITIONS: *Drawings by Old Masters from the Collection of Dr. and Mrs. Francis Springell*, no. 28, pl. 10; *Master Drawings from the Art Institute of Chicago*, no. 5, reproduced; Joachim, *A Quarter Century of Collecting*, no. 4, reproduced; Pignatti, *Venetian Drawings*, p. 16, no. 22, reproduced; Rosand, *Veronese and His Studio*, p. 58, reproduced.

Margaret Day Blake Collection, 1962.809

It is always provocative to consider the monochrome drawings of artists who are primarily known for their coloristic achievements in painting. Such is the case for Paolo Veronese who, along with Titian, brought the primacy of color to its richest expression in the Venetian Renaissance.

The drawings by Veronese cover a range of styles and techniques, and many have aroused controversy about their authenticity. In addition to his pen and ink sketches and a number of highly finished chiaroscuro compositions executed in brush with ink and gouache, Veronese also produced chalk studies of individual figures. Among the relatively small number of such drawings is this portrait of a young woman. The Tietzes were the first to associate it with the painting in the Czartoryski Gallery in Cracow, once thought to be of Esther, but upon recent cleaning, discovered to be the figure of Pomona. Pignatti suggests it might be the work of Benedetto, Paolo's younger brother (see Pignatti, *Veronese*, vol. 1, p. 176, A55; vol. 2, fig. 768). However, there seems insufficient reason to question Paolo Veronese's authorship of the drawing.

The female facial type of the Art Institute drawing occurs in many paintings by Veronese and his studio; furthermore, the sheet could have been a drawing by the master for the use of his shop. A similar chalk drawing of the head of a young woman in the Uffizi has been generally accepted as by Paolo Veronese (Santarelli 7431; see Tietze and Tietze-Conrat, *Drawings of the Venetian Painters*, p. 343, no. 2064; see Hadeln, *Venezianische Zeichnungen der Spätrenaissance*, pl. 49). Another drawing from life, *The Negro Head* in the Louvre (4649; see Tietze and Tietze-Conrat, *Drawings of the Venetian Painters*, p. 349, A 2133; see Hadeln, *Venezianische Zeichnungen der Spätrenaissance*, pl. 51), which also has been questioned by various scholars, including the Tietzes, has been vigorously supported by Terence Mullaly as an autograph Veronese (see Mullaly, *Disegni veronesi del cinquecento*, p. 63, no. 70, reproduced). Based on these comparisons and the striking quality of the drawing, the attribution of this sheet to Veronese still seems most convincing.

Attributed to Paolo Caliari (Veronese)
Verona ca. 1528–88 Venice

27 *Studies for a Descent from the Cross*, recto (pl. 28)
Studies of a Reclining Figure within a Spandrel, verso (pl. 29)

Inscribed verso, lower right, in pen and blue ink: *24*.

Pen and brown ink with brush and gray wash, over traces of black chalk, on ivory laid paper; maximum 288 x 216 mm.

WATERMARK: Sun (cf. Briquet 13949, Verona, 1569).

COLLECTIONS: Leopold I, Fürst von Anhalt-Dessau, stamp (Lugt Suppl. 1708b) verso, lower center, in black; Philip Hofer, Cambridge, Massachusetts; acquired from Durlacher Bros., New York.

LITERATURE: Tietze, "Nuovi disegni veneti del Cinquecento in collezioni americane," *Arte Veneta* 2 (1948): 56–66, figs. 69, 70.

EXHIBITIONS: *Art in New England*, pp. 119–20, no. 217, pl. 88; Schniewind, *Drawings Old and New*, p. 26, no. 54, pl. 6; *Master Drawings from the Art Institute of Chicago*, no. 6, pl. 5; Rosand, *Veronese and His Studio*, p. 59; Pignatti, *Venetian Drawings*, p. 16, no. 23, reproduced (recto and verso); Feinblatt, *Old Master Drawings*, pp. 35, 47–48, no. 50, reproduced.

Robert Alexander Waller Fund, 1943.1060

35

The attribution of this sheet to Paolo Veronese has remained in doubt since Hans Tietze first questioned it in 1948. At that time, Tietze judiciously cautioned against the presumption that all rapid pen and ink figure sketches of this type are necessarily by Veronese, although a great many of his surviving drawings are such personal "stenographic" variations on a theme.

Tietze remarked that this sheet differs from secure drawings by Veronese in several respects: the pen strokes are generally thinner and more attenuated and seem in some cases randomly placed, so they do not serve to clarify the structure of the figures. Furthermore, despite the presence of hatching and wash, the frontal figure groups lack the effect of spaciousness that is characteristic of Veronese's drawings. Tietze also indicated a variance in style between the spandrel studies on the verso of this sheet and the similar Veronese drawing of figures in cornices in the collection of Christ Church Library, Oxford (0341; see Byam Shaw, *Drawings by Old Masters*, vol. 1, pp. 213–14, no. 793; vol. 2, pl. 475).

There is a companion piece for this drawing (also from the Hofer Collection), now in the Fogg Art Museum, which seems to be by the same hand and possibly derives from the same sketchbook (1936.64; see *Art in New England*, p. 120; see Mongan and Sachs, *Drawings in the Fogg Museum*, vol. 1, pp. 107–8; vol. 2, figs. 109–10).

Recently, Pignatti accepted our drawing and compared it with another sheet, *Sketches of Figures*, for the Palazzo Trevisan at Muraro, from about 1560 (Oppé Collection; see Pignatti, *Venetian Drawings*, p. 16, no.23; see Cocke, "A New Light on Late Veronese," *Burlington Magazine* 116:31–33, pl. 45). However, Pignatti does not discuss our sheet in his catalogue raisonné of the artist's work (see Pignatti, *Veronese*).

No known painting by Veronese relates directly to this page of drawings, despite attempts to link it to paintings in Torcello and Honolulu (Schniewind, *Drawings Old and New*, p. 26, no. 54; see Pallucchini, *Mostra di Paolo Veronese*, p. 138, no. 59, Torcello painting reproduced; see Griffing, "The Kress Collection," *Honolulu Academy of Arts News Bulletin and Calendar* 16:6). Consequently, the attribution of this sheet must remain in doubt until more is understood about these drawings by Veronese and his circle. Tietze concluded that the sheet was the work of a north Italian, possibly Venetian artist of the last quarter of the sixteenth century: artists such as Battista del Moro and Felice Brusasorci might also be considered (see Mullaly, *Disegni veronesi del cinquecento*, pp. 32, 34, no. 17, reproduced, and pp. 74, 76–77, nos. 92–95, reproduced).

Taddeo Zuccaro
Sant' Angelo in Vado 1529–66 Rome

28 *Sheet of Studies for the Blinding of Elymas, Sacrifice at Lystra, and a Holy Family,* recto (pl. 37)
Studies for the Raising of Eutychus, verso (pl. 36)

Inscribed verso, upper left (inverted), in pen and brown ink: *favi—4[?]*.

Pen and brown ink with brush and brown wash, black and red chalks, and red chalk wash, on ivory laid paper; 386 x 274 mm.

COLLECTIONS: W. Young Ottley(?), sale: London, T. Philippe, June 20, 1814, lot 1492 (as Taddeo); Sir Thomas Lawrence, stamp (Lugt 2445) recto, lower left, sale: London, Christie's, 4 June 1860, lot 108 (as Michelangelo); Mr. Annesley Gore, Los Angeles; Robert B. Harshe, Chicago.

LITERATURE: Gere, *Taddeo Zuccaro*, pp. 73–74, 76–77, 138, no. 22, pls. 94–95 (recto and verso); Gere, *Il manierismo a Roma*, pp. 17, 83, pl. 17 (recto).

EXHIBITIONS: Vitzthum, *A Selection of Italian Drawings*, pp. 20–23, 114, no. 10, reproduced; Neilson, *Italian Drawings*, no. 12, reproduced; Feinblatt, *Old Master Drawings*, pp. 85, 94, 99, no. 113, reproduced.

Gift of Robert B. Harshe, 1928.196

When this large and impressive sheet entered the collection in 1928, it was ascribed to Michelangelo, which is not entirely surprising if one considers the strong influence of that artist evident in the powerfully drawn sanguine figure that dominates the sheet. Once again, Philip Pouncey was the first to recognize the hand of the major Roman artist of the subsequent generation, Taddeo Zuccaro. In fact, the true authorship of the drawing seems to have been known in the early nineteenth century, presuming it can be identified with lot 1492 in W. Y. Ottley's sale of 1814 ("Taddeo Zucchero . . . a leaf of various studies, one *in red chalk, stumped,* the rest *free pen and wash—very masterly,*" cited from Gere, *Taddeo Zuccaro*, p. 138, no. 22). Like so many drawings from the Ottley collection, this sheet passed into the hands of Sir Thomas Lawrence, and it probably can be identified with lot 108 in the Lawrence-Woodburn sale of 1860, where it received its attribution to Michelangelo ("A Sheet of Studies of various Scriptural Subjects—*in pen and bistre. In the centre, a draped female, in red chalk, of grand character,*" cited from Gere, *Taddeo Zuccaro*, p. 138, no. 22).

John Gere has identified the large seated figure as a working study for the enthroned procurator, Sergius Paulus, in Taddeo's fresco of the *Blinding of Elymas* on the side wall of the Frangipani Chapel in San Marcello al Corso, Rome. Two small compositional sketches on

the trimmed left side of the sheet pertain to the same work. Gere has also suggested that the compositional study at the upper right may represent a discarded subject for the Frangipani Chapel, the *Sacrifice at Lystra*, while the study on the verso, derived from Michelangelo's *Pietà* (in the Duomo, Florence) may be for the *Raising of Eutychus* on the vault of the same chapel. The two studies at the bottom of the sheet recto, *Two Standing Saints* and *The Holy Family with the Infant Saint John*, are not connected to the chapel decoration or any known work by Taddeo. The latter sketch may merely be Zuccaro's fanciful elaboration on a group of women with children at the right of the lower study for the Elymas composition. A Rubens copy of Zuccaro's lost *modello* for the *Blinding of Elymas* in Stockholm also includes a detail of this ultimately abandoned group (305–1863; see Gere, *Taddeo Zuccaro*, p. 204, no. 222; see also Jaffé, "Rubens as a Collector of Drawings: Part Two," *Master Drawings* 3:21–35, pl. 14). Other drawings for the fresco can be found at the Louvre (4432), Windsor Castle (01240, 6016), the Uffizi (11028F, 13598F) and the British Museum (1946-7-13-627; see Gere, *Taddeo Zuccaro*, p. 188, no. 173; p. 215, no. 253; pp. 216–17, no. 257; p. 148, no. 55; p. 155, no. 77, pl. 92; p. 167, no. 107, pls. 93a–b).

The commission for the frescoes devoted to the life of Saint Paul in the Frangipani Chapel had been awarded to Taddeo between 1556 and 1558. They were left unfinished at the time of his death in 1566. Consequently, Gere dates this sheet about 1557, adding that the unusual technique of red wash applied with the fine point of a brush was developed by Zuccaro in those years.

The importance of this sheet is summed up by Gere: "If one had to pick out a single drawing to illustrate the range and variety of Taddeo's draftsmanship, one's choice would probably fall on the sheet of studies in Chicago which displays, in intimate juxtaposition, two diametrically contrasting aspects of his way of drawing and two distinct stages in his creative process" (*Taddeo Zuccaro*, p. 76).

Gurley Memorial Collection, stamp (Lugt Suppl. 1230b) verso, center, in black.
LITERATURE: Gere, *Taddeo Zuccaro*, p. 137, no. 21.
Leonora Hall Gurley Memorial Collection, 1922.2965

John Gere has established that this drawing is a study by Taddeo Zuccaro for the prophet on the right-hand side wall of the Capella Maggiore of San Eligio degli Orefici in Rome. Little is known of Taddeo's work in this church designed by Raphael, but it was listed by Vasari among Taddeo's achievements, as "una capella nella chiesa degli orefici in strada Giulia" (see Vasari, *Le Vite*, vol. 7, p. 131).

The prophets on the side walls may be regarded as direct descendants of those by Taddeo in the Mattei Chapel in Santa Maria della Consolazione (ca. 1553), or the Frangipani Chapel in San Marcello al Corso (ca. 1558). This may have been one of the commissions left on Taddeo's sudden death in 1566 for his brother Federico to finish; documents of February and June 1569 testify that Federico was paid for some unspecified work in a chapel in that church (see Churchill, "Benvenuto Cellini, the Caradossos and Other Master Craftsmen of the Guild of the Goldsmiths of Rome," *Monatshefte für Kunstwissenschaft* 1, part 2:1100–1101). Thus, there may be some justification for Middeldorf's and Zeri's earlier attribution of the drawing to Federico instead of Taddeo Zuccaro. (Zeri identified it as a preparatory study for one of the large prophets Federico painted in the chapel at the Villa d'Este in Tivoli; see Gere, *Taddeo Zuccaro*, p. 80, n. 1.) However, Gere states that this is "certainly by TZ" (see Gere, *Taddeo Zuccaro*, p. 137) and it could be that Federico later used his brother's drawing for his own commission as demonstrated in the decorations for the casino of Pius IV (see Smith, "A Drawing for the Interior Decoration of the Casino of Pius IV," *Burlington Magazine* 112:108–10).

In spite of the water damage it received long ago, the sheet is a splendid example from Taddeo's last years.

Taddeo Zuccaro
Sant' Angelo in Vado 1529–66 Rome

29 *A Standing Prophet with a Book* (pl. 35)

Pen and brown ink with brush and brown wash, over red chalk, on ivory laid paper, squared in charcoal; 261 x 141 mm.
COLLECTIONS: PB with crown above, unidentified, stamp (not in Lugt) recto, lower left, in red; William F. E. Gurley, Chicago, stamp (not in Lugt) recto, lower left, in black; Leonora Hall

Bartolomeo Passarotti(?)
Bologna 1529–92

30 *Saint Jerome and Saint Dominic Adoring the Trinity* (pl. 40)

Pen and iron gall ink with brush and brown wash, over graphite, on tan laid paper; 379 x 267 mm.
COLLECTIONS: George, Lord Macartney's Album of / Drawings. Puttick & Simpson Sale / March 14, 1913. Lot No. 114, stamp (not in Lugt) verso, lower right, in purple; William F. E. Gurley, Chicago, stamp (not in Lugt) recto, lower center, in

black; Leonora Hall Gurley Memorial Collection, stamp (Lugt Suppl. 1230b) verso, center, in black.

Leonora Hall Gurley Memorial Collection, 1922.3971

Most scholars have agreed on the generation of the author of this drawing, but there have been different opinions about the school or precise identity. Federico Zeri suggested that it might be near Zuccaro, and this is a reasonable assumption based on the wiry line and typology of the figures. However, as an indication of the close alliance of the Roman and Bolognese schools, Taddeo Zuccaro's exact contemporary and one-time assistant from Bologna, Bartolomeo Passarotti, has also been proposed (by Catherine Johnston and Patrick Cooney) as the artist. Although it differs from the often harsh pen strokes of the drawings of anatomies and grotesqueries for which Passarotti is best known, this drawing invites comparison with another compositional drawing, *The Anatomy Lesson*, in the Louvre (Inv. 8472GF; see Baticle and Georgel, *Technique de la peinture: L'Atelier*, pp. 20–21, 62, no. 29, reproduced). The figure of Saint Dominic is extremely close to the study of a saint in a drawing at the Museo di Capodimonte, Naples (n. 86; see Johnston, *Il Seicento e il settecento a Bologna*, p. 86, fig. 3).

Federico Barocci
Urbino 1535–1612

31 *Head of the Virgin* (pl. 34)

Black and white chalks and charcoal, with stumping, on cream laid paper, incised and pieced; maximum 295 x 239 mm.; verso: base of a column, grid in charcoal.

WATERMARK: Bow and arrow (cf. Briquet 749, Lucca, 1548).
COLLECTIONS: Edward Cheney, sale: London, Sotheby's, May 5, 1885, lot 932(?); P.M., according to inscription on former mount: *P.M. from sale of Chesney* [sic] *Collection at Sotheby's— 1885;* William F. E. Gurley, Chicago, stamp (not in Lugt) recto, lower left, in black.
LITERATURE: Middeldorf, "Three Italian Drawings in Chicago," *Art in America* 27:11–14, fig. 1; Tietze, *European Master Drawings*, pp. 94–95, no. 47, reproduced; Olsen, "Federico Barocci: A Critical Study in Italian Cinquecento Painting," *Figura* 6:120; Olsen, *Federico Barocci*, pp. 152–53, no. 21; Smith, "Federico Barocci at Cleveland and New Haven," *Burlington Magazine* 120:330–33, fig. 107.
EXHIBITIONS: Gerdts and Gerdts, *Old Master Drawings*, no. 29, reproduced; Cummings, *Art in Italy, 1600–1700*, pp. 73–74, no. 64; Pillsbury and Richards, *The Graphic Art of Federico Barocci*, pp. 49–50, no. 22, reproduced.

Leonora Hall Gurley Memorial Collection, 1922.5406

The *Deposition* of 1568–69 in the Chapel of Saint Bernardino of the Cathedral of Perugia was Barocci's first monumental altarpiece. Executed after his second trip to Rome, the highly dramatic composition is focused on the expressive group of women below the cross rather than on the actual Deposition of Christ from the cross itself.

It is characteristic of Barocci's methodical approach to his major paintings that more than thirty-six studies for the *Deposition* are known; they represent every stage of the composition, from the first thoughts, studies of individual figures and parts of figures, to the *modello*, parts of the cartoon, and pastel head studies. Of these, more than twenty are devoted to the women beneath the cross alone (see Olsen, *Federico Barocci*, pp. 152–53).

A drawing in the Uffizi shows that Barocci used a nude male model for his preliminary study of the position of the Virgin (Inv. 11312 F; see Emiliani, *Mostra di Federico Barocci*, p. 75, no. 39, reproduced). A more elaborate *modello* of the painting, with special emphasis on the study of light, is also in the Uffizi (Inv. 9348 S. 822 E.; see Emiliani, *Mostra di Federico Barocci*, p. 78, no. 49, reproduced).

The nearly life-size study of the Virgin's head in the Art Institute is executed in a broad chalk and stumping technique for refined chiaroscuro effects. On a heavier paper than most drawings, it is incised for transfer in just the way that Bellori described (see Pillsbury and Richards, *The Graphic Art of Federico Barocci*, p. 50, no. 22, n. 3 and p. 24 for translation of Bellori's *Life of Barocci*). It is one of three remnants of the original cartoon that are known today; the other two, also head studies, are in the Musée des Beaux-Arts, Besançon (Inv. D 1516; see Emiliani, *Mostra di Federico Barocci*, p. 76, no. 42, reproduced) and in the Biblioteca Comunale, Urbania (Inv. 206, II; see Bianchi, *Cento disegni della Biblioteca Comunale di Urbania*, p. 39, no. 10, pl. 22). It has been suggested that the artist himself divided the cartoon either for ease of transfer or for further study and refinement. As Pillsbury has pointed out, the *Head of the Virgin* demonstrates how the artist continued to experiment with the tone and modelling of the composition even at the late stage represented by the cartoon.

Santi di Tito
Borgo San Sepolcro 1536–1603 Florence

32 *The Resurrection* (pl. 41)

Pen and brown ink with brush and brown wash, heightened with white gouache, on ivory laid paper; 303 x 200 mm.

WATERMARK: Encircled fleur-de-lis, topped by a star (Briquet 7117, Ascoli, 1536).

COLLECTIONS: Peter Lely, stamp (Lugt 2092) recto, lower right, in black; P. H. Lankrink, stamp (Lugt 2090) recto, lower right, in black; William F. E. Gurley, Chicago, stamp (not in Lugt) recto, lower right and verso, lower center, in black; Leonora Hall Gurley Memorial Collection, stamp (Lugt Suppl. 1230*b*) verso, lower center, in black.

Leonora Hall Gurley Memorial Collection, 1922.5509

Santi di Tito, a member of the younger Mannerist generation in Florence, strove for a new simplicity and clarity in his compositions, greater naturalism in his figures, and more perfect harmony in his colors. These concerns are manifest even in the drawings that remain to us, for the most part compositional *modelli* in pen and ink with wash and white heightening.

The largest collection of Santi di Tito's drawings is in the Uffizi. One of these, a *modello* for the *Resurrection of Christ*, painted by Santi in about 1565 for the Medici Chapel in Santa Croce, is very similar to (although not identical with) this sheet, and exactly the same size (Uffizi 7687F; see Barocchi et al., *Mostra di disegni*, p. 53, no. 62, fig. 45). As the Uffizi sheet is squared for transfer, it may be assumed to be the final version; it also avoids such awkward passages as the head of the angel seated on the tomb having been placed between the feet of Christ.

Furthermore, no fewer than five other drawings in the Uffizi and one in Munich can be linked with the same composition. The great number of such finished drawings with only slight variations testifies to the careful simplifying procedure of Santi di Tito's work. As pointed out by Anna Forlani regarding the *modello* in the Uffizi, the impact of Santi di Tito's Roman venture (ca. 1558–63) can be seen in the Zuccaresque elements of the soldiers seen from the back, the fallen guard, and other graphic details. Following the artist's return to Florence in 1564, he was elected a member of the academy, and so this may be considered one of the first major commissions of Santi di Tito's maturity.

Pen and brown ink with brush and brown wash, over graphite, on tan laid paper; laid down; 298 x 162 mm.

COLLECTIONS: J. R., unidentified script (not in Lugt) recto, lower right, in pen and brown ink; Dr. Wm. Ogle, London / collection sold by / Sotheby, Feb. 6, 1913, stamp (not in Lugt) verso, lower right, on mount, in purple; William F. E. Gurley, Chicago, stamp (not in Lugt) recto, lower right, in black.

LITERATURE: Gere, *Il manierismo a Roma*, pp. 19, 85–86, pl. 33.

EXHIBITIONS: Neilson, *Italian Drawings*, no. 16, reproduced.

Leonora Hall Gurley Memorial Collection, 1922.1055

Based upon two inscriptions in old hands, this sheet was attributed to Federico Zuccaro until Philip Pouncey recognized it as the work of Zuccaro's follower, Cesare Nebbia. This attribution was confirmed by John Gere. As Gere has noted, the stylized nature of the figures, with small, round heads and heavy contours are characteristic of Nebbia's mature style and derive not as much from Zuccaro as from the technique of Nebbia's second master, Girolamo Muziano.

The subject of the drawing, the *Raising of the True Cross before the Empress Helena*, links it with the series on the Legend of the True Cross painted by numerous artists for the Oratorio del Crocefiso, San Marcello al Corso, Rome, between 1568 and 1580; like those frescoes, the drawing attempts to simulate a tapestry. However, the composition of this title was painted by Giovanni de' Vecchi. The only fresco of the series painted by Nebbia was that of *Heraclius Carrying the Cross to Jerusalem*. Nebbia's drawing for this fresco, in the National Gallery of Scotland (D4906; see Andrews, *Catalogue of Italian Drawings*, vol. 1, p. 80, vol. 2, fig. 563) is very similar to our drawing and it seems possible that this sheet could represent Nebbia's ultimately rejected design for a second fresco in the series.

Federico Zuccaro
Sant' Angelo in Vado 1540/41–1609 Ancona

34 *A Pope Receiving a Dignitary in a Public Place* (pl. 42)

Inscribed recto, lower left on old mount, in pen and black ink: *Federigo Zucchero;* inscribed recto, lower center on old mount, in pen and black ink: *Public Rejoicing in a City;* inscribed recto, lower right on old mount, in pen and black ink: *5 3/4 h.–11w. / Roscoe No205/2.*

Pen and brown ink with brush and brown wash, over black chalk, on ivory laid paper; laid down; 149 x 283 mm.

COLLECTIONS: Roscoe (according to inscription recto, at lower edge on old mount, in pen and black ink), sale: Liverpool, September 23–28, 1816, lot 205; Lord Stanley, Earl of Derby

Cesare Nebbia
Orvieto 1536–1614

33 *The Raising of the True Cross before the Empress Helena* (pl. 39)

Inscribed recto, lower left, in pen and black ink: *Zuccaro;* inscribed verso, lower margin on mount, in pen and brown ink: *Súcaro, 9:11..6:3.*

(according to T. Stevens, Walker Art Gallery, Liverpool); F. Tate, 18 Percy Street, London, stamp (not in Lugt) verso, center on mount, in violet; Bought Aug. 6–7, 1914 / Puttick & Simpson, stamp (not in Lugt) verso, lower left on mount, in purple; William F. E. Gurley, Chicago, stamp (not in Lugt) recto, lower left, in black; Leonora Hall Gurley Memorial Collection, stamp (Lugt Suppl. 1230*b*) verso, center on mount, in black.

EXHIBITIONS: Neilson, *Italian Drawings*, no. 15, reproduced.

Leonora Hall Gurley Memorial Collection, 1922.1057

In 1577, the fire that gutted the Sala del Maggior Consiglio in the Palazzo Ducale, Venice, destroyed several important historical decorations, among them the *Submission of the Emperor Frederick Barbarossa to Pope Alexander III*, begun by Giovanni Bellini and finished by Titian about 1520, and the *Coronation* and *Excommunication of Frederick Barbarossa* painted by Tintoretto in 1562–64 and 1553, respectively. The replacement of these decorations was begun by Federico Zuccaro in 1582 with his famous painting of the *Submission of the Emperor*, which he finished on a later trip to Venice in 1603.

Federico Zuccaro, the younger brother and pupil of Taddeo, was one of the most important late sixteenth-century Mannerist artists, not so much for the caliber of his art, as because of his long life and numerous accomplishments, including the establishment of the Academy of drawing, writing on aesthetics, and vast travel, from Florence, Rome, and Venice to Flanders, England, and Spain. It is no wonder that he was awarded this important commission, nor that many of his drawings survive.

Drawings by Federico Zuccaro which can be connected with this decoration are in the Uffizi (1828F) and the Scholz and the Oppé collections (see Gere, "The Lawrence-Phillipps-Rosenbach 'Zuccaro Album,'" *Master Drawings* 8:123–40, and see Tietze-Conrat, "Decorative Paintings of the Venetian Renaissance Reconstructed from Drawings," *Art Quarterly* 3:15–39). In reference to these, Erica Tietze-Conrat has suggested, and John Gere has concurred, that Zuccaro must have copied the original decorations by Titian and Tintoretto during his first visit to Venice in 1563–65, and that these notations formed the basis for his own later compositions of the same events.

The Chicago drawing, *A Pope Receiving a Dignitary in a Public Place*, is stylistically quite close to the sketch of the *Submission of the Emperor in the Piazza San Marco* in the Scholz collection (see Scholz, *Italian Master Drawings*, p. xvi, no. 65, reproduced). The Roman character of the setting suggests it might represent the companion piece of the *Coronation of the Emperor Fred-*

erick Barbarossa by Pope Adrian, but the horizontal composition of our drawing differs from the shape and direction of Tintoretto's original scheme and Zuccaro's free copies of it (in the Uffizi, Oppé, and Scholz collections). The replacement of the *Coronation of the Emperor* composition was never actually commissioned; however, it is plausible that Federico was experimenting with a composition for the Roman scene at the same time.

Niccolò Martinelli da Pesaro (Il Trometta)
Pesaro ca. 1540 or 1545 to ca. 1611 Rome(?)

35 *A Group of Figures* (pl. 38)

Inscribed verso, lower center, in pen and brown ink: *120201 / No31.*

Pen and brown ink with brush and brown wash, heightened with white gouache, over black chalk and graphite, on blue laid paper; 275 x 174 mm.; verso: fragment of a female head in graphite, red, brown, and black chalks.

COLLECTIONS: Charles Deering, Chicago.

Charles Deering Collection, 1927.2718

Jacob Bean identified this drawing in 1969 as the hand of a lesser Zuccaro follower, Niccolò Martinelli, called Il Trometta. Few secure major works or even dates are known for Trometta, but John Gere clearly defined the unmistakable characteristics of his drawings (see his article, "Drawings by Niccolò Martinelli, Il Trometta," *Master Drawings* 1:3–18). There he established a hard core of drawings connected with Trometta's ceiling decorations for Santa Maria in Aracoeli, most of them sheets in the Munich Print Room which were first recognized by Herman Voss. Around these he built up an oeuvre of forty-two drawings based on an easily recognized calligraphy and technique.

A common attribute of most of Trometta's drawings is a chiaroscuro-like execution in pen and brown ink with brush and wash and white heightening on blue paper, as in this drawing. Gere's analysis of the peculiarities of Trometta's Zuccaro-derived facial types, with wide-set, "vacuously ecstatic eyes," and the disproportionate, substantial but often lumpy figures can be seen to apply to this drawing as well.

In particular, the drawing compares with the overlapping recession of figures in the *Sposalizio* of the British Museum and *A Group of Angels* in Darmstadt. It has not been possible to be more specific about the

relation of this sheet to Trometta's painted work or its place in his chronology.

Jacopo Negretti (Palma il Giovane)
Venice 1544–1628

36 *The Flagellation* (pl. 47)

Inscribed verso, lower left, in pen and brown ink: *Palma*.

Pen and brown ink with brush and brown wash, heightened with white gouache, over black chalk, on buff laid paper; maximum 266 x 203 mm.

COLLECTIONS: J. M., unidentified script (not in Lugt) verso, lower left, in graphite; William F. E. Gurley, Chicago, stamp (not in Lugt) recto, lower right, in black (faint); Leonora Hall Gurley Memorial Collection, stamp (Lugt Suppl. 1230*b*) verso, center, in black.

LITERATURE: Tietze and Tietze-Conrat, *Drawings of the Venetian Painters*, p. 201, no. 873; cf. Ivanoff, "La flagellation de Palma le jeune au Musée des Beaux-Arts de Lyons," *Bulletin des Musées Lyonnais*, 1956, pp. 1–10; Thiem, *Italienische Zeichnungen, 1500–1800*, pp. 132–33, no. 269.

Leonora Hall Gurley Memorial Collection, 1922.888

Not only the most important follower of Titian, Tintoretto, and Veronese in Venice, Palma Giovane appears to have been one of the most prolific draftsmen of his generation in Italy in the late sixteenth and early seventeenth centuries. Every major drawing collection has an abundance of his works, and the Art Institute owns thirteen sheets attributed to him. Of these, eight were listed by the Tietzes and three were published by Rafael Fernandez.

The Flagellation is a subject often treated by Palma Giovane. One of the earliest examples seems to be a painting described by Ridolfi (*Le Maraviglie dell'arte*, vol. 2, p. 175) which is known only in an engraving by E. Sadeler. Later paintings of the same subject can be found in the Musée de Lyons, the Oratorio dei Croceferi (1591), San Francesco della Vigna, and San Zaccaria, all in Venice, and a marble altar in Munich. In these later versions, the composition has been simplified and concentrated, with Christ placed in the center. There are various drawings related to these later versions, the most finished of which seems to be the drawing in Chicago. In fact, it appears to be a complete composition except for the strange discrepancy that the column to which Christ is bound does not continue above the figure.

A more sketchy version of a similar composition is in the British Museum (see Rinaldi, "Il libro dei disegni di Palma il Giovane del British Museum," *Arte Veneta* 27:133, fig. 160). In discussing a related drawing in Stuttgart, Thiem cites other examples of this subject in Copenhagen, Florence, Munich, Paris, Rome, and Bergamo (see Thiem, *Italienische Zeichnungen, 1500–1800*, pp. 132–33, no. 269, reproduced; see also Ivanoff, "La flagellation di Palma le jeune au Musée des Beaux-Arts de Lyons," *Bulletin des Musées Lyonnais*, 1956, pp. 1–10).

Precise dating of these drawings does not seem possible at this point, but the Tietzes suggested that ours is a work that falls in the seventeenth century.

Jacopo Negretti (Palma il Giovane)
Venice 1548–1628

37 *The Entombment of Christ* (pl. 48)

Inscribed recto, lower right, in pen and brown ink: *35*(?); inscribed verso, center, in pen and brown ink: *Auction Posony: 1858 M. 250*; inscribed verso, lower left, in pen and brown ink: *N. 14 Annibale Carracci*.

Pen and brown ink with brush and brown wash, heightened with gold, on blue-green laid paper; 223 x 140 mm.

COLLECTIONS: Marquis de Lagoy, stamp (Lugt 1710) recto, lower right, in black; Dr. F. Pokorny, stamp (Lugt 2036) verso, lower left, in green; A. Posonyi, script (Lugt 2040) verso, center and lower left, in pen and brown ink; R.U.F., unidentified stamp (not in Lugt) verso, lower left, in green; Lord Walston; Germain Seligman, stamp (not in Lugt) verso, lower right, in blue; acquired from Germain Seligman, New York.

EXHIBITIONS: *Master Drawings from the Art Institute of Chicago*, no. 7, reproduced; Pignatti, *Venetian Drawings*, p. 21, no. 33, reproduced.

Clarence Buckingham Collection, 1962.376

This drawing passed through numerous distinguished collections and when it was in that of A. Posonyi, it was apparently attributed to Annibale Carracci. The composition appears to be even more complete than the previous one. Because of its unusual technique (the heightening with gold), it was once assumed to be the work of Jacopo Ligozzi. Frits Lugt, who owned another example with gold heightening in a sketchbook by Palma, made the correct attribution, which has been accepted by Philip Pouncey. Yet another example with gold heightening is Palma's drawing of the *Three Fates* at Windsor Castle (Inv. no. 4799), which Popham dated after 1600 (see Popham and Wilde, *Italian Drawings*, p. 276, no. 546).

A painting of the same subject in Zagreb places great emphasis on the group of three holy women in the foreground in poses very similar to our drawing. Records indicate that this *Deposition* was acquired by the Church of San Mauro in Isola between 1587 and 1611

and Gamulin would date the composition close to an-other by Palma of the same subject for the Oratorio dei Croceferi, in the first half of the last decade of the cinquecento (see Gamulin, "Due dipinti di Palma il Giovane," *Paragone* 115:52).

Jacopo Negretti (Palma il Giovane)
Venice 1548–1628

38 *Studies for Portraits of Andriana Palma and Diogenes the Cynic,* 1596 (pl. 44)

Inscribed recto, upper right, in pen and brown ink: *andriana palma 44 | 1596;* inscribed recto, center at right, in pen and brown ink: *Diogene | Cinicho;* inscribed recto, center at left, in pen and brown ink: *Lucas;* inscribed recto, lower left, in pen and brown ink: [5?]*96 ad 18 | -ind-*[?].

Pen and brown ink, on ivory laid paper; 190 x 133 mm.

COLLECTIONS: Paul Sandby, stamp (Lugt 2112) recto, lower right, in black; J. J. Lindman, stamp (Lugt Suppl. 1479a) recto, lower right, in gray, and stamp (not in Lugt) verso, center on mount, in purple; Charles Deering, Chicago.

LITERATURE: Cf. Schwarz, "Palma Giovane and His Family: Observations on Some Portrait Drawings," *Master Drawings* 3:158–65; Fernandez, "Three Drawings by Jacopo Palma Giovane," *Museum Studies* 4:109–15, fig. 1; Schwarz, "Portrait Drawings of Palma Giovane and His Family: A Postscript," *Studi di Storia dell'Arte in onore di Antonio Morassi,* pp. 210–15.

Charles Deering Collection, 1965.422

Palma Giovane's devotion to his wife Andriana and his passion for drawing are testified to by numerous sheets of portrait sketches of her. These studies have been published in recent years by Heinrich Schwarz and this one has been added to the group by Rafael Fernandez. Our sheet is inscribed with Andriana's name, but even without this aid, the fleshy face, chin, and curly hair unmistakably identify her with the other portraits pub-lished by Schwarz, in the Pierpont Morgan Library, the Staatliche graphische Sammlung of Munich, the Uffizi, the British Museum, Turin, and in several private collections.

This sheet, which also shows the head of a bearded old man identified as Diogenes the Cynic, is dated 1596 in the upper right and lower left corners. In this re-spect, as well as stylistically, it compares most closely with two pages from the Munich sketchbook (see Schwarz, "Palma Giovane and His Family: Observa-tions on Some Portrait Drawings," *Master Drawings* 3:160, pls. 25a and b, and see Schwarz, "Portrait Draw-ings of Palma Giovane and His Family: A Postscript," *Studia di Storia dell'Arte in onore di Antonio Morassi,* p. 210, fig. 2) and a drawing in the British Museum

(Andria Palma 1596, or perhaps 1593). In addition it compares with a sheet also from the former collection of Paul Sandby (see Schwarz, *Master Drawings* 3:160, pl. 25c).

Rafael Fernandez has suggested that the number "44" in the upper right corner might refer either to a page number in a sketchbook or to Andriana's age at the time of the drawing.

Jacopo Negretti (Palma il Giovane)
Venice 1548–1628

39 *Sketches for a Lamentation of Christ, a Pietà, and Other Figures* (pl. 45)

Pen and brown ink with brush and brown wash, on buff laid paper; maximum 273 x 190 mm. (a strip ca. 3 mm. wide was added to the left margin); verso: studies of the dead Christ and miscellaneous figures in pen and brown ink with brush and brown wash.

COLLECTIONS: William F. E. Gurley, Chicago, stamp (not in Lugt) recto, lower right and verso, lower left, in black.

LITERATURE: Tietze and Tietze-Conrat, *Drawings of the Vene-tian Painters,* p. 201, no. 871.

Leonora Hall Gurley Memorial Collection, 1922.890

The dominant motif on this sheet of sketches is the central *Lamentation of Christ,* whose body is in a similar position to that in the *Entombment.* Perhaps even more significant is a smaller compositional sketch (in the lower left corner) of a *Pietà* with Christ in His mother's lap that relates directly to Titian's late *Pietà* painting, which Palma finished upon that artist's death in 1576 (see Wethey, *The Paintings of Titian,* vol. 1, pp. 122–23, no. 86, pls. 136–38). On the basis of this connection, the Tietzes have dated the drawing about 1580.

Jacopo Negretti (Palma il Giovane)
Venice 1548–1628

40 *Saint Mark* (pl. 46)

Inscribed recto, lower right, in pen and brown ink: *Palma;* inscribed verso, upper left, in pen and brown ink: *8;* inscribed verso, upper right, in pen and brown ink: *Palma.*

Pen and brown ink, on ivory laid paper; maximum 189 x 149 mm.; verso: study of a torso.

COLLECTIONS: Sir Joshua Reynolds, stamp (Lugt 2364) recto, lower left, in black; W. Bates, stamp (Lugt 2604) recto, lower right, in red-brown; encircled *R,* unidentified blind stamp (not

in Lugt) recto, lower right; Ch. Deering, stamp (Lugt 516) verso, lower right, in blue.

Charles Deering Collection, 1927.5643

This monumental drawing of the patron saint of Venice, which bears two old attributions to Palma, illustrates yet another dimension of the prolific artist's draftsmanship. Spare and abstract in its outlining of forms, it is nonetheless expressive and characteristic of some of the artist's most summary evocative notations. It may be compared with a drawing in the Accademia di San Luca (see Grassi, *Il Libro dei Disegni di Jacopo Palma il Giovane*, pl. 56a). It has not been related to any known work by the artist.

Lugt collection, Paris (4662), and the Uffizi (no. 9344F; see Forlani, *Mostra di disegni di Jacopo da Empoli*, p. 32, no. 35, fig. 20) and also in the *Studies of Shepherds* (Uffizi, no. 9327F; see Forlani, *Mostra di disegni di Jacopo da Empoli*, p. 46, no. 66, fig. 29) for the *Nativity* of San Michele Visdomini (1618–28).

This crouching figure is not known to correspond precisely with any painting given to Empoli or his circle. Traditionally, it has been assumed that the youth represented a shepherd, perhaps a study for an Annunciation or Adoration of the Shepherds. However, as a drawing probably taken from life, this fairly anonymous figure could have served the artist for many purposes.

Jacopo Chimenti (da Empoli)?
Florence 1551–1640

41 *Young Man with Outstretched Arms* (pl. 50)

Red chalk, on ivory laid paper; laid down; 383 x 247 mm.
 COLLECTIONS: Sale: Berlin, Hollstein & Puppel, May 4–6, 1931, p. 135, no. 1258, pl. 28 (as Andrea del Sarto); Mr. and Mrs. Joseph Winterbotham, Burlington, Vermont.
 EXHIBITIONS: *Art in New England*, p. 115, no. 205, pl. 86 (attributed to Andrea del Sarto).

Bequest of Joseph Winterbotham, 1954.338

For many years this drawing was attributed to Andrea del Sarto, an association undoubtedly based on its classic simplicity and red chalk technique. However, in light of the scholarship of recent years on Andrea and his followers, it now seems more appropriate to place this in the circle of early Florentine Baroque artists who looked back to the masters of the Renaissance.

Although no certain attribution can be made at this time, a likely candidate is Jacopo da Empoli. Details of the youth's face and expression, the doubly delineated contours, accents, and shading techniques are characteristic of drawings by Empoli such as the *Head of a Youth* (ca. 1608) in the Scholz Collection (see Thiem, *Florentiner Zeichner des Frühbarock*, no. 18, reproduced) and those in the Uffizi (nos. 3451F and 3453F; see Forlani, *Mostra di disegni di Jacopo da Empoli*, p. 27, no. 25, fig. 16, and p. 37, no. 46, fig. 18).

The torso of the figure, with its careful silhouetting, the *pentimenti*, and positioning of the legs and loose handling of the chalk in areas of the clothing are comparable to elements in the seated nude youths in the

Alessandro Casolani
Siena 1552–1606(?)

42 *Bishop Blessing a Child* (pl. 49)

Red chalk with traces of graphite, on ivory laid paper; laid down; 290 x 200 mm.
 COLLECTIONS: Sir Joshua Reynolds, stamp (Lugt 2364) recto, lower left, in black; A. M. Champernowne, script (Lugt 153) recto, lower left, in pen and black ink; William F. E. Gurley, Chicago, stamp (not in Lugt) recto, lower right, in black; Leonora Hall Gurley Memorial Collection, stamp (Lugt Suppl. 1230b) verso, center on mount, in black.

Leonora Hall Gurley Memorial Collection, 1922.3899

Ulrich Middeldorf was the first scholar to propose a Sienese origin for this drawing when he suggested it might be by Francesco Vanni. Its Sienese character was confirmed by Philip Pouncey and Bernice Davidson (who compared it with the work of Salimbeni), but it was not, apparently, accepted as Sienese by Peter Anselm Riedl. The draftsmanship of this sheet, however, seems closer to that of Alessandro Casolani than to either of his Sienese contemporaries, Vanni or Salimbeni.

Confusion of the three leaders of late Mannerist eclecticism in Siena is not uncommon. In fact, Casolani studied under Salimbeni for a period. However, a far greater influence on Casolani was the academic Roman Mannerist, Cristofano Roncalli, called Pomarancio, who worked for a period in Siena. From him, Casolani acquired a rhythmic flow of contour lines and a schematic modelling which can be recognized also in a drawing in a private collection, Florence (see Forlani, *I Disegni italiani del cinquecento*, pp. 270–71, pl. 115). Jacob Bean has accepted this attribution.

Alessandro Casolani?

Siena 1552–1606(?)

43 Study of Two Young Boys (pl. 51)

Black chalk heightened with white chalk, on blue-green laid paper; 240 x 309 mm.; verso: study of torso and legs.

COLLECTIONS: Sold May 15, 1914 / Puttick & Simpson (according to records, stamp (not in Lugt) verso has been removed); William F. E. Gurley, Chicago, stamp (not in Lugt) recto, lower right, in black; Leonora Hall Gurley Memorial Collection, stamp (Lugt Suppl. 1230b) verso, upper right, in black.

Leonora Hall Gurley Memorial Collection, 1922.2261

This sensitive drawing of two young boys, probably sketches for a *Lamentation of the Dead Christ*, has had many different attributions proposed for its authorship. When it entered the museum in 1922, it was listed as by Ludovico Carracci, an identification also supported by Ulrich Middeldorf. Other names have been suggested, Federico Barocci, Salimbeni, Cavedone, and Tanzio da Varallo.

We would like to suggest Alessandro Casolani on the basis of two drawings in the Art Museum, Princeton University (48-677 and 51-52; see Gibbons, *Catalogue of Italian Drawings*, vol. 1, pp. 62–63, nos. 168–69; vol. 2, reproduced), which show a similar handling of outline, shading, and white highlighting of the figures. The attribution of the *Nude Youth Resting against the Leg of Another Figure* (48-677) is long-standing and inscribed on the sheet; that of the *Two Studies of a Seated Male Nude* (51-52) was given by Pouncey and Gere. Our drawing may also be compared with one of a *Male Nude* in the Wallraf-Richartz Museum, Cologne (Inv. no. Z 2057; see Robels, *Drawings of the Fifteenth and Sixteenth Centuries*, p. 53, fig. 56).

Ludovico Carracci

Bologna 1555–1619

44 Study for an Invitation to the Defense of a Doctoral Thesis (pl. 52)

Allegorical figures surround the Duke of Mantua and his arms: Apollo, Minerva, Neptune at the left, Jupiter, Venus, Hercules at the right; a river god and a female figure represent the city of Mantua in the lower part.

Inscribed recto, lower center on mount, in pen and brown ink: *Lodovico Carracci–1555;* inscribed verso, lower left on mount, in pen and brown ink (in Esdaile's hand): *Formerly in the Collection of C. Jennings & Richardson / 1816 WE—Roscoe's coll. P 28 N 61. . . Vide Lanzi 5–72.*

Pen and brown ink, on ivory laid paper; laid down; 143 x 189 mm.

COLLECTIONS: J. Richardson, Jr., stamp (Lugt 2170) recto, lower right, in black and script (Lugt Suppl. 2997b) verso, center on mount, in pen and brown ink; H. C. Jennings, stamp (Lugt 2771) recto, lower right, in black; W. E. Roscoe, sale: Liverpool, 1816, according to an inscription recto, lower right on mount, in pen and brown ink; W. Esdaile, script (Lugt 2617) recto, lower right, in pen and brown ink and script verso, lower left on mount, in pen and brown ink (see above); William F. E. Gurley, Chicago, stamp (not in Lugt) recto, lower left and verso, center on mount, in black; Leonora Hall Gurley Memorial Collection, stamp (Lugt Suppl. 1230b) verso, center on mount, in black.

LITERATURE: Cf. Bodmer, *Lodovico Carracci*, fig. 134.

EXHIBITIONS: *Great Master Drawings of Seven Centuries*, pp. 39–40, no. 31, pl. 38; Cummings, *Art in Italy, 1600–1700*, p. 77, no. 67, reproduced.

Leonora Hall Gurley Memorial Collection, 1922.24

Ludovico was the elder cousin and first instructor of Agostino and Annibale Carracci and with them founded the famous Accademia degli Incamminati in Bologna (ca. 1585). After the departure, first of Annibale and later of Agostino, from that city, Ludovico was left in charge of this academy and, long after their early deaths, proved a major influence on the second generation of Bolognese seicento artists, such as Domenichino, Guido Reni, and Guercino.

It is possible that this drawing represents the first sketch for a design for an invitation or frontispiece to a doctoral thesis that was engraved by Oliviero Gatti (Bartsch, *Le Peintre graveur*, vol. 19, p. 18, no. 46). Malvasia, the historian of the Bolognese school, mentions the print (see Malvasia, *Felsina pittrice*, vol. 1, p. 89), which is considerably larger than our drawing.

Other drawings of the same subject exist in the Albertina (no. 2090; see Stix and Spitzmüller, *Beschreibender Katalog der Handzeichnungen*, vol. 6, p. 11, no. 77), the Ashmolean Museum (see Parker, *Drawings in the Ashmolean*, vol. 2, p. 86, no. 178, pl. 45), and the Biblioteca Ambrosiana, Milan (no. 184 of the Codex Resta, courtesy of Lenore Street). Bodmer connects the Albertina drawing with Ludovico's style of the first decade of the seventeenth century (see Bodmer, "Drawings by the Carracci: An Aesthetic Analysis," *Old Master Drawings* 8:57).

Our drawing was matted in the eighteenth century by its famous owners, the Richardsons, who inscribed the following on the verso of the mount, in pen and brown ink:

The Summonses sent about to invite their Friends to assist at the Pronouncing a / Theme (*Conclusione*) by the Scholars of the University of *Bologna* were often orna- / mented by a Print, which was commonly Designed by the Best Masters. This Drawing / is of

Ludovico Carracci, for this purpose, & was the most admired, as *Malvasia* re- / lates of all those that had appeared on these occasions. "E finalmente la tanto / celebrata Conclusione, dedicata al Duca di Mantova, detta comunemente, La / *Conclusione della Deità,* per esservi elleno contanta novità grazia, giustezza e / proprietà espresse che ben danno a divederi, *Ludovico,* nell Invenzione e nel / Disegno, aver passato ogn'altro, sottovi *Lod. Car. inv. Oliv. Gatti. Felsina Pittrice,* T.I p. 89." / *Ludovico* made a little Alteration, putting two of the Figures in a Sitting Posture, / as appears by the Print, which is otherwise beyond Imagination Inferior to y / Drawing in the Grace of the Actions & Countenances; & above all, the Inexpressa- / ble *Delicacy;* which is the predominant Virtue of this Little Star—*e, a cui cosi / non pare, dovrebbe del suo judizio dolersi,* as Count Malvasia says on another occa- / sion."

Bartolomeo Cesi
Bologna 1556–1629

45 *Seated Cleric* (pl. 54)

Inscribed recto, lower right, in pen and brown ink: *Dono.*

Red chalk heightened with white chalk, on blue laid paper; squared in black chalk; 352 x 214 mm.

COLLECTIONS: Signori Locatelli(?), Bologna; Dr. E. Peart, script (Lugt 892) recto, lower left, in pen and brown ink; Sold May 15, 1914, Puttick & Simpson (according to records; stamp [not in Lugt] verso, has been removed); William F. E. Gurley, Chicago, stamp (not in Lugt) recto, lower left, in black.

EXHIBITIONS: Vitzthum, *A Selection of Italian Drawings,* pp. 34–35, 127, no. 23, reproduced; Neilson, *Italian Drawings,* no. 21, reproduced.

Leonora Hall Gurley Memorial Collection, 1922.5404

Bartolomeo Cesi was a contemporary of the Carracci and stands out as a striking individualist in Bolognese art at the turn of the seventeenth century. Although many of his drawings from life show a general similarity to the chalk drawings by Agostino and Annibale, Cesi's straightforward and somewhat archaic representations rarely show the understanding of the structure of the human form characteristic of the Carracci; rather he delights in surface texture and light effects, as pointed out by Catherine Johnston (*Il Seicento e il settecento a Bologna,* pp. 9, 88, figs. 5, 6).

This drawing, attributed to Cesi by Middeldorf, is a characteristic example of the artist's style. A group of similar studies of youths dressed in clerical robes is in the Uffizi (nos. 1551-4F) and the same model can also be recognized in a drawing in the Albertina (no. 23368;

see Johnston, *Il Seicento e il settecento a Bologna,* fig. 5). Vitzthum suggested that an assistant in Cesi's studio probably served as the model.

Recently, Jürgen Winkelmann has identified this as a preparatory study for the painting of Saint Benedict in the convent of San Procolo in Bologna. Winkelmann, who plans to publish this discovery, connects our drawing with that mentioned by Malvasia in the possession of the Signori Locatelli (see Malvasia, *Felsina pittrice,* vol. I, p. 246). He would date this drawing (which he notes must have been very famous to be mentioned by Malvasia) rather late in the artist's career, perhaps at the beginning of the seventeenth century.

Agostino Carracci
Bologna 1557–1602 Parma

46 *Portrait of His Son, Antonio Carracci* (pl. 55)

Inscribed recto, lower left, in pen and brown ink: *Ritrato di Antonio Carraçci da Agostino;* inscribed verso, lower left, in pen and brown ink: *Ritratto da Antonio Caracci, delt. par Agostino.*

Red chalk, on cream laid paper; laid down; 361 x 256 mm.

COLLECTIONS: Charles-Gilbert Viscount Morel de Vindé; Th. Dimsdale, stamp (Lugt 2426) verso, lower left, in black (now illegible); Sir Thomas Lawrence; Samuel Woodburn, sale: London, Lawrence Gallery, 1836; Francis Egerton, 1st Earl of Ellesmere, stamp (Lugt Suppl. 2710b) recto, lower right, in black; Sir John Sutherland Egerton, Sixth Duke of Sutherland and Earl of Ellesmere, sale: London, Sotheby's, July 11, 1972, lot 30, reproduced; acquired from Marianne Feilchenfeldt, Zurich.

EXHIBITIONS: *A Catalogue of One Hundred Original Drawings by Lodovico, Agostino and Annibale Carracci, Collected by Sir Thomas Lawrence, Late President of the Royal Academy,* The Lawrence Gallery, Sixth Exhibition (London: Messrs. Woodburn's Gallery, no. 42 St. Martin's Lane, 1836), no. 45 (according to Sotheby's); *Catalogue of the Ellesmere Collection of Drawings at Bridgewater House* (London, 1898), no. 84 (according to Sotheby's); Tomory, *The Ellesmere Collection,* p. 16, no. 31, pl. 10; *Drawings by the Carracci and Other Masters* (London, P. & D. Colnaghi, 1955), no. 35 (according to Sotheby's); *The Carracci Drawings and Paintings* (Newcastle upon Tyne, 1961), no. 40 (according to Sotheby's); Goldman in Wise, *European Portraits, 1600–1900,* pp. 96–99, no. 23, reproduced, also color plate 1.

Clarence Buckingham Collection, 1973.152

Never quite achieving the monumental power in painting of his brother Annibale, Agostino nonetheless was widely influential through his numerous engravings after his own and other masters' designs and was considered the most scholarly and articulate of all the Carracci. Agostino spent long periods in Venice (ca. 1582–87), Rome (ca. 1597–1600), and Parma (1600–1602), and his engravings, which reflect the artistic

masterpieces of these areas, served as propaganda for the reform of Italian art the Carracci sought. There can be little doubt that one so well-read, well-traveled, and articulate as Agostino was one of the major forces behind their founding of the Accademia degli Incamminati (ca. 1585). Through this academy, the Carracci set about a revolution in Italian painting, turning the trend in Bologna from the Mannerist impulses of the late sixteenth century back to an emphasis on the study of nature, the masters of antiquity, and the classical High Renaissance.

It is believed that Agostino's son, Antonio, may have been born during his period in Venice, but the date of Antonio's birth is still somewhat uncertain. According to two old inscriptions, this drawing is a portrait of Antonio executed by his father. As the boy in this portrait is an adolescent, the drawing could be dated in the mid-1590s.

The bold presentation and vigorous execution of the drawing is not unlike other chalk portrait drawings by Agostino and seem to reflect the artist's training as an engraver. As Jean Goldman has pointed out, a portrait at Windsor (Inv. no. 2246; see Wittkower, *The Drawings of the Carracci*, p. 122, no. 164, pl. 22) is not necessarily a self-portrait (as suggested by Wittkower), but may also represent Antonio at about the same age. Other significant examples of drawings of this type are in the Uffizi as well as at Windsor (see Goldman in Wise, *European Portraits, 1600–1900*, pp. 98, 99 n. 3).

After his father's death in 1602, Antonio apprenticed with his uncle Annibale. Unfortunately few of Antonio's own creations remain as a result of his untimely death, but one of the few finished drawings that can be attributed to him, also from the Ellesmere collection, has recently been acquired by the Art Institute (see cat. 58).

Agostino Carracci
Bologna 1557–1602 Parma

47 *Studies of Grotesque Figures and a Bent Leg* (pl. 53)

Inscribed recto, lower right, in pen and brown ink: *Agostino Carracci.*

Pen and brown ink with traces of black chalk, on ivory laid paper; laid down; 196 x 271 mm.

COLLECTIONS: P. Crozat?, stamp (Lugt 474) recto, lower left, in black, redrawn with pen and black ink; Queen Christina of Sweden, according to an inscription verso, center on mount, in graphite (confused with Crozat[?] stamp?); From the Earl

of Clarendon Collection, according to inscription verso, center on mount, in pen and brown ink; Dr. C. D. Ginsburg, stamp (Lugt 1145) verso, lower left on mount, in black; Dr. C. D. Ginsburg, LL.D. / collection sold July / 20, 1915, Sotheby, London, stamp (not in Lugt) verso, lower left on mount, in purple; William F. E. Gurley, Chicago, stamp (not in Lugt) lower right and verso, center on mount, in black; Leonora Hall Gurley Memorial Collection, stamp (Lugt Suppl. 1230*b*) verso, center on mount, in black.

LITERATURE: See Wittkower, *The Drawings of the Carracci*, p. 125, no. 185.

Leonora Hall Gurley Memorial Collection, 1922.19

Agostino's less formal draftsmanship is represented by this pen and ink drawing in the Art Institute's collection. A creative combination of mythological creatures and studies of the human form, this sheet illustrates the free but sure calligraphy of Agostino's drawn line, characteristic of one trained as a printmaker under the guidance of Domenico Tibaldi, brother of one of the most lyrical north Italian Mannerist artists, Pellegrino.

This drawing bears an old attribution to Agostino which has been accepted by Rudolf Wittkower and Jacob Bean. The largest surviving group of similar studies by Agostino is at Windsor Castle, of which Wittkower says "the majority form a fairly coherent group of about 1595" (*The Drawings of the Carracci*, pp. 117–22).

Domenico Cresti (Passignano)
Passignano 1558–1636 Florence

48 *Saint Peter, Saint Augustine, and a Female Saint in Adoration of the Eucharist* (pl. 43)

Pen and brown ink with brush and brown wash, heightened with white gouache, over black chalk, on blue laid paper; 400 x 247 mm.

COLLECTIONS: William F. E. Gurley, Chicago, stamp (not in Lugt) recto, lower left and verso, center on mount, in black; Leonora Hall Gurley Memorial Collection, stamp (Lugt Suppl. 1230*b*) verso, center on mount, in black.

Leonora Hall Gurley Memorial Collection, 1922.45

Passignano was a prominent pupil of Federico Zuccaro with whom he traveled, from the mid 1570s to 1589, from Florence to Rome and Venice. In this way, Passignano was exposed to the most advanced artistic currents of the three major Italian centers, and when he returned to Florence in 1589, it was with a much broader base than most Florentine artists enjoyed.

The subject of the drawing, the Adoration of the Eucharist, was given special emphasis during the

Counter Reformation. The attribution of this sheet to Passignano, first suggested by Rafael Fernandez, has been confirmed by A. E. Popham. Closest to it is a drawing in Windsor Castle which is also conceived in two zones, with large figures of saints in the lower area (5980; see Popham and Wilde, *Italian Drawings*, pp. 290–92, no. 674, fig. 132). Characteristic of Passignano are the thin nervous strokes of the pen and the delicate highlighting on colored or lightly washed paper, a reflection of the dominant influence Passignano's Venetian experience held in his art.

Ludovico Cardi (da Cigoli)
Cigoli 1559–1613 Rome

49 *Soldiers* (pl. 59)

Pen and brown ink, over black chalk, on ivory laid paper; laid down; 131 x 208 mm.
COLLECTIONS: Bought Nov. 20, 1914 / Puttick & Simpson, stamp (not in Lugt) verso, lower center on mount, in purple; William F. E. Gurley, Chicago, stamp (not in Lugt) recto, lower right of center, in black; Leonora Hall Gurley Memorial Collection, stamp (Lugt Suppl. 1230*b*) verso, center on mount, in black.
Leonora Hall Gurley Memorial Collection, 1922.3059

Ludovico Cardi, called Il Cigoli, was a late sixteenth-century Florentine painter and architect whose earliest education came under Alessandro Allori and Santi di Tito, and from the study of Pontormo and Michelangelo. He also looked for inspiration outside of Florence, to Parma, Siena, Bologna, and Venice, and the result was an eclectic but progressive late Mannerist style.

Cigoli's many different drawing styles reflect this varied background. This spirited drawing is characteristic of Cigoli's rapid compositional sketches. In particular, it compares with similar sheets (ca. 1590–93) in the Yale University and Bick collections (see Pillsbury and Caldwell, *Sixteenth Century Italian Drawings*, nos. 42–43, reproduced), and a sketchbook page (ca. 1597 in the Albertina (see Thiem, *Florentiner Zeichner des Frühbarock*, p. 292, no. 38, reproduced). The spindly, elongated figures are drawn with often straight, broken lines and round or oval heads. The figure of Saint Michael at the lower left of the Bick sheet is especially close to the soldier at the left of the horse in this drawing.

The precise subject of our drawing is not known, but as Cigoli was active in many aspects of the arts, it could be that this drawing was connected with a theatrical production or pageant.

Ludovico Cardi (da Cigoli)
Cigoli 1559–1613 Rome

50 *The Marriage of the Virgin* (pl. 58)

Inscribed recto, lower left on mount, in graphite (by Skippe, according to Christie's): *Parmigianino*.
Pen and brown ink with brush and blue and gray washes, over black chalk, on ivory laid paper; laid down; 269 x 442 mm.
COLLECTIONS: John Skippe; Penelope Martin (John Skippe's sister); Martin family descendants; Edward Holland; Mrs. Rayner-Wood (Edward Holland's sister) and Edward Holland-Martin (Edward Holland's nephew); John Skippe, sale: London, Christie's, November 20–1, 1958, lot 146*a*; P. & D. Colnaghi & Co., London; John Brophy; Yvonne Tan Bunzl, London, catalog of Summer, 1975, no. 7, reproduced; acquired from Paul Drey Gallery, New York.
Gift of Mr. and Mrs. William O. Hunt, 1976.56

The eighteenth-century collector John Skippe considered this drawing to be the work of Parmigianino, as is evident from his inscription on the mount. However, A. E. Popham, in the catalog of the 1958 sale of the Skippe collection at Christie's, identified it as a copy after a drawing of the same subject by Parmigianino, now in the Ecole des Beaux-Arts, Paris (Inv. no. 223; see Popham, *Catalogue of the Drawings of Parmigianino*, vol. 1, p. 166, no. 521; vol. 2, pl. 195).

It was Philip Pouncey who pointed out that the handling of this drawing is characteristic of Cigoli, who has interpreted Parmigianino's composition in his own style and on a larger scale. The classic composition and several of the figures ultimately derive from works by Raphael and Andrea del Sarto, so that this is a creative synthesis of several of the Renaissance masters from whom Cigoli gathered much of his inspiration.

The use of pen and brown ink with blue wash is typical of Cigoli's more finished compositional drawings. In fluid musculature, retraced contours, and the expressions on the generally oval faces, this drawing compares with those in the Uffizi (Inv. 966F), the Gabinetto delle Stampe, Rome (Inv. F. C. 130625), in Hamburg (Inv. 21149), and in a private collection, Stuttgart (see Thiem, *Florentiner Zeichner des Frühbarock*, pp. 290–94, nos. 35, 37, 41, 43, reproduced).

Giuseppe Cesari, Il Cavaliere d'Arpino
Rome 1568–1640

51 *Figure Study of a Man* (pl. 61)

Red chalk, on ivory laid paper; laid down, 248 x 164 mm.
COLLECTIONS: Dr. C. D. Ginsburg, stamp (Lugt 1145) recto,

lower left on mount, in black; Dr. C. D. Ginsburg, LL.D. / collection sold July 20, 1951, Sotheby, London, stamp (not in Lugt) verso, lower left on mount, in purple; William F. E. Gurley, Chicago, stamp (not in Lugt) recto, lower right, in black; Leonora Hall Gurley Memorial Collection, stamp (Lugt Suppl. 1230b) verso, center on mount, in black.

Leonora Hall Gurley Memorial Collection, 1922.472

This sheet, like so many red-chalk figure drawings, entered the collection in 1922 with an attribution to Andrea del Sarto. Middeldorf realized that it was more likely the work of an artist at the turn of the century and suggested the Florentine Cristofano Allori. Rafael Fernandez was the first to propose that last champion of cinquecento Mannerism in Rome, Giuseppe Cesari, called Il Cavaliere d'Arpino. Jacob Bean supported this attribution, and Herwarth Röttgen confirmed it, adding that the figure was a study for a fresco in the Certosa of San Martino, Naples.

On the death of Cardinal Alessandro Farnese in 1589, Cesari left Rome to go to Naples where, on June 28 of that year, he received a commission to paint the vault of the choir of the Certosa with four New Testament scenes referring to the Eucharist, surrounded by saints and prophets. He had completed the greater part of this decoration by 7 November 1589, when he was called back to Rome because of the illness of his father.

According to van Mander, Cesari sent his younger brother Bernardino to Naples to work on this project in order to extricate him from involvement with bandits, and there is evidence that Bernardino helped to finish the vault between August 1592 and June 1593 (see Röttgen, Il Cavalier d'Arpino, pp. 27–28).

This figure of a man tugging on a sheet corresponds to one in the lower right corner of a New Testament scene related to the Eucharist on the vault of the choir (see Causa, L'Arte nella Certosa di San Martino, pl. 14). It is undoubtedly by the hand of the Cavaliere d'Arpino himself and compares with other nude male studies by him (see Röttgen, Il Cavalier d'Arpino, nos. 96–101, 120, 122, reproduced).

Guglielmo Caccia (Moncalvo)
Montabone ca. 1568–1625 Moncalvo

52 Assumption of the Virgin (pl. 56)

Inscribed recto, lower left on mount, in pen and dark brown ink: *Scola Pesarese*.

Pen and brown ink with brush and brown wash, over traces of graphite, on ivory laid paper; pieced together and laid down; 390 x 239 mm.

COLLECTIONS: William F. E. Gurley, Chicago, stamp (not in Lugt) recto, lower right, in black; Leonora Hall Gurley Memorial Collection, stamp (Lugt Suppl. 1230b) verso, center on mount, in black.

Leonora Hall Gurley Memorial Collection, 1922.2336

Guglielmo Caccia, called Moncalvo after the town between Turin and Pavia where he was active from 1593 on, was primarily a painter of altarpieces and frescoes in various cities of the Piedmont and Lombardy.

The figure of Mary surrounded by cherubim is inserted into the composition on another piece of paper. This drawing exemplifies Moncalvo's facile, nervous, and agitated draftsmanship and his habit of dividing religious compositions into celestial and terrestial spheres, in his drawings and paintings alike (see Moccagatta, "Guglielmo Caccia detto il Moncalvo: Le opere di Torino e la Galleria di Carlo Emanuele I," *Arte Lombarda* 8:186, 200, 210, pls. 1, 2, 17, 25).

It is not known whether this composition was actually used in an altarpiece by Moncalvo, but an *Assumption* is recorded in the church of San Bernardino in Carmagnola, a village south of Turin (see Venturi, *Storia dell'arte Italiana*, vol. 9, part 7, p. 568; see Vesme, *Schede Vesme*, vol. 1, p. 226, not reproduced).

Giovanni Baglione
Rome 1571–1644

53 Sheet of Studies with a Madonna and Child with Saints (pl. 60)

Pen and brown ink with red chalk and brush and red chalk wash, over traces of graphite, on ivory laid paper; 285 x 212 mm.

WATERMARK: Eagle with crown (Cf. Briquet 207 or 209, Rome or Verona, 1573–96).

COLLECTIONS: William F. E. Gurley, Chicago, stamp (not in Lugt) recto, lower right, in black.

Leonora Hall Gurley Memorial Collection, 1922.5610

At one time, this drawing bore an attribution to Michelangelo Anselmi, which was changed to Ludovico Cardi (Il Cigoli), an attribution it held until recently. Herwarth Röttgen recognized this as the early work of Baglione, and his identification has been supported by Erich Schleier. In style and technique, it compares closely with *A Sketch for an Altarpiece with God the Father above, the Marriage of Saint Catherine, Saint Mark and Saint Francis* in Christ Church, Oxford (0589; see Byam Shaw, *Drawings by Old Masters*, vol. 1, p. 164, no. 586; vol. 2, pl. 320). The attribution of that drawing

also was made by Röttgen, who connected it with a group of early drawings (ca. 1590–95).

Baglione was one of the late Maniera painters in Rome under Sixtus V and was the self-proclaimed enemy of Caravaggio; nonetheless, the influence of that artist, as well as of the Bolognese Guercino, can be seen in Baglione's panel paintings. His later career was more distinguished by his writing than by his painting; Baglione is perhaps most famous for his biographies of the late sixteenth- and early seventeenth-century Roman artists (*Le vite de' pittori, scultori, architetti ed intagliatori dal pontificato di Gregorio XIII fino a tempi di Papa Urbano VIII nel 1642* [Rome, 1642]).

Guido Reni
Bologna 1575–1642

54 *Pomona* (pl. 62)

Inscribed recto, lower center, in black chalk: *Guido Reni.*
 Black chalk, on tan paper; mounted on panel; 1725 x 845 mm.
 COLLECTIONS: Charles Loeser, Florence; acquired from Durlacher Bros., New York.
Ada Turnbull Hertle Fund, 1961.793

Guido Reni was one of the most significant figures of the second generation Bolognese school of the seventeenth century and trained many of the younger artists. Reni was educated first under the Flemish artist Denys Calvaert and then, in about 1594, in the academy under Ludovico Carracci. He left for Rome about 1600 with Domenichino and Albani, and there he was confronted directly with the artistic rivalry between Annibale Carracci and Caravaggio, both of whose works he studied. There, in the presence of Raphael's Roman legacy, he achieved his own blend of monumental classicism and idealized naturalism that he took back to Bologna. In his numerous drawings, this blend translates into a solid draftsmanship not unlike Agostino's.

At least three large, single figure cartoons attributed to Reni are known. Two of these were given to the Fogg Art Museum in 1920 and have been loosely associated with the Rospigliosi *Aurora* of about 1613 (1920.42-3; see Mongan and Sachs, *Drawings in the Fogg Museum*, vol. 1, pp. 145–46, nos. 291–92; vol. 2, figs. 140–41).

It is, however, not certain that all three drawings belonged to the same series, particularly because the *Pomona* is somewhat less spontaneous in draftsmanship and less accomplished in anatomical rendering (especially in the connection of the shoulder, neck, and head).

We owe this attribution to Otto Kurz (letter of 2 March 1960), who mentioned the fact that (according to Malvasia, *Felsina pittrice*, vol. 2, p. 70) Reni enjoyed creating "finished" cartoons for various friends and fresco painters, to enrich their *quadratura* painting.

Giovanni Biliverti
Maastricar 1576–1644 Florence

55 *Studies for the Beheading of a Saint* (pl. 57)

Red chalk with brush and red chalk wash, on ivory laid paper; 292 x 168 mm.
 COLLECTIONS: Acquired from Otto Wertheimer, Paris.
Bequest of Francis A. Elkins, 1957.374

Once attributed to Jacques Callot, the drawing is clearly the work of another artist of foreign origin active in Florence at the turn of the seventeenth century, Giovanni Biliverti, whose family came from Flanders. It is drawn in his characteristic technique of red chalk and red chalk wash, and compares with the haunting, hollow-eyed and emaciated images of other drawings by him, such as *Christ Carrying the Cross* and the *Ecce Homo* in the Uffizi (Inv. 976F and 9643F; see Thiem, *Florentiner Zeichner des Frühbarock*, pp. 328–30, nos. 88, 90, reproduced).

Jacob Bean has connected our sheet with a group of studies for a *Beheading of Saint John the Baptist* (or Saint Paul). The most finished drawing of the series, in red chalk and red chalk wash, is in the Louvre and owes its attribution to the distinguished collector Filippo Baldinucci, who once owned it (Inv. 583; see Bacou and Bean, *Disegni fiorentini*, p. 56, no. 42, pl. 46). Another version, in the Albertina, contains a Salome-like figure, suggesting the story is that of the Baptist (see *L'Art Ancien*, Catalogue 50/19 [Zurich, n.d.], no. 31, reproduced). Other related drawings are in the Uffizi (Inv. 9653F), the Courtauld (Witt no. 4234; see Blunt, *Handlist of the Drawings in the Witt Collection*, p. 72, no. 56), the Cooper-Hewitt and the Metropolitan Museum (letter from Jacob Bean, 7 January 1970).

Francesco Albani
Bologna 1578–1660

56 *Mercury* (pl. 63)

Inscribed recto, upper left, in pen and brown ink: *22.*
 Black and white chalks, on buff laid paper; laid down; maximum 420 x 260 mm.
 COLLECTIONS: Charles Deering, Chicago.
Charles Deering Collection, 1927.7665

An old attribution to Agostino Carracci was on the mount of this drawing but Rudolf Wittkower suggested that it might be by another Bolognese artist and pupil of Calvaert and the Carracci, Francesco Albani. This attribution has recently been supported by Richard Spear (letter of 5 September 1977).

Although much of the drawing is somewhat rubbed, what remains compares with a sheet in Windsor Castle (5715; also in black and white chalks, on blue paper) with drawings of *Mercury* and the *Fall of Phaeton;* Albani's unique derivation of anatomical draftsmanship from the tradition of the Carracci carries through despite the weakened condition of this drawing (see Kurz, *Bolognese Drawings*, p. 79, no. 2, pl. 2, and see Johnston, *Il Seicento e il settecento a Bologna*, p. 84, pl. 21). The Windsor Castle drawing is connected with the frescoes of the Council of the Gods, which Albani executed in the Palazzo Giustiniani (now Odescalchi), dated about 1609. It is possible that our sheet is related to the same commission; it could also be connected with Albani's Verospi Palace frescoes.

with this important early Roman work by Domenichino: the age, position, and roughly indicated setting of the study approximately correspond to the central background figure of a young spectator with a dangling leg, seated on the wall. Of the more than 1,750 drawings by Domenichino at Windsor Castle alone, there is only one other drawing (1147) which has been published in tentative connection with this major fresco, and, here too, "the pose is not . . . in full conformity with that utilised in the completed work" (see Pope-Hennessy, *Drawings of Domenichino*, p. 80, no. 885).

Furthermore, the *Seated Youth*, though badly rubbed, reveals many of the common characteristics of Domenichino's early drawings. Generally they were executed in black chalk, heightened with white chalk, on blue-gray paper (see Spear, "The Early Drawings of Domenichino at Windsor Castle and Some Drawings by the Carracci," *Art Bulletin* 49:57). Also characteristic of Domenichino is the sensitive interpretation of a specific emotion, in the case of the youth, one of wonderment, which accords well with his role in the fresco.

Domenico Zampieri (Domenichino)
Bologna 1581–1641 Naples

57 *Seated Youth* (pl. 64)

Inscribed recto, lower center on mount, in pen and black ink: *Domenichino.*

Black chalk with traces of white chalk, on blue laid paper; laid down; maximum 254 x 173 mm.

COLLECTIONS: Bought May 28, 1915 / Puttick & Simpson, stamp (not in Lugt) verso, center on mount, in black; William F. E. Gurley, Chicago, stamp (not in Lugt) recto, lower right, in black; Leonora Hall Gurley Memorial Collection, stamp (Lugt Suppl. 1230*b*) verso, center on mount, in black.

Leonora Hall Gurley Memorial Collection, 1922.1049

Domenichino was one of several young artists, like Reni and Albani, who followed their Bolognese masters Agostino and Annibale Carracci to Rome at the turn of the seventeenth century. From the time he arrived in 1602 (and for the better part of the thirty years he stayed there) Domenichino enjoyed numerous commissions and great success in the Papal City.

One of the works that helped to establish Domenichino's position in Rome was the austere fresco he completed in 1608 for Cardinal Scipione Borghese, the *Scourging of Saint Andrew* in San Gregorio Magno (see Borea, *Domenichino*, fig. 14). Jacob Bean has suggested that our drawing of a *Seated Youth* might be connected

Antonio Carracci
Venice(?) ca. 1583–1618 Rome

58 *The Virgin, the Holy Women, and Saints John, James, and Joseph of Arimathea with Christ on the Way to Calvary* (pl. 65)

Pen and brown ink with brush and blue wash, heightened with white gouache, on blue-green laid paper; 322 x 253 mm.

COLLECTIONS: Narcisse Revil, Paris; Sir Thomas Lawrence, London; Francis Egerton, 1st Earl of Ellesmere, stamp (Lugt Suppl. 2710*b*) recto, lower right, in black, sale: London, Sotheby's, July 11, 1972, lot 81, reproduced; acquired from Paul Drey Gallery, New York.

EXHIBITIONS: *A Catalogue of One Hundred Original Drawings by Lodovico, Agostino and Annibale Carracci, Collected by Sir Thomas Lawrence*, The Lawrence Gallery, Sixth Exhibition (London, Messrs. Woodburn's Gallery, no. 42 St. Martin's Lane, 1836), no. 71 (according to Sotheby's); *Catalogue of the Ellesmere Collection of Drawings at Bridgewater House* (London, 1898), no. 112 (according to Sotheby's); Tomory, *The Ellesmere Collection*, pp. 5, 37, no. 104; Mahon, *Mostra dei Carracci: . . . Disegni*, p. 169, no. 251.

Gift of Mrs. Leigh B. Block, 1977.293

Paintings and drawings by Antonio Carracci are extremely rare, perhaps because his life was short. This sheet comes from the hands of the same distinguished collectors, Sir Thomas Lawrence and the Earl of Ellesmere, as our *Portrait of Antonio* drawn by his father Agostino in the mid 1590s (see cat. 46).

This rather finished compositional drawing, which was once attributed to Annibale Carracci, was assigned to his nephew Antonio by P. A. Tomory in the Ellesmere Collection exhibition catalog of 1954. Tomory based his attribution on a comparison with the drawing of *Saint Philip Baptising the Eunuch* at Chatsworth, which bears an attribution by Padre Sebastiano Resta (471; see Mahon, *Mostra dei Carracci: . . . Disegni*, pp. 168–69, no. 250, pl. 120).

Denis Mahon agreed with this attribution and added that a third drawing in Munich, *The Deluge* (preparatory for Antonio's painting in the Louvre and also for the Quirinal fresco) creates a coherent, although restricted group of drawings for Antonio (Inv. 2880; see Mahon, *Mostra dei Carracci: . . . Disegni*, p. 168, no. 249, pl. 119).

By contrast, drawings that Wittkower attributed to Antonio—in Turin (no. 16095, bearing the inscription *Antonino*; see Bertini, *I Disegni italiani*, p. 23, no. 104) and in Oxford (with the inscription verso *Antonio Caratio Pittor fece*; see Parker, *Drawings in the Ashmolean*, vol. 2, no. 806)—are so far removed from this group that they seem of dubious attribution, according to Mahon (see Wittkower, *The Drawings of the Carracci*, p. 163, and see Mahon, *Mostra dei Carracci: . . . Disegni*, p. 169).

There is another, larger version of this drawing in the British Museum (1895-9-15-694; 357 x 257 mm.) which has not been published recently nor reproduced. It also bears an old attribution to Annibale and comes from the Esdaile, Robinson, and Malcolm collections. Mahon cites it as a copy of this drawing (see Mahon, *Mostra dei Carracci: . . . Disegni*, p. 169).

Jusepe de Ribera
Játiva, Valencia, Spain 1591–1652 Naples

59 *A Group of Figures* (pl. 67)

Illegible inscription recto, lower left, in pen and brown ink, according to Vitzthum: *Ribera fe*ᵗ, and according to Smith: *A.S.A. fe*ᵗ.

Pen and brown ink with brush and brown wash, on ivory laid paper; maximum 129 x 88 mm.

COLLECTIONS: S. Landsinger, stamp (Lugt 2358?) recto, upper left, in blue and verso, upper left, in pen and brown ink; Coll. Mrs. Forman of Seven- / Oaks, England, sold July 11, / 1913 Puttick & Simpson, stamp (not in Lugt) verso, lower left, in purple; William F. E. Gurley, Chicago, stamp (not in Lugt) recto, lower right, in black; Leonora Hall Gurley Memorial Collection, stamp (Lugt Suppl. 1230b) verso, lower left, in black.

LITERATURE: Brown, *Jusepe de Ribera*, p. 176.

EXHIBITIONS: Vitzthum, *A Selection of Italian Drawings*, pp. 50–51, 144, no. 140, reproduced; Smith, *Spanish Baroque Drawings*, pp. 62–63, no. 37, reproduced.

Leonora Hall Gurley Memorial Collection, 1922.985

Although Jusepe de Ribera, called Lo Spagnoletto, was born in Spain, he went to Italy as a youth, settled in the Spanish vice-royalty of Naples in 1616, and became one of the most significant members of the Neapolitan school as well as an accepted member of Neapolitan society. Although he also studied works of the Venetians, the Carracci, and Correggio, Ribera is primarily known as one of the most creative followers of Caravaggio's strain, particularly evident in the early works; later he turned toward Bolognese classicism, and ultimately, at the end of his life, he took on a very bizarre, sombre manner.

Ribera was also a prolific graphic artist, producing many prints as well as spirited drawings in several styles—among his most unique contributions to seventeenth-century art. Our knowledge of Ribera's drawings is still at a formative stage, although the research of Walter Vitzthum, Gridley McKim Smith, Pérez Sánchez, and Jonathan Brown have greatly advanced scholarship in this field in recent years. Nonetheless, due to a paucity of securely dated drawings, the precise ordering of Ribera's chronology and the placement of certain drawings, such as this, are subjects of controversy.

On account of the illegible inscription, this drawing was traditionally attributed to the Roman artist, Andrea Sacchi, but Walter Vitzthum recognized this error and attributed the small sheet to Ribera, connecting it with the style of studies for the altarpiece at Salamanca of 1635, *The Immaculate Conception*. Smith has agreed with this early dating, comparing the darting strokes with other works she would place in 1635–37 (see Vitzthum, "Disegni inediti di Ribera," *Arte Illustrata* 37–38:75–84, fig. 16). However, as we possess no drawings that can be securely located from 1637 to 1652, Smith cautions precision and adheres to a wider bracket for the work.

Jonathan Brown has been inclined to date our drawing late, close in date to the one dated drawing (1649), *The Martyrdom of Saint Bartholomew*, in the Pierpont Morgan Library (I,106; see Brown, *Jusepe de Ribera*, p. 176, no. 35, pl. 62). We tend to agree with this point of view, for the dissolved contours, loose pen strokes, and very slight use of wash indicate a very advanced, almost decrepit stage that we recognize as Ribera's late style. Brown also assigns the studies for *The Immaculate Conception* to this period.

Vitzthum has suggested that our drawing is a study

for an *Assumption*. While it is a most logical proposal, the title and purpose of the sketch must remain open until more is known about the role of Ribera's drawings; in fact, it seems possible that such a spontaneous, skeletal creation was made for the pure love of drawing.

Giovanni Francesco Barbieri (Guercino)
Cento 1591–1666 Bologna

60 *Jacob Blessing the Sons of Joseph* (pl. 66)

Inscribed recto, lower left, in pen and brown ink: *Gouarchin;* inscribed recto, lower right, in pen and brown ink: *85.*

Pen and brown ink with brush and gray wash, over traces of black chalk, on ivory laid paper; maximum 182 x 245 mm.; verso: studies of Saint Christopher and two figures in conversation over money, in graphite and pen and brown ink.

COLLECTIONS: Bought Dec. 1914 / Puttick & Simpson, stamp (not in Lugt) verso, lower left, in purple; William F. E. Gurley, Chicago, stamp (not in Lugt) recto, lower right, in black; Leonora Hall Gurley Memorial Collection, stamp (Lugt Suppl. 1230*b*) verso, lower center, in black.

LITERATURE: Posner, "The Guercino Exhibition at Bologna," *Burlington Magazine* 110:602–3, fig. 12.

EXHIBITIONS: Mahon, *Il Guercino: Disegni*, p. 74, no. 54, reproduced; Neilson, *Italian Drawings*, no. 28, reproduced.

Leonora Hall Gurley Memorial Collection, 1922.484

Denis Mahon has identified this drawing as a preliminary study for a painting of the same subject in his own collection in London (see Mahon, *Il Guercino: . . . dipinti*, pp. 93–94, no. 42, reproduced). According to Malvasia (*Felsina pittrice*, vol. 2, p. 259), Guercino was commissioned to do such a painting by Cardinal Jacopo Serra, Legate of Ferrara, in 1620. Mahon published three studies for the painting, citing this drawing as the earliest stage in Guercino's creative process, before the composition was reversed (see Mahon, *Il Guercino: . . . disegni*, pp. 74–75, nos. 54–56, reproduced).

This enthusiastic habit of experimenting with reversal was apparently characteristic of the young Guercino before he went to Rome in 1621 (see Mahon, *Il Guercino: . . . disegni*, pp. 30–31). The lively and fluent line shows the influence of Ludovico Carracci on Guercino's early drawing style. The two later drawings, in the collection of Jacques Petithory, Paris, and the Pushkin Museum, Moscow (inv. 4816) are in the same direction as the painting.

This forceful, naturalistic drawing illustrates how, at this specific point in his career, Guercino was concerned with capturing the transitory, critically dramatic moments of a story (see Mahon, *Il Guercino: . . . dipinti*, p. 94). In this case, it is Joseph's attempt to guide the blessing arm of the nearly blind Jacob away from his younger son, Ephraim, to Manasse (Genesis 48:13–18). The spiritual affinity between Rembrandt and Guercino is never more apparent than in the treatment of this intimate subject. So, too, the impact of that other illustrious seventeenth-century master of chiaroscuro painting, Caravaggio, is visibly felt.

Giovanni Francesco Barbieri (Guercino)
Cento 1591–1666 Bologna

61 *Christ on the Cross* (pl. 70)

Inscribed verso, upper center on mount, in pen and brown ink: *Francesco Barbieri detto il Guercino;* inscribed verso, lower portion of drawing, in pen and iron gall ink, partially illegible: *Ricordo p: comprare un cenzo di unzio di | loro mare che cia sopra il . . . [?] | Cosi le p: lavorare in un rame picolo | in un panno della madona dal | . . . R. A. Padre don Marcho da | Venezia profesore di detto agin | in Santa Maria della Va . . . à Ferrara.*

Pen and iron gall ink, on buff laid paper; laid down; maximum 258 x 175 mm.; verso: caricature in profile.

COLLECTIONS: Dr. Benno Geiger, Vienna; Charles Deering, Chicago.

LITERATURE: Planiczig and Voss, *Drawings . . . from the Collection of Dr. Benno Geiger*, p. 13, no. 35, reproduced.

EXHIBITIONS: Neilson, *Italian Drawings*, no. 31, reproduced.

Charles Deering Collection, 1927.7754

Guercino treated the subject of the Crucifixion numerous times throughout his career in both paintings and drawings. This sheet with the crucified Christ is connected with one of his earliest such compositions, the altarpiece *The Crucifixion, with the Virgin, the Magdalene, Saint John the Evangelist, and Saint Prospero, Bishop of Reggio* in the church of the Madonna della Ghiara, Reggio Emilia, which Guercino painted in about 1624, immediately after his return from Rome (see Mahon, *Il Guercino: . . . Dipinti*, p. 100). Except for slight differences in the placement of the legs, the correspondence of this study with the painting is exact (see Mahon, *Il Guercino: . . . Dipinti*, pp. 143–46, no. 58, reproduced).

Several other drawings related to this altarpiece illustrate the extent to which Guercino experimented with the composition and various figure groups (see Mahon, *Il Guercino: . . . Disegni*, pp. 98–103, nos. 92–100, reproduced). Ultimately, he altered the scene from one of great depth and diagonal movement (Haarlem, Teylers Museum, n. H. 3, and Rome, Gabinetto nazionale delle stampe, Inv. F. N. 120, formerly 22615; see Mahon, *Il Guercino: . . . Disegni*, p. 99, nos. 94–95, reproduced) to one of almost no depth at all, as seen in our sheet and one in the Brera (Inv. 9; see Emiliani, *Mostra di Disegni*

del *seicento emiliano*, p. 52, no. 69, reproduced). Mahon has pointed out the significance of this series, which reveals Guercino's first inclination toward a solution characteristic of the full-blown, early Baroque style of his Roman years, and then his disciplined modification of that composition (under the influence of his Roman experience) into a more simplified, classicist solution (see Mahon, *Il Guercino: . . . Disegni*, pp. 32–35).

If this drawing of the crucified Christ seems superficially comparable with a sheet of the same subject in the Mahon collection (see Mahon, *Il Guercino: . . . Disegni*, pp. 141–42, no. 149, reproduced), closer scrutiny of Guercino's development as a draftsman indicates that they are stylistically far removed; it is a preparatory study for the later *Crucifixion with the Madonna, the Magdalen, and Saint John the Evangelist* for the family chapel in the church of the Rosary at Cento, of 1644 (see Mahon, *Il Guercino: . . . Dipinti*, p. 176, cat. no. 77A, reproduced). The Mahon drawing does not have the same long, fluid, and expressive contours characteristic of our drawing, but dates twenty years later, to a period of Guercino's increased classicism in the style of Guido Reni.

The handwriting that penetrates the drawing from the verso seems to accord with published examples of Guercino's handwriting (see Mahon, *Il Guercino: . . . Disegni*, pls. 256a–58).

Giovanni Francesco Barbieri (Guercino)
Cento 1591–1666 Bologna

62 *Saint Francis Receiving the Stigmata* (pl. 69)

Pen and brown ink, on oatmeal paper; laid down; 274 x 184 mm.

COLLECTIONS: U. Price, script (Lugt 2048) verso, upper left on mount, in pen and brown ink; Bought at his sale, R. S. B., unidentified inscription (not in Lugt) verso, upper left on mount, in red chalk; Dr. Wm. Ogle, London / collection sold by / Sotheby, Feb. 6, 1913, stamp (not in Lugt) verso, lower right on mount, in purple; William F. E. Gurley, Chicago, stamp (not in Lugt) recto, lower right, in black; Leonora Hall Gurley Memorial Collection, stamp (Lugt Suppl. 1230b) verso, center on mount, in black.

EXHIBITIONS: Mahon, *Il Guercino: . . . Disegni*, pp. 131–32, no. 136, reproduced; Neilson, *Italian Drawings*, no. 32, reproduced.

Leonora Hall Gurley Memorial Collection, 1922.492

Guercino is known to have painted the subject of the stigmatization of Saint Francis three times within two years. In 1632, Guercino began one altarpiece for the Church of the Cappuccines in Piacenza and another for the Church of Saint Francis Stigmata in Ferrara. The third, now lost, was begun in 1633 for the parochial church of Saint John in Persiceto, as can be determined by payments made to Guercino.

Although the two paintings that remain are in poor condition, it is possible to determine that the figure of Saint Francis has his arms raised in the Piacenza version, and lowered in that of Ferrara. Therefore, Denis Mahon has connected the sketch in Chicago with the Piacenza altarpiece, which he says was not completed until 1634. A sheet in Mahon's personal collection bears two sketches of Saint Francis in the two different attitudes of the Piacenza and Ferrara altars, confirming the simultaneous development of Guercino's ideas for the two commissions (see Mahon, *Omaggio al Guercino*, p. 47, no. 23, fig. 25). Ulrich Middeldorf noted that another drawing in the opposite direction of the Chicago *Saint Francis* is in the Witt collection (no. 1369; see Blunt, *Handlist of the Drawings in the Witt Collection*, p. 76).

Giovanni Francesco Barbieri (Guercino)
Cento 1591–1666 Bologna

63 *The Martyrdom of Saint Bartholomew* (pl. 68)

Pen and iron gall ink with brush and brown wash, on ivory laid paper; tipped in; 296 x 204 mm.

COLLECTIONS: Mr. and Mrs. Norman H. Pritchard.

Gift of Mr. and Mrs. Norman H. Pritchard, 1960.832

Denis Mahon has identified this drawing as a preliminary study for the painting *The Martyrdom of Saint Bartholomew* in the church of San Martino in Siena, painted by Guercino between January 1635 and April 1637. Although the painting still hangs in the church, it is damaged, and a contemporary copy by Giacinto Campana, in San Barnaba at Marino near Rome, purportedly touched up by Guercino himself (see Malvasia, *Felsina pittrice*, vol. 2, pp. 290–91), is apparently more legible.

Two other drawings for this commission are in other American collections, one in the Pierpont Morgan Library (I, 101e; see Bean and Stampfle, *Drawings from New York Collections*, vol. 2, pp. 38–39, no. 41, reproduced) and one in the Art Museum, Princeton University (48-734; see Bean, *Italian Drawings in the Art Museum, Princeton University*, p. 33, no. 40, and see Gibbons, *Catalogue of Italian Drawings*, vol. 1, pp. 102–3, no. 272, vol. 2, pl. 272). Yet two more drawings of the martyrdom of Saint Bartholomew are noted by Bean and

Stampfle, one in the Witt Collection (no. 1337; see Blunt, *Handlist of the Drawings in the Witt Collection*, p. 75), the other in the possession of Stephen Korda, London. Reference is also made to another painting of this subject (now lost?) listed in Guercino's account book for 1660–61, but the three drawings in American collections seem to accord with the earlier commission.

Pietro Berrettini (da Cortona)
Cortona 1596–1669 Rome

64 *The Martyrdom of Saint Stephen* (pl. 74)

Inscribed verso, upper center on mount, in pen and brown ink: *Di Pietro da Cortona. Primo Pensiere p. la Tavola del Sig^r | Barone Franceschini del Martirio di S. Lorenzo nella Chiesa di | S. Michele degli Antinori in Firenze.*

Pen and iron gall ink, on ivory laid paper; laid down; 310 x 190 mm.

COLLECTIONS: S. E. (or G. E.), unidentified script (not in Lugt) recto, lower left, in graphite; A. Donnadieu, stamp (Lugt 726) recto, lower right, in black (faint); Bought Dec. 18, 1914 | Puttick & Simpson, stamp (not in Lugt) verso, lower center on mount, in purple; William F. E. Gurley, Chicago, stamp (not in Lugt) recto, lower right, in black; Leonora Hall Gurley Memorial Collection, stamp (Lugt Suppl. 1230*b*) verso, center on mount, in black.

EXHIBITIONS: Neilson, *Italian Drawings*, no. 41, reproduced.

Leonora Hall Gurley Memorial Collection, 1922.495

The traditional attribution of this drawing to one of the founders of the Roman High Baroque, Pietro da Cortona (inscribed on the verso of the mount), has been confirmed by Ulrich Middeldorf, Ludwig Schudt, Walter Vitzthum, and others. However, each of these scholars has pointed out that the identification given in the inscription is not correct; although the painting *The Martyrdom of Saint Lawrence* by Pietro da Cortona can still be seen today in the church of San Michele e Gaetano in Florence, it does not correspond to our rapid compositional sketch (see Briganti, *Pietro da Cortona*, fig. 267).

Instead, the drawing is a preliminary study for *The Martyrdom of Saint Stephen*, a subject painted by Pietro da Cortona for the church of San Ambrogio della Massima toward the end of his second Roman period (1647–69). Although the original altarpiece has been destroyed, an autograph replica is in the Hermitage, Leningrad (no. 281; see Briganti, *Pietro da Cortona*, pp. 262–63, not reproduced). This drawing is a prime example of a first hasty sketch by Cortona for a major project, extremely well-organized and close to the final

composition in spite of its seemingly rough and spontaneous execution.

Pietro Berrettini (da Cortona)
Cortona 1596–1669 Rome

65 *The Holy Trinity with Saint Michael Conquering the Dragon* (pl. 75)

Pen and brown ink with brush and brown and gray wash, heightened with white gouache, over traces of black chalk, on buff laid paper; laid down; maximum 458 x 360 mm.

COLLECTIONS: Viscount Churchill; Earl of Harewood, sale: Christie's, London, July 6, 1965, lot 122, reproduced; acquired from H. Calmann, London.

EXHIBITIONS: Joachim, *A Quarter Century of Collecting*, no. 7, reproduced; Neilson, *Italian Drawings*, no. 40, reproduced; Feinblatt, *Old Master Drawings*, pp. 87, 94–95, no. 117, reproduced.

Margaret Day Blake Collection, 1965.860

If a drawing can be said to rival the High Baroque splendor of Pietro da Cortona's ceiling frescoes, this sheet could eminently qualify. The illusionism of the triumphant holocaust seems to burst the limits of the page and yet is restrained by the rhythmically ordered structure of the background—a significant reminder of Cortona's other career as architect. The drawing probably is a *modello* for a painting, possibly *Saint Michael Slaying the Dragon* (Revelations 12:3–7), once in the Vatican but now lost.

The popularity of the composition is evident from the fact that it was used, at least twice, as the engraved title page for contemporary books. It can be found at the front of a *Missale Romanum* in an engraving by François Spierre (1643–81), a pupil of Pietro da Cortona's in Rome from 1666–69 (see Le Blanc, *Manuel de l'amateur d'estampes*, vol. 2, p. 572, no. 22). The composition also appears in a moralistic book, *Virtus contra Vitia*, published in Cologne in 1677.

The great virtuosity in handling the medium is characteristic of Cortona's last years. The drawing is very close to another apocalyptic vision, *Angels Sealing the Foreheads of the Children of Israel* (Rev. 7), in the Metropolitan Museum of Art (66.134.1a–c; see Bean and Stampfle, *Drawings from New York Collections*, vol. 2, p. 51, no. 66, reproduced), which can be dated around 1668. It shares the dynamism of the artist's broadly handled brush and wash technique on brownish paper; Bean and Stampfle compared it with a drawing in the British Museum (1959-5-9-I) for the *Martyrdom of Saint Martina* (Pinacoteca, Siena), thus creating a

group of dramatic compositions drawn at the end of the artist's life.

A chalk study by Cortona in the Louvre shows the figure of Christ as He appears among the Holy Trinity in this composition (528; see Briganti, *Pietro da Cortona*, p. 288, fig. 60).

Pietro Berrettini (da Cortona)?
Cortona 1596–1669 Rome

66 *Aeolus Releasing the Winds* (pl. 73)

Inscribed recto, lower center, in pen and brown ink: *P. Cortona;* inscribed verso, lower left, in pen and brown ink: *P. da Cortona nella Ville lory*[?].

Pen and brown ink, with brush and brown wash over red chalk, on cream laid paper; laid down; maximum 258 x 353 mm.

COLLECTIONS: Bought May 15, 1914 / Puttick & Simpson, stamp (not in Lugt) verso, lower center on mount, in purple; William F. E. Gurley, Chicago, stamp (not in Lugt) recto, lower right, in black; Leonora Hall Gurley Memorial Collection, stamp (Lugt Suppl. 1230b) verso, center on mount, in black.

EXHIBITIONS: *Master Drawings from the Art Institute of Chicago,* no. 8.

Leonora Hall Gurley Memorial Collection, 1922.494

This fascinating drawing has puzzled many scholars. It bears old inscriptions assigning it to "P. Cortona," and it was accepted as a work of the master by Ludwig Schudt (letter of October 1947). Walter Vitzthum at first rejected this attribution, but later wrote (in a letter of 9 November 1960): "When I saw the original some time ago I excluded Cortona as the author; but in the meantime the drawings at Windsor connected with the Pamphili Gallery in Blunt's new volume [see Blunt and Cooke, *Roman Drawings*, no. 606], especially inv. no. 4526, made me wonder whether it may not be, after all, a first idea for the *Quos ego* on that ceiling. But I am afraid I still find this drawing very difficult to judge."

Despite the reluctance of Cortona scholars to ascribe this sheet without reservation to the master at this point, it is hard to imagine another artist of similar force and spontaneous energy, so clearly at the center of the High Roman Baroque, who could be the author of this drawing. Cortona's graphic style had its foundations in the Florentine tradition of *disegno*, but developed into an ever freer, more colorful, and daring calligraphy, of which this might serve as a representative example. Certainly, it is a drawing of sufficiently high quality to merit further investigation.

Giulio Benso
Pieve di Teco ca. 1601–1668

67 *The Last Supper* (pl. 76)

Inscribed recto, lower center on mount, in pen and brown ink: *Federico Zucchero.*

Pen and brown ink with brush and brown and gray wash, over traces of black chalk, on ivory laid paper; laid down; 195 x 285 mm.

COLLECTIONS: William F. E. Gurley, Chicago, stamp (not in Lugt) recto, lower center, in black; Leonora Hall Gurley Memorial Collection, stamp (Lugt Suppl. 1230b) verso, center on mount, in black.

Leonora Hall Gurley Memorial Collection, 1922.1061

Before publication of the *Genoese Baroque Drawings* exhibition catalog in 1972, our drawing had been tentatively ascribed to Federico Zuccaro, but thanks to Mary Newcome's description of Giulio Benso's nervous and highly personal drawing style, there is no longer any question that this drawing should be added to his corpus as a typical example of his early work. Other drawings in Stuttgart pertaining to the Passion have been published recently by Christel Thiem (Inv. 6233, C63/1148; see Thiem, *Italienische Zeichnungen 1500–1800,* pp. 38–42, nos. 61 and 64, reproduced). Personal and unusual also is his interpretation in *The Last Supper*, with Christ and Saint John at the left and the devil at the very right, pointing to Judas, who is leaving the table in great agitation.

Alessandro Algardi
Bologna 1602–54 Rome

68 *Allegorical Scene* (pl. 71)

The coat-of-arms of Bologna are suspended in a fruit tree below which stand Mercury and Minerva, surrounded by genii; the river god Reno sits to the right with the town of Bologna behind him.

Inscribed verso, lower right, in pen and brown ink: *d'algardi.*

Graphite, on ivory laid paper; maximum 375 x 510 mm.

WATERMARK: Encircled fleur-de-lis topped by a crown (cf. Briquet 7111, Perugia, 1544).

COLLECTIONS: Bought Feb. 12, 1915 / Puttick & Simpson, stamp (not in Lugt) verso, center on mount and verso, lower right, in purple; William F. E. Gurley, Chicago, stamp (not in Lugt) recto, lower center, in black; Leonora Hall Gurley Memorial Collection, stamp (Lugt Suppl. 1230b) verso, center on mount, and verso, lower right, in black.

LITERATURE: Vitzthum, "Disegni di Alessandro Algardi," *Bollettino d'Arte* 48:75–98, reproduced (figs. 5 and 6 confuse Capodimonte and Chicago drawings).

Leonora Hall Gurley Memorial Collection, 1922.3479

This large and interesting sheet bears a traditional attribution to the Bolognese sculptor, Alessandro Algardi, which Walter Vitzthum supported in his article on Algardi drawings. There he cited this and another version of the composition in Capodimonte as the sort of preparatory drawings Algardi made for engravings, although he was unable to determine whether a print of this subject exists. The version in Capodimonte (Inv. no. 10), which represents a more sketchy stage of development executed in pen and ink over black chalk, is of nearly identical dimensions (380 x 510 mm.).

Such a design was probably intended for a purpose similar to the drawing by Ludovico Carracci (cat. 44), and a comparison of the two drawings suggests the growth of the Bolognese tradition within the limits of the first half of the seventeenth century. In fact, Algardi was a pupil of Ludovico and worked in the academy before going to Rome (ca. 1625), where he was the chief representative of Bolognese classicism in opposition to Bernini.

through the monumental gateway crowned with his arms. After the death of Sixtus V in 1590, La Magliana fell into such neglect that ultimately all vestiges of the former pontifical splendor were removed and the remnants of the castle were taken over as farm buildings, the broken fountain serving as a trough.

Grimaldi's distinctive draftsmanship is evident in the wiry foliage with accentuated contours, parallel hatching and horizontal emphasis. A conservative member of the Bolognese academy, Grimaldi (called Il Bolognese) went to Rome early in his career and remained there until just before his death in 1680. He was a prolific and highly popular landscape painter and draftsman and spread the Carracci landscape tradition throughout Europe in his many drawings and prints. However, even in his finest landscapes, such as this, he never quite achieved the sensitive, poetic vision that Annibale Carracci or Domenichino brought to the subject.

Giovanni Francesco Grimaldi
Bologna 1606–80 Rome

69 *View of La Magliana* (pl. 72)

Inscribed recto, lower right, in pen and brown ink: *maliana;* inscribed recto, lower right, in pen and brown ink: *39*[?]; inscribed recto, lower center on mount, in pen and brown ink: *Gio-Fran*co *Bolognese.*

Pen and brown ink, over traces of graphite, on ivory laid paper; tipped in; 132 x 260 mm.

COLLECTIONS: William F. E. Gurley, Chicago, stamp (not in Lugt) recto, lower left, in black; Leonora Hall Gurley Memorial Collection, stamp (Lugt Suppl. 1230b) verso, lower right, in black.

Leonora Hall Gurley Memorial Collection, 1922.3346

La Magliana served as a papal retreat in the Campagna from the end of the fifteenth century until about 1590, when it was abandoned probably because of its malaria-infested site. Founded by Sixtus IV (1471–84) just five miles to the south of Rome, it was enlarged by Innocent VIII (1484–92) and Julius II (1503–13), and was the favorite hunting castle of Raphael's great patron, the Medici pope, Leo X (1513–21), who spent months at a time there, to the astonishment of Rome; in fact, it was at La Magliana that Leo X contracted the illness that led to his early death. Another Medici pope, Pius IV (1559–65), from Milan (purportedly a distant branch of the famous Florentine line), restored the courtyard and the magnificent fountain glimpsed in this drawing

Francesco Montelatici (Cecco Bravo)
Florence 1607–61 Innsbruck

70 *The Dream of Cecco Bravo* (pl. 77)

Inscribed recto, across upper margin, in pen and brown ink: *Sogno. Di Fran*co *Montelatici Pittor Fior*o *P il suo grande spirito dal Disegnare, chiamato da fatti Cecco Bravo.*

Black and red chalks, heightened with white chalk, on buff laid paper; laid down; 247 x 315 mm.

COLLECTIONS: F. M. N. Gabburri, inscription (Lugt Suppl. 2992b) recto, upper margin, in pen and brown ink; Paul Sandby, stamp (Lugt 2112) recto, lower left, in black; Parsons & Sons, stamp (Lugt Suppl. 2881) recto, upper right, and verso, lower right on mount, in black: Bought Jan. 15, 1915 / Puttick & Simpson, stamp (not in Lugt) verso, center on mount, in purple; William F. E. Gurley, Chicago, stamp (not in Lugt) recto, lower right and verso, center on mount, in black; Leonora Hall Gurley Memorial Collection, stamp (Lugt Suppl. 1230b) verso, center on mount, in black.

LITERATURE: Thiem, *Florentiner Zeichner des Frühbarock*, p. 394, no. 197, reproduced.

Leonora Hall Gurley Memorial Collection, 1922.5468

Francesco Maria Nicolò Gabburri (1675–1742), the Florentine *marchand-amateur* who assembled the famous album of Fra Bartolommeo drawings and attributed them to Andrea del Sarto (see cat. 7), also inscribed his identification on this drawing, which was in his possession among a group of about thirty similar pieces by Francesco Montelatici, called Cecco Bravo. Such drawings of dreams were a specialty of the visionary Florentine Baroque artist and, not surprisingly, Luigi Lanzi, in his *Storica pittorica della Italia* (1789, 1795), called him

"disegnatore bizzarro e di spirito" (cited in Thiem, *Florentiner Zeichner des Frühbarock*, p. 391).

This dream apparently has to do with a shipwrecked young man on a raft being rescued by an apparition in flowing garments with a nimbus of stars. Many corpses are floating in the sea. At the upper right, a figure gestures toward the distance, and that figure is being followed by a taller one, again with a nimbus. In the far left distance is an assembly of various, not clearly recognizable figures. Suggestive of the work of the nineteenth-century Belgian, James Ensor, the meaning behind this futuristic vision, as with most, is still open to interpretation.

In spite of the rubbed condition of the drawing, Cecco Bravo's lively and incisive style is still entirely identifiable. The combination of red and black chalks is frequent among these drawings. Other examples of Cecco Bravo's *sogni* (or dreams) are in the following collections: the Ashmolean Museum, Oxford (see Parker, *Drawings in the Ashmolean*, vol. 2, p. 466, no. 917); the National Gallery of Scotland, Edinburgh (Inv. RSA 189; see Andrews, *Catalogue of Italian Drawings*, vol. 1, p. 77; vol. 2, fig. 546); the Louvre, Paris (Inv. 1, 348; see Thiem, *Florentiner Zeichner des Frühbarock*, pp. 394–95, no. 198, reproduced); and the Pierpont Morgan Library, New York (1958.17; see Bean and Stampfle, *Drawings from New York Collections*, vol. 2, p. 60, no. 81, reproduced; and Inv. IV, 178; see Thiem, *Florentiner Zeichner des Frühbarock*, p. 394, no. 195, reproduced).

Giovanni Benedetto Castiglione

Genoa 1609–ca. 1665 Mantua

71 *Birds and Animals around a Dead Tree* (pl. 81)

Inscribed recto, lower left, in pen and brown ink: *Castiglion*.
 Pen and brown ink, over traces of graphite, on ivory laid paper; laid down; maximum 296 x 205 mm.
 COLLECTIONS: Moscardo, Verona, inscription (Lugt Suppl. 2990b–g?) recto, lower left, in pen and brown ink.
 EXHIBITIONS: *Master Drawings from the Art Institute of Chicago*, no. 9; Percy, *Giovanni Benedetto Castiglione*, pp. 68, 70, no. 12, reproduced, and cf. p. 66, no. 10 for provenance.

David Adler Fund, 1950.1408

Giovanni Benedetto Castiglione (called Il Grechetto) never left Italy but, through his art, entered into one of the broadest European dialogues of the seventeenth century. Aspects of his painting, printmaking, and drawing proved a significant link with contemporary art in the north of Europe which had a resonance in eighteenth-century Italy and France.

Taught in Genoa by Van Dyck, among others, Castiglione found inspiration for his painting in Rubens and for his printmaking in Rembrandt. He also was a member of Poussin's and Claude's circle in Rome, where his taste for pastoral subject matter found ever more sophisticated and erudite connotations.

Even in his lifetime, Castiglione was highly praised for his lively studies of animals, which are nearly always plentiful in his large compositions. This charming, informal study sheet attests to his keenness of observation and his virtuosity with the pen.

The drawing can possibly be grouped with those in Windsor Castle which Anthony Blunt labelled as the early Roman pen drawings produced between 1634 and 1640 (see Blunt, *Drawings of G. B. Castiglione and Stefano della Bella*, pp. 28–29, nos. 8–16). They reflect the strong, early influence on Castiglione in Genoa of Sinibaldo Scorza, a specialist in animals and arcadian subjects, and of Jan Roos, the animal painter who had studied with Franz Snyders.

Giovanni Benedetto Castiglione

Genoa 1609–ca. 1665 Mantua

72 *A Pagan Sacrifice* (pl. 82)

Brush with blue, green, red, brown, and white oil paints, on tan laid paper; laid down; 576 x 425 mm.
 COLLECTIONS: Sir W. Drake, stamp (Lugt 736) recto, lower right, in black; E. Parsons, London (in 1928, according to Ann Percy); Lord Kenneth Clark of Saltwood, sale: London, Sotheby's, April 20, 1967, lot 11, reproduced; acquired from Charles Slatkin Galleries, New York.
 LITERATURE: *Art at Auction*, pp. 105–8, reproduced.
 EXHIBITIONS: Percy, *Giovanni Benedetto Castiglione*, pp. 38, 43, 72–73, no. 21, reproduced; Neilson, *Italian Drawings*, no. 38, reproduced.

Clarence Buckingham Collection, 1968.77

This drawing is a magnificent example of Castiglione's fully developed style and his application of oil colors within the drawing medium. The technique of using a brush loaded with oil pigment to sketch on paper was undoubtedly adopted by Castiglione under the influence of the examples of Van Dyck and Rubens, first encountered in Genoa and then, later, in Rome. In this case, Castiglione has used the painterly method to create what is in effect, a small painting—certainly an independent work of art rather than a study for another.

The subject of this monumental drawing is the sacri-

fice of an ox to a pagan deity on the right, whose identity cannot be determined because he is the only lightly sketched figure in an otherwise fully executed drawing. Such pagan subjects began to appear in Castiglione's work in the early 1630s, under the influence of Nicolas Poussin, whom Castiglione befriended in Rome. Ann Percy has pointed out that the carefully constructed, highly classical composition of this drawing, which was stimulated by his contact with Poussin, is characteristic of Castiglione's brush drawings of the late 1640s. She further notes that the precise archaeological detail used in this scene could have as its source Guillaume du Choul's *Discours de la religion des anciens romains* ([Lyons, 1581], pp. 314 ff.; observed by Sir Anthony Blunt). Such references would not have been lost to the erudite, select Roman audience these works were created to please.

More subtle and complex implications for this piece may be surmised when the likelihood of a Christian pendant for it is considered. Percy first noted that a drawing of identical technique, dimensions, and composition, *Tobit Burying the Dead* (now lost), also came from the collections of Sir William Drake and E. Parsons (see Blunt, "A Poussin-Castiglione Problem," *Journal of the Warburg and Courtauld Institutes* 3:144, pl. 27c). Furthermore, this and other similar pagan sacrifices bear an extraordinary resemblance to Castiglione's Old Testament sacrificial representations, such as those of Noah. Percy postulates that, again under the influence of Poussin and his circle, Castiglione is here attempting an oblique reference to religious syncretism by paralleling pagan and Christian sacrifice in these two highly finished presentation drawings (see Percy, *Giovanni Benedetto Castiglione*, p. 72).

Giovanni Benedetto Castiglione

Genoa 1609–ca. 1665 Mantua

73 *Studies of Cattle* (pl. 80)

Pen and brown ink, on ivory laid paper; laid down; 285 x 212 mm.

COLLECTIONS: P. & D. Colnaghi & Co., London; Mr. and Mrs. James W. Alsdorf, Winnetka, Illinois.

EXHIBITIONS: *Treasures of Chicago Collectors*, no number; Percy, *Giovanni Benedetto Castiglione*, pp. 130, 134, no. 125, reproduced (attributed to Francesco).

Gift of Mr. and Mrs. James W. Alsdorf, 1966.536

Francesco Castiglione, the son and pupil of Giovanni Benedetto, has been proposed as the draftsman of this

sheet by Ann Percy, Mary Newcome, and others. The style of penmanship, however, appears sufficiently close to Benedetto himself. It may be compared with drawings by the father, such as *The Deluge* in the Cooper-Hewitt Museum, New York (1931-73-316), and the *Adoration of the Crucified Christ* in the Philadelphia Museum of Art (Academy Collection, 32; see Percy, *Giovanni Benedetto Castiglione*, pp. 81, 85, no. 37, reproduced; pp. 89, 92, no. 51, reproduced). A similar broad and nervous pen line can also be found in *The Assumption* and *The Satyr Family* at Windsor (3940 and 3911; see Blunt, *Drawings of G. B. Castiglione and Stefano della Bella*, p. 31, no. 23, fig. 12; p. 32, no. 54, pl. 18). It may be dated somewhat later than the previous pen drawing (ca. 1640–55).

Giovanni Benedetto Castiglione

Genoa 1609–ca. 1665 Mantua

74 *The Angel Departing from the Family of Tobit*(?) (pl. 79)

Inscribed recto, upper center, in pen and brown ink: *54;* inscribed recto, upper right, in pen and brown ink: *16*[?]; inscribed verso, lower right, in graphite: *Ln. 63 | Nr. 19*[?] *| 1199-0-0.*

Brush with reddish-orange pigment mixed with oil, on ivory laid paper; maximum 420 x 546 mm.

COLLECTIONS: Dr. C. R. Rudolf stamp (Lugt Suppl. 2811b) recto, lower left (stamp has been obliterated), sale: London, Sotheby's, May 21, 1963, lot 19, reproduced; A. Pringer(?); acquired from Richard Zinser, New York.

EXHIBITIONS: *Old Master Drawings from the Collection of Mr. C. R. Rudolf*, London: Arts Council, 1962, no. 13, cited in Percy, *Giovanni Benedetto Castiglione*, pp. 94–95, no. 57, reproduced.

Clarence Buckingham Collection, 1966.34

In contrast to the drawing *A Pagan Sacrifice*, which is highly finished, this sheet represents the rapid, spontaneous type of brush drawing which Castiglione frequently made in red linseed oil. The freedom of the technique is highly appropriate to the sense of sudden surprise suggested in the scene.

Stories of the Patriarchs, the journeys of Abraham, Isaac, and Jacob, and other Old Testament episodes involving nomadic life were favorite themes of Castiglione. It is often difficult to determine his subjects precisely perhaps because the artist was more intent on creating a certain mood than in illustrating a specific

story, and pagan and Christian elements frequently mingle in his compositions.

This drawing has been variously titled *The Annunciation to the Shepherds*, *The Offering*, *The Journey of Jacob*, and *The Angel Departing from the Family of Tobit*. The suggestion of a classical architectural backdrop on the left, the loaded donkey and herds of cattle and sheep, and the impression of momentary excitement and awe lead us to believe that in this case, Castiglione opted for the endearing episode from the Book of Tobit, when Tobias and his wife Sarah returned to the home of his blind father and were able to restore Tobit's sight with fish gall, directed by their guide Raphael. After giving thanks to the Lord for this miracle, Tobias and his father offered Raphael half of their animals and wealth in payment for his services as guide and protector. Suddenly, Raphael revealed to them that he was one of the seven archangels, sent by the Lord to test Tobit's faith and ultimately to cure him; as they knelt in fear and thanks, he was carried away from their sight.

The fluency of line and illusion of dynamic motion in this drawing mark it as a late work. Percy assigns a date about 1655 to the sheet; it compares with similar drawings of patriarchal journeys in Philadelphia and Windsor (see Percy, *Giovanni Bennedetto Castiglione*, pp. 125, 128, no. 115, reproduced, and Blunt, *Drawings of G. B. Castiglione and Stefano della Bella*, pp. 38–40, fig. 19, pls. 36–37, 46).

Giovanni Battista Salvi (Sassoferrato)
Sassoferrato 1609–85 Rome

75 *Head of a Cleric* (pl. 84)

Red chalk heightened with white chalk, on blue laid paper; laid down; 289 x 188 mm.

COLLECTIONS: Ch. Rogers, stamp (Lugt 625) recto, left edge at center, in brown; A. M. Champernowne, script (Lugt 153) recto, lower right, in pen and black ink; Coll. of Dr. Ridley, of / Croyden, Eng., Sotheby's / Sale April 2, 1912, stamp (not in Lugt) verso, lower right on mount, in purple; William F. E. Gurley, Chicago, stamp (not in Lugt) recto, lower left and verso, center on mount, in black.

LITERATURE: Tietze, *European Master Drawings*, pp. 164–65, no. 82, reproduced.

EXHIBITIONS: Neilson, *Italian Drawings*, no. 35, reproduced; cf. Moir, ed., *Drawings by Seventeenth Century Italian Masters*, pp. 126–27, no. 101, reproduced.

Leonora Hall Gurley Memorial Collection, 1922.5407

Giovanni Battista Salvi, called Sassoferrato, took an individual path among seventeenth-century Roman artists. Brought up in the Carracci tradition of Domenichino's workshop in Naples, he was to be heavily influenced by their works and their crusade to look back to the masters of the High Renaissance for purifying inspiration. In fact, throughout his career, Sassoferrato's devotion to the works of earlier periods was truly extraordinary; not only did he copy earlier masters, particularly Raphael, but he used these elements in his own, archaistic compositions (see Russell, "Sassoferrato and His Sources: A Study of Seicento Allegiance," *Burlington Magazine* 119:694–700).

Also unique for his period was Sassoferrato's apparent avoidance of all public commissions, and the private demand that must have existed for his highly derivative, frequently devotional work has led Francis Russell to observe recently that Sassoferrato's art was aimed at a less sophisticated, less articulate clientele, such as conservative members of the clergy. This is a striking contrast to the erudite and often complex works that artists such as Poussin and Castiglione produced in Rome at the same time, for another, highly literate and intellectually demanding clientele.

Perhaps it was in his portrait drawings that Sassoferrato was forced to make his most personal observations; yet even in this realm a certain reserve and conservatism overrules communication of a personality. This drawing was originally attributed to Ottavio Leoni, an early seventeenth-century Roman artist who devoted himself exclusively to portraiture. However, as Middeldorf observed, this work lacks his typically haunting dark eyes and the expression of character of Leoni's works.

Wolfgang Stechow was the first to propose the name of Sassoferrato for this drawing, and Jacob Bean supported the attribution, which is made plausible by comparison with the portraits of ecclesiastics by Sassoferrato at Windsor Castle (6102, 6100; see Blunt and Cooke, *Roman Drawings*, p. 105, no. 897, pl. 35, and no. 926, pl. 34), and in the Scholz collection (see Scholz, *Italian Master Drawings*, p. xix, no. 100, reproduced). These sedate character studies share a clarity of form, a smoothness of texture with shading in even, transparent hatchings, and a careful but somewhat generalized handling of details of the face and dress. Carlo Maratta has also been proposed as the author of this drawing, but his portraits, such as those at Windsor, show a much more vivacious and aggressive temperament (4366; see Blunt and Cooke, *Roman Drawings*, p. 60, no. 320, pl. 61).

The attribution of this sheet to Sassoferrato seems fairly certain, therefore, and it is to be hoped that, with

a renewed interest in Sassoferrato, his particular contribution to seicento art and something of his patronage will be defined in the near future.

Stefano della Bella
Florence 1610–64

76 Dancer (pl. 78)

Pen and brown ink with brush and gray wash, over graphite, on ivory laid paper; laid down; 240 x 166 mm.
COLLECTIONS: Alfred E. Hamill, Chicago.
EXHIBITIONS: Vitzthum, *A Selection of Italian Drawings*, pp. 62–63, 156, no. 52, reproduced.
Gift of Alfred E. Hamill, 1944.197

Stefano della Bella was the most talented and creative of the followers of Jacques Callot in Florence. Much of his extensive graphic work revolves around stage productions and festivals, and costume drawings such as this make up a great part of it. The soft, fluent, and delicate style of this drawing points to a fairly late date in the artist's career, toward the end of his stay in Paris (1639–50) or in the years following his return to Florence.

A great number of similar studies survive, among them: nine costume drawings in the British Museum, some in the Uffizi, and others at Windsor Castle (see Blunt, *Drawings of G. B. Castiglione and Stefano della Bella at Windsor Castle*, pp. 94–95, nos. 20–39). Phyllis Massar has been able to connect them with specific Florentine theatrical productions of the 1650s and early 1660s (see Massar, "Costume Drawings by Stefano della Bella for the Florentine Theater," *Master Drawings* 8:243–66, pls. 10–21).

Our drawing appears to belong to a group of nearly forty drawings associated with the opera *Hipermestra*, first performed in 1658 under the patronage of Gian Carlo, Cardinal de' Medici; the libretto was by Giovan Andrea Moniglia, and the composer was the Venetian Francesco Cavalli, a pupil of Monteverdi. According to the myth, of fifty Danaïds who were ordered by their father to kill their husbands on their wedding night, only Hypermnestra refused. Since our figure bears Juno's emblem of a lily, she may represent that goddess, who appears in the first scene of act three to assure Hypermnestra of her protection, promising to transform war to peace and hatred to love.

Simone Cantarini (Il Pesarese)
Oropezza (Pesaro) 1612–48 Verona

77 *Studies of the Madonna and Child* (pl. 89)

Pen and brown ink with traces of red chalk, on ivory laid paper; laid down; maximum 273 x 202 mm.
COLLECTIONS: P. J. Mariette, stamp (Lugt 2097) recto, lower left in black; Comte Moriz von Fries, dry stamp (Lugt 2903) recto, lower left; W. Mayor, stamp (Lugt 2799) recto, lower right, in black; William F. E. Gurley, Chicago, stamp (not in Lugt) recto, lower left and verso, on mount, in black; Leonora Hall Gurley Memorial Collection, stamp (Lugt Suppl. 1230b) verso on mount, in black.
LITERATURE: Mancigotti, *Simone Cantarini*, p. 272, fig. 145.
Leonora Hall Gurley Memorial Collection, 1922.66

This drawing must be counted among the finest seventeenth-century pieces in the collection and, not surprisingly, it has a brilliant history.

Although not Bolognese himself, Simone Cantarini, as a pupil of Guido Reni, is closely linked to the Bolognese school. One of the most gifted of Emilian draftsmen, he was greatly admired by his contemporaries for his drawing. Carlo Cesare Malvasia, the first historian of the Bolognese school, remarked of Cantarini in 1678, "there has been no more graceful and delightful draftsman since the days of Parmigianino" (see Malvasia, *Felsina pittrice*, vol. 2, p. 382, translated in Kurz, *Bolognese Drawings*, p. 7). Furthermore, next to Guido Reni, Salvator Rosa, and Pietro Testa, Cantarini ranks as the most outstanding printmaker of the middle of the seventeenth century (see Stubbe, *Die italienische Graphik des Barock*, p. 24).

The largest collection of drawings by Cantarini is in the Brera, Milan, where 165 drawings are preserved (see Emiliani, *Mostra di disegni del seicento emiliano*, pp. 27–48, nos. 1–65, some reproduced). These sheets are characterized by a delicate, sensitive, and nervous line. The artist seems to have been fond of putting together a variety of small figures in various positions on a single sheet. While our drawing presents eight variations on the theme of the Madonna with the Child sleeping or resting, a sheet in the Pierpont Morgan Library shows a lively child in a variety of poses (1963.4; see Bean and Stampfle, *Drawings from New York Collections*, vol. 2, p. 67, no. 98, reproduced).

It is not altogether surprising that this charming drawing cannot be connected with any known painting or print, since the artist considered drawing an end in itself (see Kurz, *Bolognese Drawings*, p. 7). The rest on the flight into Egypt and the Madonna were among Cantarini's favorite themes; the countless versions of

these that exist attest to the restless activity of Cantarini's artistic imagination and link him to those other incessant draftsmen, Raphael in the sixteenth century and the two Tiepolos in the eighteenth.

Because of the short span of the artist's life, a secure dating for this sheet would be difficult to determine beyond the fact that this certainly is a mature work.

Roman period (ca. 1650–57), which might also be the time when this drawing of *Saint Peter Appearing to Saint Agatha*, a story from the *Golden Legend*, was done. It is executed in Mola's characteristic technique of pen and brown ink with brush and brown wash over a red chalk base.

Pier Francesco Mola?
Coldrerio (Como) 1612–66 Rome

78 *Saint Peter Appearing to Saint Agatha* (pl. 83)

Inscribed recto, lower center on mount, in pen and brown ink: *Guerchino;* inscribed recto, lower right on mount, in pen and brown ink: *Guercino;* inscribed verso, lower left on mount, in pen and brown ink: *W. E. 1822 No. 100.*

Pen and brown ink with brush and brown wash, over red chalk, on ivory laid paper; laid down; maximum 287 x 416 mm.

COLLECTIONS: P. Crozat?, stamp (Lugt 474) recto, upper right, in gray; John Barnard, script (Lugt 1419) recto, lower right, in pen and brown ink, on mount; W. Esdaile, script (Lugt 2617) recto, lower right, in pen and brown ink and verso, lower left on mount, in pen and brown ink; H. Walpole, according to inscription, verso, lower left on mount, in graphite; Bought Feb. 12, 1916 / Puttick & Simpson, stamp (not in Lugt) verso, lower left on mount, in purple; William F. E. Gurley, Chicago, stamp (not in Lugt) recto, lower right and verso, center on mount, in black; Leonora Hall Gurley Memorial Collection, stamp (Lugt Suppl. 1230b) verso, center on mount, in black.

EXHIBITIONS: *Catalogue of Early Italian Drawings,* no. 18 (as Guercino).

Leonora Hall Gurley Memorial Collection, 1922.44

Two old inscriptions on the mount of this drawing read "Guercino," and there is a certain affinity to Guercino's hand, but an attribution to Pier Francesco Mola seems more reasonable, as Hugh Macandrew agrees.

Confusion between the drawings of these two Bologna-trained masters is not unusual; in fact, Mola was taught not only by Giuseppe Cesare and Francesco Albani, but also by Guercino himself before Mola continued his studies in Venice. Guercino's influence is particularly evident in Mola's atmospheric drawings, but Cortona's loose pen stroke and Poussin's classic compositional sense also play important roles in Mola's work, as is clearly brought out in this dramatic sheet.

In particular, this sheet is comparable to works by Mola such as: *Saint John the Baptist Preaching, Joseph Greeting His Brothers,* and *Saint Peter Baptizing in Prison* (see Cocke, *Pier Francesco Mola,* pp. 45–46, no. 9, figs. 46–50; p. 58, no. 49, figs. 60–62; p. 59, no. 53, figs. 73, 75–80). These works are assigned to the artist's early

Mattia Preti
Taverna (Calabria) 1613–99 Malta

79 *Angels Supporting a Cloud* (pl. 85)

Red chalk on buff laid paper; laid down; maximum 252 x 195 mm.

COLLECTIONS: George, Lord Macartney's Album of / Drawings, Puttick & Simpson Sale / March 14, 1913, Lot no. 114, stamp (not in Lugt) verso, lower right on mount, in purple; William F. E. Gurley, Chicago, stamp (not in Lugt) recto, lower right, in black; Leonora Hall Gurley Memorial Collection, stamp (Lugt Suppl. 1230b) verso, center on mount, in black.

EXHIBITIONS: Vitzthum, *A Selection of Italian Drawings,* pp. 66–67, 161, no. 57, reproduced; *The Order of Saint John in Malta,* pp. 329–30, no. 414; Neilson, *Italian Drawings,* no. 44, reproduced.

Leonora Hall Gurley Memorial Collection, 1922.2970

Mattia Preti, called Il Cavaliere Calabrese, was trained in the Roman tradition of Caravaggio, Guercino, and Lanfranco; studies in Venice also impressed him very deeply. Ultimately, he was a primary force in Late Neopolitan Baroque Art. Leaving Rome for Modena, Naples, and finally Malta, Preti was accepted as Cavaliere di Grazia into the Order of the Knights of Malta on 15 September 1661. Contrary to tradition, Preti's move to Malta and his offer to paint the ceiling of the Conventual Church of the Order of Saint John, Valletta, without remuneration were not precipitated by this honor. John Spike has recently pointed out that Preti's dealings with the Knights of Malta can be dated as early as 1656 and that his proposed designs for the decoration of the church were under consideration at exactly the same moment, coincidentally, as his candidacy for elevation to the order. Preti's extraordinarily generous proposal was accepted on 30 September 1661; the work was finished by December 1666 (see Spike, "Mattia Preti's Passage to Malta," *Burlington Magazine* 120:497–507).

This drawing had been attributed to Gaulli and Lanfranco until Erich Schleier recognized the hand of Preti. Walter Vitzthum identified it as a rough sketch for the two angels below the figure of God the Father

in the central part of the third bay of the church in Valletta.

Over thirty drawings are connected with this project. One of these contains a study for the figure of God the Father on the recto and the feet of the angels of the Chicago sheet on the verso (Miss Mary Williamson Collection, Toronto; see Vitzthum, *A Selection of Italian Drawings*, pp. 64–65, 160, no. 56, reproduced).

Domenico Maria Canuti
Bologna 1620–84 Rome

80 *Head of a Nun, Study for the Ecstasy of Saint Dominic* (pl. 87)

Inscribed recto, lower center on mount, in pen and brown ink: *M. Canutti;* inscribed verso, upper center on mount, in pen and brown ink: *F / No 29;* inscribed verso, lower right on mount, in pen and brown ink: *Scholar of Gu*[?]; inscribed verso, lower center on mount, in graphite: *May 11th 1715;* inscribed verso, upper right on mount, in graphite: (*Richardson's Collection?*).

Red, black, and white chalks, on gray-brown laid paper; laid down and pieced in upper corners; 230 x 185 mm.

COLLECTIONS: J. Richardson, Sr., inscriptions (Lugt 2983–84) verso, upper center and upper right on mount, in pen and brown ink and in graphite; Earl Spencer, stamp (Lugt 1530) recto, lower right, in black; Dr. Wm. Ogle, Lon. / collection sold by / Sotheby Feb. 6, 1913, stamp (not in Lugt) verso, lower right on mount, in purple; William F. E. Gurley, Chicago, stamp (not in Lugt) recto, lower left, in black; Leonora Hall Gurley Memorial Collection, stamp (Lugt Suppl. 1230b) verso, center on mount, in black.

LITERATURE: Feinblatt, "D. M. Canuti and Giuseppe Rolli: Further Studies for Frescoes," *Master Drawings* 7:164–68, pl. 37.

Leonora Hall Gurley Memorial Collection, 1922.664

Domenico Maria Canuti, a pupil of Guido Reni, was one of the leading figures of Bolognese painting in the second half of the seventeenth century. In 1672, at the height of his career, he was called to Rome by the Dominican nuns of Saints Domenico and Sisto to decorate the ceiling of their church. This project, which proved to be Canuti's major Roman fresco and perhaps his masterpiece, was completed for the Holy Year in 1675 (see Poensgen, "Some Unknown Drawings by Domenico Maria Canuti," *Master Drawings* 5:165).

The wide space of the vault shows *Saint Dominic Admitted to Heaven*. In the apse, the *Ecstasy of Saint Dominic* is represented: the saint is surrounded by other members of his order, among them a group of nuns. A preliminary drawing for this composition, conceived in more intimate terms with only a few figures, is in the Albertina (see Feinblatt, "Some Drawings by Canuti Identified," *Art Quarterly* 24:277, fig. 23). On the right-

hand side of this drawing appears the figure of a nun kneeling in adoration, her head turned upward to the apparition of Christ. The drawing in Chicago appears to be an independent study for the head of this nun (see Feinblatt, "D. M. Canuti and Giuseppe Rolli: Further Studies for Frescoes," *Master Drawings* 7:166, pl. 37). In what may be a later study in the Louvre, the nun is accompanied by others, possibly in an attempt to adjust more effectively to the wider space of the projected apsidal fresco (see Feinblatt, *Art Quarterly* 24:277, fig. 21). In the bottom zone of this same drawing, the nun appears with a companion of equal size, while in the fresco itself this companion is given the dominant position. The nun for which the Chicago drawing is a study kneels meekly in the midst of her sisters in the Louvre study.

Flaminio Torre
Bologna 1621–61 Modena

81 *Rest on the Flight into Egypt* (pl. 88)

Inscribed recto, lower center on mount, in pen and red ink: *Flaminio Torre, Bolognese.*

Red chalk heightened with white chalk, on gray laid paper; 245 x 169 mm.

COLLECTIONS: Ch. Rogers, stamp (Lugt 624) recto, lower center, in black; Frederick R. Aikman / coll. sold Mch. 14, 1913 / by Puttick & Simpson, stamp (not in Lugt) verso, center on mount, in purple; William F. E. Gurley, Chicago, stamp (not in Lugt) recto, lower right, and verso, center on mount, in black; Leonora Hall Gurley Memorial Collection, stamp (Lugt Suppl. 1230b) verso, center on mount, in black.

Leonora Hall Gurley Memorial Collection, 1922.74

Flaminio Torre was in Guido Reni's studio together with Simone Cantarini, and it is not surprising that their styles are quite similar—Torre's perhaps less elegant and refined than Cantarini's.

The old attribution, "Flaminio Torre, Bolognese," written on the eighteenth-century mount of the drawing, may be confirmed by comparison with examples of Torre's draftsmanship published in the Windsor catalog of Bolognese drawings (see Kurz, *Bolognese Drawings*, pp. 139–41, nos. 543–57). Among them is a *Rest on the Flight into Egypt* (3475; no. 546, fig. 108), which corresponds in several respects to our drawing of the subject: the Holy Family is seated on the ground; Joseph, who leans over the Virgin's shoulder, is a mirror image of the same figure in our drawing; furthermore, the head of the Virgin in the Chicago version is quite

similar in structure to the head of a *Youth Drawing*, also at Windsor Castle (3354; no. 552, fig. 109).

The Holy Family was one of Torre's favorite subjects: of approximately fifteen known paintings, one is in Stockholm (see Göthe, *Notice descriptive des tableaux du Musée national de Stockholm*, part 1, p. 349, no. 179); a second, *The Holy Family with the Infant Saint John*, in Dresden, is similar in composition to the Chicago version; and a third related painting, *The Virgin Nursing the Christ Child*, was formerly in Bologna (see Raimondi, "Il pittore Flaminio Torri detto Flaminio degli Ancinelli," *Studi in onore di Matteo Marangoni*, pp. 260–66, figs. 137–38).

Castello did a painting of the same subject that corresponds to our drawing except that Mary is shown full face, looking down on the children, whereas in our drawing her head is seen in profile, turned toward Joseph. As a result, the drawing is richer in tension and movement than the painting (Deposito dell' Accademia Ligustica Galleria di Palazzo Bianco, Genoa; see Marcenaro, *Mostra dei pittori genovesi*, pp. 198–99, no. 82, reproduced).

Mary Newcome dates this broad and summary style with "darting pen strokes" to the late 1640s and early 1650s. Jacob Bean did not accept the attribution of this sheet (*Master Drawings* 11:293–94).

Valerio Castello
Genoa 1624–59

82 *Holy Family with the Infant Saint John* (pl. 93)

Pen and brown ink with brush and light brown wash, over red chalk with traces of red chalk wash and graphite, on ivory laid paper; laid down; maximum 153 x 179 mm.

COLLECTIONS: Charles H. Marcellis[?], stamp (Lugt Suppl. 609) recto, lower right, in black; R. Lamponi, stamp (Lugt 1760) recto, lower left, in blue; Mr. and Mrs. Norman H. Pritchard, Chicago.

LITERATURE: Bean, Review of *Genoese Baroque Drawings*, *Master Drawings* 11:293–94; Newcome, "The Drawings of Valerio Castello," *Master Drawings* 13:29, pl. 12.

EXHIBITIONS: Newcome, *Geneose Baroque Drawings*, p. 28, no. 69, reproduced.

Gift of Mr. and Mrs. Norman H. Pritchard, 1960.835

Valerio Castello was the innovative son of the more traditional Genoese artist, Bernardo Castello (1557–1629). Valerio began as the student of Fiasella, and possibly of G. A. de Ferrari, but from about 1640–45 he left Genoa to travel to Milan and Parma, where he studied the works of G. C. Procaccini, Correggio, and Parmigianino. This exposure, coupled with his father's alliances with Rome and Florence, fed the young artist's work with influences from all over Italy. He developed an aggressive, painterly temperament which laid the foundations in mid seventeenth-century Genoa for the dramatic genius of Alessandro Magnasco at the end of the century.

At first sight, this drawing may seem somewhat chaotic, but a closer look will reveal a well thought out, unusually lively, and subtle composition. As Mary Newcome has pointed out, the impact of Correggio is particularly noticeable in the mood and structure of this work.

Valerio Castello
Genoa 1624–59

83 *The Annunciation* (pl. 92)

Pen and brown ink with brush and pale brown wash, over red chalk, on ivory laid paper; tipped in; 295 x 210 mm.; verso: the annunciation, in red chalk.

WATERMARK: Coat of arms (cf. Heawood 727–75, Genoese).

COLLECTIONS: Sir Joshua Reynolds, stamp (Lugt 2364) recto, lower right, in black; A. M. Champernowne, script (Lugt 153) recto, lower right, in pen and black ink; William F. E. Gurley, Chicago, stamp (not in Lugt) recto, lower right, in black; Leonora Hall Gurley Memorial Collection, stamp (Lugt Suppl. 1230b) verso, lower center, in black.

LITERATURE: Newcome, "The Drawings of Valerio Castello," *Master Drawings* 13:29, pl. 11.

EXHIBITIONS: Newcome, *Genoese Baroque Drawings*, p. 28, no. 68, reproduced.

Leonora Hall Gurley Memorial Collection, 1922.3898

In spite of its very poor condition, this sheet must be considered a major drawing by the artist and represents one of his most felicitous compositional thoughts. It has been identified as the work of Valerio Castello by Jacob Bean, who also connected it with the fresco on the nave vault of Santa Marta, completed in the early 1650s. Mary Newcome has pointed out that Domenico Piola was working with Castello on this project and that some of Piola's sense of structure may be perceived in Valerio's style at this time. The effect of this summary drawing is, however, much lighter and more baroque than any work by Piola and is very similar in style to the preceding drawing, but even more elaborate. Almost the entire sheet is covered with intricate line work, which, however, leaves no doubt about the artist's compositional intention.

Francesco Allegrini
Gubbio ca. 1624–ca. 1663 Rome

84 *Pope Innocent III Establishing the Franciscan Order* (pl. 99)

Pen and brown ink with brush and brown wash, heightened with white gouache, over black chalk, on buff laid paper; 310 x 219 mm.

COLLECTIONS: William F. E. Gurley, Chicago, stamp (not in Lugt) recto, lower center, in black.
LITERATURE: Gere, *Il manierismo a Roma*, pp. 20, 86, pl. 34.
EXHIBITIONS: Neilson, *Italian Drawings*, no. 36, reproduced.

Leonora Hall Gurley Memorial Collection, 1922.1058

Because of many reminiscences of late sixteenth-century draftsmanship, this drawing had been classified within the sixteenth century until Philip Pouncey identified it as a study by Francesco Allegrini for the fresco of *Pope Innocent III Establishing the Franciscan Order*, undertaken during the papacy of Urban VIII (1623–44), in the courtyard of the church of Saints Cosmos and Damian in Rome.

Little is known of Allegrini's life, nor has much been published on his paintings. He was a pupil and follower of Giuseppe Cesari, Cavaliere d'Arpino, and was active in Rome about the middle of the seventeenth century. Allegrini's style appears to be somewhat archaic for his generation. The largest collection of his drawings is in the National Gallery of Scotland (see Andrews, *Catalogue of Italian Drawings*, vol. 1, pp. 3–8; vol. 2, figs. 12–84).

In the drawing, the papal audience takes place under a neatly drawn barrel-vaulted hall. In the center of the composition, Saint Francis humbly receives the papal blessing. According to Philip Pouncey, the foreground figures have been slightly changed in the fresco.

The composition may have been inspired by a painting of the same subject by Niccolò Circignani (Il Pomarancio) for the fifth chapel on the left in San Giovanni dei Fiorentini in Rome. Gere also published the drawing for this fresco, which is in the Real Academia de Bellas Artes de San Fernando, Madrid (album 3, no. 349; see Gere, *Il manierismo a Roma*, p. 86, pl. 35).

A drawing of the same subject by Allegrini was offered for sale at Christie's in London, March 26, 1974, no. 72, pl. 33.

Carlo Maratta
Camerano 1625–1713 Rome

85 *Apotheosis of a Saint* (pl. 94)

Inscribed recto, in pen and brown ink, a scale 1–14; inscribed verso, lower right, in pen and brown ink: *2*.

Pen and brown ink, over graphite, on ivory laid paper; maximum 281 x 282 mm.

COLLECTIONS: C. M., unidentified script (not in Lugt) verso, lower right, in pen and brown ink; Ch. Deering, stamp (Lugt 516) verso, lower center, in blue.

Charles Deering Collection, 1927.4214

Recently Jennifer Montagu has identified this lively pen and ink sketch as the work of Carlo Maratta, possibly a preparatory design for the stucco work over the altar of Saint Francis Xavier in the church of Il Gesù in Rome. Her attribution has been supported by Manuela Mena Marques.

The first study for this project, begun in 1674 and completed in 1679, is in the British Museum (inv. no. 1950-2-11-11). (For a list of other drawings related to this project, see Harris and Schaar, *Die Handzeichnungen von Andrea Sacchi und Carlo Maratta*, pp. 113–15, nos. 285–92, pl. 64; stylistically, it may also be related to no. 465, pl. 24 and no. 342, pl. 85.)

It is curious to associate such a spirited and calligraphic drawing with the last exponent of Sacchi's restrained classicism in seventeenth-century Rome, but Maratta's vast graphic oeuvre encompasses a wide range of styles and demonstrates a distinctive development over the course of his long career. His later drawings, such as this, are generally characterized by a more expressive, wiry line that is far from the Domenichino-like chalk drawings of his earlier years.

Domenico Piola
Genoa 1627–1703

86 *Descent from the Cross* (pl. 90)

Inscribed recto, upper left, in pen and brown ink: *π 81r*; inscribed recto, upper center, in pen and brown ink: *Piola*.

Pen and brown ink with brush and brown wash, over traces of black chalk, on ivory laid paper; laid down; maximum 269 x 202 mm.

COLLECTIONS: William F. E. Gurley, Chicago, stamp (not in Lugt) recto, lower right, in black.
EXHIBITIONS: Neilson, *Italian Drawings*, no. 42, reproduced; Newcome, *Genoese Baroque Drawings*, p. 33, no. 84, reproduced.

Leonora Hall Gurley Memorial Collection, 1922.638

One of the major decorators in Genoa in the second half of the seventeenth century, Domenico Piola developed his popular and highly influential fresco style from such Genoese predecessors as Castiglione and Castello. Piola and his son-in-law, Gregorio de Ferrari, created a lyrical yet bold decorative idiom that pro-

vided Genoa with a Late Baroque style that rivalled the activity of contemporary Rome.

Piola's close association with Gregorio is particularly evident in this compact group. Mary Newcome and Jacob Bean both agree that this is an unusually strong and compelling example of Piola's draftsmanship. The other eight Piola drawings in the Art Institute's collection are comparatively weaker. The dramatic yet well-balanced composition of this drawing suggests that it might have been a study for a painting, but no such painting has been found to date.

Nancy Ward Neilson has suggested that the vigorous style of this drawing may have been influenced by the artist's trip to Emilia and Central Italy in 1684–85; but it is also possible that this influence could have been felt in Genoa earlier than that, brought to the city by artists who traveled more extensively than Piola.

Carlo Cignani
Bologna 1628–1719 Forli

87 *Praying Magdalene* (pl. 86)

Inscribed recto, lower left, in pen and brown ink: *Carlo Cignani;* inscribed verso, lower right on mount, in pen and brown ink: *SW 791.*

Red chalk heightened with white chalk and stumping, on blue-gray laid paper; laid down; 175 x 202 mm.

COLLECTIONS: Samuel Woodburn(?) script verso, lower right on mount, in pen and brown ink; Frederick R. Aikman / coll. sold Mch. 14, 1913 / by Puttick & Simpson, stamp (not in Lugt) verso, lower left on mount, in purple; William F. E. Gurley, Chicago, stamp (not in Lugt) recto, lower right, in black; Leonora Hall Gurley Memorial Collection, stamp (Lugt Suppl. 1230*b*) verso, center on mount, in black.

EXHIBITIONS: Neilson, *Italian Drawings,* no. 46, reproduced.

Leonora Hall Gurley Memorial Collection, 1922.690

Together with such artists as Domenico Maria Canuti and Lorenzo Pasinelli, Carlo Cignani continued the classical Bolognese tradition of the Carracci, Guido Reni and his master Francesco Albani; however, unlike Canuti he lived well into the eighteenth century. In 1706 he became *principe* of the recently founded Accademia Clementina.

The often sentimental character of Bolognese painting at the end of the century expressed itself in such themes as the penitent Magdalene, which Cignani painted at least four times. Nevertheless, this drawing is a fine example of his accomplished draftsmanship and reflects Cignani's study of Reni's structure and Correggio's fluid light. In this way, it may be seen as an extension toward eighteenth-century developments.

Luca Giordano
Naples 1632 or 1634 to 1705

88 *Rape of Europa* (pl. 91)

Inscribed recto, lower center, in pen and brown ink: [?] . . . *Giordano;* inscribed verso, left of center, in pen and brown ink: *91.*

Brush and brown ink with black chalk, heightened with white gouache, on buff laid paper; laid down; maximum 173 x 236 mm.

COLLECTIONS: Bought May 15, 1914 / Puttick & Simpson, stamp (not in Lugt) verso, lower center on mount, in purple; William F. E. Gurley, Chicago, stamp (not in Lugt) recto, lower right, in black; Leonora Hall Gurley Memorial Collection, stamp (Lugt Suppl. 1230*b*) verso, center on mount, in black.

EXHIBITIONS: Vitzthum, *A Selection of Italian Drawings,* pp. 68–70, 165, no. 61, reproduced.

Leonora Hall Gurley Memorial Collection, 1922.797

The nickname *Luca fa presto* ("Luca creates quickly") applies equally well to the spontaneity and variability of Luca Giordano's draftsmanship as to his paintings. From the outset a pupil of Ribera and a follower of Cortona, Giordano also fell under the influence of Venetian art, both in Venice and at the Spanish court of Charles II (1692–1702). Perhaps it is not accidental, then, that the diagonal position of the figure of Europa in this drawing is vaguely reminiscent of Titian's painting of the same subject in the Isabella Stewart Gardner Museum, Boston (see Wethey, *The Paintings of Titian,* vol. 3, pp. 172–75, no. 32, pl. 141). The painting hung in the Alcazar until 1704.

The inscription of Giordano's name at the lower edge of the drawing appears to be in an eighteenth-century hand and this attribution has never been questioned. Walter Vitzthum first published the sheet and pointed out the connection with Titian; however, he believed this sketch to be preliminary to Giordano's own painting of the subject, of 1686, in the Wadsworth Atheneum, Hartford (see Ferrari and Scavizzi, *Luca Giordano,* vol. 3, fig. 283). As this is substantially prior to Giordano's visit to the Spanish court where Titian's painting was then to be found, the probability of a later date, about 1692–1702, must be considered.

The drawing is executed in a broad, painterly manner with brush and an oily dark brown ink with accents of white gouache.

Andrea Celesti
Venice(?) 1637–1712(?) Toscolano

89 *The Miraculous Pool at Bethesda* (pl. 96)

Inscribed recto, upper center, in pen and brown ink: *Ad. a Celesti;* inscribed recto, upper right, in pen and brown ink:

No 56; inscribed recto, lower right, in pen and brown ink: *56;* inscribed verso, lower left, in graphite: *6 Novembre 1829;* inscribed verso, lower left, in graphite: *La Probatica Piscina | Scuolo Veneziana | vi e scritte al Cav. Celesti | questo sogetto ha dipinto il Cav. Celesti | a Venezia nel chiesa del Ascensione ed e tenuta uno delle più bell'opere | e ben conje—ata.*

Red chalk, on ivory laid paper (two pieces joined); maximum 190 x 505 mm.

WATERMARK: Unidentified.

COLLECTIONS: Unknown script (Lugt Suppl. 3005*f*) verso, lower left, in graphite; Bought May 15, 1914 / Puttick & Simpson, stamp (not in Lugt) verso, lower center, in purple; William F. E. Gurley, Chicago, stamp (not in Lugt) recto, lower right, in black; Leonora Hall Gurley Memorial Collection, stamp (Lugt Suppl. 1230*b*) verso, lower right, in black.

EXHIBITIONS: Pignatti, *Venetian Drawings,* p. 26, no. 45, reproduced.

Leonora Hall Gurley Memorial Collection, 1922.893

Once attributed to Palma Giovane, whose influence is evident in the loose, pictorial handling of the chalk, the drawing is actually inscribed "Ad. a Celesti" and identified as the *Pool at Bethesda* (*Probatica Piscina*) in an old hand on the verso. Jacob Bean first called our attention to the fact that this subject was painted by Andrea Celesti for the Church of the Ascension in Venice, which was demolished in 1824.

This unusually large drawing, on two pieces of paper, is an interesting addition to our knowledge of Celesti as a draftsman. In general, Celesti came under the influence of Luca Giordano's neo-Venetian manner, but because of its close affinity with the drawings of Palma Giovane, Pignatti believes that this drawing must be earlier than those previously known: *David and Goliath* in the Morassi collection; *Heliodorus Chased from the Temple* (ca. 1690), in the Correr museum (no. 5409; see Pignatti, "Disegni veneti del seicento," *La Pittura del seicento a Venezia,* pp. 185–86, nos. 83–84, reproduced); and an *Allegory* (ca. 1700), in the Metropolitan Museum (64.13; see Bean and Stampfle, *Drawings from New York Collections,* vol. 2, p. 81, no. 129, reproduced).

Gregorio de Ferrari
Porto Maurizio 1647–1726 Genoa

90 *Female Figures with Putti in Clouds* (pl. 97)

Inscribed recto, lower right, in pen and brown ink: *52*[?].

Pen and brown ink with brush and brown wash, over black chalk, on ivory laid paper; maximum 357 x 504 mm.

COLLECTIONS: William F. E. Gurley, Chicago, stamp (not in Lugt) recto, lower left, in black; Leonora Hall Gurley Memorial Collection, stamp (Lugt Suppl. 1230*b*) verso, center, in black.

LITERATURE: Newcome Schleier, *Maestri Genovesi dal cinque al settecento,* p. 34; Newcome, "Lorenzo de Ferrari Revisited," *Paragone* 335:66–67, fig. 72.

EXHIBITIONS: Newcome, *Genoese Baroque Drawings,* p. 37, no. 99, reproduced.

Leonora Hall Gurley Memorial Collection, 1922.452

Jacob Bean recognized this drawing as the work of Gregorio de Ferrari, and G. V. Castelnovi identified it as a study for a portion of the octagonal dome cupola in the church of San Camillo e Santa Croce, Genoa, painted with the help of Lorenzo de Ferrari in 1715–26. There are drawings by Gregorio and Lorenzo in the Palazzo Rosso and the Manning Collection which may also be connected with the cupola (see Gavazza, *Lorenzo de Ferrari,* pp. 87–88, no. 1, reproduced; and see Suida Manning and Manning, *Genoese Masters,* no. 81, reproduced).

This fresco marks the end of Gregorio's career. The style of the drawing appears to be Gregorio's; drawings by his son Lorenzo seem to be less exuberant and more classical. The close correlation of the drawing with the fresco makes it plausible that much of the cupola design was the work of Gregorio.

Anton Domenico Gabbiani
Florence 1652–1726

91 *The Apotheosis of Hercules* (pl. 98)

Inscribed verso, lower right, in graphite: *Minerve enlève Hercule des bras d'Omphale.*

Pen and brown ink with brush and brown wash, heightened with white gouache, over traces of graphite, on pale gray-green laid paper; maximum 255 x 370 mm.

WATERMARK: Bird in a circle (not in Briquet nor Heawood).

COLLECTIONS: M. Komor, stamp (Lugt Suppl. 1882*a*) verso, lower right, in blue.

Gift of Mrs. Leigh B. Block, 1961.883

When this drawing was acquired by the Art Institute in 1961, it had a tentative attribution to Sebastiano Ricci. It was Rafael Fernandez who suggested the late Florentine Baroque artist Anton Domenico Gabbiani, and he connected it with the stuccoed vault of the *Apotheosis of Hercules* in the Corsini Palace, Florence.

Gabbiani was trained in Florence by Susterman and later by Vincenzo Dandini, the student of Pietro da Cortona. In May, 1673, Cosimo III sent Gabbiani and several other students to Rome to the school of that more significant follower of Pietro da Cortona, Ciro Ferri. Gabbiani remained in Rome for almost five years, but his exposure to Venice in 1678 or 1679 was equally

important for the evolution of his style. Gabbiani specialized in works favored by the Florentine nobility—portraits and decorative frescoes extolling the famous families were a large part of his production. One of the most monumental of these decorations was the *Exaltation of Cosimo the Elder*, painted for Poggio a Caiano in 1698 (see Bartarelli, "Domenico Gabbiani," *Rivista d'arte* 27:120–22, fig. 6). Bartarelli has observed that a similar Cortonesque style is employed in the vast decoration of the *Apotheosis of Hercules* executed two years later, perceptible even in a preparatory drawing for the fresco in the Uffizi (see Bartarelli, *Rivista d'arte* 27:122–23, fig. 7) or in the smaller variation in Chicago.

According to Fernandez, from the life of Gabbiani written by his faithful pupil Ignatius Hugford (son of an English clockmaker and repairman at the Medici court), it appears that the fresco was commissioned by the Marchese Filippo Corsini about 1695. Hugford's life of Gabbiani and the 100 facsimile reproductions of Gabbiani's drawings it contains were published in Florence in 1762.

Giuseppe Bartolomeo Chiari
Rome 1654–1727

92 *Pietà* (pl. 95)

Inscribed recto, lower left, in graphite: *Giuseppe Chiari*.
Red chalk, on ivory laid paper; laid down; 201 x 176 mm.
COLLECTIONS: Sir Thomas Lawrence, embossed stamp (Lugt 2445) recto, lower left; J. Richardson, Sr., stamp (Lugt 2184) recto, lower left, in black; R. Houlditch, stamp (Lugt 2214) recto, lower right, in black; Dr. C. D. Ginsburg, stamp (Lugt 1145) recto, lower left, in black; Dr. C. D. Ginsburg, LL.D. / collection sold July 20, / 1915, Sotheby, London, stamp (not in Lugt) verso, lower left on mount, in purple; William F. E. Gurley, Chicago, stamp (not in Lugt) recto, lower right and stamp verso, center on mount, in black; Leonora Hall Gurley Memorial Collection, stamp (Lugt Suppl. 1230b) verso, center on mount, in black.
LITERATURE: Kerber, "Giuseppe Bartolomeo Chiari," *Art Bulletin* 50:75–86, fig. 22.

Leonora Hall Gurley Memorial Collection, 1922.5414

Giuseppe Bartolomeo Chiari was a pupil of Carlo Maratta, whom he assisted in the mosaics in the dome of Saint Peter's.

This drawing has been linked by Middeldorf and Kerber with Chiari's painting of the same subject in the Accademia di San Luca. The painting may be identified with a Pietà commissioned by Cardinal Ottoboni, who patronized the artist during the second decade of the eighteenth century.

The orientation of the painting is reversed from that of the drawing. Furthermore, there are other slight variations in detail at the same time that there is a similarity of motif (derived from the sculptures of this subject by Michelangelo in Rome and in Florence) to insure that this drawing was preliminary to, and not after, the painted work. Kerber has pointed out that the sketch is still free of the characteristic schematization imposed by Chiari on his paintings.

Pietro Antonio de' Pietri
Cremia 1663–1716 Rome

93 *Presentation in the Temple* (pl. 100)

Inscribed verso, center on mount, in pen and brown ink: *Tieppilo*.
Pen and brown ink with brush and brown wash, over graphite, heightened with white gouache, on buff laid paper; laid down; maximum 407 x 273 mm.
COLLECTIONS: J. Richardson, Jr., stamp (Lugt 2170) recto, lower right, in black; Benjamin West, embossed stamp (Lugt recto, lower center; acquired from Nathan Chaikin.

Worcester Sketch Fund, 1972.323

The brilliant execution of this monumental drawing refutes the reputation of Pietro de' Pietri as a second-rate follower of Carlo Maratta (see Blunt and Cooke, *Roman Drawings*, p. 85). Anthony M. Clark, in a letter of March 14, 1965, calls this drawing "a fine, and exceptionally rich, work by Pietro de' Pietri." He believed the attribution to be self-evident for stylistic reasons and also because the Richardsons, who owned this drawing, were well acquainted with the artist's work. Clark, himself, owned a smaller drawing for the same composition, and there are two other drawings of the same subject at Windsor Castle (4409 *a* and *b*) and one at Christ Church, Oxford (1261), all three of them in oval shape (see Blunt and Cooke, *Roman Drawings*, p. 87, nos. 671–72, fig. 66; and see Byam Shaw, *Drawings by Old Masters at Christ Church*, vol. 1, p. 177, no. 656; vol. 2, pl. 369). These drawings are directly connected with the oval painting in Santa Maria di Via Lata, which is a very late work (ca. 1715).

In addition to the oval painting, the artist made several other versions of the same subject: one of these was in the chapel of the Pallavicini palace in Rome (present whereabouts unknown) and another in the Musée des Beaux-Arts, Rouen.

Alessandro Magnasco
Genoa ca. 1667–1749

94 *Picaresque Group with a Monkey and a Magpie* (pl. 102)

Brush with brown ink and brown wash, heightened with white chalk, over black chalk, on faded blue laid paper; maximum 478 x 372 mm.

WATERMARK: Circle and star (not in Briquet or Heawood).

COLLECTIONS: Gentile de Giuseppe, Paris (according to Slatkin); sale: Paris, Galerie Charpentier, 24 May, 1955, no. 132, pl. 6; Otto Wertheimer, Paris; acquired from Charles Slatkin Galleries, New York.

LITERATURE: Scholz, "Drawings by Alessandro Magnasco," *Essays in the History of Art Presented to Rudolf Wittkower*, p. 239; Joachim, *Helen Regenstein Collection*, pp. 12–13, no. 3, reproduced; Franchini Guelfi, *Alessandro Magnasco*, pp. 219, 225, reproduced.

EXHIBITIONS: *Master Drawings from the Art Institute of Chicago*, no. 13.

Helen Regenstein Collection, 1962.586

No other artist epitomizes so evocatively the transition between seventeenth- and eighteenth-century art in northern Italy as this Genoese artist who worked for the most part in Milan. Alessandro Magnasco's highly individual style, rooted perhaps in Jacques Callot's etchings and Salvator Rosa's wild landscapes, was most appropriately translated in a feverish, rapid brush stroke, thick with impasto, and seldom was as successfully conveyed in his drawings.

Few among Magnasco's drawings can compare "with the quite extraordinary, spectacularly fine pair of drawings" in Chicago (see Scholz, "Drawings by Alessandro Magnasco," *Essays in the History of Art Presented to Rudolf Wittkower*, p. 239).

The subjects of these two drawings (cat. 94 and 95) have often been treated by the artist. The picaresque subject revolves about a seated, disheveled soldier who is being deloused by a monkey, while an assortment of strange figures hover around him. One of these is perhaps a sculptor, who could be the creator of the unfinished clay bust; in his hand, he holds a bowl of water in front of a magpie (the monkey and magpie were among Magnasco's favorite paraphernalia). Pieces of armor and a musket are strewn about the cellar, and the scene may be compared with *Women and Soldiers at a Table*, in the San Francisco Museum of Fine Arts (see Morassi, *Mostra del Magnasco*, pp. 39–40, no. 54, fig. 58). Another recurrent figure of Magnasco's is the haggard old woman with the baby at the left. It is possible that this was intended as a parody of the cowardly soldier who prefers a lazy existence to deeds of valor. The

vibrancy of the flickering brush work in red, brown, and white perfectly fits the subject.

The painting in San Francisco has been tentatively dated to 1720–25, and this could well be the date of our drawings, which show Magnasco's drawing style in its complete freedom, but before the evanescent dissolution of forms of his later years.

Alessandro Magnasco
Genoa ca. 1667–1749

95 *Ballad Singer with a Shrine of the Virgin* (pl. 101)

Brush with brown ink and brown wash, heightened with white chalk, over black chalk, on faded blue laid paper; maximum 467 x 370 mm.

WATERMARK: *SS* in a circle topped by three balls (not in Briquet or Heawood).

COLLECTIONS: Gentile de Giuseppe, Paris (according to Slatkin); sale: Paris, Galerie Charpentier, 24 May 1955, no. 131, pl. 6; Otto Wertheimer, Paris; acquired from Charles Slatkin Galleries, New York.

LITERATURE: Scholz, "Drawings by Alessandro Magnasco," *Essays in the History of Art Presented to Rudolf Wittkower*, p. 239; Joachim, *Helen Regenstein Collection*, pp. 10–11, no. 2, reproduced.

EXHIBITIONS: *Master Drawings from the Art Institute of Chicago*, no. 12; Feinblatt, *Old Master Drawings*, pp. 108, 110, no. 131, reproduced.

Helen Regenstein Collection, 1962.585

The ballad singer (*cantastorie*) with a portable shrine of the Virgin is a recurrent theme of Magnasco's. Two paintings of this subject were shown at the Mostra del Magnasco in 1949 (see Morassi, *Mostra del Magnasco*, p. 26, nos. 6–7, figs. 6–7), both in the Gatti-Casazza Collection in Venice. In both paintings and our drawing, the ballad singer is before the open shrine of the Virgin, singing to groups of people, mostly children.

But the surrounding figures of the drawing are different from those of the paintings, as is the background, which consists of rocky scenery with some dead trees and a grottolike opening at the right instead of the ruins in the two paintings. The paintings are not dated, but since the drawing is obviously a companion piece to the picaresque scene, the date must be the same.

It would be interesting to know if these two drawings were planned as a pair or if they belonged to a larger set. They are finished works of art in themselves and not necessarily studies for paintings.

Donato Creti
Cremona 1671–1749 Bologna

96 *Rinaldo and Armida* (pl. 105)

Pen and brown ink, on ivory laid paper; maximum 150 x 192 mm.

COLLECTIONS: Charles Henri Marcellis(?), stamp (Lugt Suppl. 609) recto, lower right, in blue; R. Lamponi, stamp (Lugt 1760) recto, lower left, in blue.

LITERATURE: Milkovitch, *Sebastiano and Marco Ricci in America*, pp. 48, 51, no. 65, reproduced; Vitzthum, "Publications Received: *Sebastiano and Marco Ricci in America*," *Master Drawings* 4:185, pl. 48; Johnston, "Donato Creti," *L'Oeil* 168:46; Roli, "Drawings by Donato Creti: Notes for a Chronology," *Master Drawings* 11:25–32.

Gift of Mr. and Mrs. Norman H. Pritchard, 1960.836

When this drawing came to the Art Institute in 1960, it was tentatively ascribed to Sebastiano Ricci (and published by Michael Milkovitch as such; see Milkovitch, *Sebastiano and Marco Ricci in America*, pp. 48, 51, no. 65, reproduced). However, Walter Vitzthum recognized the hand of Donato Creti, and Roli, who acknowledged the affinity of its lively pen work with that of Sebastiano Ricci, cited it as "one of the most intense attainments of the master's graphic art" (see Roli, "Drawings by Donato Creti: Notes for a Chronology," *Master Drawings* 11:26).

Another drawing of the same subject, very similar in style but somewhat loose-jointed, is in Stuttgart (Inv. C 1931/39; see Thiem, *Italienische Zeichnungen 1500–1800*, p. 124, no. 250). Both drawings show a sleeping warrior who is approached by a young woman in flowing garments, wielding a dagger in her right hand, obviously intending to plunge it into the sleeping man's heart. One putto arrests her arm while other putti float in the surrounding air. It is therefore most unlikely that the subject of the drawing could be *Diana and Endymion* (as the Stuttgart drawing is titled). It must refer to the story of *Rinaldo and Armida* as told in the fourteenth Canto of Tasso's *Gerusalemme Liberata*:

Then from her ambush forth Armida start
Swearing revenge, and threatening torments smart;
But when she looked on his face awhile
And saw how sweet he breath'd, how still he lay,
How his fair eyes though closed seem to smile,
At first she stay'd astound with great dismay:
Then sat her down (so love can art beguile)

.

Which late congeal'd the heart of that fair dame
Who, late a foe, a lover now became.

[Torquato Tasso, *Jerusalem Delivered*, p. 367]

A summary sketch of Rinaldo's torso reclining in the opposite direction can be seen at the lower right corner of our sheet, which corresponds directly to that used in the Stuttgart drawing. As the drawing in Chicago shows two alternate postures of Armida's right arm holding the dagger, it may be assumed that this version is earlier than the one in Stuttgart where there are no *pentimenti*; yet another version of the subject is on the verso of the sheet in Stuttgart. Catherine Johnston has pointed out that a third sheet related to this group is in Philadelphia (Pennsylvania Academy of Fine Arts, no. 349). It seems to represent a later moment in the story, after Armida has put down the dagger and is gazing more directly into Rinaldo's eyes.

Roli has dated the drawing in Chicago about 1693, based on its stylistic connection with drawings in the Cini Foundation (foto n. 31495; see Roli, *Donato Creti*, pl. 106) and in the collection of Mrs. Richard Krautheimer (see Roli, *Master Drawings* 11:26, pl. 9), which are reliably dated in inscriptions by Count Fava.

Donato Creti
Cremona 1671–1749 Bologna

97 *The Astronomers* (pl. 104)

Pen and brown ink with brush and brown wash, on ivory laid paper; maximum 242 x 325 mm.

COLLECTIONS: Undistinguishable seal (not in Lugt) verso, lower left, in orange; G. Seligman, New York, stamp (not in Lugt) recto, lower right, in black; acquired from Jacques Seligmann & Co., New York.

LITERATURE: Van Schaack, "Drawings from the Art Institute of Chicago," *Arte Antica e Moderna* 25:110, pl. 38a; Roli, *Donato Creti*, pp. 32, 105, fig. 121; Roli, "Drawings by Donato Creti: Notes for a Chronology," *Master Drawings* 11:25–32.

EXHIBITIONS: *Master Drawings from the Art Institute of Chicago*, no. 11.

Worcester Sketch Fund, 1962.791

Donato Creti was forty years old and one of the leading painters of Bologna when in 1711 he received a commission from Count Luigi Marsigli in Rome to do a series of eight paintings based on the planets. Creti was advised on this project by the astronomer Eustachio Manfredi, who gave precise instructions about the instruments used and also specified the times of day and night suitable for observation of the planets (see the letter from Manfredi to Marsigli of August 30, 1711, in Roli, *Donato Creti*, p. 60, n. 38). Today the paintings

are in the Pinacoteca Vaticana, Rome, where they were transferred in 1932 from Castelgandolfo.

The drawing in Chicago represents Mars and shows an almost identical group of men as that in the painting, but with the *quadrant a pendolo*, which is not shown in the painting (see Roli, *Donato Creti*, fig. 21). A similar instrument is found in the painting entitled *Venus* and in the drawing for it in the Pinacoteca Nazionale, Bologna (see Roli, *Donato Creti*, figs. 24 and 122).

This commission gave Donato Creti the opportunity of indulging his inclination toward a lyrical vision of landscape, which shows a strong affinity with Giorgione and is almost unique for this period. The drawing in Chicago shows the gentle, silvery quality and the vibrating light characteristic of his finest drawings.

Filippo Juvarra
Messina 1676–1736 Madrid

98 *Design for an Altar in the Church of the Confraternity of Santissima Trinità, Turin* (pl. 103)

Inscribed recto, upper right, in pen and dark brown ink: *72 | uno degli Altari della chiesa | Conf*ta *della SS*ma *Trinità;* inscribed recto, lower right, in pen and light brown ink: *A Gd. P*mo *Basori[?] di Trivegliano alias Ignacce | Giuseppe Aivonia[?] Aglando[?] | Giuseppe Bacheirs C | ma madalena colucci priora | fra . . . | Antonio Carella | Gio. Batta. Carella;* inscribed recto, lower right, in pen and brown ink: *Verra DC nogesgrd[?];* inscribed verso, lower edge, in pen and brown ink: *Disegno della Capella di Stefano et Agnese fatta da Sign. Cavag*le *D. Filippo Juvarra P*m.

Pen and black ink with brush and watercolor, over graphite, on buff laid paper; 612 x 444 mm.

WATERMARK: TDVPBY (not in Heawood).

Gift of Mr. and Mrs. Henry C. Woods, 1964.43

Filippo Juvarra was without doubt the most significant architect in eighteenth-century Italy and enjoyed a remarkable international reputation in his own day. The son of a silversmith in Messina, Juvarra went to Rome in about 1704 to work in the studio of the academic, Late Baroque architect Carlo Fontana and at once began an enormous production of drawings that testify to the many facets of his interests and involvements from the very beginning. By 1711 he was receiving commissions from courts outside of Italy and for stage designs for the Vienna theater; in 1714 he became architect to the King of Savoy at Messina. From 1719 to 1720, Juvarra traveled to Portugal and on to London and Paris, but he returned to Turin, where his major work was done, and remained there until he was called to Madrid to design a palace for Philip V in 1735; he came to an untimely death only one year later.

According to the catalog of Juvarra's drawings compiled by his pupil G. B. Sacchetti, the architect worked on the refurbishing of Vitozzi's early seventeenth-century church of Santissima Trinità in Turin on at least two occasions, in 1721 and 1734. In the latter year he worked on a "disegno dell'altare di Santo Stefano per la confraternita della SS. Trinità a Torino." The Chicago drawing carries the inscription at the top "uno degli Altari della Chiesa / Confta della SSma Trinità" in the architect's own hand. The drawing corresponds to both of the side altars in Santissima Trinità, one of the Madonna del Popolo and the other of Santo Stefano, both traditionally assigned to Juvarra.

Brinckmann notes that the final design for the altar of Santo Stefano is in the Biblioteca Nazionale in Turin (f. 2 of vol. 59-2; see de Vecchi di Val Cismon et al., *Filippo Juvarra*, vol. 1, p. 100). The drawing in Chicago could be the earlier study presented to the confraternity for approval, which seems to have been given with the seven signatures at the lower right. The ground plan and section correspond to that of the altar, except for the pattern of the marble on the floor and the lack of sculptural decoration that was to be added by Tavigliano. Neither of the alternate schemes for the flanking doors, represented here on either side, seems to have been executed.

Giovanni Battista Piazzetta
Venice 1682–1754

99 *Portrait of Field Marshal Count von der Schulenburg* (pl. 108)

Inscribed recto, lower right, in graphite: *375.*

Black and white chalks and stumping, on buff laid paper; laid down; maximum 505 x 385 mm.

COLLECTIONS: Count Johann Matthias von der Schulenburg, Venice, and Descendants, Germany; acquired from Paul Drey Gallery, New York.

LITERATURE: *Inventaire de la Gallerie de Feu S.E. Mgr. le Feldmarechal Comte de Schulenburg*, p. 9 (according to Paul Drey Gallery); Morassi, "Settecento Inedito III," *Arte Veneta* 6:85–91, fig. 82, reproduced; Pallucchini, *Piazzetta*, p. 53, fig. 147; Binion, "From Schulenburg's Gallery and Records," *Burlington Magazine* 112:297–303; Joachim, *Helen Regenstein Collection*, pp. 14–15, no. 4, reproduced.

EXHIBITIONS: See R. Pallucchini in Precerutti-Garberi, *Giambattista Piazzetta e L'Accademia*, preface and no. 3; Goldman in Wise, *European Portraits, 1600–1900*, pp. 105–7, no. 26, reproduced, also color plate 3.

Helen Regenstein Collection, 1971.325

In 1715, Field Marshal Count Johann Matthias von der Schulenburg (1661–1742) was called out of his fourth year of retirement in his home in Emden near Magdeburg by the Venetian Senate to lead the forces of the republic as the last hope for salvation from the Turks. By 1718, after several ferocious campaigns against incredible odds, the count triumphed over the Turks at Corfu and pursued them into Albania. In the space of these three intense years, a fruitful alliance developed between this Hapsburg military officer and the Venetian territory, its people, and, above all, its painters, and the count remained in the service of the republic for the following thirty years. On his death in Verona in 1747, he was buried at the Arsenal in Venice.

It was in 1724 that the count began to collect the works of numerous Venetian artists, commissioning, among others, Antonio Guardi and Pittoni, Canaletto, Diziani, and Simonini (see Precerutti-Garberi, *Giambattista Piazzetta e L'Accademia*, no. 3). It was not until 1731 that Schulenburg's first contact with Piazzetta is recorded. Piazzetta served not only as the "expert" and cataloguer of the count's important collection, but he also provided that collection, on commission, with the largest single group of his own works. Over thirteen paintings and nineteen drawings by Piazzetta were in the count's collection. Among them were the Art Institute's paintings *Pastorale* and *The Beggar Boy* (Worcester Collection, 1937.68 and 1930.747, which were sold from the Schulenburg collection in London, 1775, against the wishes set down in Schulenburg's will), and the nine drawings that are described here. These were kept in the Schulenburg family until recently, at the residence of Hehlen in Hehlen an der Weser (see Binion, "From Schulenburg's Gallery and Records," *Burlington Magazine* 112:302).

Although born in Venice, Piazzetta's formative early years (until 1711) were spent in Bologna, where Giuseppe Maria Crespi, with his robust naturalism, his love of earthly genre subjects, and his glowing palette made a strong impression on the younger artist.

As Piazzetta was considered a slow painter by his contemporaries, it is not surprising that his reputation was built on his drawings as much as on his paintings. His studies of heads were enormously popular and widely imitated, but only Piazzetta could give them their full-blooded presence and, at the same time, softness of modelling with elusive contours. Therefore, this set of nine drawings from the Schulenburg collection is doubly important because of its impeccable, documented history.

The commanding portrait of the Field Marshal Count

von der Schulenburg at the age of seventy-seven is one of three portraits of the count that are known by Piazzetta: one in red wash, *Portrait with Virtues Being Lifted to Heaven by Angels* (listed in the appendix to the Inventory of 1741) is now lost; the other, a three-quarter pose, is in the Trivulzio Collection, Milan. In discussing the latter, Precerutti-Garberi noted that on 18 August 1738 (the count's birthday) Piazzetta received "7 zecchini e 5 lire e mezza" for a portrait "di Sua Eccellenza," followed by a second payment of "3 zecchini" on August 26 (see Precerrutti-Garberi, *Giambattista Piazzetta e L'Accademia*, no. 3). This, she believes, certainly refers to the drawing now in Chicago. Morassi has described it as "un capolavoro di 'carattere', e forse il più bel ritratto che l'artista abbia mai delineato" (see Morassi, "Settecento Inedito III," *Arte Veneta* 6:88). The drawing in Chicago seems more honest and penetrating a portrayal of the count than the flattering, idealized drawing in Milan, which was probably commissioned as a presentation piece (ca. 1735).

Giovanni Battista Piazzetta
Venice 1682–1754

100 Portrait of Ferdinand Ludwig Count von Oeynhausen-Schulenburg (pl. 106)

Inscribed recto, lower right, in graphite: #.
 Black and white chalks and stumping, on gray laid paper; laid down; maximum 506 x 369 mm.
 COLLECTIONS: Count Johann Matthias von der Schulenburg, Venice, and Descendants, Germany; acquired from Paul Drey Gallery, New York.
 LITERATURE: *Inventaire de la Gallerie du Feu S.E. Mgr. le Feldmarechal Comte de Schulenburg*, p. 9 (according to Paul Drey Gallery); Binion, "From Schulenburg's Gallery and Records," *Burlington Magazine* 112:301; Joachim, *Helen Regenstein Collection*, pp. 16–17, no. 5, reproduced.

Helen Regenstein Collection, 1971.327

Fifteen of the nineteen drawings in the field marshal's collection were "heads" and portraits, and from the aristocratic bearing, clothing, and hairstyle, it is obvious that this portrait figure represents a member of the Schulenburg family. A descendant of the field marshal, Albert Graf von der Schulenburg, has confirmed the identity of the portrait for us (letter of 28 April, 1973). It is of Ferdinand Ludwig Count von Oeynhausen (1701–54), General Master of Ordnance, whose mother was Sophie Juliane von der Schulenburg, sister of the field marshal, and whose father was Raban Christoph von Oeynhausen. Ferdinand Ludwig was the field

marshal's favorite nephew and in 1747 he was adopted by Schulenburg, at which time he changed his name to von Oeynhausen-Schulenburg.

Giovanni Battista Piazzetta
Venice 1682–1754

101 *Portrait of a Lady* (pl. 107)

Inscribed recto, lower right, in graphite: *385*.
 Black and white chalks and stumping, on gray laid paper; laid down; 513 x 381 mm.
 COLLECTIONS: Count Johann Matthias von der Schulenburg, Venice, and Descendants, Germany; acquired from Paul Drey Gallery, New York.
 LITERATURE: *Inventaire de la Gallerie de Feu S.E. Mgr. le Feldmarechal Comte de Schulenburg*, p. 9 (according to Paul Drey Gallery); Binion, "From Schulenburg's Gallery and Records," *Burlington Magazine* 112:301; Joachim, *Helen Regenstein Collection*, pp. 18–19, no. 6, reproduced.
Helen Regenstein Collection, 1971.328

This *Portrait of a Lady* has not been identified, but it is likely that she, too, was either a member of the Schulenburg family or held an important station in their household. On the basis of its correspondence to the preceding portrait of Count von Oeynhausen-Schulenburg, it is tempting to associate this portrait with his wife, Maria Anna Countess Kottulinsky (1707–88), widow of Fürst Liechtenstein. Ferdinand Ludwig did not marry until 1740, however, and the Schulenburg drawings have generally been dated to the early 1730s (see Binion, "From Schulenburg's Gallery and Records," *Burlington Magazine* 112:301). Thus, either the proposed association of the two noble portraits must remain speculative, or it might indicate that they were executed a few years later than the rest of the group.

Giovanni Battista Piazzetta
Venice 1682–1754

102 *Boy Feeding a Dog* (pl. 111)

Inscribed recto, lower right, in graphite: *386;* inscribed verso, upper left on mount, in graphite: *386*.
 Black and white chalks and stumping, on gray laid paper; laid down; maximum 534 x 432 mm.
 COLLECTIONS: Count Johann Matthias von der Schulenburg, Venice, and Descendants, Germany; acquired from Paul Drey Gallery, New York.
 LITERATURE: *Inventaire de la Gallerie de Feu S.E. Mgr. le Feldmarechal Comte de Schulenburg*, p. 9 (according to Paul Drey Gallery); Binion, "From Schulenburg's Gallery and Records,"

Burlington Magazine 112:301; Joachim, *Helen Regenstein Collection*, pp. 20–21, no. 7, reproduced.
Helen Regenstein Collection, 1971.326

Count Schulenburg had a great liking for genre subjects, and he may even have influenced Piazzetta in that direction. One of the finest surviving examples is this drawing, *Boy Feeding a Dog*. There is evidence to suggest that the artist especially treasured this sheet, for records show that, although he sold a drawing of "a boy holding a piece of bread, with a girl's head and a dog" to Schulenburg for 6 *zecchini* in October 1739, he appraised it at 20 only a few years later (see Binion, "From Schulenburg's Gallery and Records," *Burlington Magazine* 112:301).

A number of Piazzetta's drawings show similar half-length groups of two or three young people gathered around a dog, a songbird, or a fowl. Two very similar sheets are in the Walter C. Baker Collection, New York (see Bean and Stampfle, *Drawings from New York Collections*, vol. 3, pp. 33–34, nos. 40–41, reproduced). Of these, *Young People Feeding a Dog* (no. 40) included the same youth holding out a twisted roll (or *cornuto*) to the dog as in our drawing. Moreover, unlike those drawings, this composition is vertical in format. What singles out this drawing from similar subjects is the dramatic power of the upraised arm with spectacular light effects on the pleated sleeve as the apex of the composition.

The young boy who served as a model in this work appears in many other drawings and paintings by Piazzetta, among them *The Beggar Boy*, also from the Schulenburg collection and now in the Art Institute of Chicago (Worcester Collection, 1930.747), where he wears an identical costume (see Rich, *Bulletin of the Art Institute of Chicago* 26:55–56, reproduced p. 53).

Giovanni Battista Piazzetta
Venice 1682–1754

103 *Portrait of a Young Man Holding a Sword* (pl. 112)

Inscribed recto, lower right, in graphite: *382;* inscribed verso, upper left, on mount, in graphite: *382*[?].
 Black and white chalks and stumping, on gray laid paper; pieced at right; laid down; maximum 390 x 296 mm.
 COLLECTIONS: Count Johann Matthias von der Schulenburg, Venice, and Descendants, Germany; acquired from Paul Drey Gallery, New York.
 LITERATURE: *Inventaire de la Gallerie de Feu S.E. Mgr. le Feldmarechal Comte de Schulenburg*, p. 9 (according to Paul Drey

Gallery); Binion, "From Schulenburg's Gallery and Records," *Burlington Magazine* 112:301; Joachim, *Helen Regenstein Collection*, pp. 26–27, no. 12, reproduced.

Helen Regenstein Collection, 1971.329

This handsome, elegantly dressed young man can be easily recognized as another frequently used model of Piazzetta's. It was precisely this sort of drawing that appealed to the field marshal's taste, and nearly one-third of his collection was devoted to such representations of a human likeness. In the lower right corner of this sheet, one can clearly read the inventory number assigned to each piece in the Schulenburg collection. "Heads" by Giuseppe and Bartolomeo Nogari, Ghislandi, and Ceruti were numbered from 330 to 370; Piazzetta's "heads" or portraits were numbers 375 to 389 (see Binion, "From Schulenburg's Gallery and Records," *Burlington Magazine* 112:298, 301). This sheet, like others by Piazzetta in this group and eleswhere, has been pieced along one side.

Giovanni Battista Piazzetta
Venice 1682–1754

104 *Portrait of a Young Boy* (pl. 113)

Inscribed recto, lower right, in graphite: *378.*
 Black and white chalks and stumping, on gray laid paper; pieced at right and left; laid down; 395 x 300 mm.
 COLLECTIONS: Count Johann Matthias von der Schulenburg, Venice, and Descendants, Germany; acquired from Paul Drey Gallery, New York.
 LITERATURE: *Inventaire de la Gallerie de Feu S.E. Mgr. le Feldmarechal Comte de Schulenburg*, p. 9 (according to Paul Drey Gallery); Binion, "From Schulenburg's Gallery and Records," *Burlington Magazine* 112:301; Joachim, *Helen Regenstein Collection*, p. 22, no. 8, reproduced.

Helen Regenstein Collection, 1971.330

A closely similar drawing of the same young boy holding an apple in his hand is in the Trivulzio Collection in Milan (see Precerutti-Garberi, *Giambattista Piazzetta e L'Accademia*, no. 6, reproduced). In her catalog of that collection, Mercedes Precerutti-Garberi points out that this youth with large, sad eyes also appears, in a similar pose, in the painting *Alfiere* in Dresden (see Pallucchini, *Piazzetta*, fig. 40), dated about 1725–30. She assigns the drawing in Milan to a slightly later period, which also accords with our drawing.

 Other similar studies of the same young boy, in Lausanne, Windsor, Cleveland, and Padua, are reproduced together by Pallucchini (*Piazzetta*, figs. 119–22).

Giovanni Battista Piazzetta
Venice 1682–1754

105 *Portrait of a Gondolier* (pl. 114)

Inscribed verso, upper left, on mount, in graphite: *382.*
 Black and white chalks and stumping, on gray laid paper; pieced at left; laid down; maximum 388 x 299 mm.
 COLLECTIONS: Count Johann Matthias von der Schulenburg, Venice, and Descendants, Germany; acquired from Paul Drey Gallery, New York.
 LITERATURE: *Inventaire de la Gallerie de Feu S.E. Mgr. le Feldmarechal Comte de Schulenburg*, p. 9 (according to Paul Drey Gallery); Binion, "From Schulenburg's Gallery and Records," *Burlington Magazine* 112:301; Joachim, *Helen Regenstein Collection*, p. 25, no. 11, reproduced.

Helen Regenstein Collection, 1971.331

Piazzetta's character studies were enormously popular in his own time: they represent colorful personalities typical of Venetian life or models impersonating them. This portrait of a mustachioed gondolier wearing a cap at a rakish angle and holding his pole, may be compared with studies of Moors, warriors, Levantines, and old men (note especially the ferocious *Man in a Furry Hat* in Cleveland; see Pallucchini, *Piazzetta*, figs. 123–24, 127, and 155 and Precerutti-Garberi, *Giambattista Piazzetta e l'Accademia*, nos. 11–15, reproduced). It is interesting to note that Piazzetta himself was characterized by Algarotti as an artist "habile et bizare," so that his sympathy with such colorful types is understandable (see Posse, *Jahrbuch der preussischen Kunstsammlungen* 52 [1931], quoted by Precerutti-Garberi, *Giambattista Piazzetta e l'Accademia*, no. 3).

Giovanni Battista Piazzetta
Venice 1682–1754

106 *Portrait of a Young Woman* (pl. 110)

Inscribed verso, upper left, on mount, in graphite: *377.*
 Black and white chalks and stumping, on gray laid paper; laid down; maximum 395 x 296 mm.
 COLLECTIONS: Count Johann Matthias von der Schulenburg, Venice, and Descendants, Germany; acquired from Paul Drey Gallery, New York.
 LITERATURE: *Inventaire de la Gallerie de Feu S.E. Mgr. le Feldmarechal Comte de Schulenburg*, p. 9 (according to Paul Drey Gallery); Binion, "From Schulenburg's Gallery and Records," *Burlington Magazine* 112:301; Joachim, *Helen Regenstein Collection*, p. 24, no. 10, reproduced.

Helen Regenstein Collection, 1971.332

This unidentified young woman is clearly from a different social stratum from the other female portrait

of the group. It is small wonder that these drawings of soft beauties found great favor among Piazzetta's contemporaries and were collected by such notable connoisseurs as Antonio Maria Zanetti, Francesco Gabburi, Pierre-Jean Mariette, and Count Tessin. In 1733 Count Zanetti wrote of Piazzetta, "one can only say that although his painted work is highly prized and distinguished enough, there is that of his drawings of heads on paper with white and black chalks; no one will ever see more beautiful examples of this kind than these" (Pallucchini in Precerutti-Garberi, *Giambattista Piazzetta e l'Accademia* (p. ii).

Giovanni Battista Piazzetta
Venice 1682–1754

107 *Portrait of a Man* (pl. 109)

Inscribed recto, lower right, in graphite: *379;* inscribed verso, upper left, on mount, in graphite: *379.*

Black and white chalks and stumping, on gray laid paper; pieced at left; laid down; 393 x 297 mm.

COLLECTIONS: Count Johann Matthias von der Schulenburg, Venice, and Descendants, Germany; acquired from Paul Drey Gallery, New York.

LITERATURE: *Inventaire de la Gallerie de Feu S.E. Mgr. le Feldmarechal Comte de Schulenburg,* p. 9 (according to Paul Drey Gallery); Binion, "From Schulenburg's Gallery and Records," *Burlington Magazine* 112:301; Joachim, *Helen Regenstein Collection,* p. 23, no. 9, reproduced.

Helen Regenstein Collection, 1971.333

One of the most unforgettable characters among Piazzetta's studies of heads is this decidedly masculine roguish character with a sly expression.

Giovanni Battista Piazzetta
Venice 1682–1754

108 *Projects for an Altar with Saint Margaret of Cortona, Saint Sebastian, and Saint Roch,* recto (pl. 115)
Studies for an Altar, verso (pl. 116)

Inscribed recto, at center right, in pen and brown ink: *S. Sebastian, S. Rocco, S. Margarita da Cortona.*

Pen and brown ink, over black chalk, on ivory laid paper (recto and verso); 192 x 278 mm.

COLLECTIONS: Sale: Düsseldorf, C. G. Boerner, October 1973, 120–1, lot 121, reproduced (recto and verso); acquired from Adolphe Stein.

Worcester Sketch Fund, 1976.425

Until recently, Piazzetta's drawings have been thought to be primarily of two or three kinds: the evocative portraits and studies of various characters in black and white chalks on toned paper (such as the others discussed here) and the meticulous illustrations made for engravings of such works as Tasso's *Gerusalemme Liberata* (many of them now in Bergamo; see Ruggeri, *Disegni Piazzetteschi*). There are also many sheets of academic nude studies by Piazzetta and his shop, but these, too, are chalk drawings of a very finished nature (see White and Sewter, *I Disegni di G. B. Piazzetta*).

There seemed to be no evidence of Piazzetta's rough compositional work for his monumental paintings until, in 1957, Terisio Pignatti identified a group of drawings as preliminary sketches by Piazzetta (see Pignatti, "Nuovi disegni del Piazzetta," *Critica d'arte* 4:395–403). Pignatti's research was substantiated by that of Rodolfo Pallucchini, who, though he had other views on the precise definition of this group, also underscored the importance of this kind of drawing within Piazzetta's work (see Pallucchini, "Altri disegni preparatori del Piazzetta," *Arte Veneta* 13–14:220–22; see Pallucchini, in Precerutti-Garberi, *Giambattista Piazzetta e L'Accademia* [pp. i–ii]).

These compositional drawings were executed either in chalk or in pen and ink, such as this recent addition to the group, a double-sided sheet apparently for an unknown altarpiece with Saint Sebastian, Saint Roch, and Saint Margaret of Cortona, according to its inscription. At least one drawing in each medium can be identified as a preparatory study for a known painting by Piazzetta: a red chalk drawing in the Corner (Inv. 7700; see Pignatti, "Nuovi disegni del Piazzetta," *Critica d'arte* 4:396–99, fig. 44) relates to an altarpiece for San Vidal, Venice, in the Museo Correr (see Pignatti, "Nuovi disegni del Piazzetta," *Critica d'arte* 4:396–99, fig. 43) and a pen and ink drawing in the Scholz collection (see Pignatti, *I Disegni veneziani del settecento,* no. 45, reproduced) is connected with the *Virgin and Child Appearing to Saints Urban, Gotthard, Philip, and James Minor* in Meduno (ca. 1739–44; see Pallucchini, "Opere tarde del Piazzetta," *Arte Veneta* 1:115, fig. 103). On the basis of a close stylistic resemblance to these drawings, others of this type have been attributed to the artist, although their links to known paintings by Piazzetta are less direct. Among these are two double-sided pen drawings very similar to ours, one in the Scholz collection (see Pignatti, "Nuovi disegni del Piazzetta," *Critica d'arte* 4:396–99, figs. 45–46) and the other recently acquired by the National Gallery of Art (B–26.782; see Bohlin in *Recent Acquisitions,* pp. 77–78, no. 36, reproduced).

Whereas the chalk drawing in the Correr has been dated about 1720 on the basis of its relationship to a painting of that date, scholars concur in dating the several pen studies to the late 1730s and 1740s.

There is no known altarpiece that corresponds precisely with our drawing, although it is a type that is very close to a number of Piazzetta's religious altarpieces. It has been suggested that it might represent a commission that was never carried out. The inscription has led to the assumption that such a commission might have been traceable to the canonization of Saint Margaret of Cortona as the patron saint of that city in 1728 (see C. G. Boerner, *Alte und neuere Graphik und Zeichnungen*, pp. 120–21, lot 121). If that supposition could be substantiated, this sheet would be the earliest known surviving example of a preparatory study by Piazzetta in pen and ink. From comparison with other examples of Piazzetta's handwriting that can be found, it seems probable that the inscription is in the artist's own hand (see Pallucchini, "Miscellanea Piazzetesca," *Arte Veneta* 22:130, fig. 188).

Gaspare Diziani
Belluno 1689–1767 Venice

109 *The Death of Saint Joseph* (pl. 118)

Inscribed recto, lower right, in pen and brown ink: *Gaspare Diziani Bellunese*.

Pen and black ink with brush and gray wash, over traces of graphite, on ivory laid paper; 284 x 172 mm.

WATERMARK: Letter *A* set within letter *V* (not in Briquet or Heawood).

COLLECTIONS: Unidentified Venetian, script (Lugt Suppl. 3005c–d) recto, lower right, in pen and brown ink; J. Fitchett Marsh, stamp (Lugt 1455) recto, lower right, in black; Coll. of Dr. Ridley, of / Croyden, Eng. Sotheby's / Sale, April 2, 1912, stamp (not in Lugt) verso, lower right, in purple; William F. E. Gurley, Chicago, stamp (not in Lugt) recto, lower left, in black; Leonora Hall Gurley Memorial Collection, stamp (Lugt Suppl. 1230b) verso, lower center, in black.

EXHIBITIONS: Bettagno, *Disegni di una collezione veneziana del settecento*, p. 75, no. 90, reproduced; Neilson, *Italian Drawings*, no. 59, reproduced.

Leonora Hall Gurley Memorial Collection, 1922.722

Gaspare Diziani was certainly one of the most prolific Venetian draftsmen of the eighteenth century, but by no means one of the most inspired. In fact, he was subject to many influences during the course of his life. Born and first trained in Belluno, he received further training in Venice after 1700. In the second decade, he traveled to Munich, Dresden, and Rome, and finally settled in Venice about 1730. Sebastiano Ricci (his teacher), Pellegrini, and Tiepolo each had a tremendous effect on Diziani's art during various periods of his life.

The attribution of this drawing, as well as the four other sheets in the Art Institute's collection (22.37a [no. 110], 22.37b, 22.38, and 22.723) is based on the inscription in the "reliable Venetian hand" (Lugt Suppl. 3005c–d; see Bettagno, *Disegni di una collezione veneziana del settecento*). That collector may have been Anton Maria Zanetti, and his attributions have been regarded by modern art historians with great respect. Whether or not this one is correct, it is possible to assume that their author was especially familiar with the artists active in the first half of the eighteenth century, like Diziani, for these attributions are unerring. But, even without such an aid, the broken and sparing lines and flickering light effects identify this drawing as a work by Diziani under the influence of his master, Sebastiano Ricci, characteristic of his drawings during the 1730s (Budapest 2372; see Fenyö, *Disegni veneti del Museo di Budapest*, p. 57, no. 78, reproduced; and Stockholm 1528/1863; see Bjurström, *Drawings from Stockholm*, p. 27, no. 41, reproduced).

Diziani treated the subject of the death of Saint Joseph several times during his career, and paintings of it can be found in Lavariano, Belluno, Treviso, and Beverly Hills (see Zugni-Tauro, *Gaspare Diziani*, pls. 25, 40–42), all dateable between 1730 and 1740. Although our altar-shaped drawing does not correspond precisely with any of these, it is closest to the Lavariano version in composition.

Gaspare Diziani
Belluno 1689–1767 Venice

110 *Bacchus and Ariadne* (pl. 117)

Inscribed recto, lower left, in pen and brown ink: *Gaspare Diziani Bellunese*.

Pen and brown ink with brush and brown wash, over graphite, on ivory laid paper; 251 x 153 mm.

COLLECTIONS: Unidentified Venetian, script (Lugt Suppl. 3005c–d) recto, lower right, in pen and brown ink; W. Bates, stamp (Lugt 2604) recto, lower right, in red; Bought Feb. 17, 1916 / Puttick & Simpson, stamp (not in Lugt) verso, at left, in purple; William F. E. Gurley, Chicago, stamp (not in Lugt) recto, lower right, and verso, lower center, in black; Leonora Hall Gurley Memorial Collection, stamp (Lugt Suppl. 1230b) verso, lower center, in black.

LITERATURE: Pignatti, *I Disegni veneziani del settecento*, pp. 162–63, fig. 33; Pignatti, *La Scuola veneta*, p. 84, pl. 25.

EXHIBITIONS: Bettagno, *Disegni di una collezione veneziana del settecento*, p. 74, no. 86, reproduced; Pignatti, *Venetian Drawings*, pp. 32–33, no. 58, reproduced.

Leonora Hall Gurley Memorial Collection, 1922.37a

The "reliable Venetian hand" is again responsible for the attribution of this drawing to Diziani, and it must surely rank among his most attractive graphic creations. The lyrical subject matter of the scene (which has been identified as the moment when Bacchus takes the foresaken Ariadne for his wife) is suited to the late Tiepolo-influenced style of Diziani's draftsmanship of the 1750s. It has compared with paintings of that era, such as *Omphale*, in the Sambon Collection, Paris (see Martini, *La Pittura veneziana del settecento*, fig. 174) and in the Palazzo Ricati frescoes (see Zugni-Tauro, *Gaspare Diziani*, pls. 81–82). It might also be compared with the paintings of *Hagar and Ishmael* (Paris, Collection Lepauze; see Zugni-Tauro, *Gaspare Diziani*, pl. 98), also of the late 1740s, or the paintings *Endymion and Selene* and *Pan and Syrinx* (whereabouts unknown; see Zugni-Tauro, *Gaspare Diziani*, pls. 151–52), dated 1750–55.

A comparable drawing of Hercules and Omphale in the Metropolitan Museum of Art (80.3.384), can be connected with a painting of that subject in Geneva (1912/475), also dated 1750–60 (see Bean and Stampfle, *Drawings from New York Collections*, vol. 3, p. 38, no. 50, reproduced; see Zugni-Tauro, *Gaspare Diziani*, pp. 75–76, pls. 245–46, 352).

Giovanni Domenico Ferretti (da Imola)
Florence ca. 1692–ca. 1769

111 *The Holy Ghost and Angels* (pl. 119)

Brush and gray wash, over black chalk, on white paper; 260 x 210 mm.
COLLECTIONS: William F. E. Gurley, Chicago, stamp (not in Lugt) recto, lower right, in black.
LITERATURE: Maser, *Gian Domenico Ferretti*, no. 151, reproduced.

Leonora Hall Gurley Memorial Collection, 1922.767

Edward A. Maser has provided the following commentary:

The most outstanding painter of Florence during the first half of the eighteenth century was Giovanni Domenico Ferretti. Born in Florence in 1692, and educated there and in Bologna, he became, fairly early in his career, one of the most prolific painters, primarily in fresco, of his native city. Not only Florence,

but all of Tuscany can boast of examples of his vigorous and masculine style. Unlike the followers of the "Cortonesque" or the "Giordanesque" trends in Florentine painting in the early part of the century, Ferretti revived in his carefully drawn and plastically modelled painting the great Florentine tradition of draftsmanship that had fallen into neglect during the preceding century.

This drawing, representing the Dove of the Holy Ghost being adored by angels, is undoubtedly a preparatory drawing for an Annunciation to the Virgin: the angel on the left is probably the Archangel Gabriel. It is a prime example of Ferretti's mature style, when he had already become an important member of the Florentine Accademia del Disegno and teacher of its life drawing class. His light and fluid stokes of pencil indicate with economy and security the rather massive forms of the angels and putti, forms that can be considered Ferretti's trademark. The pale washes, sparingly but effectively used, further accentuate the three-dimensionality toward which Ferretti strove throughout his career. Considered in comparison with other major drawings by this artist, chiefly those in the collections of the Uffizi Galleries in Florence and the Musée Wicar in Lille, this example can clearly be seen to represent the best period of the artist's production, that during the third and fourth decades of the eighteenth century.

Giovanni Battista Tiepolo
Venice 1696–1770 Madrid

112 *The Meeting of Abraham and Melchizedek,* or *Moses Receiving the Offerings of the Princes* (pl. 120)

Inscribed recto, lower right, in graphite: *Tiepolo Ven. | in e del.*
Pen and brown ink with brush and brown and gray washes, over black chalk, on ivory laid paper; 370 x 510 mm.
COLLECTIONS: J. Gulston(?), script (Lugt 2986) verso, lower left, in graphite; Bühnemann, Munich; acquired from Jacques Seligmann & Co., New York.
LITERATURE: Pignatti, "Tiepolo incisore e disegnatore," *La Fiera letteraria*, June 17, 1951, n. 11; Benesch, "Marginalien zur Tiepolo-Ausstellung in Venedig," *Alte und neue Kunst* 1:67; Ragghianti, *Tiepolo*, p. 26, no. 11; Joachim, "A Tiepolo Drawing," *Art Institute of Chicago Quarterly* 53:23–25, reproduced; Knox, *Catalogue of the Tiepolo Drawings in the Victoria and Albert Museum*, pp. 10, 38, n. 18; Pignatti, "The Exhibition of Tiepolo Drawings at Udine," *Master Drawings* 4:307–8, n. 8; Morassi, "Sui disegni del Tiepolo nelle recenti mostre di Cambridge, Mass. e di Stoccarda," *Arte Veneta* 24:296; Muraro, *Richerche su Tiepolo Giovane*, p. 26 (cited by Pignatti); Vigni, *Disegni del Tiepolo*, p. 34; Pignatti, *Tiepolo, disegni*, no. 6, pl. 6.
EXHIBITIONS: Pignatti, "Disegni di G. B. Tiepolo," in Lorenzetti, *Mostra del Tiepolo*, no. 11; *Master Drawings from the Art*

Institute of Chicago, no. 14; Rizzi, *Disegni del Tiepolo*, no. 2, reproduced (not exhibited); Knox, *Tiepolo: A Bicentenary Exhibition*, no. 3, reproduced.

Given in Memory of Carl O. Schniewind, 1958.554

Giovanni Battista (or Giambattista) Tiepolo produced a vast graphic work over the course of his long and illustrious artistic career, and his role as the greatest decorative artist of the Venetian Rococo has a more intimate parallel in the light and spontaneous drawings he created. Though comparatively small in number, the Art Institute's group of Tiepolo drawings derives considerable importance from the fact that it illustrates at least five crucial phases of the artist's evolution, from the formative period, in the 1720s, when he was travelling in the north of Italy, open to the influence of Piazzetta and Sebastiano Ricci as well as the decorations of Paolo Veronese, through the period of his great decorations in Venice, Würzburg (ca. 1750–53, and Spain (1762–70).

Earliest of the group is the magnificent sheet formerly called the *Meeting of Abraham and Melchizedek* but recently named by George Knox *Moses Receiving the Offering of the Princes*. Once tentatively assigned to the artist's son Domenico, this drawing was first identified by Antonio Morassi as a youthful work of Giambattista (see Pignatti, in Lorenzetti, *Mostra del Tiepolo*, no. 11). Quite possibly it is the earliest completed large-scale drawing by the artist. The great concept of the drawing is beyond dispute, yet there are signs pointing to a considerable struggle in the final shaping of the composition. There is extensive underdrawing in black chalk beneath the work in pen and wash. Human figures can be discerned where the altar now stands, the tall figure of the shepherd(?) in the left foreground was originally placed near the right edge, and the head of Moses was less sharply inclined, to name but a few elements not visible in the reproduction. The wash is rigidly contained within carefully defined boundaries, and there is little gradation of tonality. This is a curiously primitive beginning for an artist who later was to reach the highest degree of sophistication in handling the medium. But even here the wash is very effective in suggesting volume, space, and dazzling sunlight.

The general scheme of the composition is not unlike the Udine fresco, *Rachel Hiding the Idols*, of 1725–26. However, the various moments of hesitation in the drawing suggest that it may have preceded the fresco by several years. Knox suggests a date about 1719; Rizzi prefers to place it in 1722–25. The closest relative in style to our drawing is the even larger, unfinished study

in Innsbruck for *The Crucifixion* in Burano (see Rizzi, *Disegni del Tiepolo*, pp. 49–50, no. 1, reproduced).

Giovanni Battista Tiepolo
Venice 1696–1770 Madrid

113 *Three Angels Appearing to Abraham* (pl. 121)

Pen and brown ink with brush and brown and gray wash, over graphite, on ivory laid paper; maximum 432 x 286 mm.

COLLECTIONS: Unidentified stamp (not in Lugt) recto, lower center, in red; Vicomte Jacques de Canson; Germain Seligman, stamp (not in Lugt) verso, lower right, in black; acquired from Jacques Seligmann & Co., New York.

LITERATURE: Pallucchini, *Giambattista Tiepolo*, no. 15 (cited by Pignatti).

EXHIBITIONS: Joachim, *A Quarter Century of Collecting*, no. 16, reproduced; Pignatti, *Venetian Drawings*, pp. 35–36, no. 66, reproduced.

Margaret Day Blake Collection, 1970.41

A long step toward greater freedom in handling pen and wash was made in Giambattista's evocative sheet *Three Angels Appearing to Abraham*. Not only does the pen line show a more dynamic rhythmic sweep, but the washes in gray and deep brown with their impatient zigzag pattern take an active part in the dramatic excitement of the whole composition. Again, there is prepatory work, this time in graphite. The head of the angel at right was differently placed, and there was an angel's wing where we now see the dramatically raised arm of the center angel.

Perhaps it is not merely accidental that the knobby soles of Abraham's feet strongly resemble those of a kneeling apostle in both Schongauer's and Dürer's *Death of the Virgin*. Northern prints most certainly were known in Venice.

In 1725–26, Tiepolo painted this subject in the archbishop's palace in Udine in a calmer and more lyrical manner. Perhaps it would be safe to assume that our drawing originated a few years later, possibly in 1728–30. Closest in style and technique to our sheet are the drawings *Apollo, the Muses, and Chronos* in the Museo Civico in Trieste (see Rizzi, *Disegni del Tiepolo*, pp. 64–65, no. 19, reproduced) and *Roman Sacrifice* in the Fogg Art Museum (see Knox, *Tiepolo: A Bicentenary Exhibition*, no. 7, reproduced). The latter is dated about 1728 by Knox and this date might well apply to the drawing in Chicago, too.

In his last years in Madrid, Tiepolo returned to the basic elements of our drawing, but in a looser and more spacious composition, in a painting in the collection of

the Duke of Luna-Villahermosa in Madrid (see Morassi, *A Complete Catalogue of . . . G. B. Tiepolo*, p.22, fig. 3).

Giovanni Battista Tiepolo
Venice 1696–1770 Madrid

114 *The Temptation of Saint Anthony* (pl. 122)

Inscribed verso, along bottom edge, in pen and brown ink: *vdi 4 Marzo 1760 Venezia | dal Sig^r Davide Ant^o Fosati o riceputo io Pietro Monaco | zecchini tre e questo per pagamento del Presente | disegno originale de Sig^r Gio. Batta. Tiepolo al 260.*

Pen and brown ink with brush and brown wash, heightened with white gouache, over black chalk, on ivory laid paper; 402 x 250 mm.

WATERMARK: Three crescents (similar to Heawood 865).

COLLECTIONS: Pietro Monaco; Davide Antonio Fosati; Galerie Pardo, Paris; Leo Franklyn, London; acquired from Charles Slatkin Galleries, New York.

LITERATURE: Knox, "A Group of Tiepolo Drawings Owned and Engraved by Pietro Monaco," *Master Drawings* 3:389–97, reproduced; Joachim, *Helen Regenstein Collection*, pp. 28–29, no. 13, reproduced.

EXHIBITIONS: Knox, *Tiepolo:A Bicentenary Exhibition*, no. 11, reproduced.

Helen Regenstein Collection, 1964.347

The Tempatation of St. Anthony is a drawing of an altogether different type; it is carried to such a degree of finish that it must have been intended as a presentation piece or as a model for an engraving. It is one of eight drawings by Giambattista which were owned and engraved by Pietro Monaco (1707–72), who established himself as a portrait engraver in Venice about 1732. On the back of the sheet, an inscription (see above) testifies that on March 4, 1760, Pietro Monaco received 3 zecchini from Davide Antonio Fosati in payment for this original drawing by Giovanni Battista Tiepolo, thus confirming the history of the sheet (this inscription and the engraving by Monaco are reproduced in Knox, "A Group of Tiepolo Drawings Owned and Engraved by Pietro Monaco," *Master Drawings* 3:389–97).

The drawing is rich in subtle gradations of the wash, ranging from the lightest gray-brown to a deep black-brown. The crowded composition has an almost northern Gothic flavor. The interplay of expressive hands and the face of the snub-nosed urchin devil are once again reminiscent of Schongauer and Dürer prints.

Knox dates the majority of the so-called Monaco drawings between 1725 and 1732, but for this particular drawing he suggested a date of about 1734. Because of the tightness of the composition, which leaves practically no blank paper, an earlier date, such as about 1730, seems more plausible.

Giovanni Battista Tiepolo
Venice 1696–1770 Madrid

115 *Two Monks Contemplating a Skull* (pl. 124)

Pen and brown ink with brush and brown wash, over traces of graphite, on ivory laid paper; laid down; maximum 437 x 297 mm.

COLLECTIONS: Prince Alexis Orloff, sale: Paris, Galerie Georges Petit, April 29–30, 1920, no. 153, reproduced; Vicomte Bernard d'Hendecourt, sale: London, Sotheby's, May 9, 1929, no. 2; acquired from Durlacher Bros., New York.

LITERATURE: Rich, "A Drawing by Tiepolo," *Bulletin of the Art Institute of Chicago* 25:90–91, reproduced; Knox, "The Orloff Album of Tiepolo Drawings," *Burlington Magazine* 103:269–75.

EXHIBITIONS: *Catalogue of a Century of Progress*, p. 87, no. 821; Rich, *Loan Exhibition of . . . Tiepolos*, no. 55.

Gift of the Print and Drawing Club, 1931.454

The extreme economy of means and the judicious use of blank paper set this drawing aside from the elaborate compositions of the three preceding drawings. The feeling of a desert could not be more strongly suggested than it is here by the almost oppressive emptiness of the sheet.

It should not escape our attention that, at times, Tiepolo appears to have enjoyed drawing on slightly creased papers, which make pen and brush skip, thereby heightening the desired effect of debility and decay; in this case, the crease goes right through the head of the monk at the left, which adds another eerie element to the drawing.

The drawing comes from the famous Orloff album, where it was numbered 153. Knox has dated it about 1725–35. We are inclined to place it toward the end of that period.

Giovanni Battista Tiepolo
Venice 1696–1770 Madrid

116 *Fantasy on the Death of Seneca* (pl. 123)

Pen and brown ink with brush and brown wash, over black chalk, on white laid paper; 340 x 240 mm.

COLLECTIONS: Gustave Deloye, stamp (Lugt 756) recto, lower right, in brown, sale: Paris, June 12–15, 1899, no. 132; Ferdinand Roybet, sale, Paris: Hôtel Drouot, Dec. 14–16, 1920, no. 25; Lucien Guirauld, sale: Paris, Hôtel Drouot, June 14–16, 1956, no. 68, reproduced; acquired from M. Knoedler & Co., New York.

LITERATURE: Joachim, "A Late Tiepolo Drawing," *Art Institute of Chicago Quarterly* 54:18–19, reproduced; Joachim, *Helen Regenstein Collection*, pp. 30–31, no. 14, reproduced.

EXHIBITIONS: *Tiepolo et Guardi*, no. 22, reproduced; *Master Drawings from the Art Institute of Chicago*, no. 16, pl. 9; Knox, *Tiepolo:A Bicentenary Exhibition*, no. 16, reproduced.

Helen Regenstein Collection, 1959.36

The *Fantasy on the Death of Seneca* is by no means an historically accurate description of the great philosopher's suicide, which was ordered by Nero. It is rather an evocation of that episode, very much in the spirit of Tiepolo's set of etchings, the *Scherzi di fantasia* of the 1740s, typical of Tiepolo in its mixture of a tragic and whimsical masquerade, and the drawing probably belongs to that period or slightly earlier; Knox dates it 1735–40. The brilliant luminosity of the wash, the effective distribution of accents, and the economy of means show the artist at his full maturity. As with the *Two Monks Contemplating a Skull*, Tiepolo has utilized a slightly creased paper to heighten the combined effects of fantasy and tragedy and to enhance further the dazzling luminosity of the scene.

Giovanni Battista Tiepolo
Venice 1696–1770 Madrid

117 *Punchinellos' Repast* (pl. 125)

Pen and brown ink with brush and brown wash, over graphite, on ivory laid paper; 196 x 230 mm.

COLLECTIONS: Italico Brass, Venice; acquired from E. V. Thaw & Co., New York.

LITERATURE: Rizzi, *Disegni del Tiepolo*, p. 82, no. 48, reproduced; Joachim, *Helen Regenstein Collection*, pp. 32–33, no. 15, reproduced.

Helen Regenstein Collection, 1972.108

Punchinello, the popular character of the commedia dell'arte, occurs in at least eighteen drawings by Giambattista (see Knox, *Tiepolo: A Bicentenary Exhibition*, no. 84). His son Domenico, however, devoted a series of well over one hundred large drawings to this subject. The drawings by the father are much less ambitious compositions, but they are no less effective and witty because of their conciseness.

The drawing in Chicago shows a group of Punchinelli having a repast of soup, and the artist deliberately obscured the issue of how many persons are involved. A central figure between the two groups is outlined in graphite, but not carried out in pen and wash.

There is little agreement among Tiepolo scholars about the date of these drawings. We think that, on account of the still relatively firm outlines, our drawing could not be much later than the 1740s or early 1750s. Similar sheets can be found in the Courtauld Institute, London (Witt inv. no. 2475); the Fondazione Giorgio Cini, Venice; the H. Shickman Gallery, New York; E. V. Thaw and Company, New York; and other collections.

Giovanni Battista Tiepolo
Venice 1696–1770 Madrid

118 *Caricature of a Man, Full Length, Facing Left* (pl. 127)

Pen and brown ink with brush and brown wash, on ivory laid paper; 224 x 149 mm.; verso: Madonna and Child, in red chalk.

COLLECTIONS: Arthur Kay, Edinburgh, sale: London, Christie's, April 9, 1943; Arcade Gallery, London(?); acquired from Koetser Gallery, New York.

LITERATURE: Pignatti, *I Disegni veneziani del settecento*, p. 182, pl. 69; Held and Posner, *Seventeenth and Eighteenth Century Art*, p. 344, fig. 356.

EXHIBITIONS: *Caricature and Its Role in Graphic Satire*, pp. 30, 75, no. 36, reproduced.

Samuel P. Avery Fund, 1944.173

The mode of caricature developed by the Carracci and their circle in seventeenth-century Bologna and Rome was highly popular in eighteenth-century Venice. It was particularly suited to the wit and spontaneous, evocative draftsmanship of Giambattista Tiepolo; one hundred and six such sheets by Tiepolo have survived in an album entitled *Tomo Terzo di Caricature*, which, according to Knox, should be dated 1754–62.

The freedom of handling and the dazzling light effects make these sheets typical examples of Tiepolo's late style. On the reverse side of this sheet is a fragment of a drawing of what is probably a *Madonna and Child*, in red chalk. It is undoubtedly by Giambattista's own hand and suggests the character of such late drawings as his *Rest on the Flight into Egypt*.

Giovanni Battista Tiepolo
Venice 1696–1770 Madrid

119 *Caricature of a Man, Full Length, Facing Front* (pl. 126)

Pen and brown ink with brush and brown wash, on ivory laid paper; 196 x 134 mm.

COLLECTIONS: Arthur Kay, Edinburgh, sale: London, Christie's, April 9, 1943; Arcade Gallery, London(?); acquired from Koetser Gallery, New York.

Samuel P. Avery Fund, 1944.174

The specific quality of caricature is less evident in the figure seen from the front, but the sovereign handling of pen and wash links it with the entire series. Other examples of such caricatures are in the Metropolitan Museum of Art, the Museum of Trieste, the Castello of Milan, and the Princeton Museum of Art (see Pignatti, *I Disegni veneziani del settecento*, p. 182).

Giovanni Battista Tiepolo
Venice 1696–1770 Madrid

120 *Rest on the Flight into Egypt* (pl. 128)

Pen and brown ink with brush and gray wash, over black chalk, on ivory laid paper; 284 x 204 mm.

COLLECTIONS: Edward Cheney(?), sale: London, Sotheby's, May 5, 1885; Alessandro Contini, Rome; Mrs. D. Kilvert, New York; acquired from Rosenberg & Stiebel, New York.
LITERATURE: Ojetti, *Il settecento italiano*, vol. 1, pl. 192, fig. 289; Joachim, *Helen Regenstein Collection*, pp. 34–35, no. 16, reproduced.

Helen Regenstein Collection, 1968.311

Tiepolo was engaged with the subject of the flight into Egypt at various periods of his life. The earlier set, mainly large compositions, usually with boatmen and animals, can be dated about 1735–40, and drawings of much smaller sizes and less elaborate compositions may be dated about 1760, These delightful drawings represent the last phase of his drawing style, when all nonessential details are omitted and forms are suggested rather than articulated. As Knox says of the drawing *The Virgin and Child and the Young Saint John*, in the collection of Mr. and Mrs. Jacob M. Kaplan, New York (see Knox, *Tiepolo Exhibition*, no. 89, reproduced), "They float on the page like exquisite arabesques, a marvellous monument to Giambattista's talent and virtuosity as a draughtsman."

Giovanni Battista Tiepolo?
Venice 1696–1770 Madrid

121 *Study of a Hand* (pl. 130)

Red chalk heightened with white chalk, on blue laid paper; maximum 190 x 196 mm.

WATERMARK: Undecipherable (cupid?).
COLLECTIONS: C. M. Metz(?), script (Lugt Suppl. 598b) verso, lower left, in pen and brown ink; Dr. H. Wendland, Lugano (according to Ball); acquired from A. & R. Ball, New York.

Simeon B. Williams Fund, 1942.455

Until recent years red chalk drawings heightened with white on blue paper of this type were attributed to Giambattista Tiepolo without hesitation, but it is now believed that many of them, for example, those in the album in the Museo Correr, should be distributed among Giambattista and his two sons Domenico and Lorenzo. Thus, the four sheets in Chicago can no longer be assigned unequivocally to Giambattista; an exception might be the *Study of a Hand*, which shows a remark-

able freedom of draftsmanship characteristic of the father's masterly style.

Giovanni Battista Tiepolo?
Venice 1696–1770 Madrid

122 *Head of a Boy with a Turban* (pl. 129)

Red chalk heightened with white chalk, on blue laid paper; 276 x 210 mm.

COLLECTIONS: Dr. H. Wendland, Lugano (according to Ball); acquired from A. & R. Ball, New York.
LITERATURE: Benesch, *Venetian Drawings*, p. 33, no. 32, reproduced.
EXHIBITIONS: Schniewind, *Drawings Old and New*, p. 25, no. 51, pl. 4; *Master Drawings from the Art Institute of Chicago*, no. 15.

Simeon B. Williams Fund, 1942.453

The *Head of a Boy with a Turban*, which is somewhat trimmed on all sides, has a quality of dashing outlines and broad handling that suggests the hand of Giambattista.

Giovanni Domenico Tiepolo?
Venice 1727–1804

123 *Diana Seated* (pl. 132)

Red chalk heightened with white chalk, on blue laid paper; maximum 178 x 237 mm.; verso: angel's head, in red chalk.

COLLECTIONS: C. M. Metz(?), script (Lugt Suppl. 598b) verso, lower left, in pen and brown ink; Dr. H. Wendland, Lugano (according to Ball); acquired from A. &. R. Ball, New York.
LITERATURE: Benesch, *Venetian Drawings*, p. 33, no. 31, reproduced.

Simeon B. Williams Fund, 1942.454

Diana Seated occurs on the ceiling of the *Glorification of Prince-Bishop Carl Phillipp von Greiffenklau* in the grand stairway of the Würzburg residence, which was carried out in the 1750s. However, the somewhat nervous and jagged character of line seems to indicate the hand of Domenico.

Giovanni Domenico Tiepolo?
Venice 1727–1804

124 *Angel Holding a Book* (pl. 131)

Red chalk heightened with white chalk, on blue laid paper; 253 x 193 mm.

COLLECTIONS: Dr. H. Wendland, Lugano (according to Ball); acquired from A. & R. Ball, New York.

LITERATURE: Benesch, *Venetian Drawings*, p. 33, no. 33, reproduced.

EXHIBITIONS: Schniewind, *Drawings Old and New*, p. 25, pl. 4; *Catalogue of the Carl O. Schniewind Memorial Exhibition*, no. 32; Farmer, *The Tiepolos: Painters to Princes and Prelates*, pp. 122–23, no. 124, reproduced.

Simeon B. Williams Fund, 1942.456

The *Angel Holding a Book* can be found in a modello for the *Last Judgement* in a private collection in Intra, Lago Maggiore (see Morassi, *A Complete Catalogue of the Paintings of G. B. Tiepolo*, fig. 222), but here again, the brittleness of line points to Domenico rather than Giambattista. George Knox sees a relationship of this drawing with the two angels blowing trumpets in the Museum of Fine Arts, Boston, which he dates about 1750 (acc. nos. 95.1395 and 95.1397; see Knox, *Tiepolo: A Bicentenary Exhibition*, pp. 52–53).

Antonio Canal (Canaletto)
Venice 1697–1768

125 *A Bridge near a Church in Venice* (pl. 135)

Inscribed recto, upper right, in pen and brown ink: *Capitano agiunte allo Stato Maggiore*[?].

Pen and brown ink and graphite, on ivory laid paper; 140 x 193 mm.; verso: architectural studies, in pen and brown ink and graphite.

COLLECTIONS: Acquired from Adolphe Stein.

Worcester Sketch Fund, 1976.424

Antonio Canal (called Canaletto) established a popular genre of city views, or *vedute*, with subjects drawn from his native Venice and also drawn from one or more visits to Rome. A limited number of rapid sketches such as this survive today as examples of Canaletto's first thoughts for more finished drawings, paintings, and etchings. Such hasty sketches of actual sites in Venice must have been drawn on the spot; it has not been possible to link this with any finished composition.

Stylistically, this small sheet compares with a sketch of *The Molo: The Old Fish Market*, in the Philadelphia Museum of Art, dated about 1720 (see Constable, *Canaletto* [2d ed.], vol. 1, no. 568, pl. 103; vol. 2, p. 499; or Constable, *Canaletto*, 1964, p. 51, no. 14, reproduced). The inscription, which identifies it as a chapter house adjoining the general staff building, is in Canaletto's own hand (see Constable, *Canaletto* [2d ed.] vol. 1, pl. 1).

Antonio Canal (Canaletto)
Venice 1697–1768

126 *Capriccio: A Street Crossed by Arches* (pl. 133)

Inscribed verso, lower right, in pen and brown ink: *A present from Sig. Canale / commonly called Canaletto.*

Pen and brown ink with brush and gray wash, over graphite, on ivory laid paper; 294 x 210 mm.; verso: sketch for doorway, staircase, and second floor of building.

WATERMARK: Bird in profile (not in Heawood or Briquet).

COLLECTIONS: J. MacGowan, stamp (Lugt 1496) verso, upper left, in black; Count Seilern (1942, according to Constable); Art Institute of Chicago, stamp (Lugt Suppl. 32b) verso, lower left, in brown.

LITERATURE: Benesch, *Venetian Drawings*, p. 37, no. 50, reproduced; Constable, *Canaletto* vol. 1, no. 845, pl. 160; vol. 2, p. 566 (p. 618 in 2d ed.); Ames, *Drawings of the Masters*, p. 29, reproduced.

EXHIBITIONS: Schiewind, *Drawings Old and New*, p. 10, no. 7, pl. 1; *Master Drawings from the Art Institute of Chicago*, no. 17, pl. 8; Constable, *Canaletto*, 1964, p. 99, no. 79, reproduced.

Samuel P. Avery Fund, 1943.514

In contrast to the preceding rapid sketch, Canaletto made many finished drawings with pen and wash, either for presentation or for sale. Sometimes they depict an actual scene, but just as often they are fantasies (or *capricci*). This drawing may be based on reminiscenses of the little town of Chioggia.

Benesch connected this sheet with a drawing in the Scholz collection, once owned by Seilern and MacGowan, with a similar inscription: *Canaletto presented me be I. Hayes;* he presumed that they were companion pieces (see Benesch, *Venetian Drawings*, p. 37, no. 51, reproduced), but there is little to support such a theory. Both drawings are executed in a particularly loose, broad, and cursive pen stroke, perhaps indicative of a later period.

There is a slightly larger, early copy of this drawing in Sir John Soanes's museum, London (395 x 292 mm.), noted by Constable.

Antonio Canal (Canaletto)
Venice 1697–1768

127 *Capriccio: A Ruined Classical Temple* (pl. 136)

Pen and brown ink with brush and gray wash, over graphite, on ivory laid paper; 292 x 205 mm.; verso: architectural details, archway and two floors of building.

COLLECTIONS: Contessa Rosa Piatti-Lochis, stamp (Lugt Suppl. 2026c) recto, bottom edge, right of center in violet (faded);

F. Asta, stamp (Lugt Suppl. 116a) recto, lower right, in blue; 80, unidentified stamp (not in Lugt) recto, lower right, in black; acquired from Alfred Strolin.

LITERATURE: Constable, *Canaletto* vol. 1, pl. 153, no. 812; vol. 2, p. 555 (p. 604 in 2d ed.).

Mrs. Potter Palmer Memorial Fund, 1957.328

With the impact of the War of the Austrian Succession on Italy in the early 1740s, there was a great reduction in English tourism in Venice and thus a reduced market for the *vedute* that were Canaletto's specialty. It was probably at this time that Canaletto turned to more fanciful landscape subjects, creating *capricci* of ruined buildings or juxtaposing physically removed architectural elements within the same scene.

The drawing *Capriccio: A Ruined Classical Temple* surely dates from this period, and typically the Roman or Greek character of the temple is set against a more exotic Venetian setting, with an obelisk, a Venetian house, and a domed church.

This drawing and other similar pieces indicate that Canaletto traveled to Rome, but the actual visits are difficult to document. It is likely that he went south in about 1715–20; moreover, because of the lack of any records of Canaletto's presence in Venice and the preponderance of Roman-inspired works in those years, it has been suggested by some that he must have returned to Rome in the 1740s.

Whether Canaletto went to Rome or not, the fanciful combination of elements in this scene does not depend on a direct Roman experience; Constable has even suggested that it might be based on a drawing or engraving of a Greek temple. The free calligraphic style of the drawing and the application of layered washes suggests a date later than the previous work, in the 1740s.

Giovanni Antonio Guardi
Venice 1699–1760

128 *Il Ridotto* (pl. 134)

Inscribed verso, in pen and brown(?) ink (now visible only under ultraviolet light): *Ant. Guardi.*

Pen and brown ink with brush and brown wash, over black chalk, on ivory laid paper; 295 x 516 mm.

COLLECTIONS: Gustavo Frizzoni (according to Simonson); Paul von Schwabach, Berlin; acquired from Durlacher Bros., New York.

LITERATURE: Frizzoni, "Miscellanea: Notizie di Germania," *L'Arte* 5:340–46; Simonson, "La Mascherata al Ridotto in Venezia di Francesco Guardi," *L'Arte* 10:241–46; Voss, "Studien zur venezianischen Vedutenmalerei des 18. Jahrhunderts, "*Repor-torium für Kunstwissenschaft* 47:42, 45, pl. 20; Modigliani, "Ancora sul 'Ridotto' di Giovanni Antonio Guardi al Museo Correr," *Dedalo* 7:438–42, reproduced; Byam Shaw, "Some Venetian Draughtsmen of the Eighteenth Century," *Old Master Drawings* 7:48, n. 2; Lasareff, "Francesco and Antonio Guardi," *Burlington Magazine* 65:53–72; Pallucchini, *I Disegni del Guardi*, p. 15; Arslan, "Per la definizione dell'arte di Francesco, Giannantonio e Niccolò Guardi," *Emporium* 100:2–28; Benesch, *Venetian Drawings*, pp. 38–39, no. 56, reproduced; Tietze, *European Master Drawings*, p. 190, no. 95, reproduced; Pallucchini, "Disegni veneziani del settecento in America," *Arte Veneta* 2:157–58; Byam Shaw, *Drawings of Francesco Guardi*, pp. 43–44, 47; Morassi, "Conclusioni su Antonio e Francesco Guardi," *Emporium* 94:202; Moschini, *Francesco Guardi*, pp. 9–10, fig. 5; Morassi, "A Signed Drawing by Antonio Guardi and the Problem of the Guardi Brothers," *Burlington Magazine* 95:263, n. 1, 264; Pignatti, "Un Disegno di Antonio Guardi donato al Museo Correr," *Bolletino dei Musei Civici Veneziani* 1–2:23, 29, no. 5; Taubes, "Guardi and the Romantic Spirit," *American Artist* 21:39, reproduced; cf. Pignatti, *Il Museo Correr*, p. 96; cf. Dobroklonsky, *Drawings of the Italian School*, no. 206; cf. Salmina, *Disegni veneti del Museo di Leningrado*, no. 74; Pallucchini, "Note alla Mostra dei Guardi," *Arte Veneta* 19:223–24; Cailleux, "Les Guardi et Pietro Longhi," *Problemi Guardeschi*, pp. 51–54; Pignatti, *Disegni dei Guardi*, p. 9, pl. 16; Morassi, *Guardi*, vol. 1, pp. 351–52, no. 233; vol. 2, fig. 253; Morassi, *Guardi: Tutti i disegni*, pp. 18–19, 89–90, no. 56, fig. 50; Binion, *Antonio and Francesco Guardi*, pp. 232–34, no. 88, 408, fig. 113.

EXHIBITIONS: Schniewind, *Drawings Old and New*, p. 18, no. 29, pl. 3; Richardson, *Venice, 1700–1800*, p. 36, no. 41; Kelleher and Taggart, "The Century of Mozart," *Nelson Gallery–Atkins Museum Bulletin* 1:36, 63, no. 142, fig. 27; Rearick, *Eighteenth Century Italian Drawings*, no. 33, pl. 15; *Master Drawings from the Art Institute of Chicago*, no. 18; Zampetti, *Mostra dei Guardi*, pp. xxxviii, 303, 309, no. 9, reproduced; Joachim, *A Quarter Century of Collecting*, no. 17, reproduced; Pignatti, *Venetian Drawings*, pp. 30–31, no. 54, reproduced.

Margaret Day Blake Collection, 1944.579

The works of Antonio Guardi and his more famous younger brother Francesco Guardi, have frequently been confused. This sheet is one of the critical pieces in the Guardi brothers controversy, and it is also one of the most often published drawings in the collection. It is especially important and complex, for it is related to a painting of the same subject assigned by some scholars to Pietro Longhi and by others (such as Frizzoni, Berenson, and Fiocco) to Francesco Guardi. It shows the *camera lunga* of the Ridotto, a famous public gambling house opened in Venice in 1638 by Marco Dandolo. Only patricians were allowed in the gambling house unmasked.

This double-sided drawing was first fully published by Herman Voss in 1926, who attributed it and its related painting in the Ca'Rezzonico to Antonio Guardi on the basis of the signature on the back of the sheet (now visible only under ultraviolet light), and his attribution was affirmed in the same year by E. Modigliani. In 1933, Byam Shaw pointed out that this signature

was not authentic when compared with a signed and dated drawing of a *Farm Boy* in Venice (see Pignatti, "Un Disegno Di Antonio Guardi donato al Museo Correr," *Bollettino dei Musei Civici Veneziani* 1–2:22, fig. 21), and again raised the possibility of Francesco's collaboration in the execution of the painting. Pallucchini and Schniewind, however, vigorously supported the attribution of this drawing to Antonio, which was maintained by Benesch and Tietze in 1947, though not without reservations.

In 1957, Pignatti put forth the opinion that the drawing was not preparatory for the painting, but derived from it, an opinion repeated by Zampetti in the Mostra dei Guardi of 1965, an exhibition that further supported the attribution of the painting (and others related to it) to Francesco (see Zampetti, *Mostra dei Guardi*, nos. 23–25). Based on such a situation, Pignatti deduced that the painting was created in about 1750, when there was the greatest overlap between the brothers, and Antonio's *ricordo* of the painting in his mind confirms that both were the product of a common shop.

In his recent catalogues raisonnés of the paintings and drawings of the Guardi, Morassi has attributed the painting to Francesco and the drawing to Antonio, but he has postulated that the drawing served as a *modello* for, not a *ricordo* of the painting. At the same time, however, Pignatti proposed a few basic assumptions about the drawing: the authorship of the drawing does not depend on that of the painting and the composition of the *Ridotto* may not be by either Antonio or Francesco but could have originated with the slightly older Pietro Longhi, who made numerous versions of it. Pignatti concludes that Antonio made his drawing after some lost model, for the use of the Guardi workshop, and that Francesco used it when painting the Ca'Rezzonico canvas.

Pietro Bracci
Rome 1700–1773

129 *Project for the Tomb of James III, the Old Pretender* (pl. 137)

Inscribed recto, lower left, in pen and brown ink: *Pet. Bracci Inv. et Deli / Palmi* and numbered grid; inscribed recto, lower right, in pen and brown ink: *Trenta*.
 Pen and brown ink with brush and brown and blue washes, heightened with gouache, over traces of graphite, on tan tinted paper; squared in graphite; 375 x 250 mm.
 COLLECTIONS: The artist's family (according to Pini di San Miniato); acquired from Count Arturo di San Miniato.

EXHIBITIONS: Joachim, *A Quarter Century of Collecting*, no. 18, reproduced; Broeder, *Rome in the Eighteenth Century*, pp. 71–72, no. 61, fig. 17.
Gift of Margaret Day Blake in Memory of Robert Allerton, 1966.353

When the Old Pretender to the English throne, the so-called James III, of the Stuart family, died in 1766, there was a proposal for a tomb to be placed across the aisle from that of his wife Maria Clementina Sobieski (died 1734), in Saint Peter's in Rome. Pietro Bracci, who had made the sculpture for her tomb, was also to have worked on that of James III. Although Bracci's monument was never erected, there are at least five extant drawings connected with it, all formerly in the Bracci family collection. These drawings, described by Kurt von Domarus in his monograph on Bracci (see von Domarus, *Pietro Bracci*, pp. 62–63), are alternative ideas for the elaborately regal monument. The Art Institute drawing, which came from a descendant of the sculptor, may well be the fourth one mentioned by von Damarus.

James sits with a scepter in his right hand in the guise of a Roman emperor. The allegorical figures represented are Courage bearing a shield at left and Truth with a mirror at right. The lion at the base, an attribute of Courage, may here represent the lion of England. The helmet and arms resting on the tomb and the sword at his right portray James in the role of a warrior fallen in battle. This representation is appropriate for the man who was a distinguished soldier in the French army and whose hopes to restore a Catholic monarchy in England were shattered by several unsuccessful campaigns.

In pose and form the figures are similar to earlier sepulchral monuments by Bracci. Courage reiterates the same figure in the monument to Leo XI and Truth is stylistically close to Innocence on the monument to Benedict XII. The rather squat and strongly modeled forms are also typical of Bracci's sculpture.

A tomb designed by Canova and commissioned by the English government, dedicated to James III and his two sons, was eventually erected in Saint Peter's in 1819.

Francesco Zuccarelli
Pitigliano (Tuscany) 1702–88 Florence

130 *Portrait of an Old Man* (pl. 138)

Inscribed verso, lower right, in red chalk: *Zuccarelli*.
 Black and white chalks, on blue-gray laid paper; maximum 201 x 166 mm.

COLLECTIONS: Acquired from Paul Kleinberger & Co., New York.

LITERATURE: Joachim, *Helen Regenstein Collection*, pp. 38–39, no. 18, reproduced.

EXHIBITIONS: *Master Drawings from the Art Institute of Chicago*, no. 19.

Helen Regenstein Collection, 1960.560

It is one of the curiosities of art history that Zuccarelli is generally considered a member of the Venetian school. He was Tuscan by birth, did not arrive in Venice until he was nearly thirty years old, and spent almost twenty-five years of his career in England, where he became one of the founding members of the Royal Academy in 1768. He is best known for idyllic landscapes, which were widely popular throughout Europe in his day.

A hitherto unknown facet of his art came to light with the discovery of an album of portrait drawings made by Zuccarelli for Count Francesco Maria Tassi in 1748 (see Bassi-Rathgeb, *Un Album inedito di Francesco Zuccarelli*). The portraits in this album, as well as this one in Chicago and two from the Duc de Talleyrand collection, reveal Zuccarelli's lively yet realistic manner, his agitated yet purposeful line (see Morassi, *Dessins vénitiens du dix-huitième siècle de la collection du Duc de Talleyrand*, pls. 77–78). It has not been possible to identify the subject of this drawing.

Stefano Pozzi

Rome ca. 1707–69

131 *Marcus Curtius* (pl. 155)

Black and white chalks, on blue laid paper; maximum 302 x 224 mm.

COLLECTIONS: William F. E. Gurley, Chicago, stamp (not in Lugt) recto, lower right and verso, lower right, in black.

LITERATURE: Clark, "Roman Eighteenth-Century Drawings in the Gilmor Collection," *Baltimore Museum of Art News* 24:8, n. 11.

Leonora Hall Gurley Memorial Collection, 1922.3661

Stefano Pozzi, a student of Carlo Maratta, spent his life in Rome, and with his contemporary Pompeo Battoni he shared what Anthony M. Clark characterized as a "tendency that was distinctly anti-Rococo in spirit, and sought to regain dignity and monumentality without however dismissing the Rococo graces."

Clark related this drawing in technique and in period to the *Triumph of Galatea* by Pozzi, in the Gilmor Collection on permanent loan to the Baltimore Museum of Art. He cited these works as particularly reminiscent of

Carlo Maratta and typical of the conservative trend in Roman decorations of the eighteenth century.

Stefano Pozzi

Rome ca. 1707–69

132 *Boreas and Orithyia* (pl. 156)

Black chalk heightened with white chalk, on blue laid paper; squared in black chalk; laid down; 534 x 390 mm.

COLLECTIONS: Ch. Deering, stamp (Lugt 516) recto, on mount, in blue.

Charles Deering Collection, 1927.7692

This drawing was for a long time attributed to Ciro Ferri, a facile follower of Pietro de Cortona, as suggested by Ulrich Middeldorf. However, Rafael Fernandez suggested, and Jacob Bean concurred, that it might be the work of Stefano Pozzi, based on comparison with drawings in the Metropolitan Museum and in Düsseldorf (see *Italienische Handzeichnungen des Barock*, pp. 45–46, nos. 133–34, pl. 44). The two drawings in Düsseldorf are also of mythological subjects, *Luna and Endymion* (FF3386) and *Apollo and Coronus* (FF3385).

Furthermore, the Düsseldorf drawings compare with this one in technique and proportions, and one might speculate that they were designed for similar, possibly the same, mythological series. However, no definite association or identification can be made at this time.

Anthony M. Clark held to the belief that this drawing is by an earlier hand, perhaps someone like Luigi Garzi (1638–1721), the contemporary and rival of Pozzi's mentor Carlo Maratta.

Francesco Guardi

Venice 1712–93

133 *Adoration of the Shepherds*, recto (pl. 139)
Three Landscape Sketches, verso (pl. 140)

Pen and brown ink with brush and brown wash, on gray laid paper; 383 x 517 mm.

COLLECTIONS: Acquired from H. Calmann, London.

LITERATURE: Pignatti, "Nuovi disegni di figura dei Guardi," *Critica d'arte* 11:63, 72, n. 17, fig. 100; de'Maffei "La Questione Guardi: Precisazione e Aggiunte," *Arte in Europa: Scritti di storia dell 'Arte in onore di Edoardo Arslan*, vols. 1–2, p. 859, fig. 582; Morassi, *Guardi: Tutti i disegni*, p. 101, cat. 122, fig. 125; verso: p. 180, cat. 587, fig. 579; Binion, *Antonio and Francesco Guardi*, pp. 154, 256, no. 25, fig. 141.

EXHIBITIONS: *Master Drawings from the Art Institute of Chicago*, no. 20.

Clarence Buckingham Collection, 1961.48

Of the Francesco Guardi drawings in the collection, this double-sided sheet must be the earliest. Francesco Guardi, who handled small figures so elegantly in his work, generally is quite rough and rustic with figures on a larger scale, and with the nervous, broken outlines and flickering brushwork he is apt to give them an aspect of weather-beaten, deeply fissured rocks. This, however, should not be taken as symptomatic of an immature beginner, but rather as a deliberate stylistic trend. In fact, Morassi considers this a mature work by the artist.

Alice Binion has pointed out that the composition on the recto derives from an altarpiece of the same subject by Sebastiano Ricci (ca. 1705) for the Duomo di Saluzzo and that Guardi may have known this composition from a copy of it in Joseph Smith's collection or from the engraving by Pietro Monaco.

The landscape sketches on the back were used in three different paintings (see Morassi, *Guardi*, vol. 1, p. 493, cat. 992; vol 2, fig. 874, p. 475, cat. 893; vol. 2, fig. 799, p. 491, cat. 980; vol. 2, fig. 869). They probably depict actual views and therefore differ in style from the imaginary type of the *capriccio*, which the artist developed to such virtuosity in later years. As Morassi assigns the date about 1770 to one of the landscape paintings, this might serve as a *terminus ante quem* for our drawing. Binion prefers to date the sheet about 1755–65.

Francesco Guardi
Venice 1712–93

134 *Gateway near a Landing Bridge* (pl.141)

Pen and brown ink with brush and brown wash, over black chalk, on ivory laid paper; maximum 304 x 456 mm.
WATERMARK: Initial *H* with knots.
COLLECTIONS: Lucille Cohen, Paris; Marquis de Biron; Duc de Talleyrand, Paris; acquired from Rosenberg & Stiebel, New York.
LITERATURE: Morassi, *Dessins vénitiens du dix-huitième siècle de la collection du Duc de Talleyrand*, no. 67, reproduced; Joachim, *Helen Regenstein Collection*, pp. 42–43, no. 20, reproduced; Morassi, *Guardi: Tutti i disegni*, p. 187, cat. 632, fig. 614.
EXHIBITIONS: *Tiepolo et Guardi*, no. 109; *La Peinture italienne au XVIIIe siècle*, no. 311.

Helen Regenstein Collection, 1968.310

The motif of this drawing occurs in many paintings, but the closest is in the Uffizi (see Morassi, *Guardi*, vol.

1, cat. 930; vol. 2, fig. 826). That the extensive under-drawing in black chalk was not completely followed in the execution in pen and wash is especially noticeable in the sails of the boats at the right and in one of the porters on the bridge.

Although this drawing, which Morassi refers to as an "opera bellisima della maturità," anticipates the *capricci* of Guardi's last years, it does not yet show the often bizarre and nervous calligraphic idiosyncrasies of those later *capricci*. Therefore, the date might be placed in the early or middle eighties.

Francesco Guardi
Venice 1712–93

135 *Capriccio with a Squall on the Lagoon* (pl. 142)

Pen and brown ink with brush and brown wash, over black chalk, on ivory laid paper; maximum 270 x 386 mm.
WATERMARK: Initial *H* with knots.
COLLECTIONS: Lucille Cohen, Paris; Marquis de Biron; Duc de Talleyrand, Paris; acquired from Rosenberg & Stiebel, New York.
LITERATURE: Morassi, *Dessins vénitiens du dix-huitième siècle de la collection du Duc de Talleyrand*, p. 30, no. 69, reproduced; Joachim, *Helen Regenstein Collection*, pp. 40–41, no. 19, reproduced; Morassi, *Guardi: Tutti i disegni*, pp. 188–89, cat. 643, fig. 617.
EXHIBITIONS: *Tiepolo et Guardi*, no. 108; *La Peinture italienne au XVIIIe siècle*, no. 310.

Helen Regenstein Collection, 1968.309

The effect of this drawing depends primarily on the nervous and excited strokes of the pen and only secondarily on the sparingly used wash. The reverse is true of another version of this drawing in the E. V. Thaw collection (see Bean and Stampfle, *Drawings from New York Collections*, vol. 3, p. 86, no. 205; and see Stampfle and Denison, *Drawing from the Collection of Mr. and Mrs. Eugene V. Thaw*, pp. 57–58, no. 52).

Obviously both this drawing and the Thaw drawing are by Francesco. The extensive, very rapid under-drawing in black chalk suggests that the drawing in Chicago is the earlier version of the composition; the black chalk underdrawing was not always followed by the pen, as in the figures in the boat and the running figure in the foreground.

The quivering, electric penmanship of this drawing, which admirably fits the subject of a storm, points to the artist's late years. There are several paintings related to this subject; one, in a different format, was formerly in the Matthiesen collection, London (see Morassi, *Guardi*, vol. 1, cat. 976–78; vol. 2, figs. 860–62).

Giovanni Battista Piranesi

Mogliano near Mestre(?) 1720–78 Rome

136 *Palatial Courtyard with a Fountain* (pl. 143)

Inscribed recto, lower left, in pen and brown ink: *Piranesi*.
 Pen and brown ink with brush and brown wash, on cream laid paper; 260 x 390 mm.
 COLLECTIONS: Baron von Hirsch, Basel; acquired from Charles Slatkin Galleries, New York.
 EXHIBITIONS: *Master Drawings from the Art Institute of Chicago*, no. 22, pl. 6.
Ada Turnbull Hertle Fund, 1963.139

Active as a draftsman, etcher, and publisher of architectural fantasies and monuments of Roman antiquity, Piranesi stands unequalled in the history of European art and his influence has been tremendous. After his early training in Venice, he went to Rome in 1740 but returned to Venice in 1743 for a year; during that year he is supposed to have studied etching with Giambattista Tiepolo. From 1745 until his death in 1778, he lived in Rome, where he published more than a thousand prints.

The *Palatial Courtyard with a Fountain* has the airy and light Venetian quality that Hylton Thomas describes as the "scribbling" manner of the early period, perhaps about 1750. Especially close to this drawing is a *Court before Colonnades*, formerly in the Janos Scholz and Henry Regnery collections (see Thomas, *The Drawings of Giovanni Battista Piranesi*, p. 45, no. 30, reproduced). The signature in the lower left corner is probably authentic. It should be compared with many others, principally that of the *Central View of a Church Interior*, in the Pierpont Morgan Library (1959.14; see Bean and Stampfle, *Drawings from New York Collections*, vol. 3, p. 91, no. 217, reproduced).

Giovanni Battista Piranesi

Mogliano near Mestre(?) 1720–78 Rome

137 *Sheet of Six Figure Studies* (pl. 144)

Inscribed recto, lower right, in pen and black-brown ink: *Originale di Giam . . . Piranesi / celebre incisore*.
 Pen and brown ink, on ivory laid paper; 231 x 366 mm.; verso: study of a man with his arm raised and heads of angels, in pen and brown ink.
 COLLECTIONS: Private collection, Paris (according to Wildenstein); Caroline R. Hill (according to Wildenstein); Wildenstein & Co., New York; acquired from Charles Slatkin Galleries, New York.
 LITERATURE: Cassirer, *Roma*, 1924, vol. 2, pl. 49, fig. 1 (cited by Thomas); Thomas, *The Drawings of Giovanni Battista Piranesi*, p. 61, no. 73, reproduced.

EXHIBITIONS: *Drawings from Four Centuries*, Wildenstein, 1949, no. 48 (according to Thomas); Rearick, *Eighteenth Century Italian Drawings*, no. 53, pl. 20; *Master Drawings from the Art Institute of Chicago*, no. 20, pl. 6b; Joachim, *A Quarter Century of Collecting*, no. 19, reproduced.
Margaret Day Blake Collection, 1959.3

Although the human figures in Piranesi's etchings never distract from the architectural theme, upon close inspection they reveal an unsuspected wealth of keen observation and imaginative draftsmanship. Fortunately, quite a few figure studies have survived. They range from relatively objective depictions to utterly fantastic *groteschi*, direct descendants of Callot and Magnasco. The Art Institute sheet is undoubtedly based on actual observation in the streets of Rome, and the rare subject of human communication between three pairs of figures —two fishermen (talking about the size of fish?), a priest talking to a child, and a woman handing an object to a child—puts this drawing in a very special category. The assured and forceful handling of the reed pen clearly indicates that this drawing dates from the last decade of the artist's life.

Giovanni Domenico Tiepolo

Venice 1727–1804

138 *God the Father Supported by Angels in the Clouds, I* (pl. 146)

Inscribed recto, lower right, in pen and brown ink: *Dom Tiepolo f;* inscribed recto, upper left, in brush and brown ink: *15*.
 Pen and brown ink with brush and brown-gray wash, over traces of black chalk, on ivory laid paper; 279 x 196 mm.
 COLLECTIONS: Acquired from Seligmann, Rey & Co., New York.
 LITERATURE: Byam Shaw, *Drawings of Domenico Tiepolo*, p. 32.
 EXHIBITIONS: *Catalogue of a Century of Progress*, p. 87, no. 822; Rich, *Loan Exhibition of . . . the Two Tiepolos*, pp. 44, no. 96.
Gift of Mr. and Mrs. Francis Neilson, 1926.443

Active for many years as an able assistant to his father Giovanni Battista Tiepolo in the execution of frescoes, Domenico Tiepolo developed into a major artist in his own right; particularly as a draftsman, he exhibited a distinctly individual character that has been increasingly appreciated in recent years.

Domenico's inexhaustible and whimsical imagination induced him to treat his favorite subjects in large sets of drawings, of both sacred and profane subject matter.

The Art Institute owns two drawings belonging to one of the earliest biblical series, *God the Father Supported*

by Angels in the Clouds. Of the other drawings in this series, which Byam Shaw estimates at about sixty, the largest group (fourteen) is in the Correr Museum, Venice; five were in the collection of Count Giustiniani, two are in the Albertina, and others are in private collections. Byam Shaw also notes that this group is almost uniform in dimensions, shape, signature, and numbering in the upper left corner, which runs at least as high as 102.

Based on the relationship of these compositions to Giovanni Battista's altar at Este, these drawings are generally dated about 1759.

Giovanni Domenico Tiepolo
Venice 1727–1804

139 *God the Father Supported by Angels in the Clouds,* II (pl. 145)

Inscribed recto, lower right, in pen and brown ink: *Dom Tiepolo f;* inscribed recto, upper left, in brush and brown ink: *17.*
Pen and brown ink with brush and brown-gray wash, over traces of black chalk, on ivory laid paper; 279 x 197 mm.
COLLECTIONS: Acquired from Seligmann, Rey & Co., New York.
LITERATURE: Byam Shaw, *Drawings of Domenico Tiepolo,* p. 32.
EXHIBITIONS: *Catalogue of a Century of Progress,* p. 87, no. 823; Rich, *Loan Exhibition of . . . the Two Tiepolos,* p. 44, no. 97.
Gift of Mr. and Mrs. Francis Neilson, 1926.444

The second drawing of *God the Father Supported by Angels in the Clouds* is, if anything, more dramatic than the first because of the gesture of God the Father. It therefore serves as a telling illustration for the anecdote reported by Moschini and de Vesme and cited by Byam Shaw (see *Drawings of Domenico Tiepolo,* p. 31), that Domenico created his series of twenty-two etchings of the flight into Egypt to prove his originality to one of his patrons. Whether or not this incident is true, it is obvious from such tireless variations on a theme that Domenico set great personal store in the value of such creative exercises, exercises both of wit and of hand. As compositions, these two drawings and the rest of the series are still remarkably close to the style of his father, except for the much more brittle, staccato, movement of the pen.

It is interesting to note that, although this drawing shares the same provenance as the other one in the collection, they are two numbers apart in the "near-contemporary" pagination of the series (see Byam Shaw, *Drawings of Domenico Tiepolo,* p. 32. n. 4).

Giovanni Domenico Tiepolo
Venice 1727–1804

140 *Satyr Surprising a Satyress* (pl. 152)

Inscribed recto, lower right, in pen and brown ink: *Dom Tiepolo f.*
Pen and brown and gray ink with brush and brown and gray wash, over black chalk, on ivory laid paper; 193 x 277 mm.
WATERMARK: Cross surmounting crown (not in Heawood).
COLLECTIONS: Italico Brass, Venice; acquired from Alessandro Brass, Venice.
LITERATURE: Ojetti, *Il Settecento italiano,* p. 30, nos. 49–54.
Edward E. Ayer Fund, 1952.140

Domenico Tiepolo devoted at least as much energy to his series of drawings on profane subjects as he did to biblical themes. Some of these can be identified with actual mythological stories, but many are fanciful combinations of their pagan characters. Among his most numerous and delightful subjects are variations on scenes of satyrs or centaurs. In this case, also, there is a general uniformity of dimensions (ca. 190 x 275 mm.) for the entire series, which at one time numbered as high as 102.

Byam Shaw has pointed out the unusual technique of these drawings. Frequently they seem to have been drawn in pen and pale gray ink initially, redrawn and corrected with darker ink, and shaded in slashing pen strokes similar to Domenico's etchings (see Byam Shaw *Drawings of Domenico Tiepolo,* p. 41). A good example of such *pentimenti* are the feet of the young satyress, which have been changed from human form to goats' feet.

Similar themes can be found over a long span of time in Domenico's painted oeuvre, in the frescoes of 1759 in the Camera dei Satiri in the Tiepolo family villa of Zianigo near Padua and those in the Camera dei Centauri, dated 1791. It is likely that these drawings were made at some point between these two dates.

Giovanni Domenico Tiepolo
Venice 1727–1804

141 *Lion, Lioness, and Cubs* (pl. 150)

Inscribed recto, lower left, in pen and brown ink: *Dom° Tiepolo f.*
Pen and brown ink with brush and brown wash, over black chalk, on ivory laid paper; maximum 183 x 273 mm.
COLLECTIONS: W. Esdaile, script (Lugt 2617) recto, lower right, in pen and brown ink; Frederick R. Aikman, / collection sold Mch. 14, 1913 by Puttick & Simpson, stamp (not in Lugt) verso, lower right on mount, in black; William F. E. Gurley,

Chicago, stamp (not in Lugt) recto, lower right and verso, center on mount, in black; Leonora Hall Gurley Memorial Collection, stamp (Lugt Suppl. 1230*b*) verso, center on mount, in black.

EXHIBITIONS: Farmer, *The Tiepolos: Painters to Princes and Prelates*, p. 113, no. 112, reproduced.

Leonora Hall Gurley Memorial Collection, 1922.5416

Yet another series of drawings by Domenico Tiepolo is devoted to animals, but they are loosely connected, for they differ in size and their dating is often uncertain.

In this case, however, the *Lion, Lioness, and Cubs* can be identified with frescoes of *The Pride of Lions* in the Tiepolo villa of Zianigo near Padua. It may be assumed that the artist did not draw these animals from life, but rather depended on other sources, such as the etchings of Stefano della Bella or Johann Elias Ridinger of Augsburg (see Byam Shaw, *Drawings of Domenico Tiepolo*, p. 43).

Giovanni Domenico Tiepolo
Venice 1727–1804

142 *Jesus in the House of Jairus* (pl. 148)

Inscribed recto, lower right, in pen and brown ink: *Dom Tiepolo f.*

Pen and brown ink with brush and brown and gray washes, over black chalk, on ivory laid paper; maximum 480 x 382 mm.

WATERMARK: Three crescents and coat of arms.

COLLECTIONS: Luzarches, Tours; Rogier Cormier, Tours, sale: Paris, Galerie Georges Petit, April 30, 1921, no. 26; acquired from J. Seligmann & Co., New York.

EXHIBITIONS: *Master Drawings from the Art Institute of Chicago*, no. 23, pl. 7; Joachim, *A Quarter Century of Collecting*, no. 21, reproduced.

Gift of Tiffany and Margaret Blake 1960.547

It is estimated that Domenico Tiepolo drew more than two hundred and fifty drawings of religious subjects in his later years, which Byam Shaw calls the "large biblical series" (*Drawings of Domenico Tiepolo*, pp. 36–37). All of these drawings are nearly identical in size (ca. 485 x 375 mm.) and were at one time bound into albums; one hundred and thirty-eight sheets are still bound in the folio of the Recueil Fayet in the Cabinet des Dessins of the Louvre. This drawing is one of eighty-two sheets from the Luzarches and R. Cormier collections, Tours, which were dispersed at a sale in Paris in 1921.

The scene depicted is the resurrection of Jairus's daughter, one of the miracles of the life of Christ told by Matthew (9:18, 23–25), Mark (5:22–24, 35–42), and Luke (8:41–42, 49–56), in which the daughter of the ruler of the synagogue is brought back to life by Jesus despite the skepticism of the witnesses.

Particularly impressive is the dramatic use of the dark brown wash in this drawing, which makes the few white accents appear so brilliant that one expects them to be gouache, when, in fact, they are created by the paper itself.

Giovanni Domenico Tiepolo
Venice 1727–1804

143 *Saints Peter and Rhoda* (pl. 147)

Inscribed recto, lower left, in brush and brown ink: *Domᵒ Tiepolo f.*

Pen and brown ink with brush and brown wash, over black chalk, on ivory laid paper; 491 x 381 mm.

WATERMARK: Imperial crest and three crescents (cf. Heawood 820, Venice, 1784).

COLLECTIONS: Luzarches, Tours; Rogier Cormier, Tours, sale: Paris, Galerie Georges Petit, April 30, 1921, no. 11; Duc de Trévise, sale: Paris, Hôtel Drouot, December 8, 1947, no. 28, reproduced; acquired from R. Lebel, New York.

LITERATURE: Guerlin, *Au temps du Christ*, pp. 115–16, reproduced.

Gift of Mrs. Potter Palmer, 1948.16

One of the most endearing traits of Domenico's art is his preference for simple and seldom told biblical stories, such as the episode depicted here from Acts 12:11–19. Saint Peter, liberated from prison, arrives at the house of Mary and the maid Rhoda answers his knock. She is unable to persuade the others that it is Peter, and not a vision of him, that she has seen.

The astonishing simplification of this drawing, with but two relatively small figures and the large expanse of brick walls, seems to herald the approaching classicism of those final years of the eighteenth century. Within these spare means, the artist creates the eerie effect of a moonlit night.

Giovanni Domenico Tiepolo
Venice 1727–1804

144 *The Wedding of Punchinello* (pl. 151)

Inscribed recto, at right on pillar, in pen and brown ink: *Domo / Tiepolo / f;* inscribed recto, upper left (outside margin of composition) in pen and brown ink: *3.*

Pen and brown ink with brush and brown wash, over graphite, on ivory laid paper; 352 x 472 mm.

WATERMARK: Irregular crescent (see Bean and Stampfle, *Drawings from New York Collections*, vol. 3, watermark 13).

COLLECTIONS: Duc de Talleyrand; Mrs. D. Kilvert, New York; acquired from Rosenberg & Stiebel, New York.

LITERATURE: Joachim, *Helen Regenstein Collection*, pp. 36–37, no. 17, reproduced; Byam Shaw, *Drawings of Domenico Tiepolo*, pp. 57–58.

Helen Regenstein Collection, 1968.312

The last great series of Domenico's drawings are those dealing with Punchinello and scenes from contemporary life. The wedding of Punchinello is third in that set of 102 drawings plus title page. Entitled "Divertimenti per gli ragazzi" by Domenico himself, the series seems directed at a sophisticated audience, one that could perceive the associations and reflections of the compositions. This drawing is a parody of the marriage of Barbarossa in the Emperor's Hall of the archepiscopal residence in Würzburg, by Domenico's father, Giambattista. The event here is the marriage of a Punchinello (perhaps the father of the hero of the series) with a normal young lady. It falls within a group of related drawings: the *Bridal Procession* and *Honeymoon* of Punchinello's parents are reproduced in Byam Shaw's *Drawings of Domenico Tiepolo* (pls. 82–83), and the *Wedding Feast*, no. 5 of the series, is in the collection of E. V. Thaw, New York (see Stampfle and Denison, *Drawings from the Collection of Mr. and Mrs. Eugene V. Thaw*, p. 65, no. 62, reproduced).

Giovanni Domenico Tiepolo
Venice 1727–1804

145 *Punchinello Chopping Logs* (pl. 149)

Inscribed recto, lower right, in pen and brown ink: *Dom Tiepolo f*; inscribed recto, upper left (outside margin of composition) in pen and brown ink: *52*.

Pen and brown ink with brush and brown wash, over graphite, on ivory laid paper; maximum 346 x 468 mm.

WATERMARK: GAF surmounted by a crown (cf. Heawood 876–84).

COLLECTIONS: Conte Alessandro Contini, Rome; acquired from M. Knoedler & Co., New York.

LITERATURE: Ojetti, *Il Settecento italiano*, vol. 1, no. 296, pl. 196.

EXHIBITIONS: *Catalogue of the Carl O. Schniewind Memorial Exhibition*, no. 33; *Master Drawings from the Art Institute of Chicago*, no. 24.

Gift of Emily Crane Chadbourne, 1957.309

Until the Sotheby sale of July 6, 1920, the entire set of the Punchinello series, containing 103 individual sheets, had been kept together. This series of drawings describes the imagined ancestry, various stages and occupations of the life, travels, and ultimate death of the sly but idle character made popular in the commedia dell'arte by the Neapolitan actor Silvio Fiorillo at the beginning of the seventeenth century. Other drawings of this type are those of Punchinello as a tailor's assistant, as a dressmaker, and as a portrait painter in the collections of Robert Lehman and Mr. and Mrs. Jacob M. Kaplan, New York (see Bean and Stampfle, *Drawings from New York Collections*, vol. 3, pp. 109–10, nos. 277–79, reproduced).

Giovanni Battista Cipriani
Florence 1727–85 London

146 *Birth of Adonis* (pl. 157)

Inscribed verso, center on mount, in graphite: *157*; inscribed verso, lower right on mount, in graphite: *157*.

Pen and black ink with brush and black wash, over traces of graphite, on blue wove paper; laid down; maximum 269 x 409 mm.

COLLECTIONS: Dr. E. Peart, script (Lugt 891) recto, lower left, in pen and black ink; W. Mayor, stamp (Lugt 2799) recto, lower right, in black; Sir R. L. Mond, stamp (Lugt Suppl. 2813a) verso, lower center on mount, in brown; acquired from Schaeffer Galleries, New York.

Gift of the Ponte del' Arte Society, 1974.25

Giovanni Battista Cipriani was the student of Bartolozzi, but it was particularly from studying the works of Anton Domenico Gabbiani and Ignatius Hugford, that he developed his renowned ability as a draftsman. In 1795, he left Italy and traveled to England, where he was commissioned to restore various works at Windsor and the Rubens ceiling in the chapel at Whitehall. But Cipriani's greatest legacy was in drawings: more than one thousand were presented at the sale held in the year after his death in London in 1785.

It is not surprising, thus, to see that this drawing comes from several distinguished English collections. Dr. Edward Peart (1756–1824) could have acquired the sheet directly from the artist or from the sale of his estate, and William Mayor (d. 1874) was a celebrated collector and dealer in old master drawings.

The scenes on this sheet tell the story of the birth of Adonis: the wife of Cinyras the Cyprian once boasted that her daughter Smyrna was more beautiful than Aphrodite. The goddess, overhearing this remark, avenged herself by making Smyrna fall in love with her father. When Cinyras realized he was both father and grandfather to his daughter's unborn babe, he drove her from the palace, sword in hand. Aphrodite then took pity on Smyrna and turned her into a myrrh tree before

her father could slay her. In his rage, Cinyras split the tree, and out fell the infant Adonis, later nursed by wood nymphs.

This drawing clearly shows Cipriani's position as a transitional artist between the rococo style of Gabbiani and the neoclassicism of the nineteenth century.

Ubaldo Gandolfi?
Bologna 1728–81 Ravenna

147 *The Assumption of the Virgin* (pl. 154)

Pen and brown ink with brush and brown wash, over graphite, on ivory laid paper; laid down; 295 x 210 mm.

COLLECTIONS: George, Lord Macartney's Album of / Drawings. Puttick & Simpson Sale / March 14, 1913, Lot 114, stamp (not in Lugt) verso, lower right on mount, in purple; William F. E. Gurley, Chicago, stamp (not in Lugt) recto, lower right, in black; Leonora Hall Gurley Memorial Collection, stamp (Lugt Suppl. 1230*b*) verso, center on mount, in black.

EXHIBITIONS: Neilson, *Italian Drawings*, no. 77, reproduced.

Leonora Hall Gurley Memorial Collection, 1922.588

Once attributed to Annibale Carracci, this drawing was recognized by Middeldorf, A. M. Clark, Mimi Cazort Taylor, and others as the work of the eighteenth-century Bolognese artist, Ubaldo Gandolfi. Taylor cited it as a late work by the artist (ca. 1780), and Neilson pointed out that it can be related to the decoration of *The Apotheosis of San Vitale* in the Ravenna church of that name, dating from 1780. Neilson cited, in this connection, the drawing in the Bick collection (see Hurd, *Selections from the Collection of Esther S. and Malcolm W. Bick: Italian Drawings*, no. 44); yet another drawing for this project, *The Apotheosis of San Vitale*, is in the Held Collection (see *Selections from the Drawing Collection of Mr. and Mrs. Julius S. Held*, no. 122).

As Neilson pointed out, the composition also exists in a weaker version in Lille (where it is attributed to Gaetano Gandolfi), a sheet which was once thought to be associated with an early painting in Castel San Pietro; a red chalk study of the Madonna and angels is in the Brera (see Emiliani, *Disegni del seicento emiliano*, p. 68, no. 100).

Ubaldo Gandolfi?
Bologna 1728–81 Ravenna

148 *Ceiling with Bacchus, Ariadne, Diana, and Minerva* (pl. 153)

Inscribed recto, at bottom, in graphite: *Ecole milanaise Pedrini filippo XVII siècle.*

Pen and brown ink with brush and brown wash, over graphite, on ivory laid paper; laid down; 332 x 307 mm.

COLLECTIONS: J. J. Lindman, stamp (Lugt Suppl. 1479*a*) recto, lower right, in purple; William F. E. Gurley, Chicago, stamp (not in Lugt) recto, lower right, in black; Leonora Hall Gurley Memorial Collection, stamp (Lugt Suppl. 1230*b*) verso, center on mount, in black.

EXHIBITIONS: *The Eighteenth Century*, pp. 21–22, no. 28; *Master Drawings from the Art Institute of Chicago*, no. 25.

Leonora Hall Gurley Memorial Collection, 1922.3340

There is still much confusion concerning the hands of various members of the Gandolfi family and their Bolognese contemporaries. However, if the preceding drawing can be accepted as the work of Ubaldo Gandolfi it would not be difficult to do likewise with this mythological scene. Both drawings reveal the same kind of agitated and energetic draftsmanship associated with Ubaldo. An early nineteenth-century(?) inscription on the bottom of the drawing reads "Ecole milanaise Pedrini filippo XVII siècle," an attribution supported by M. C. Taylor. However, Filippo Pedrini (1758–1844), was actually a Bolognese painter in the second half of the eighteenth century. This problem needs further investigation.

Pietro Antonio Novelli
Venice 1729–1804

149 *Faith Overcoming Heresy* (pl. 160)

Inscribed recto, lower left, in pen and black ink: *Piede . . . / . . . / . . . / . . . / Lunghezza Piedi 26;* inscribed recto, lower right, in pen and black ink: *Larghezza Piedi 19.*

Pen and black ink with brush and watercolors, over traces of black chalk, on ivory laid paper; 542 x 396 mm.; verso: tracing of a ceiling.

WATERMARK: Seven-pointed star with a tail (not in Heawood).

COLLECTIONS: P. J. Sachs, stamp (Lugt 2091) verso, lower center, in brown; acquired from Victor Spark, New York.

LITERATURE: Pignatti, *I Disegni veneziani del settecento*, p. 215, fig. 123.

EXHIBITIONS: Pignatti, *Venetian Drawings*, p. 54, no. 115, reproduced.

Gift of Mr. and Mrs. William O. Hunt, 1963.761

A prolific painter, illustrator, etcher, and poet, Pietro Antonio Novelli carried the decorative style of the Venetian Rococo into the late eighteenth century in numerous frescoes and altarpieces such as those in Venice, Padua, Bologna, and Udine.

We owe the attribution of this drawing to Otto Benesch, and the calligraphic line and delicate shading are characteristic of the drawings by Novelli in the

Albertina, Correr, and Hermitage. Even the same notations of height and width can be found on a drawing in the Seminario at Padua (for the altarpiece of Saint Leo) and on three drawings in Leningrad.

The size and nature of the composition suggest that it is a design for a religious ceiling decoration, which remains unidentified. A similar ceiling for the sacristy of the cathedral at San Martino di Lupari, of 1791, is mentioned in the artist's memoirs (*Memorie della Vita di Pietro Antonio Novelli scritti da lui medesimo* [Padua, 1834], p. 54), but the association of this drawing with it must remain highly tentative.

Drawings like this one reveal Novelli's insufficiently recognized debt to Bolognese draftsmen such as Donato Creti.

Mauro Antonio Tesi
Montalbano 1730–66 Bologna

150 *Architectural Fantasy*, recto (pl. 158)
Architectural Details, verso (pl. 159)

Pen and brown ink, with brush and brown wash and watercolor, on ivory laid paper (recto and verso); 277 × 187 mm.
COLLECTIONS: Cav. Prof. Armando Perera, 18 via Babuino, Roma, stamp (not in Lugt) verso, lower left, in purple and script(?; not in Lugt) verso, at left, in pen and blue ink; Edmond Fatio, stamp (?; not in Lugt) recto, lower right, in black, sale: Geneva, Nicolas Rauch S.A., June 3–4, 1959, pp. 11–12, no. 10, reproduced (recto); acquired from William H. Schab, New York.
LITERATURE: Joachim, *Helen Regenstein Collection*, pp. 44–45, no. 21, reproduced (recto and verso).
EXHIBITIONS: *The Eighteenth Century*, no. 5, pl. 8, (attributed to Bibiena); *Master Drawings from the Art Institute of Chicago*, no. 10; Lamantia, *Drawings and Architecture*, no. 4, reproduced (attributed to Bibiena); Kelder, *Drawings by the Bibiena Family*, no. 11 (attributed to Bibiena).

Helen Regenstein Collection, 1959.185

Listed in the Fatio catalog as a work by Ferdinand Galli di Bibiena, this drawing has since been tentatively given to Mauro Tesi, a perspectivist, ornamental and architectural painter working in Bologna a generation later. In 1968 Diane Kelder reattributed it to Bibiena and compared it with other drawings by him in Vienna and Florence (see Kelder, *Drawings by the Bibiena Family*, no. 11). There is a superficial resem-

blance with those drawings cited, but it is apparent that the Art Institute drawing is freer and more open in form and less encrusted with decoration than any of those attributed to Bibiena.

Although Tesi continues the use of the *scena per angolo* for stage painting originated by the Bibiena family about 1700, he has here, by the use of colorful wash and open hatching, achieved an airier and more Rococo space. Tesi can be credited with initiating a lighter form of ornamentation than had been practiced previously in Bologna. A further comparison of this drawing with some of the Tesi drawings in the Ashmolean Museum, Oxford suggests his authorship (see Parker, *Drawings in the Ashmolean*, vol. 2, pp. 528–34, nos. 1070–75).

Giuseppe Cades
Rome 1750–99

151 *The Rape of Lucretia* (pl. 161)

Inscribed recto, lower right, in pen and brown ink: *Gius. Cades.*
Pen and dark brown and black inks with brush and brown wash, over black chalk, on ivory laid paper; 435 × 275 mm.
WATERMARK: J. HONIG & ZOONEN (Heawood 3344, Berne, 1787).
COLLECTIONS: William F. E. Gurley, Chicago, stamp (not in Lugt) recto, lower right, in black; Leonora Hall Gurley Memorial Collection, stamp (Lugt Suppl. 1230b) verso, lower center, in black.
EXHIBITIONS: Broeder, *Rome in the Eighteenth Century*, pp. 125–26, no. 121.

Leonora Hall Gurley Memorial Collection, 1922.648

Cades belongs to the generation (with Canova, Jacques-Louis David, and Flaxman) that delivered the coup-de-grâce to the world of Rococo. The drawing of *The Rape of Lucretia* is a fine example of Cades's neoclassicism, which still shows a delight in ornamental flourish, however restrained it may be. The drawing is closely related in style to *The Birth of the Virgin*, of 1784 (Collection of Mr. and Mrs. Edward A. Maser, Chicago; see Clark, "An Introduction to the Drawings of Giuseppe Cades," *Master Drawings* 2 [Spring 1964]: 20, pl. 9). Clark noted that a more finished version of this drawing, signed and dated 1795, is in the Thorwaldsen Museum, Copenhagen. F. den Broeder observed that this is the kind of drawing Cades produced for sale.

PLATES

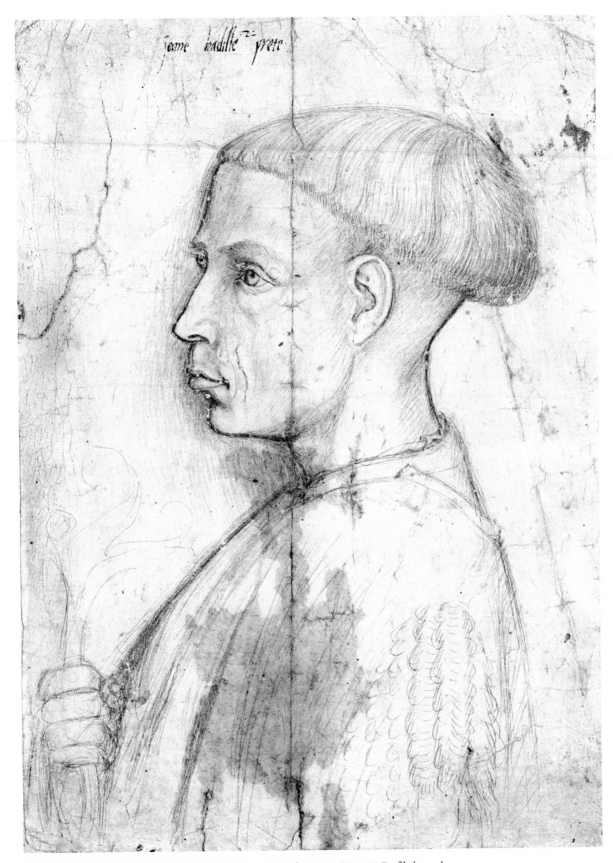

I · ANONYMOUS NORTH ITALIAN · *Bust of a Young Priest in Profile* (cat. 1)

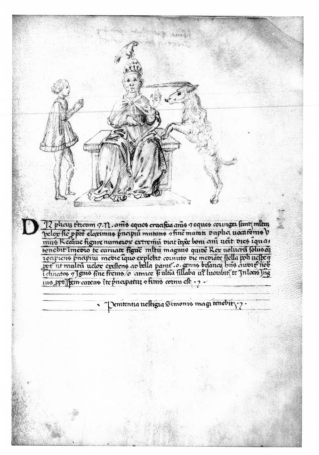

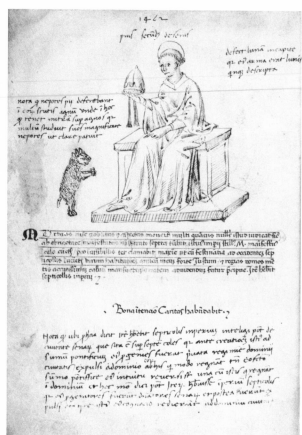

2 · ANONYMOUS NORTH ITALIAN
Papal Prophecy, folio 2 recto (cat. 3)

3 · ANONYMOUS NORTH ITALIAN
Papal Prophecy, folio 6 verso (cat. 3)

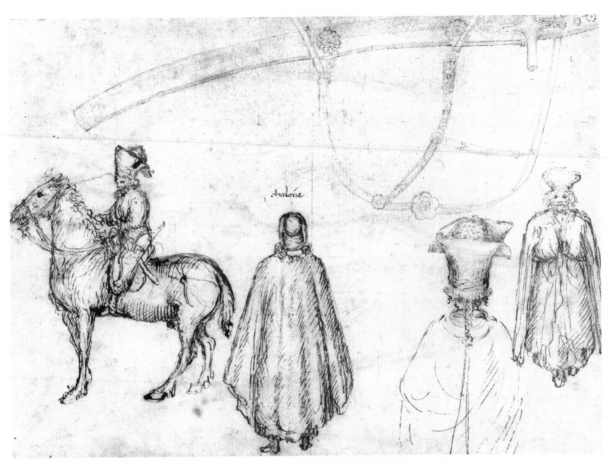

4 · ANTONIO PISANO (PISANELLO) · *Studies of the Emperor John VIII Palaeologus, a Monk, and a Scabbard*, recto (cat. 2)

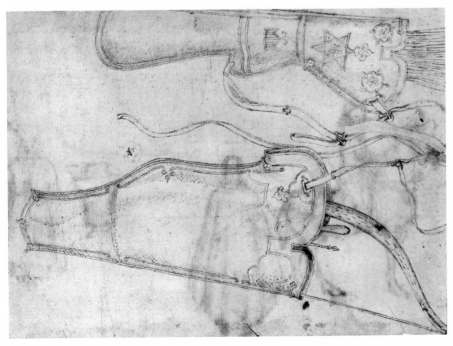

5 · ANTONIO PISANO (PISANELLO) · *Bowcase and Quiver of Arrows*, verso (cat. 2)

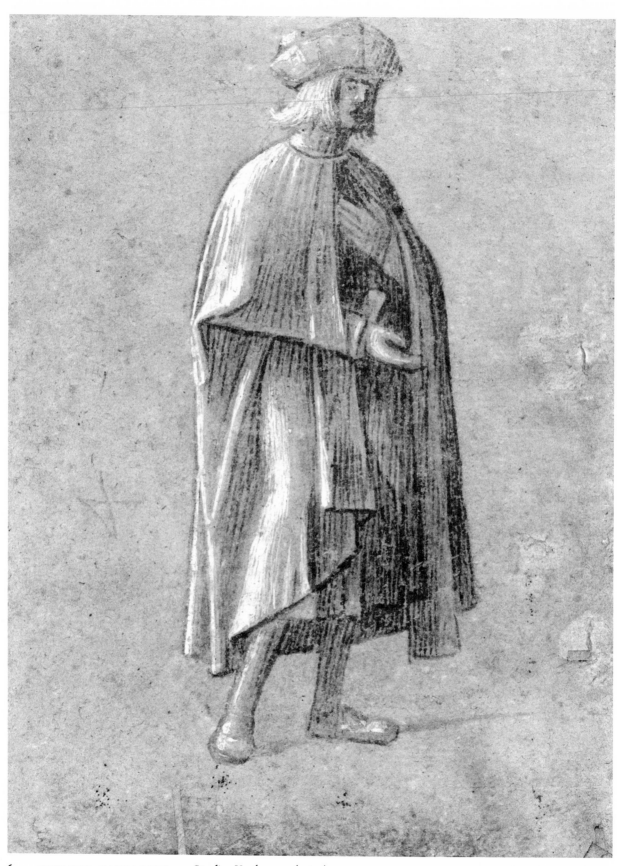

6 · VITTORE CARPACCIO · *Standing Youth*, verso (cat. 4)

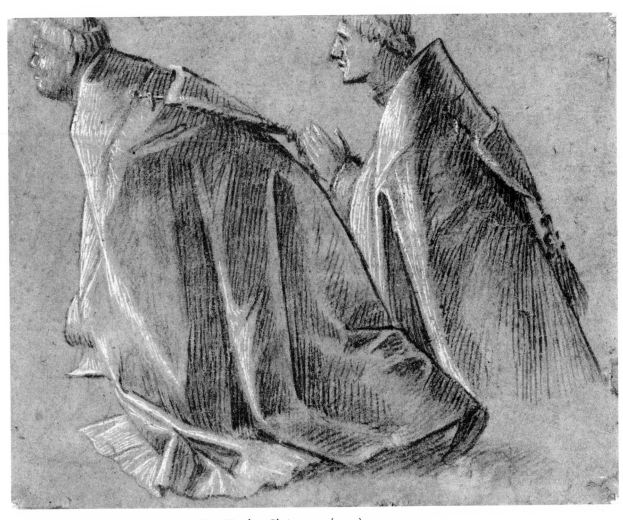

7 · VITTORE CARPACCIO · *Two Kneeling Clerics,* recto (cat. 4)

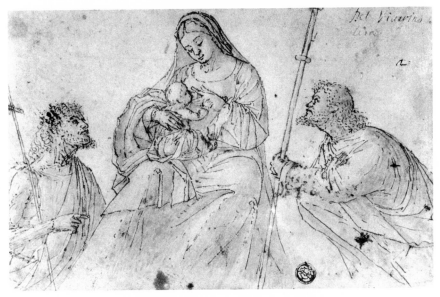

8 · VITTORE CARPACCIO (studio) · *Madonna and Child with
Saint John the Baptist and Saint Roch* (cat. 5)

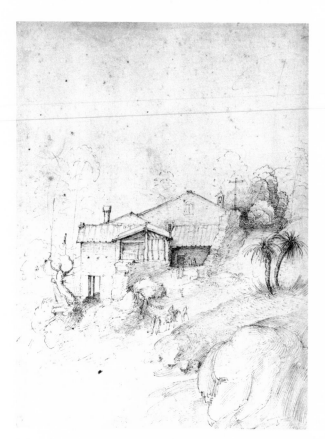

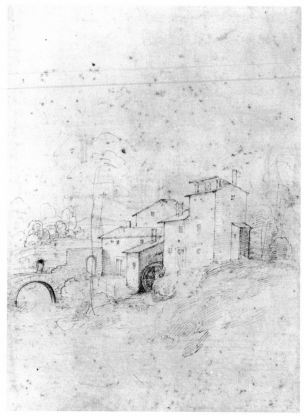

9 · BACCIO DELLA PORTA
(FRA BARTOLOMMEO)
Monastery on the Slope of a Rocky Hill, recto (cat. 7)

10 · BACCIO DELLA PORTA
(FRA BARTOLOMMEO)
Watermill with Figures on an Arched Bridge, verso (cat. 7)

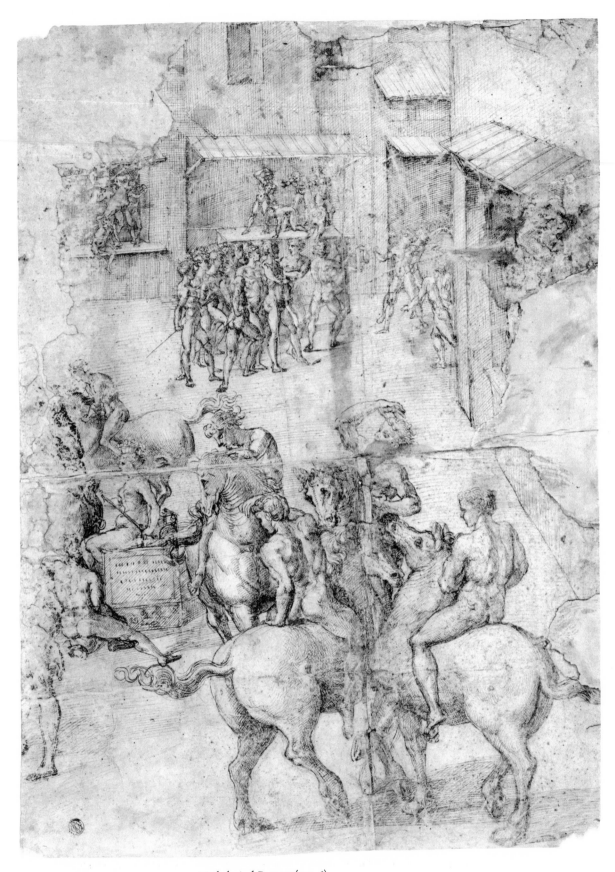

11 · GIROLAMO GENGA · *Mythological Pageant* (cat. 6)

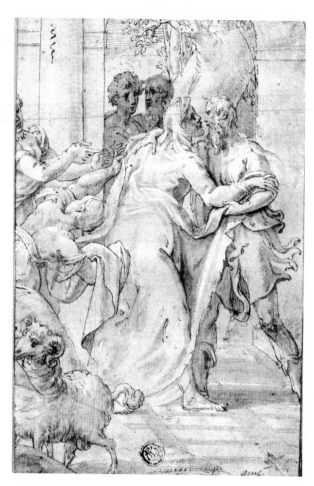

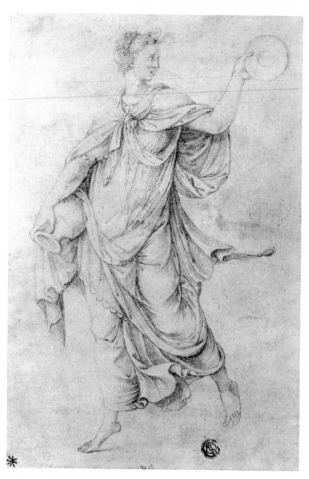

12 · GIROLAMO MAZZOLA BEDOLI
The Meeting of Joachim and Anna at the Golden Gate
(cat. 9)

13 · GIROLAMO DA CARPI · *Temperance* (cat. 11)

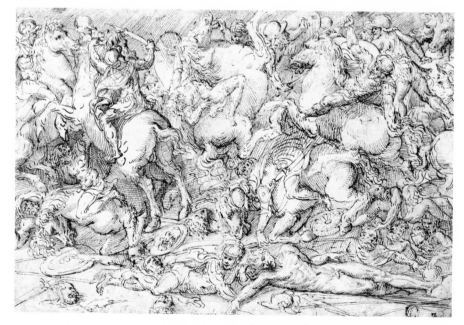

14 · DOMENICO CAMPAGNOLA · *Battle Scene with Horses and Men* (cat. 8)

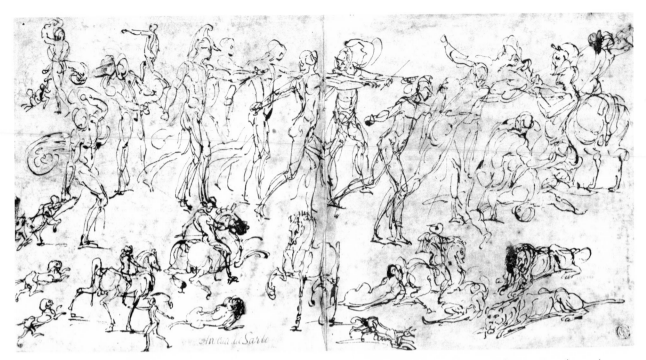

15 · PIETRO BUONACCORSI (PERINO DEL VAGA) · *Studies of Warriors, Horsemen and Lions,* recto (cat. 10)

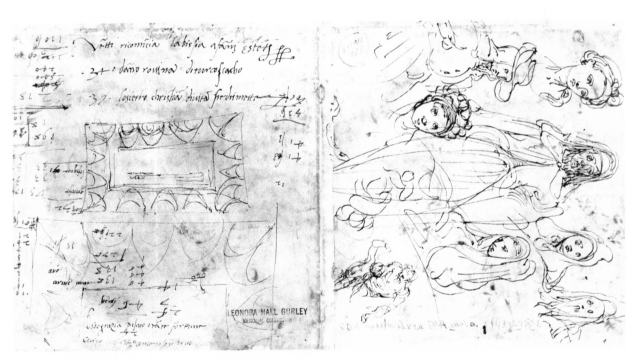

16 · PIETRO BUONACCORSI (PERINO DEL VAGA) · *Studies of Heads, Plan of a Ceiling, and Inscriptions,* verso (cat. 10)

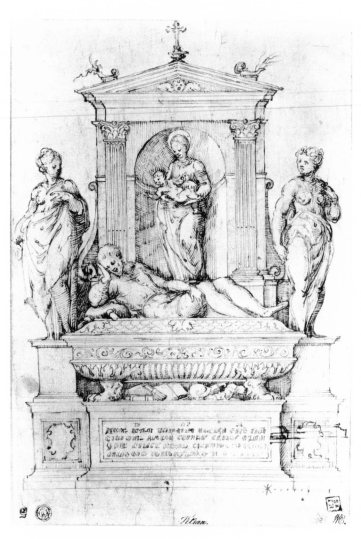

17 · GIULIO CAMPI OR ANTONIO CAMPI
Project for a Tomb (cat. 12)

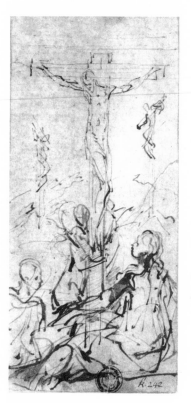

18 · FRANCESCO MAZZOLA
(PARMIGIANINO)
Crucifixion (cat. 13)

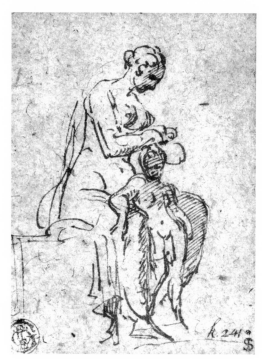

19 · FRANCESCO MAZZOLA
(PARMIGIANINO)
Study of a Woman and Child (cat. 14)

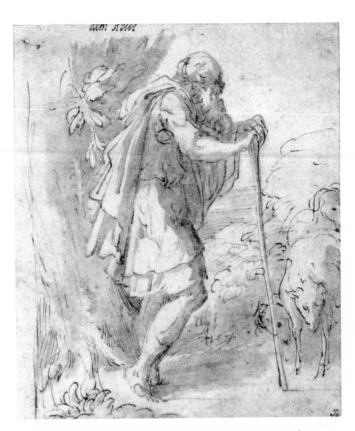

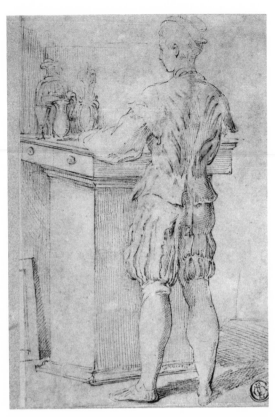

20 · FRANCESCO MAZZOLA (PARMIGIANINO)
The Old Shepherd (cat. 15)

21 · FRANCESCO MAZZOLA (PARMIGIANINO)
Painter's Apprentice, or *Valet Serving Wine* (cat. 17)

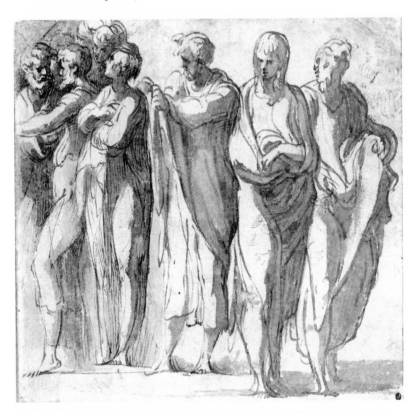

22 · FRANCESCO MAZZOLA (PARMIGIANINO)
A Group of Nine Standing Figures (cat. 16)

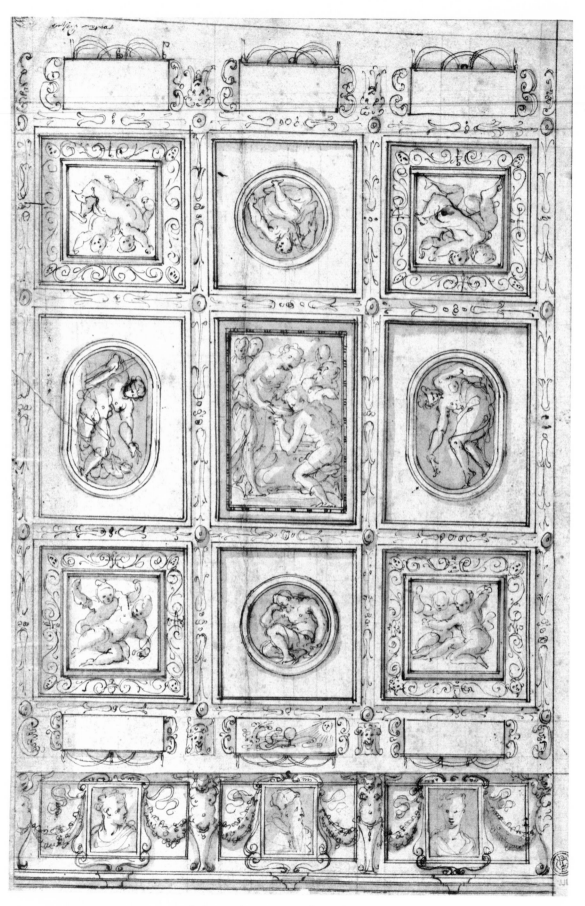

23 · GIORGIO VASARI · *Study for a Ceiling Decoration* (cat. 18)

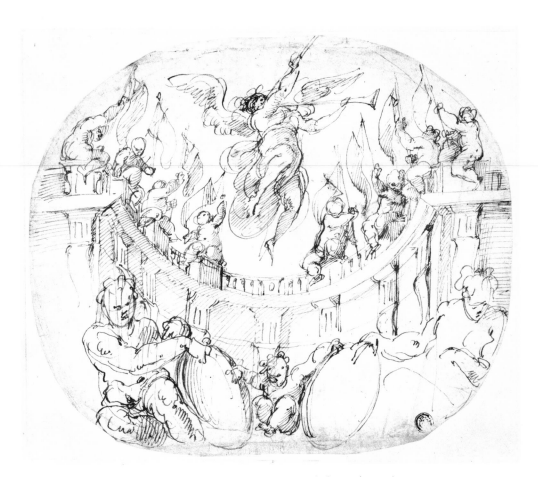

24 · GIORGIO VASARI · *Allegory of Two Quarters of Florence* (cat. 19)

25 · JACOPO ROBUSTI (TINTORETTO) OR STUDIO · *Male Nude* (cat. 21)

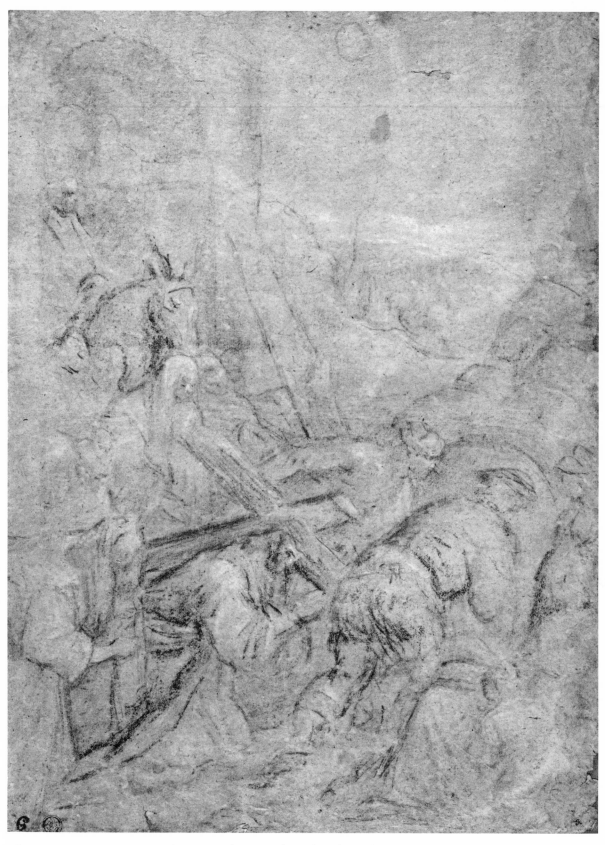

26 · JACOPO DA PONTE (BASSANO) · *Road to Calvary* (cat. 20)

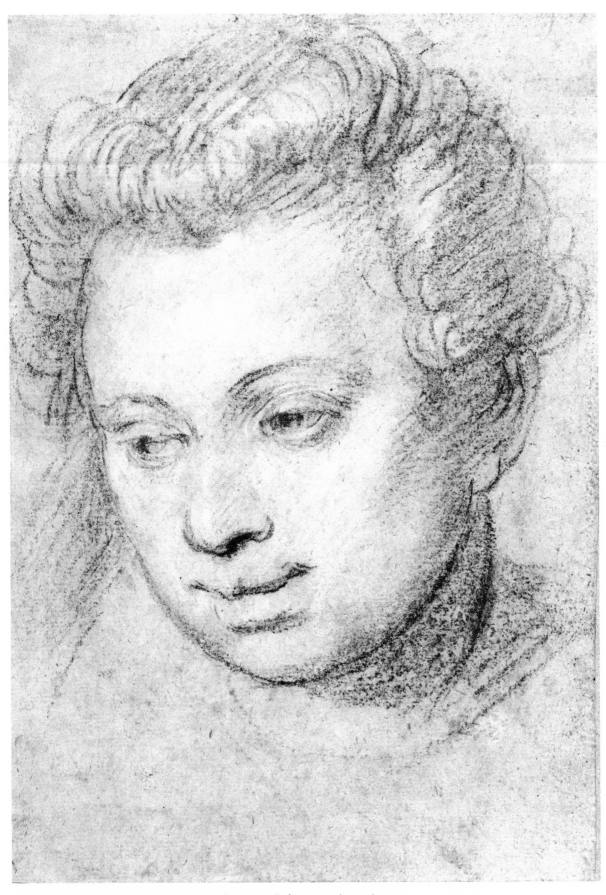

27 · PAOLO CALIARI (VERONESE) · *Head of a Woman* (cat. 26)

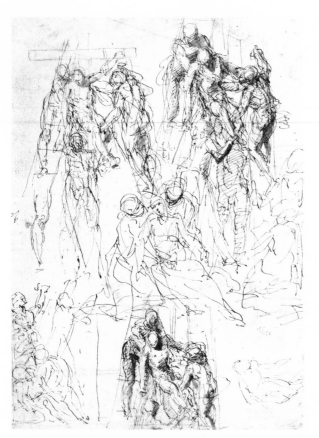

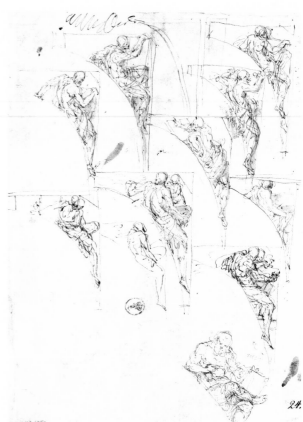

28 · ATTRIBUTED TO PAOLO CALIARI
(VERONESE) · *Studies for a Descent from the Cross,*
recto (cat. 27)

29 · ATTRIBUTED TO PAOLO CALIARI
(VERONESE) · *Studies of a Reclining Figure
within a Spandrel,* verso (cat. 27)

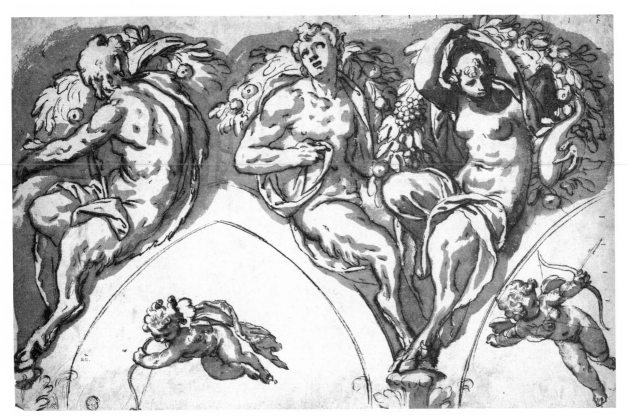

30 · PAOLO FARINATI · *Spandrel Design: Two Satyrs and a Satyress with Putti* (cat. 23)

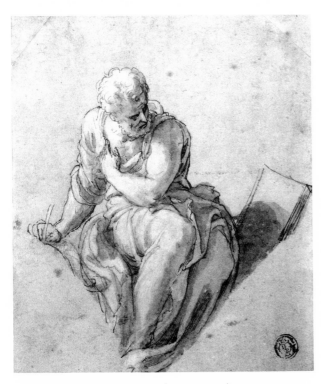

31 · GIUSEPPE PORTA (SALVIATI)
Seated Figure: Study for a Pendentive (cat. 22)

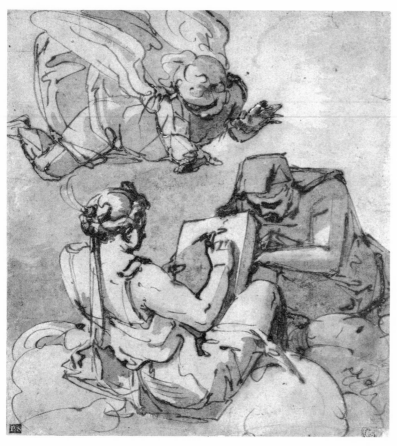

32 · LUCA CAMBIASO · *Allegorical Subject* (cat. 25)

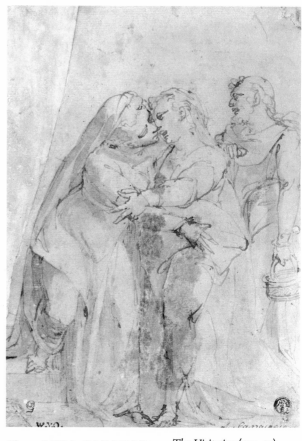

33 · LUCA CAMBIASO · *The Visitation* (cat. 24)

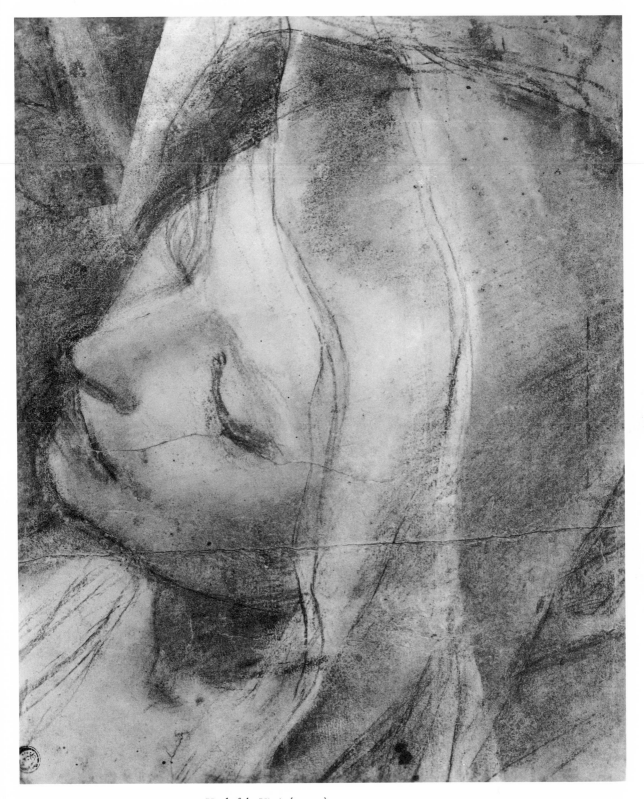

34 · FEDERICO BAROCCI · *Head of the Virgin* (cat. 31)

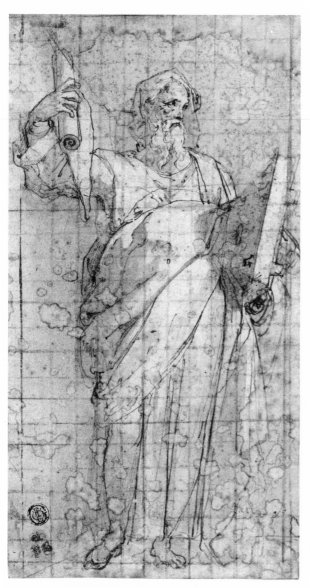

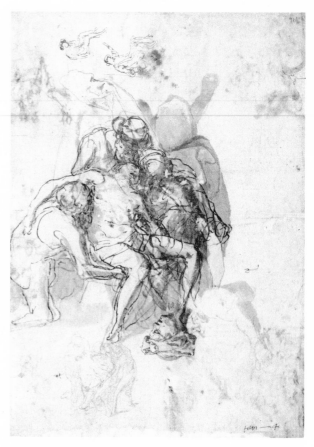

36 · TADDEO ZUCCARO
Studies for the Raising of Eutychus, verso (cat. 28)

35 · TADDEO ZUCCARO
A Standing Prophet with a Book (cat. 29)

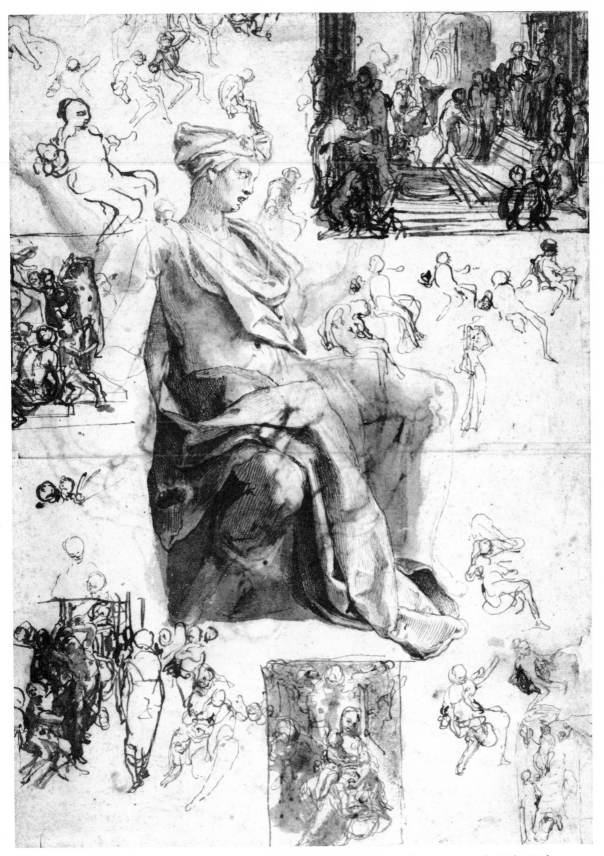

37 · TADDEO ZUCCARO · *Sheet of Studies for the Blinding of Elymas, Sacrifice at Lystra, and a Holy Family*, recto (cat. 28)

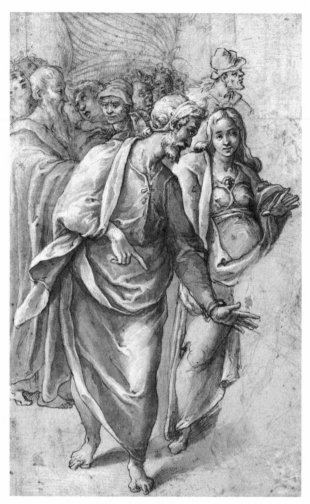

38 · NICCOLÒ MARTINELLI DA PESARO
(IL TROMETTA) · *A Group of Figures* (cat. 35)

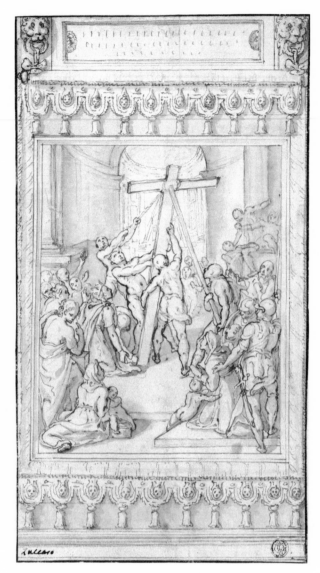

39 · CESARE NEBBIA · *The Raising of the True
Cross before the Empress Helena* (cat. 33)

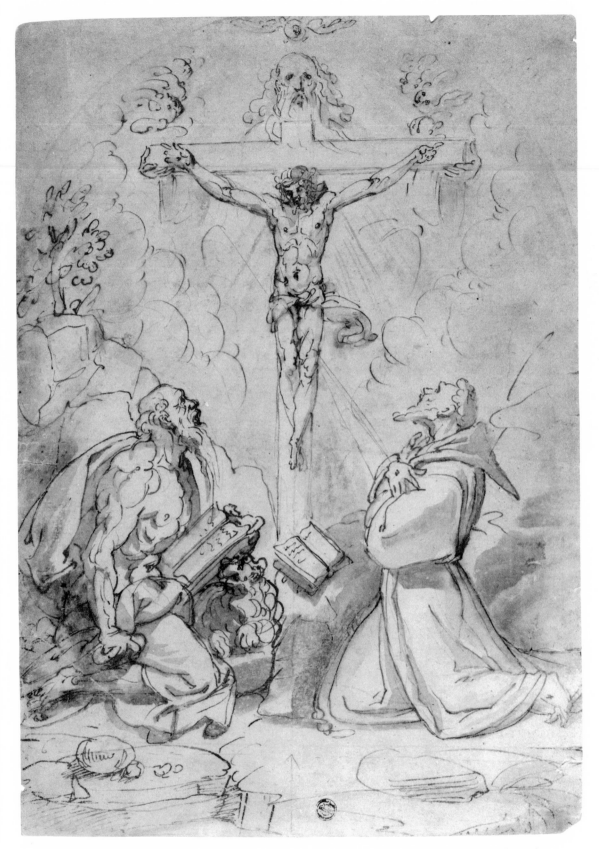

40 · BARTOLOMEO PASSAROTTI(?) · *Saint Jerome and Saint Dominic Adoring the Trinity* (cat. 30)

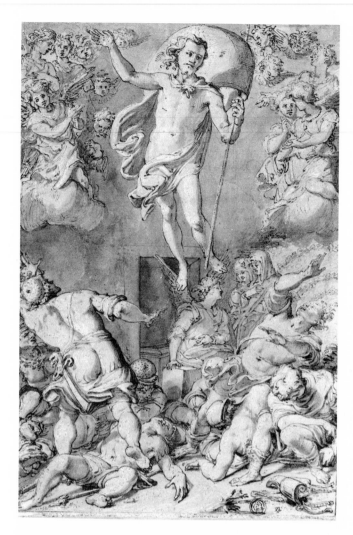

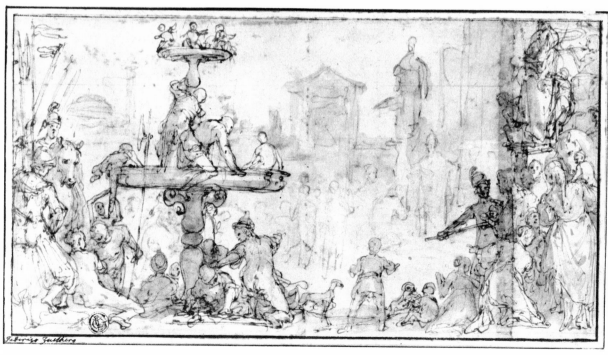

42 · FEDERICO ZUCCARO · *A Pope Receiving a Dignitary in a Public Place* (cat. 34)

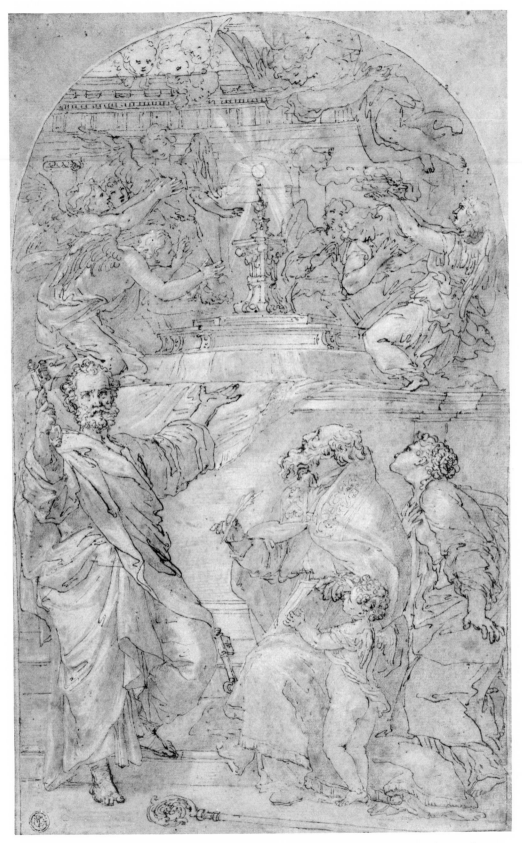

43 · DOMENICO CRESTI (PASSIGNANO) · *Saint Peter, Saint Augustine, and a Female Saint*
in Adoration of the Eucharist (cat. 48)

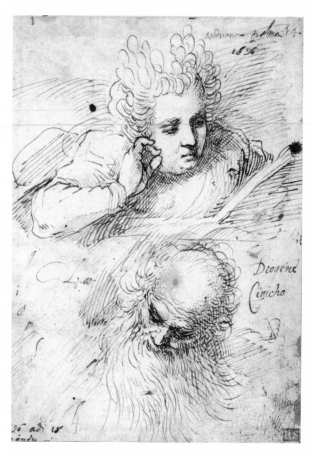

44 · JACOPO NEGRETTI (PALMA IL GIOVANE)
*Studies for Portraits of Andriana Palma
and Diogenes the Cynic* (cat. 38)

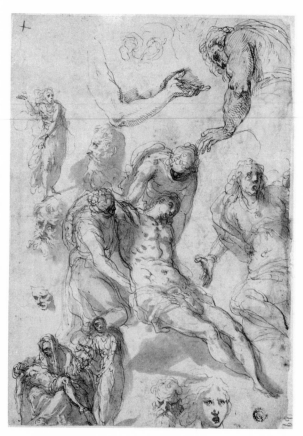

45 · JACOPO NEGRETTI (PALMA IL GIOVANE)
*Sketches for a Lamentation of Christ, a Pietà, and Other
Figures* (cat. 39)

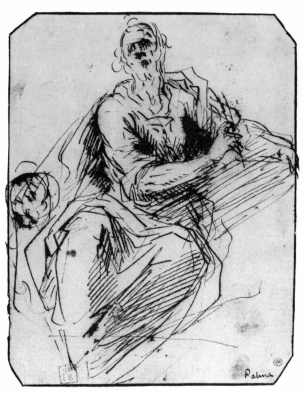

46 · JACOPO NEGRETTI (PALMA IL
GIOVANE) · *Saint Mark* (cat. 40)

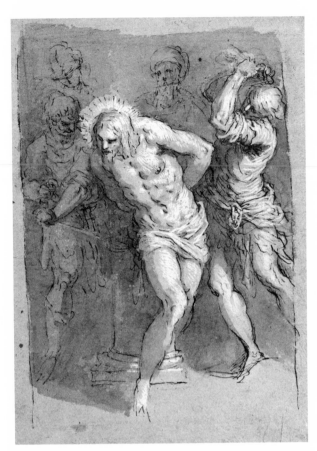

47 · JACOPO NEGRETTI (PALMA IL GIOVANE)
The Flagellation (cat. 36)

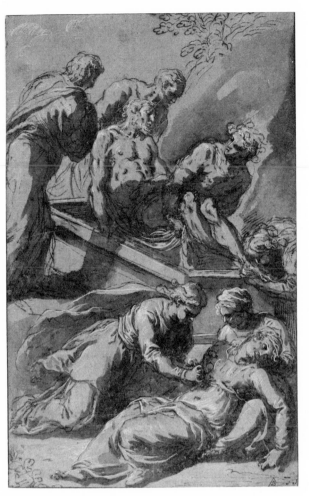

48 · JACOPO NEGRETTI (PALMA IL GIOVANE)
The Entombment of Christ (cat. 37)

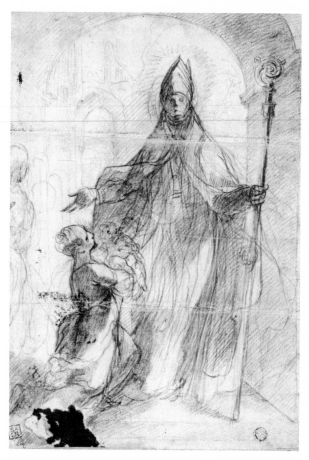

49 · ALESSANDRO CASOLANI
Bishop Blessing a Child (cat. 42)

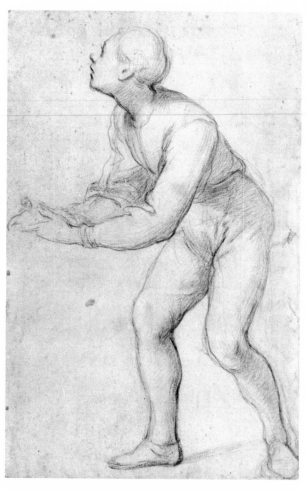

50 · JACOPO CHIMENTI (DA EMPOLI)
Young Man with Outstretched Arms (cat. 41)

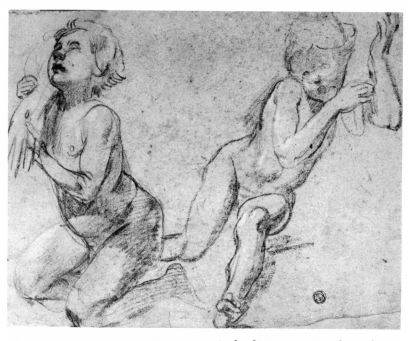

51 · ALESSANDRO CASOLANI · *Study of Two Young Boys* (cat. 43)

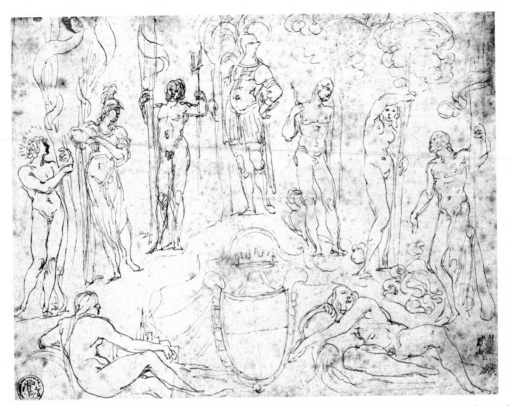

52 · LUDOVICO CARRACCI · *Study for an Invitation to the Defense of a Doctoral Thesis* (cat. 44)

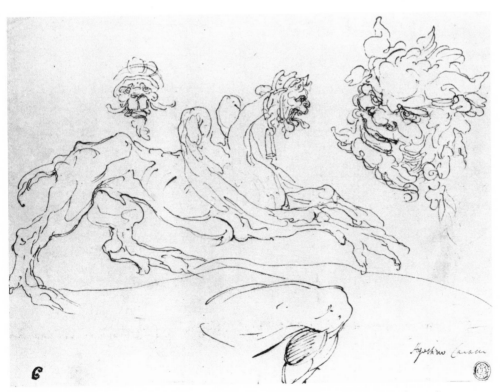

53 · AGOSTINO CARRACCI · *Studies of Grotesque Figures and a Bent Leg* (cat. 47)

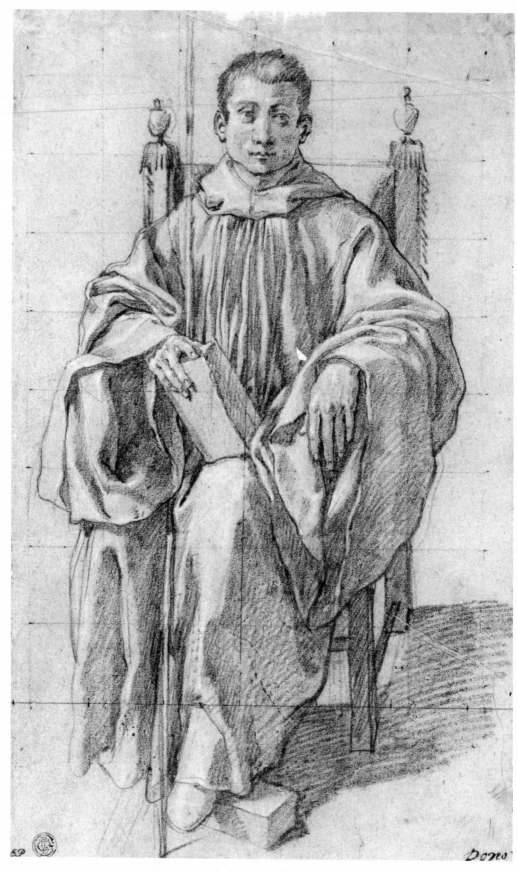

54 · BARTOLOMEO CESI · *Seated Cleric* (cat. 45)

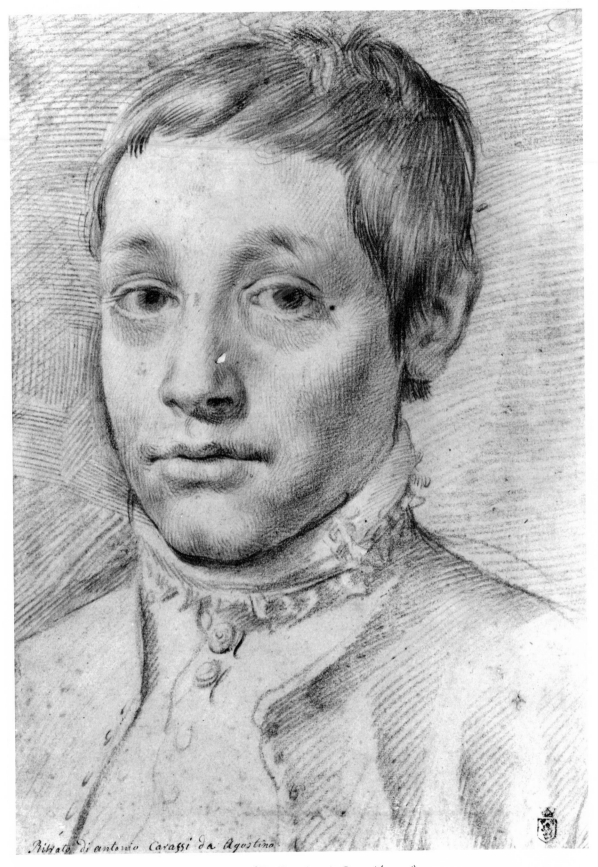

Ritrato di antonio Carassi da Agostino

55 · AGOSTINO CARRACCI · *Portrait of His Son, Antonio Carracci* (cat. 46)

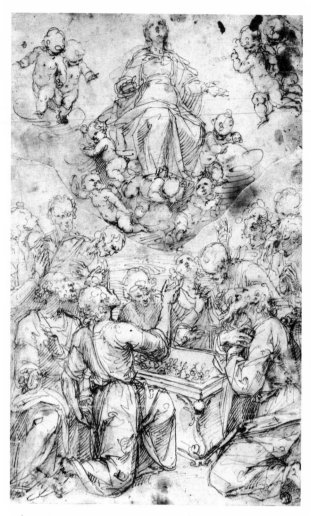

56 · GUGLIELMO CACCIA (MONCALVO)
Assumption of the Virgin (cat. 52)

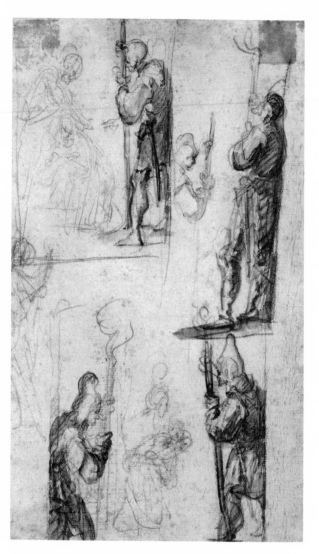

57 · GIOVANNI BILIVERTI
Studies for the Beheading of a Saint (cat. 55)

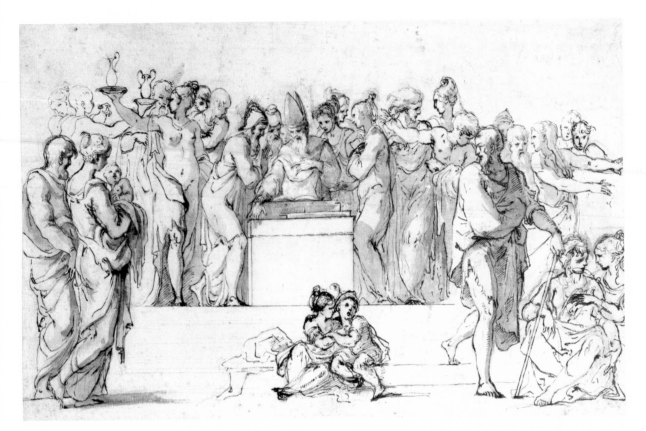

58 · LUDOVICO CARDI (DA CIGOLI) · *The Marriage of the Virgin* (cat. 50)

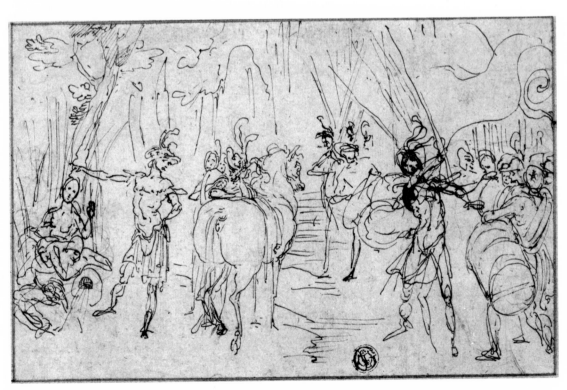

59 · LUDOVICO CARDI (DA CIGOLI) · *Soldiers* (cat. 49)

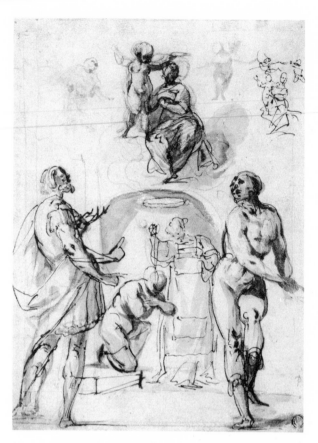

60 · GIOVANNI BAGLIONE · *Sheet of Studies with
a Madonna and Child with Saints* (cat. 53)

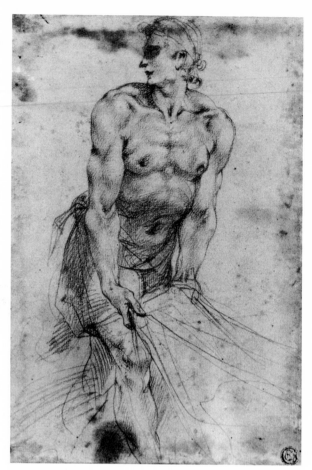

61 · GIUSEPPI CESARI, IL CAVALIERE D'ARPINO
Figure Study of a Man (cat. 51)

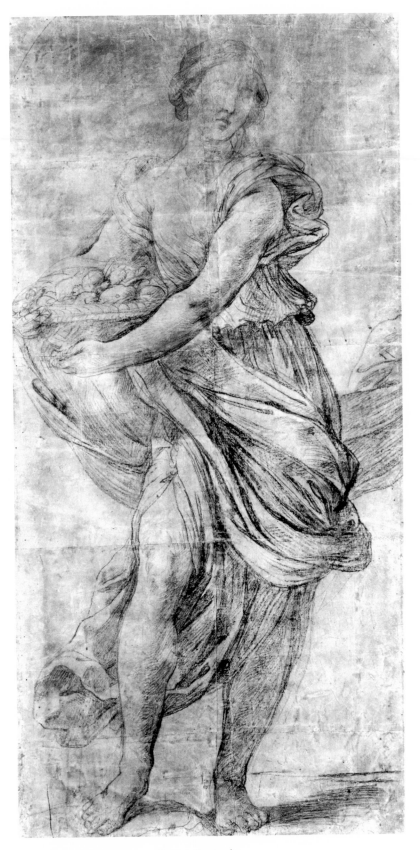

62 · GUIDO RENI · *Pomona* (cat. 54)

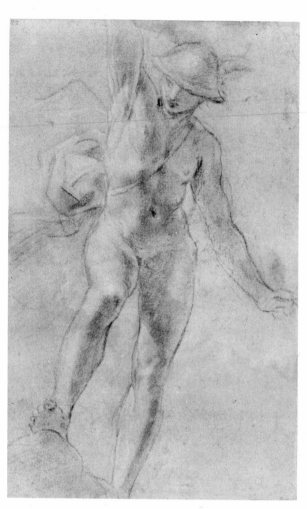

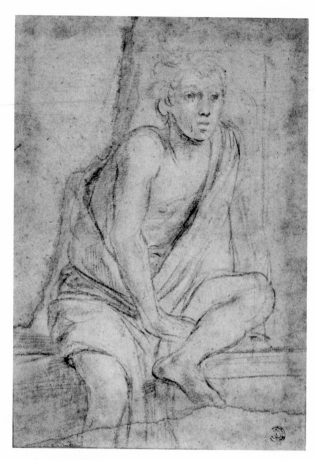

64 · DOMENICO ZAMPIERI (DOMENICHINO)
Seated Youth (cat. 57)

63 · FRANCESCO ALBANI · *Mercury* (cat. 56)

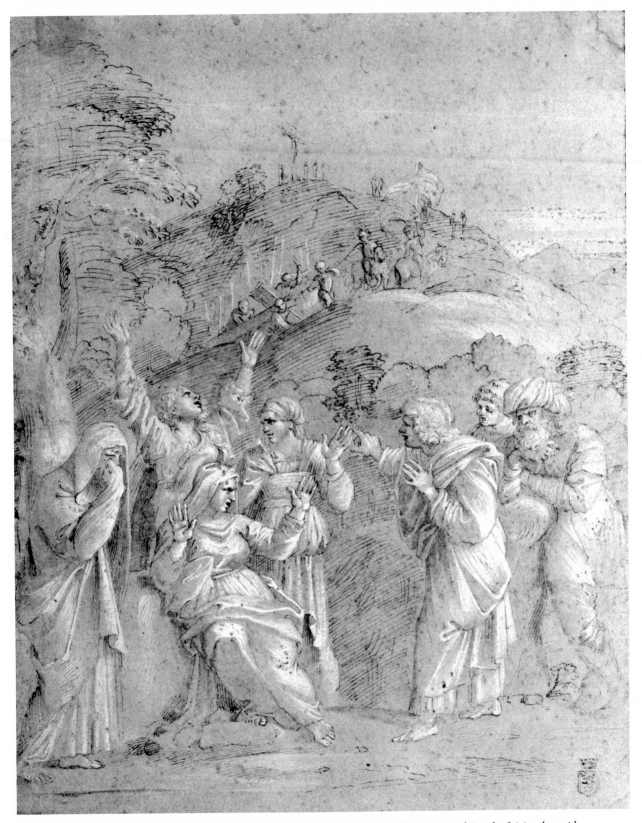

65 · ANTONIO CARRACCI · *The Virgin, the Holy Women, and Saints John, James and Joseph of Arimathea with Christ on the Way to Calvary* (cat. 58)

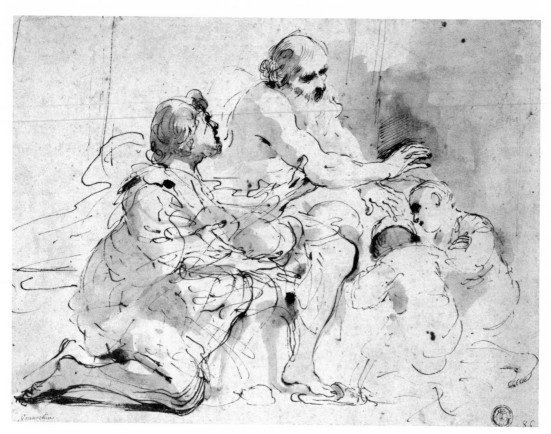

66 · GIOVANNI FRANCESCO BARBIERI (GUERCINO) · *Jacob Blessing the Sons of Joseph* (cat. 60)

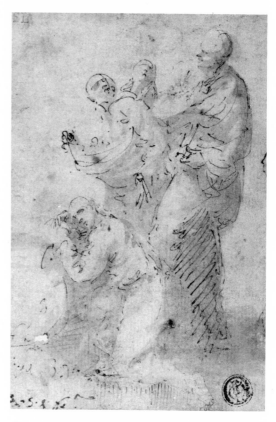

67 · JUSEPE DE RIBERA
A Group of Figures (cat. 59)

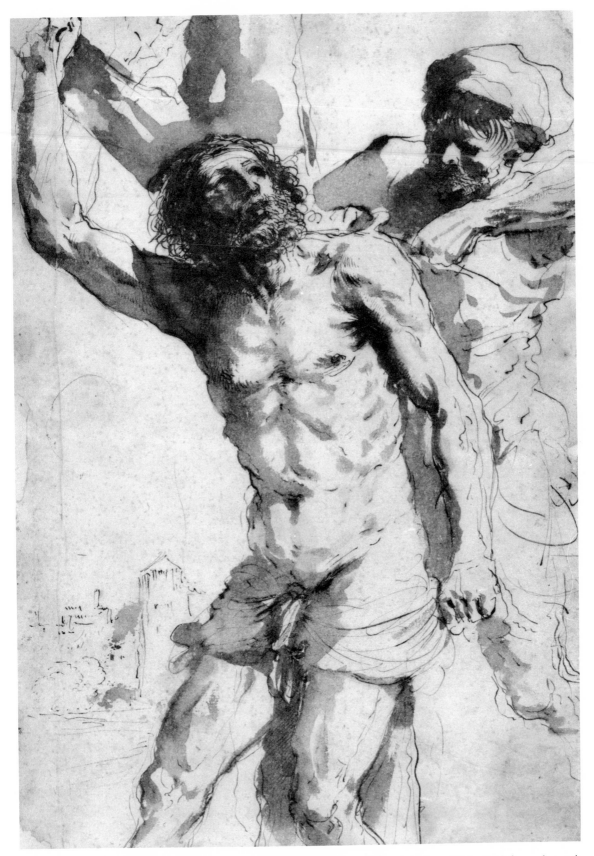

68 · GIOVANNI FRANCESCO BARBIERI (GUERCINO) · *The Martyrdom of Saint Bartholomew* (cat. 63)

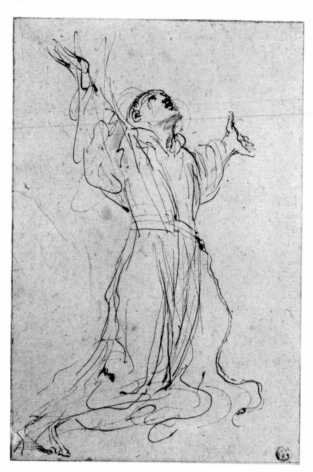

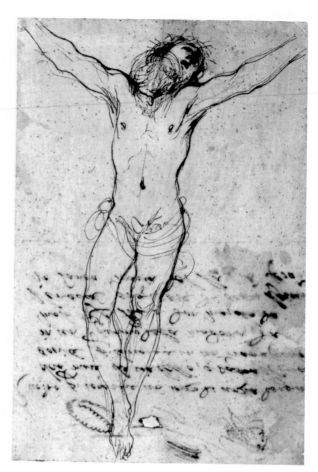

69 · GIOVANNI FRANCESCO BARBIERI
(GUERCINO) · *Saint Francis Receiving the
Stigmata* (cat. 62)

70 · GIOVANNI FRANCESCO BARBIERI
(GUERCINO) · *Christ on the Cross* (cat. 61)

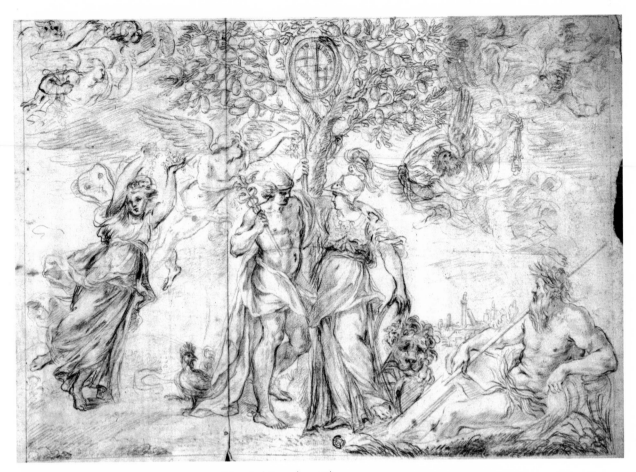

71 · ALESSANDRO ALGARDI · *Allegorical Scene* (cat. 68)

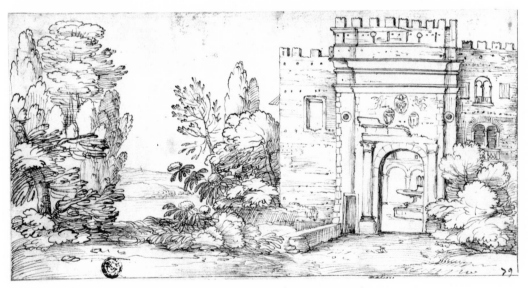

72 · GIOVANNI FRANCESCO GRIMALDI (IL BOLOGNESE)
View of La Magliana (cat. 69)

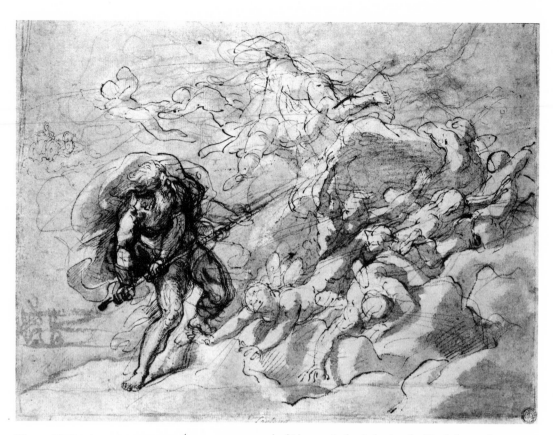

73 · PIETRO BERRETTINI (DA CORTONA) (?) · *Aeolus Releasing the Winds* (cat. 66)

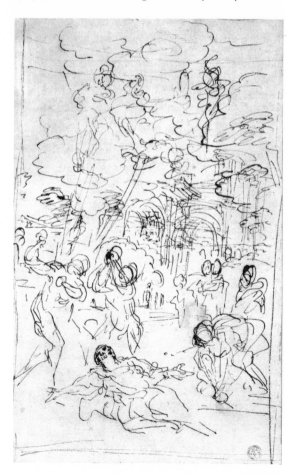

74 · PIETRO BERRETTINI (DA CORTONA)
The Martyrdom of Saint Stephen (cat. 64)

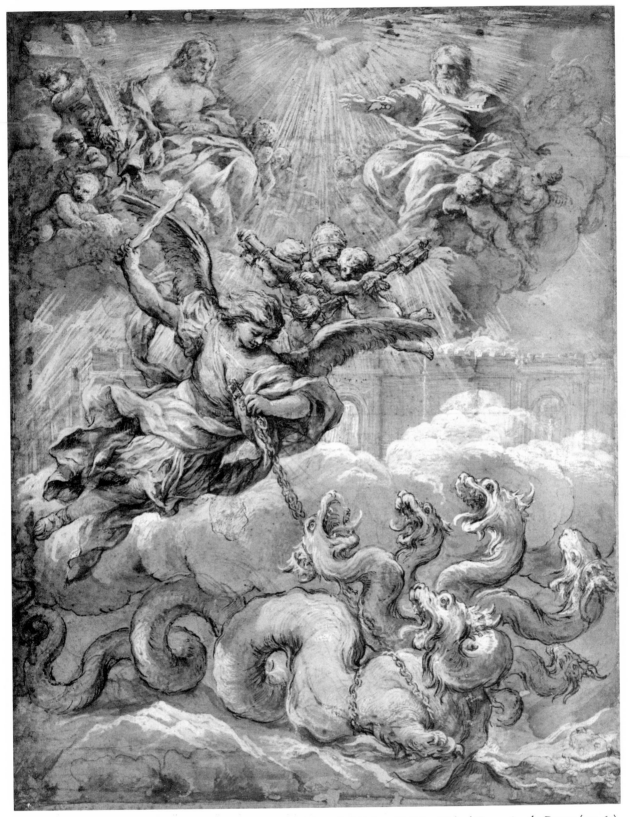

75 · PIETRO BERRETTINI (DA CORTONA) · *The Holy Trinity with Saint Michael Conquering the Dragon* (cat. 65)

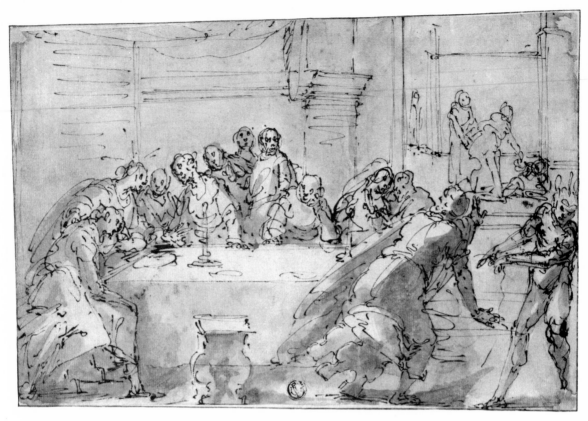

76 · GIULIO BENSO · *The Last Supper* (cat. 67)

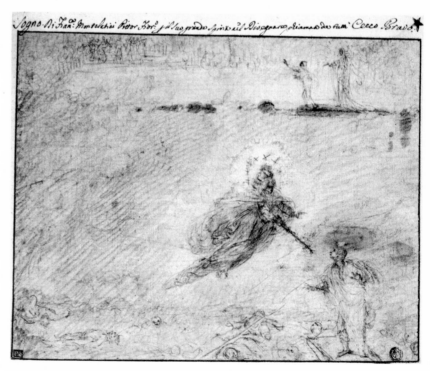

77 · FRANCESCO MONTELATICI (CECCO BRAVO)
The Dream of Cecco Bravo (cat. 70)

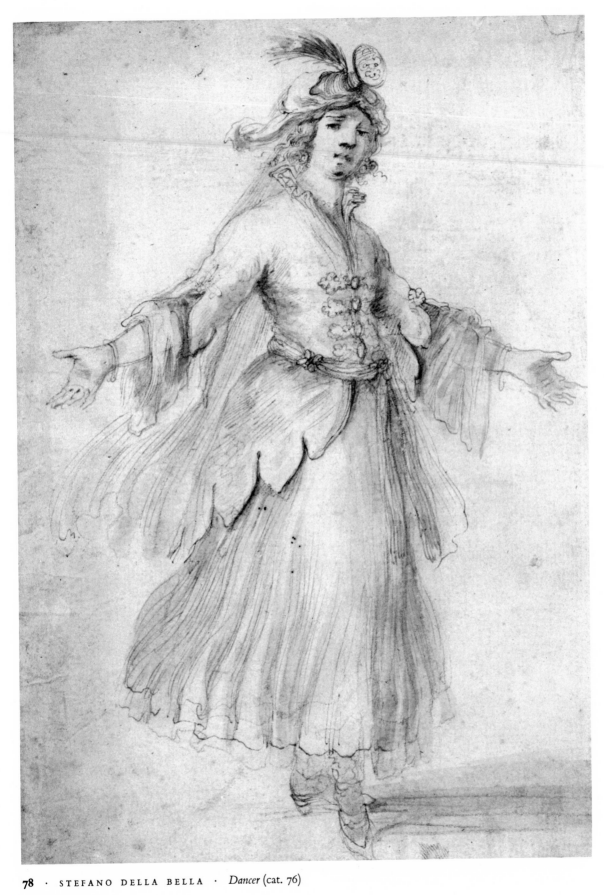

78 · STEFANO DELLA BELLA · *Dancer* (cat. 76)

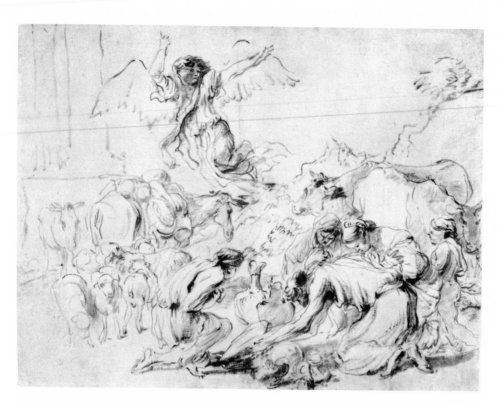

79 · GIOVANNI BENEDETTO CASTIGLIONE · *The Angel Departing from
the Family of Tobit(?)* (cat. 74)

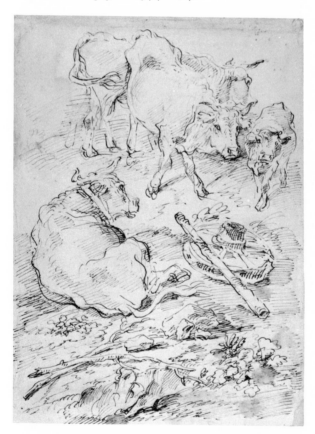

80 · GIOVANNI BENEDETTO CASTIGLIONE
Studies of Cattle (cat. 73)

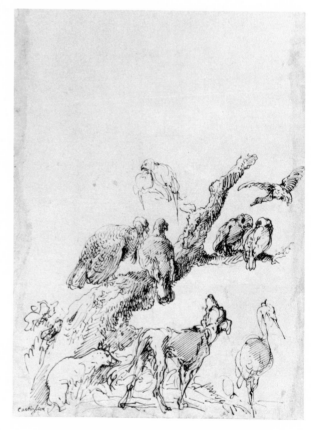

81 · GIOVANNI BENEDETTO CASTIGLIONE
Birds and Animals around a Dead Tree (cat. 71)

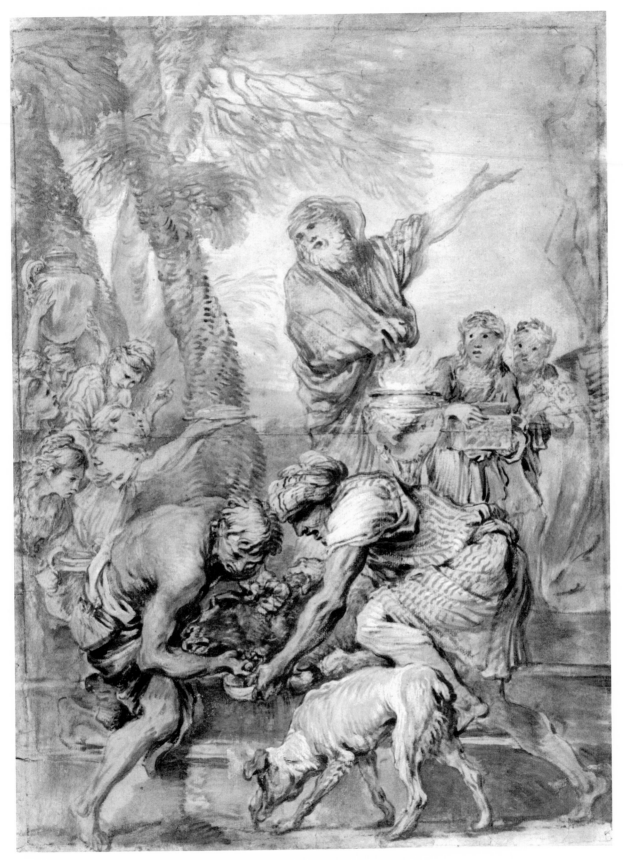

82 · GIOVANNI BENEDETTO CASTIGLIONE · *A Pagan Sacrifice* (cat. 72)

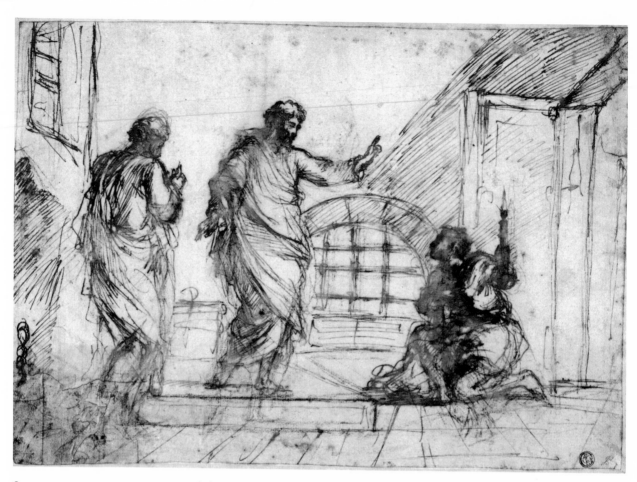

83 · PIER FRANCESCO MOLA(?) · *Saint Peter Appearing to Saint Agatha* (cat. 78)

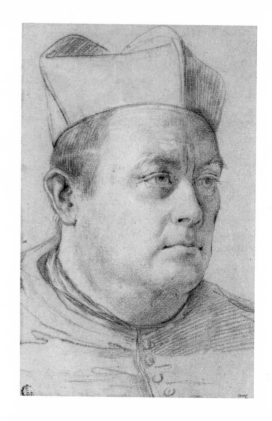

84 · GIOVANNI BATTISTA SALVI (SASSOFERRATO)
Head of a Cleric (cat. 75)

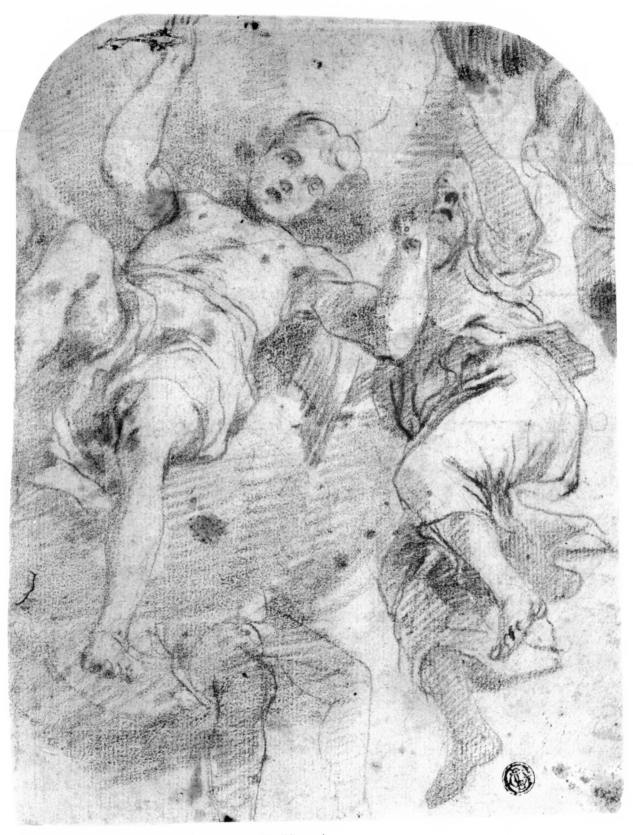

85 · MATTIA PRETI · *Angels Supporting a Cloud* (cat. 79)

86 · CARLO CIGNANI
Praying Magdalene (cat. 87)

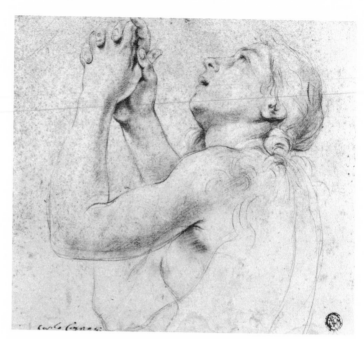

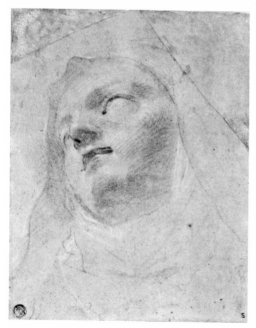

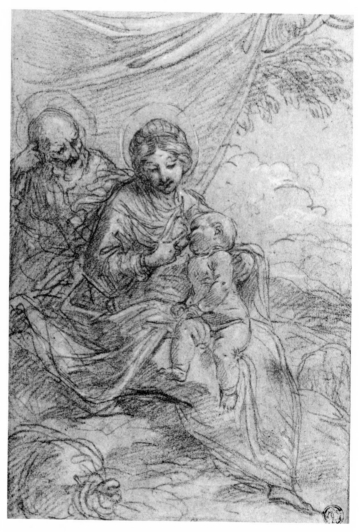

87 · DOMENICO MARIA CANUTI
*Head of a Nun, Study for the Ecstasy of
Saint Dominic* (cat. 80)

88 · FLAMINIO TORRE · *Rest on the Flight into Egypt* (cat. 81)

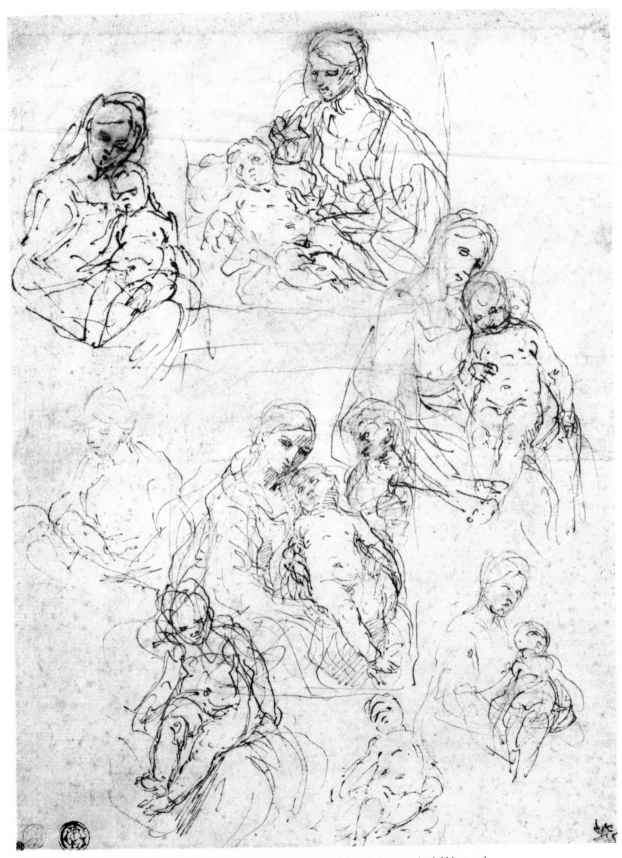

89 · SIMONE CANTARINI (IL PESARESE) · *Studies of the Madonna and Child* (cat. 77)

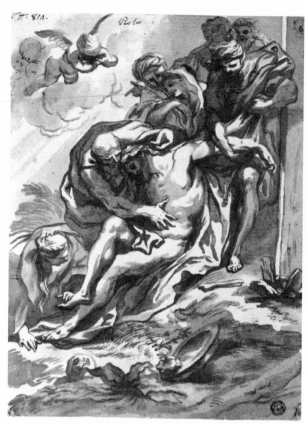

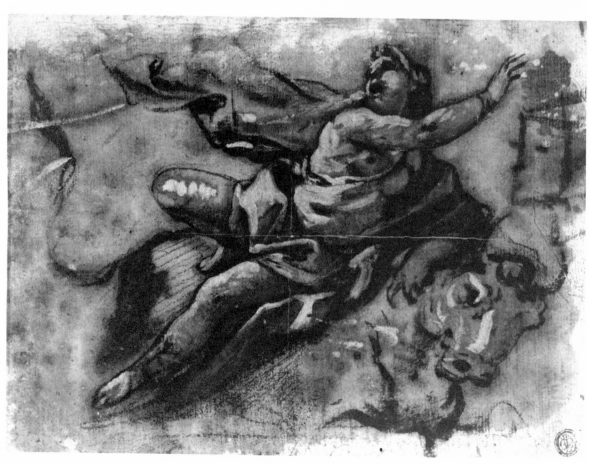

91 · LUCA GIORDANO · *Rape of Europa* (cat. 88)

92 · VALERIO CASTELLO
The Annunciation (cat. 83)

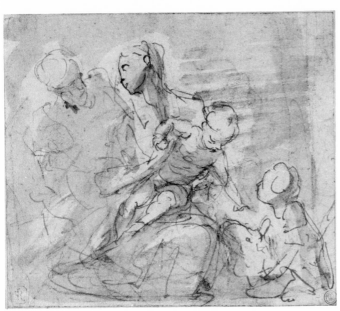

93 · VALERIO CASTELLO
Holy Family with the Infant Saint John (cat. 82)

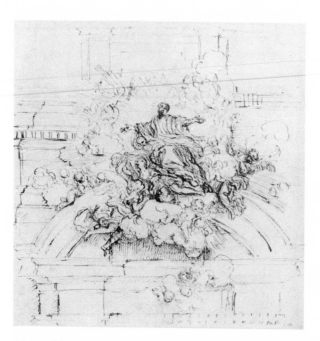

94 · CARLO MARATTA
Apotheosis of a Saint (cat. 85)

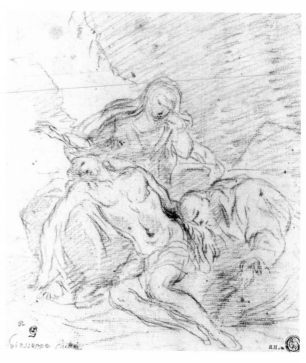

95 · GIUSEPPE BARTOLOMEO CHIARI
Pietà (cat. 92)

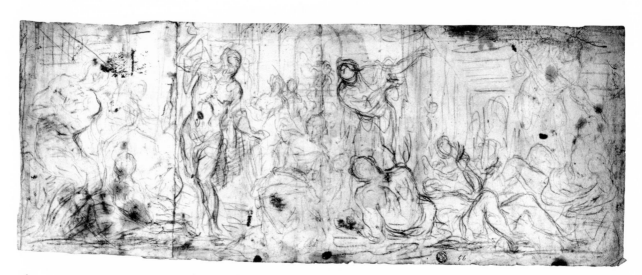

96 · ANDREA CELESTI · *The Miraculous Pool at Bethesda* (cat. 89)

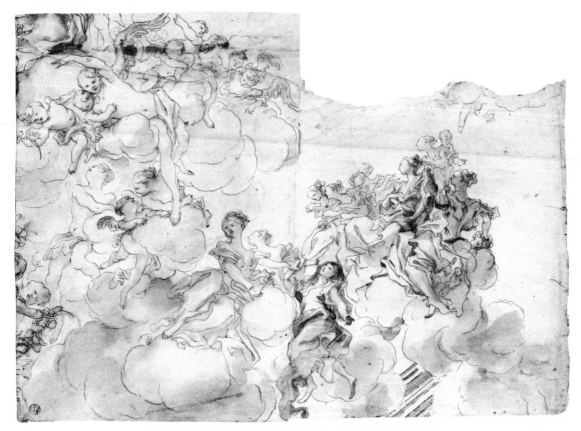

97 · GREGORIO DE FERRARI · *Female Figures with Putti in Clouds* (cat. 90)

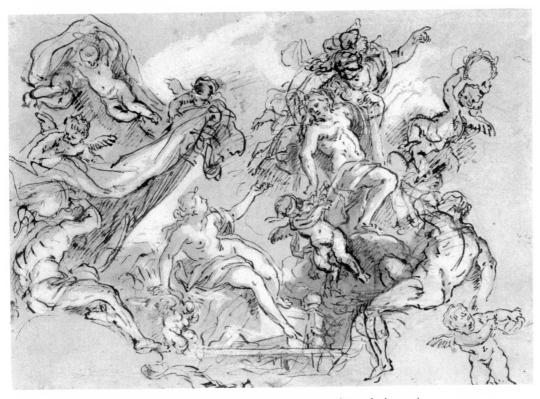

98 · ANTON DOMENICO GABBIANI · *The Apotheosis of Hercules* (cat. 91)

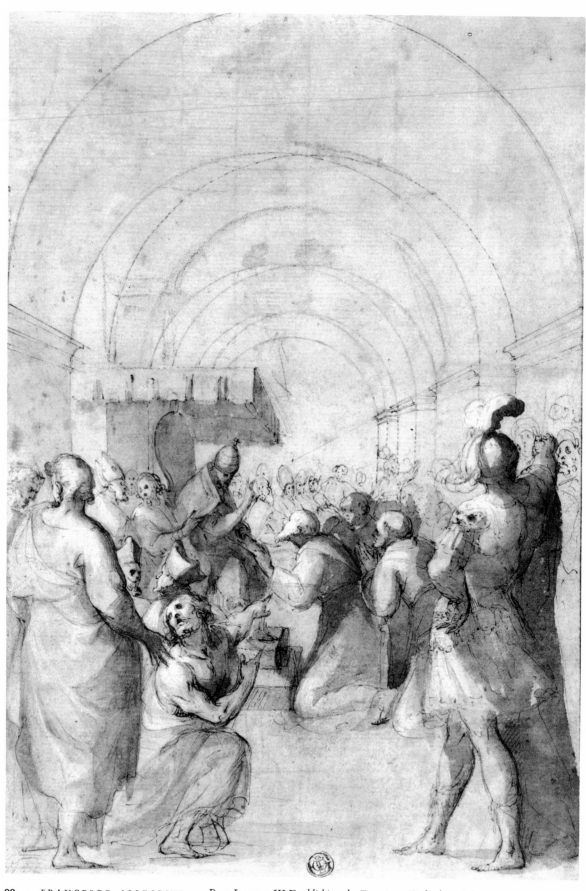

99 · FRANCESCO ALLEGRINI · *Pope Innocent III Establishing the Franciscan Order* (cat. 84)

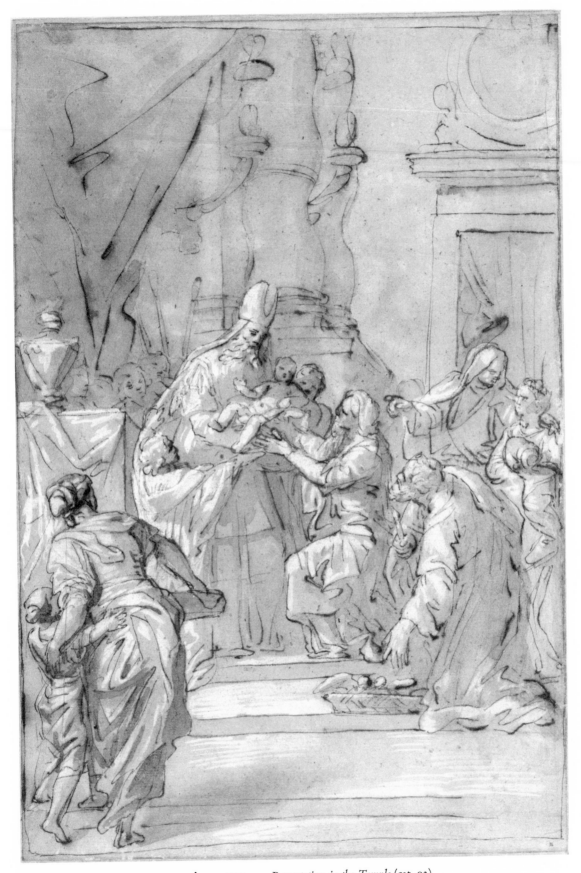

100 · PIETRO ANTONIO DE' PIETRI · *Presentation in the Temple* (cat. 93)

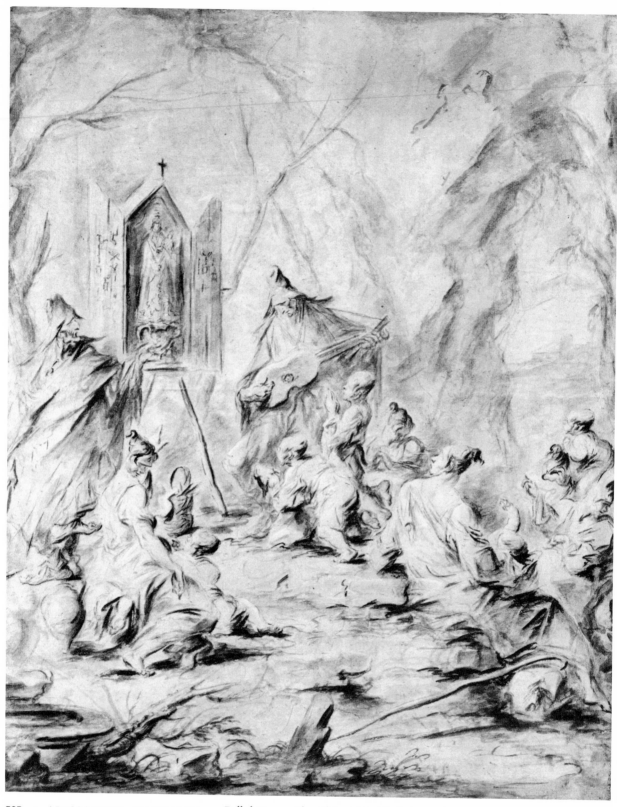

101 · ALESSANDRO MAGNASCO · *Ballad Singer with a Shrine of the Virgin* (cat. 95)

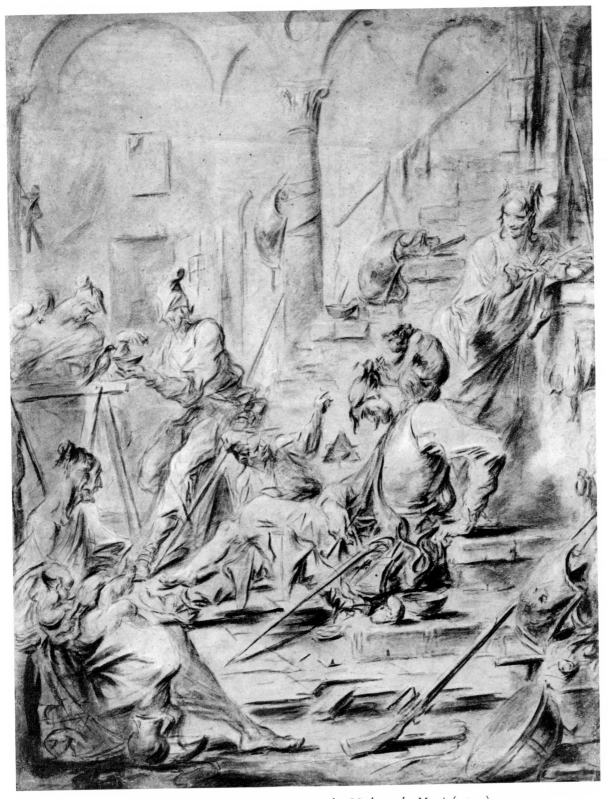

102 · ALESSANDRO MAGNASCO · *Picaresque Group with a Monkey and a Magpie* (cat. 94)

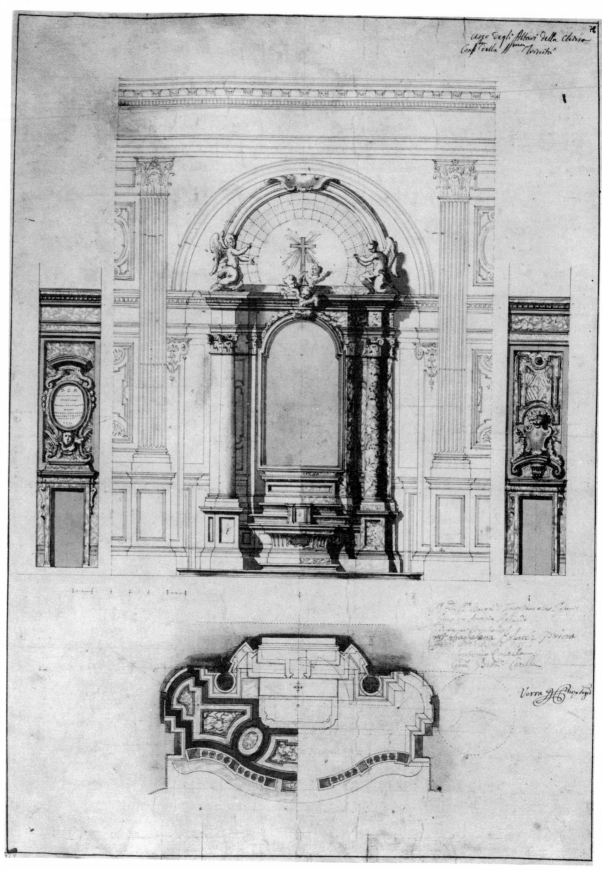

· FILIPPO JUVARRA · *Design for an Altar in the Church of the Confraternity Santissima Trinità, Turin (cat. 98)*

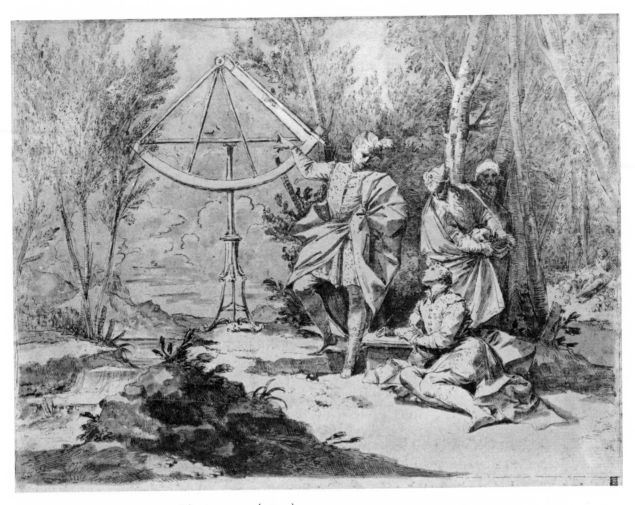

104 · DONATO CRETI · *The Astronomers* (cat. 97)

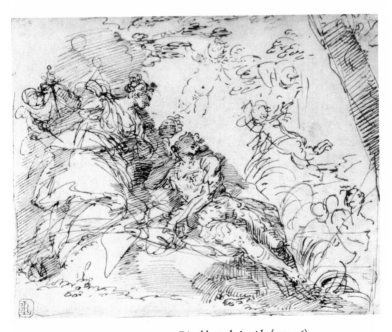

105 · DONATO CRETI · *Rinaldo and Armida* (cat. 96)

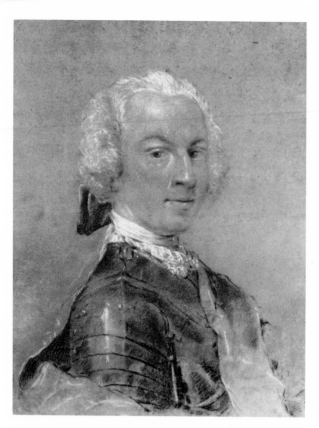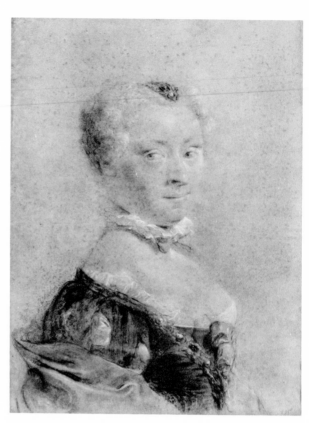

106 · GIOVANNI BATTISTA PIAZZETTA
*Portrait of Ferdinand Ludwig Count von
Oeynhausen-Schulenburg* (cat. 100)

107 · GIOVANNI BATTISTA PIAZZETTA
Portrait of a Lady (cat. 101)

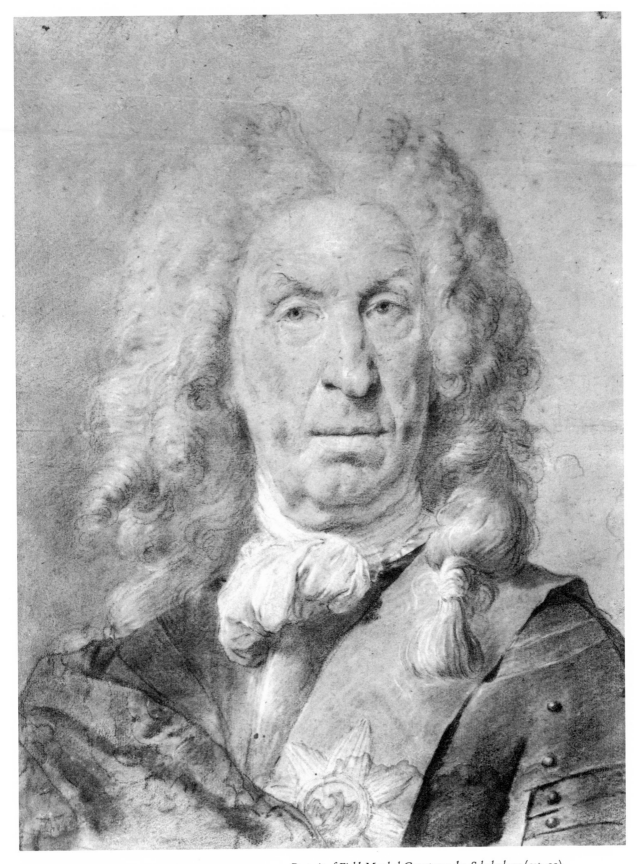

108 · GIOVANNI BATTISTA PIAZZETTA · *Portrait of Field Marshal Count von der Schulenburg* (cat. 99)

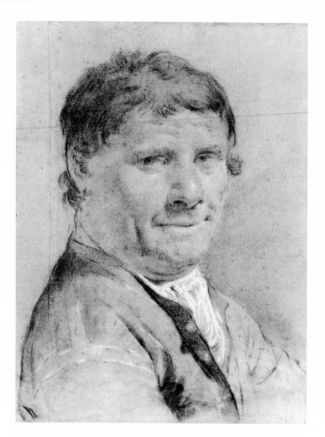

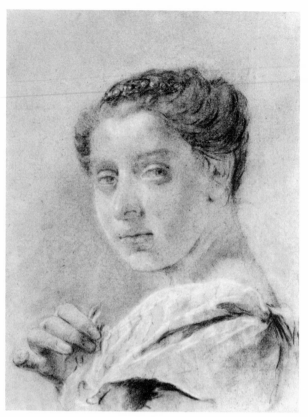

109 · GIOVANNI BATTISTA PIAZZETTA
Portrait of a Man (cat. 107)

110 · GIOVANNI BATTISTA PIAZZETTA
Portrait of a Young Woman (cat. 106)

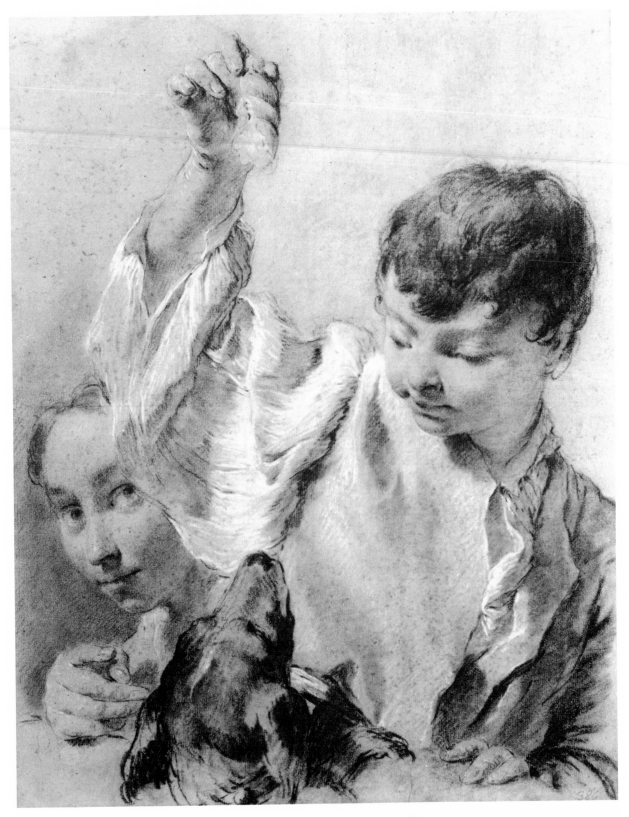

III · GIOVANNI BATTISTA PIAZZETTA · *Boy Feeding a Dog* (cat. 102)

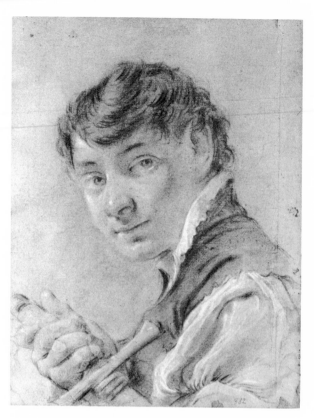

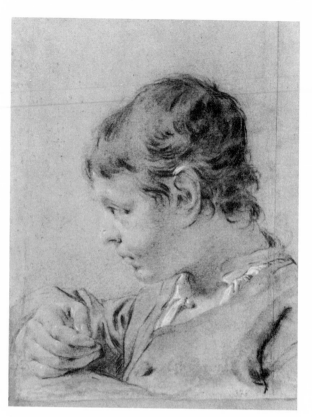

112 · GIOVANNI BATTISTA PIAZZETTA
Portrait of a Young Man Holding a Sword (cat. 103)

113 · GIOVANNI BATTISTA PIAZZETTA
Portrait of a Young Boy (cat. 104)

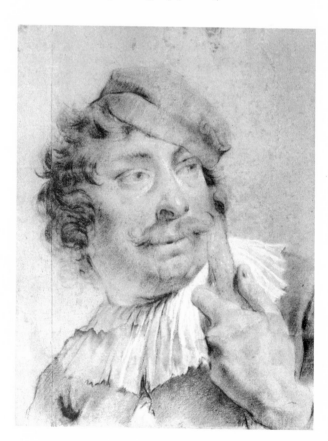

114 · GIOVANNI BATTISTA PIAZZETTA
Portrait of a Gondolier (cat. 105)

115 · GIOVANNI BATTISTA PIAZZETTA
Project for an Altar with Saint Margaret of Cortona,
Saint Sebastian, and Saint Roch, recto (cat. 108)

116 · GIOVANNI BATTISTA PIAZZETTA
Studies for an Altar, verso (cat. 108)

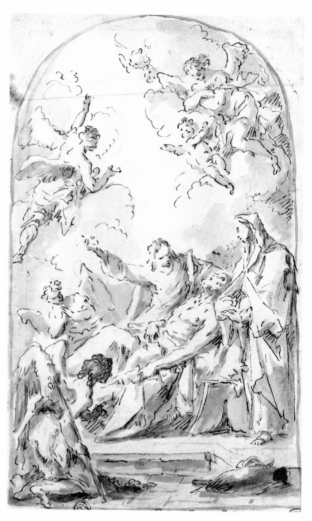

117 · GASPARE DIZIANI
Bacchus and Ariadne (cat. 110)

118 · GASPARE DIZIANI
The Death of Saint Joseph (cat. 109)

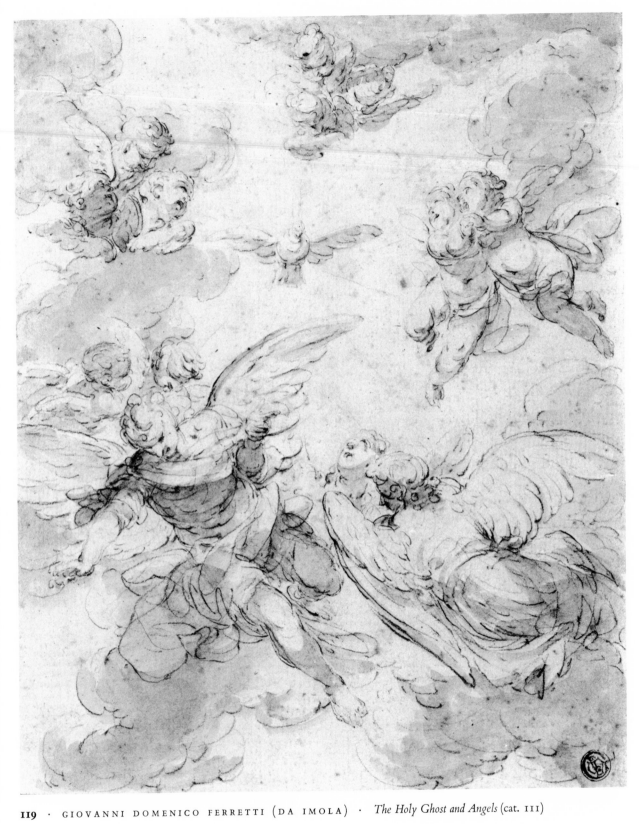

119 · GIOVANNI DOMENICO FERRETTI (DA IMOLA) · *The Holy Ghost and Angels* (cat. 111)

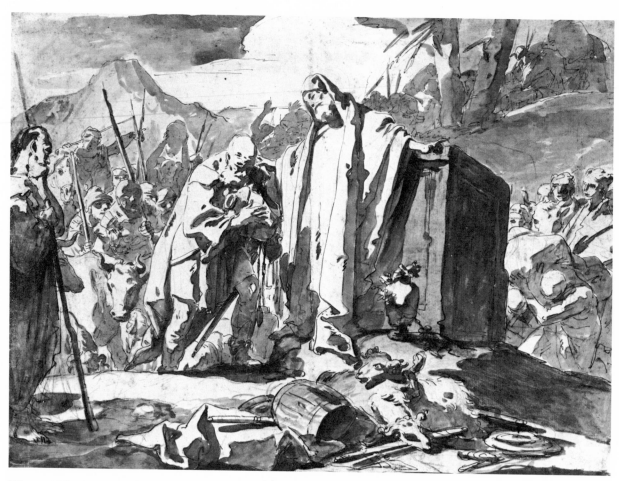

120 · GIOVANNI BATTISTA TIEPOLO · *The Meeting of Abraham and Melchizedek,* or *Moses Receiving the Offerings of the Princes* (cat. 112)

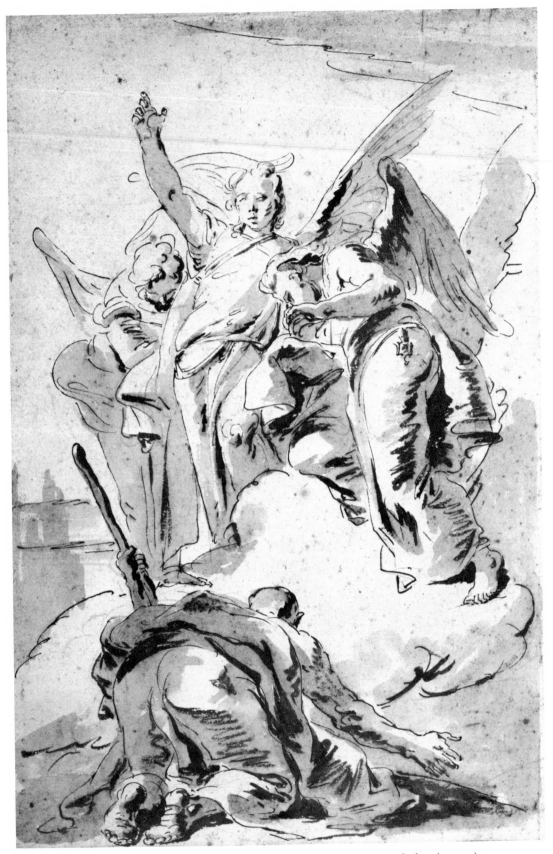

121 · GIOVANNI BATTISTA TIEPOLO · *Three Angels Appearing to Abraham* (cat. 113)

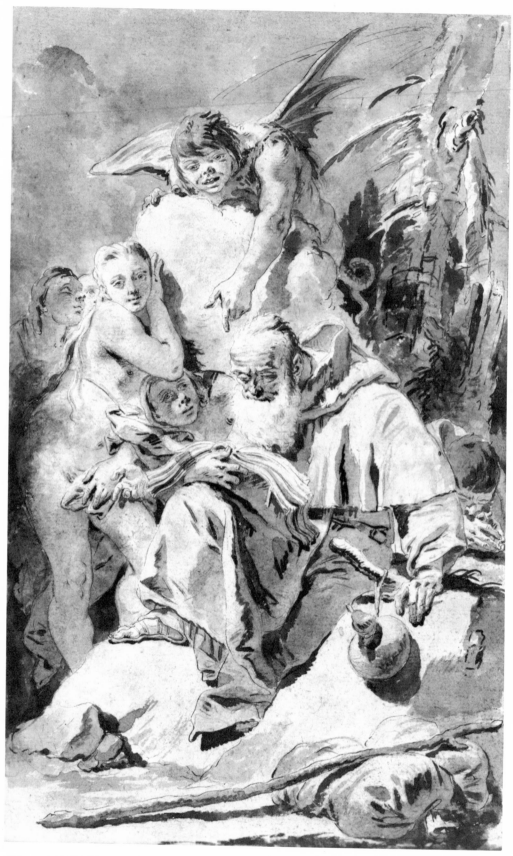

122 · GIOVANNI BATTISTA TIEPOLO · *The Temptation of Saint Anthony* (cat. 114)

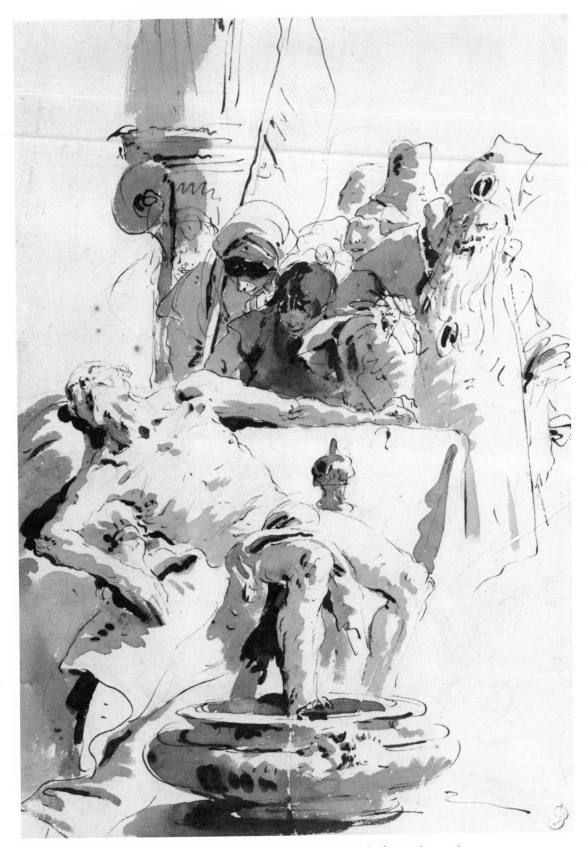

123 · GIOVANNI BATTISTA TIEPOLO · *Fantasy on the Death of Seneca* (cat. 116)

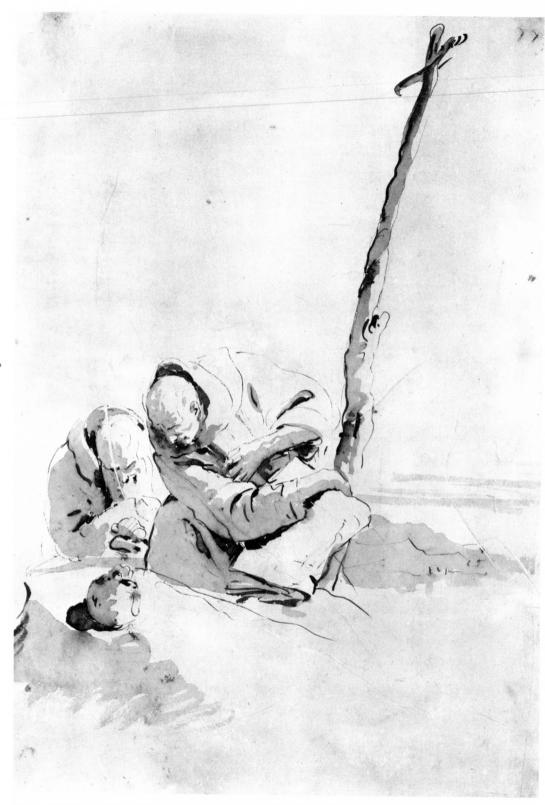

124 · GIOVANNI BATTISTA TIEPOLO · *Two Monks Contemplating a Skull* (cat. 115)

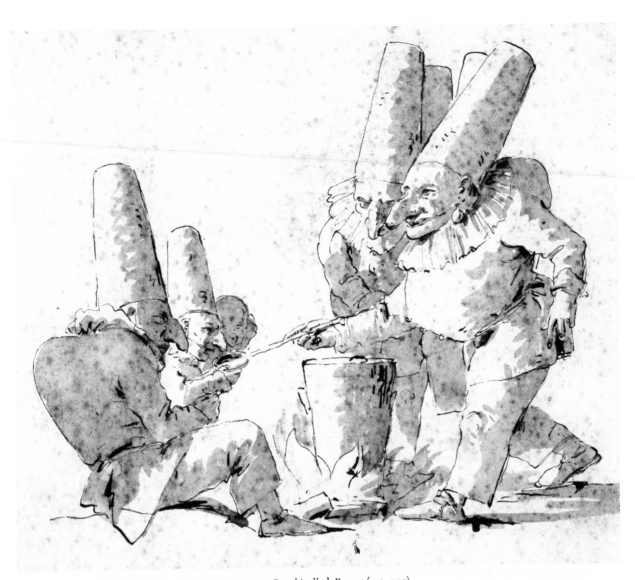

125 · GIOVANNI BATTISTA TIEPOLO · *Punchinellos' Repast* (cat. 117)

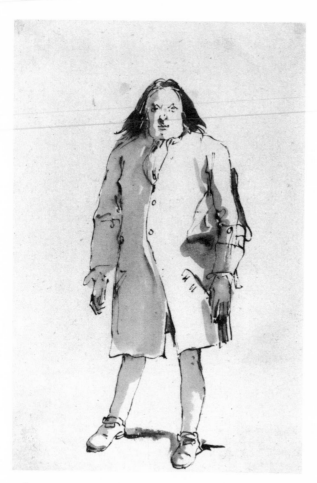

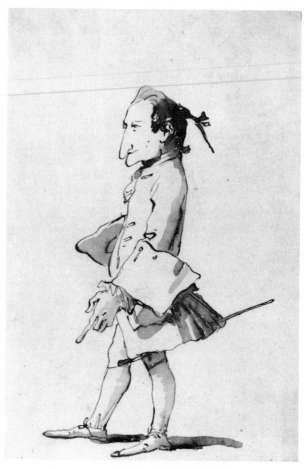

126 · GIOVANNI BATTISTA TIEPOLO
Caricature of a Man, Full Length, Facing Front (cat. 119)

127 · GIOVANNI BATTISTA TIEPOLO
Caricature of a Man, Full Length, Facing Left (cat. 118)

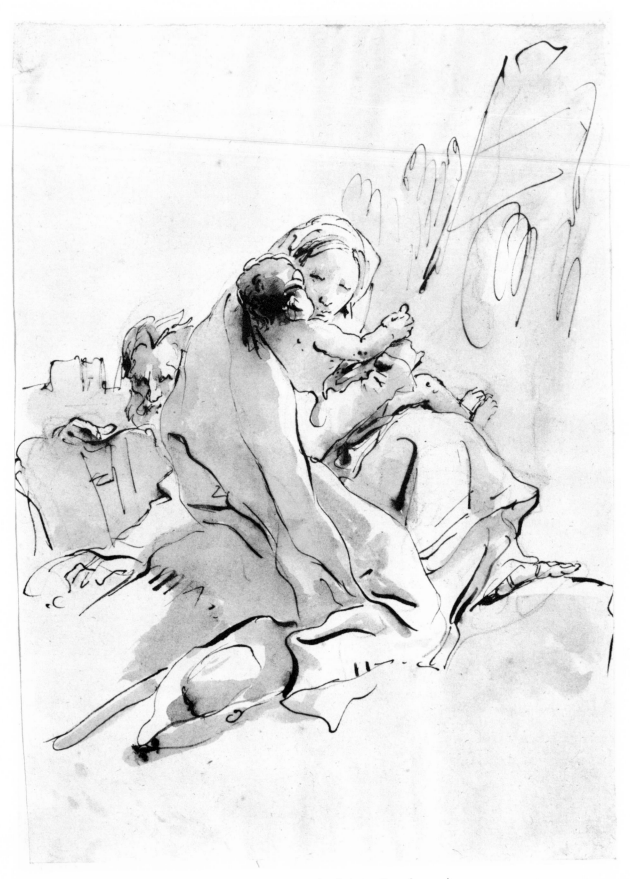

128 · GIOVANNI BATTISTA TIEPOLO · *Rest on the Flight into Egypt* (cat. 120)

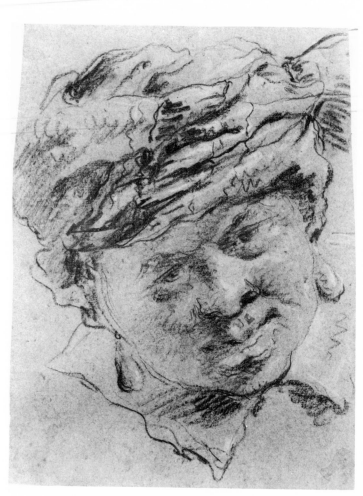

129 · GIOVANNI BATTISTA TIEPOLO(?)
Head of a Boy with a Turban (cat. 122)

130 · GIOVANNI BATTISTA TIEPOLO(?)
Study of a Hand (cat. 121)

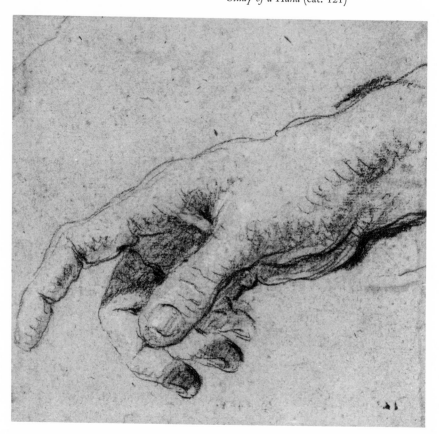

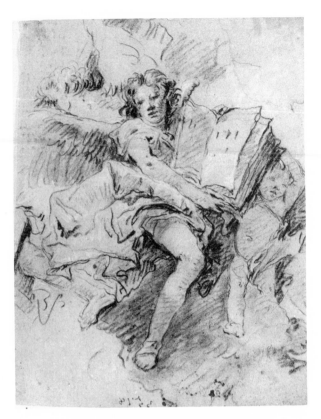

I3I · GIOVANNI DOMENICO TIEPOLO(?)
Angel Holding a Book (cat. 124)

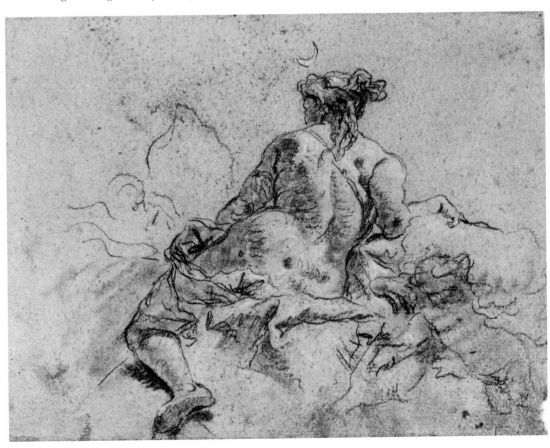

I32 · GIOVANNI DOMENICO TIEPOLO(?) · *Diana Seated* (cat. 123)

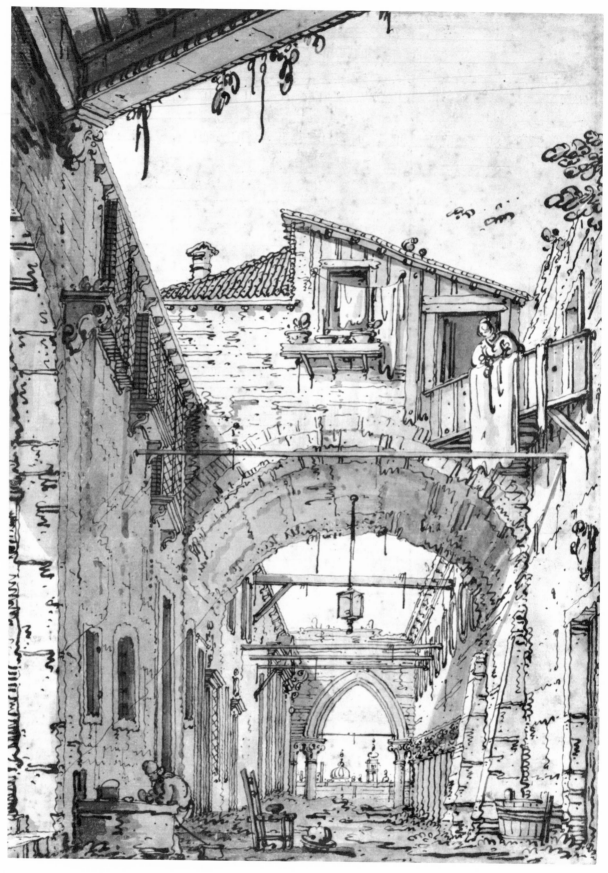

133 · ANTONIO CANAL (CANALETTO) · *Capriccio: A Street Crossed by Arches* (cat. 126)

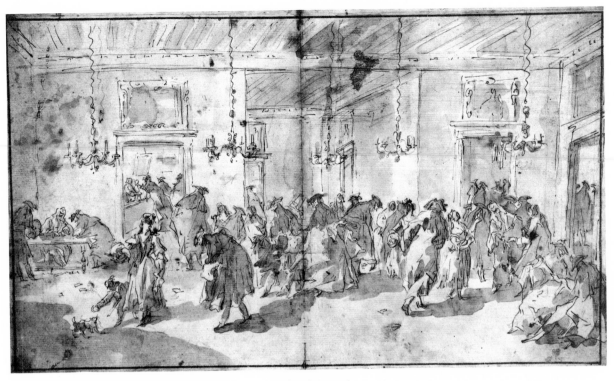

134 · GIOVANNI ANTONIO GUARDI · *Il Ridotto* (cat. 128)

135 · ANTONIO CANAL (CANALETTO) · *A Bridge near a Church in Venice* (cat. 125)

136 · ANTONIO CANAL (CANALETTO)
Capriccio: A Ruined Classical Temple (cat. 127)

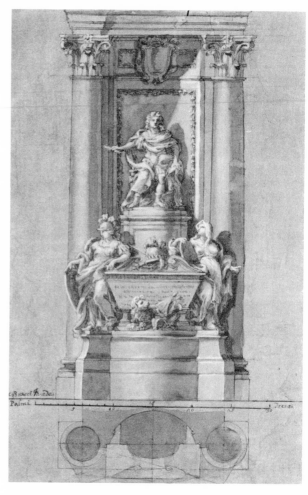

137 · PIETRO BRACCI · *Project for the Tomb of James III, the Old Pretender* (cat. 129)

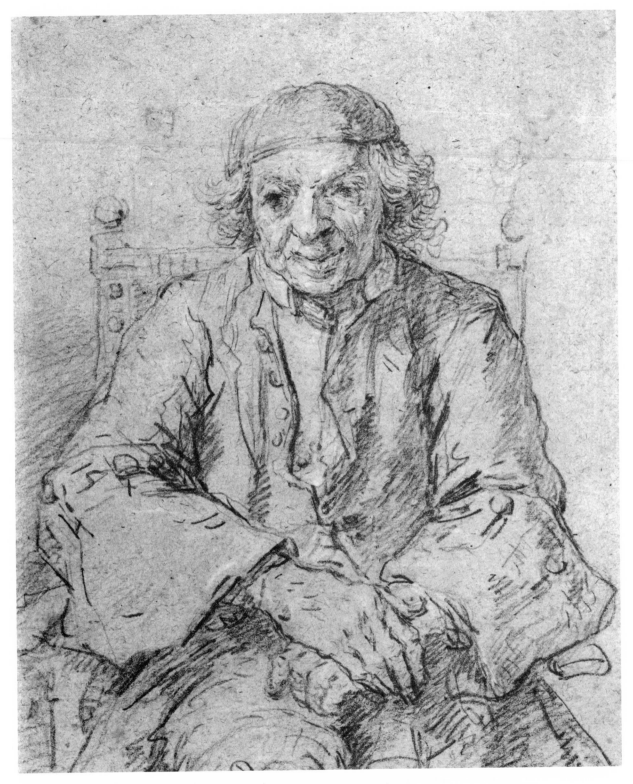

138 · FRANCESCO ZUCCARELLI · *Portrait of an Old Man* (cat. 130)

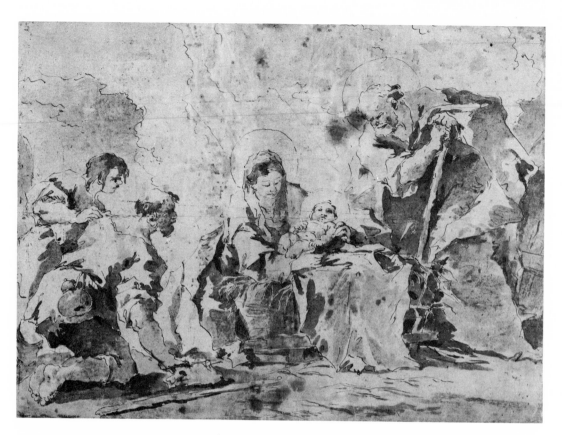

139 · FRANCESCO GUARDI · *Adoration of the Sheperds*, recto (cat. 133)

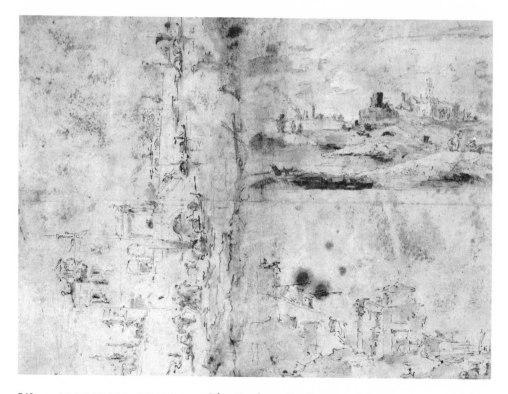

140 · FRANCESCO GUARDI · *Three Landscape Sketches*, verso (cat. 133)

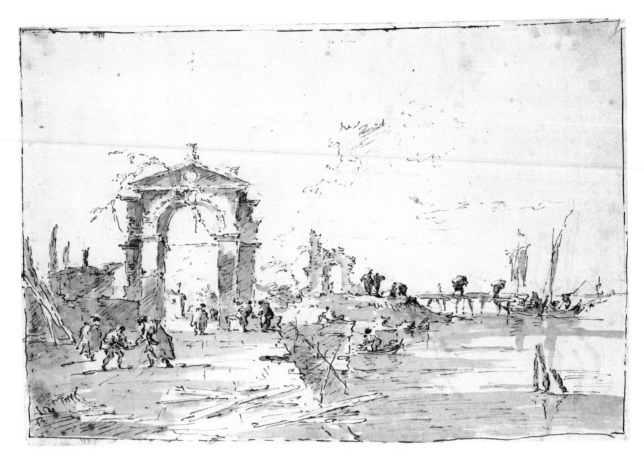

141 · FRANCESCO GUARDI · *Gateway near a Landing Bridge* (cat. 134)

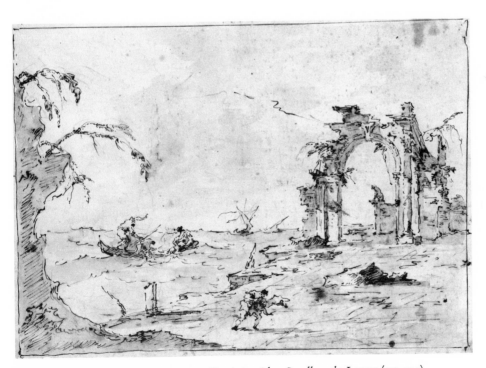

142 · FRANCESCO GUARDI · *Capriccio with a Squall on the Lagoon* (cat. 135)

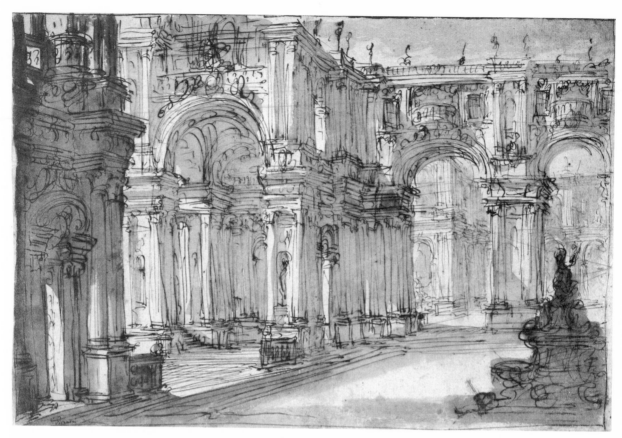

143 · GIOVANNI BATTISTA PIRANESI · *Palatial Courtyard with a Fountain* (cat. 136)

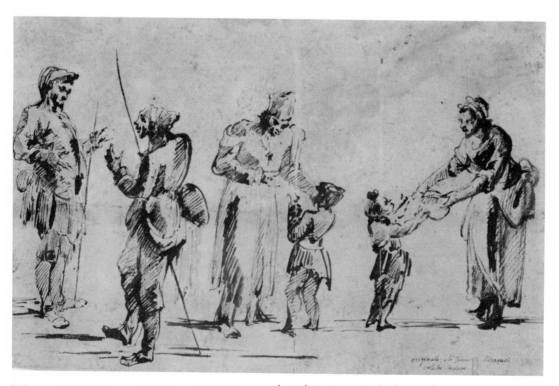

144 · GIOVANNI BATTISTA PIRANESI · *Sheet of Six Figure Studies* (cat. 137)

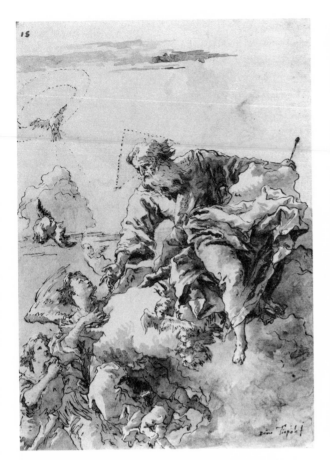

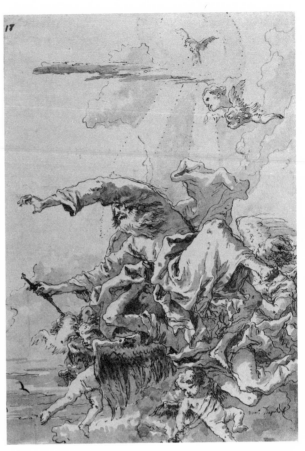

145 · GIOVANNI DOMENICO TIEPOLO
God the Father Supported by Angels in the Clouds, II
(cat. 139)

146 · GIOVANNI DOMENICO TIEPOLO
God the Father Supported by Angels in the Clouds, I
(cat. 138)

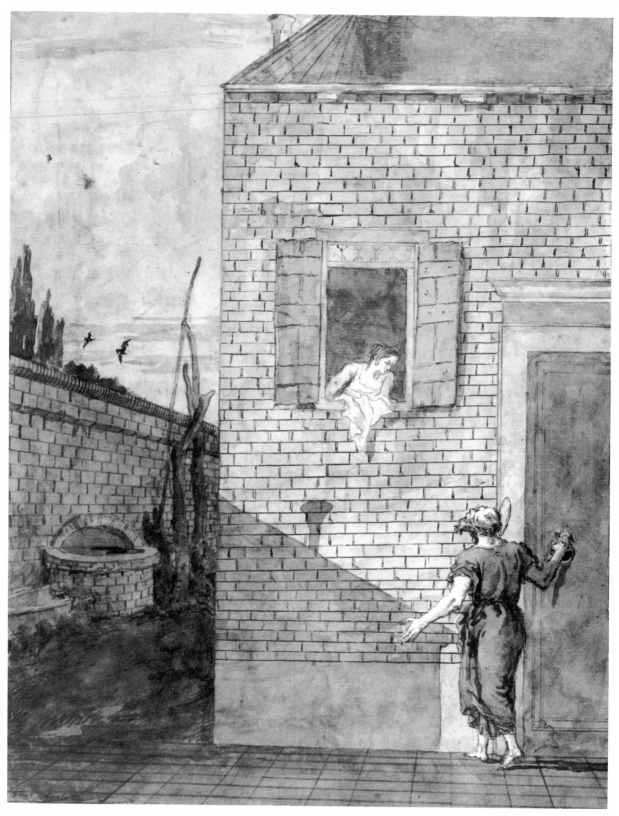

147 · GIOVANNI DOMENICO TIEPOLO · *Saints Peter and Rhoda* (cat. 143)

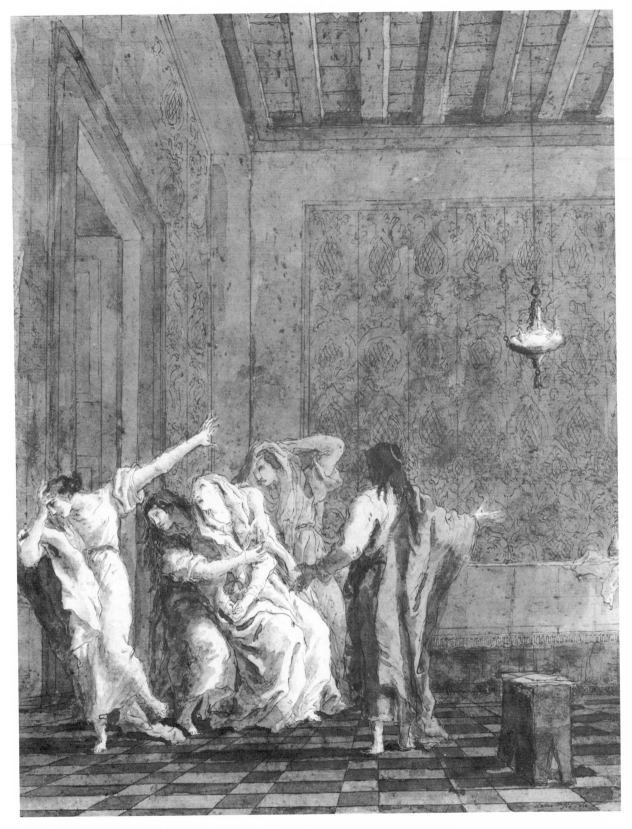

148 · GIOVANNI DOMENICO TIEPOLO · *Jesus in the House of Jairus* (cat. 142)

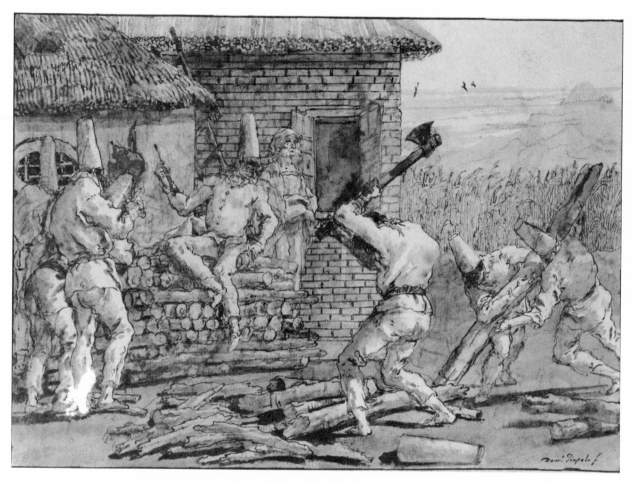

149 · GIOVANNI DOMENICO TIEPOLO · *Punchinello Chopping Logs* (cat. 145)

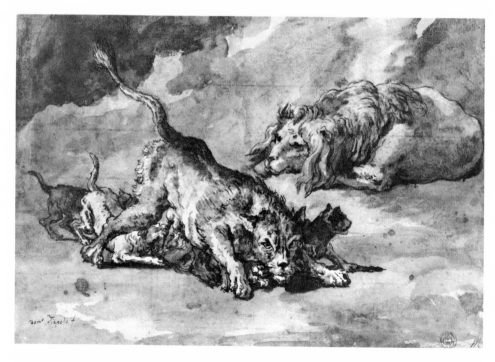

150 · GIOVANNI DOMENICO TIEPOLO · *Lion, Lioness, and Cubs* (cat. 141)

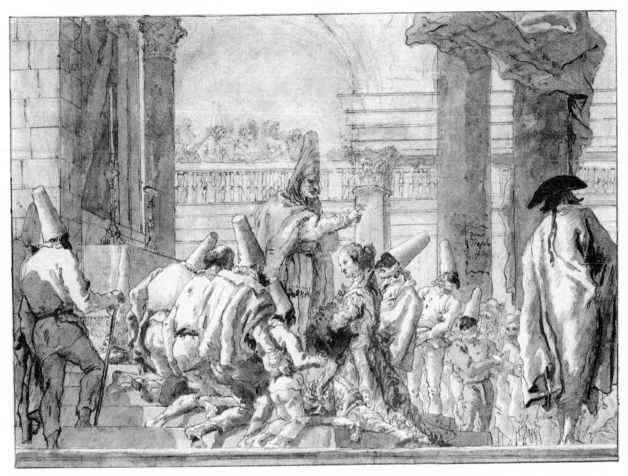

151 · GIOVANNI DOMENICO TIEPOLO · *The Wedding of Punchinello* (cat. 144)

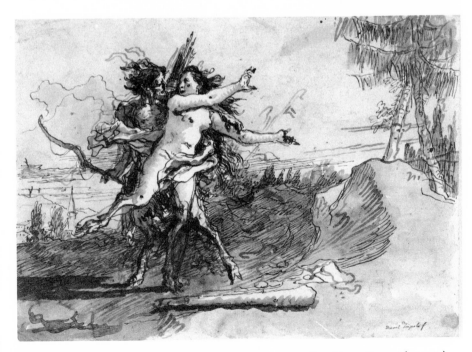

152 · GIOVANNI DOMENICO TIEPOLO · *Satyr Surprising a Satyress* (cat. 140)

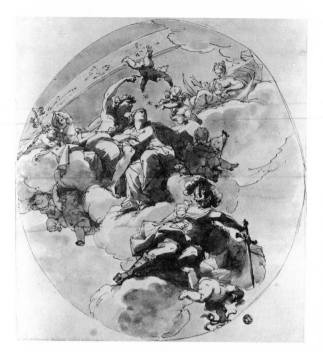

153 · UBALDO GANDOLFI(?) · *Ceiling with Bacchus, Ariadne, Diana and Minerva* (cat. 148)

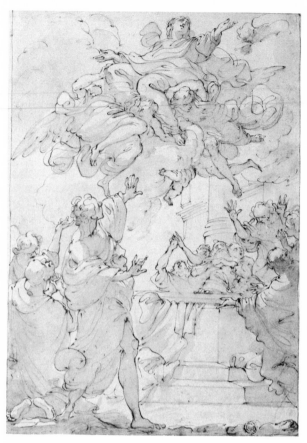

154 · UBALDO GANDOLFI(?)
The Assumption of the Virgin (Cat. 147)

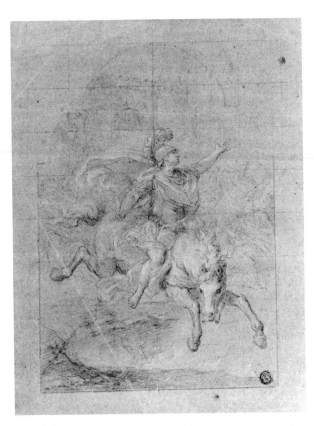

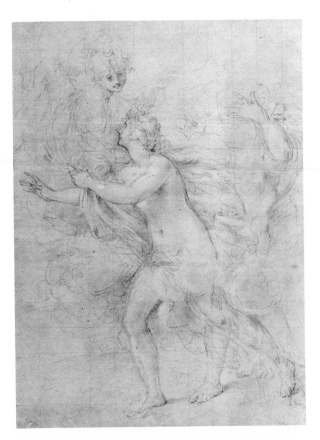

155 · STEFANO POZZI · *Marcus Curtius* (cat. 131)

156 · STEFANO POZZI · *Boreas and Orithyia* (cat. 132)

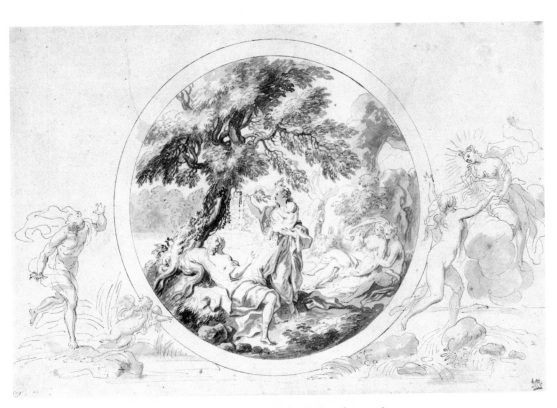

157 · GIOVANNI BATTISTA CIPRIANI · *Birth of Adonis* (cat. 146)

158 · MAURO ANTONIO TESI
Architectural Fantasy, recto (cat. 150)

159 · MAURO ANTONIO TESI
Architectural Details, verso (cat. 150)

160 · PIETRO ANTONIO NOVELLI · *Faith Overcoming Heresy* (cat. 149)

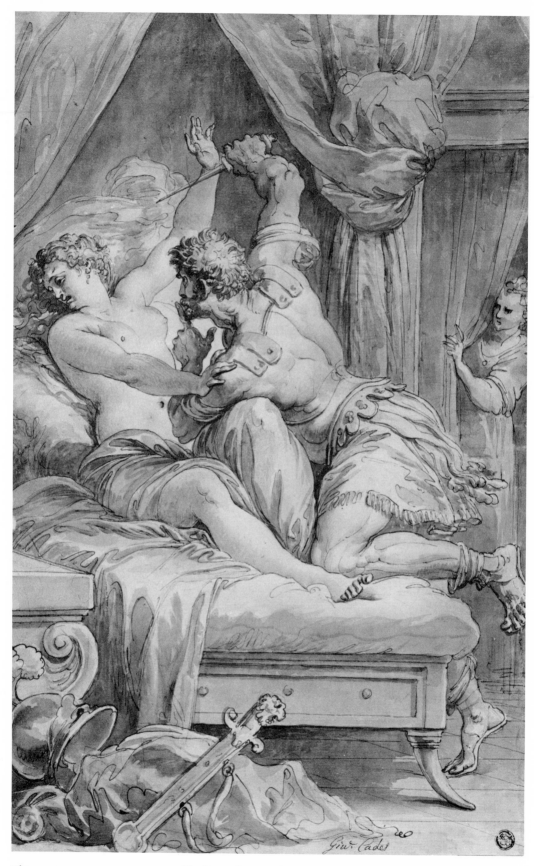

161 · GIUSEPPE CADES · *The Rape of Lucretia* (cat. 151)

BIBLIOGRAPHY

The Age of Vasari. Binghamton, N.Y.: University Art Gallery of the State University of New York at Binghamton, 1970.

Ames, W. *Drawings of the Masters: Italian Drawings from the Fifteenth to the Nineteenth Century*. New York: Shorewood Publishers, 1963.

Andrews, K. *Catalogue of Italian Drawings*. 2 vols. Edinburgh: National Gallery of Scotland, 1968.

Antal, F. "Drawings by Salviati and Vasari after a Lost Picture by Rosso." *Old Master Drawings* 14 (September 1939–March 1940): 47–49.

Arslan, E. *I Bassano*. 2 vols. Milan: Casa Editrice Ceschina [1960].

———. "Per la definizione dell'arte di Francesco, Giannantonio e Niccolò Guardi." *Emporium* 100 (December 1944): 2–28.

Art at Auction: The Year at Sotheby's and Parke-Bernet, 1966–67. New York: American Heritage, 1967.

Art in New England: Paintings, Drawings, Prints from Private Collections in New England. Boston: Museum of Fine Arts, 1939.

Askew, P. "Perino del Vaga's Decorations for the Palazzo Doria, Genoa." *Burlington Magazine* 98 (February 1956): 46–53.

Bacou, R., and Bean, J. *Mostra di disegni fiorentini del Museo del Louvre, dalla collezione di Filippo Baldinucci*. Rome: Gabinetto nazionale delle stampe, 1959.

Barocchi, P.; Bianchini, A.; Forlani, A.; and Fossi, M. *Mostra di disegni dei Fondatori dell'Accademia delle Arti del Disegno nel IV Centenario della fondazione*. Vol. 15. Florence: Gabinetto dei disegni e delle stampe degli Uffizi, 1963.

Bartarelli, A. "Domenico Gabbiani." *Rivista d'Arte* 27 (1951–52): 107–30.

Bartsch, A. *Le Peintre graveur*. 21 vols. Vienna: J. V. Degan, 1803–21.

Bassi-Rathgeb, R. *Un Album inedito di Francesco Zuccarelli*. Bergamo: Edizione Idea, 1949.

Baticle, A., and Georgel, P. *Technique de la peinture: l'Atelier*.

Dossiers de la Département des Peintures 12. Paris: Museé du Louvre, 1976.

Bean, J. *Les Dessins italiens de la collection Bonnat*. Vol. 4 of *Inventaire Général des dessins des Musées de Province*. Paris: Editions des Musées Nationaux, avec le concours du Centre national de la recherche scientifique, 1960.

———. "Form and Function in Italian Drawings." *Metropolitan Museum of Art Bulletin* 21 (March 1963): 225–39.

———. *Italian Drawings in the Art Museum, Princeton University*. Princeton: Art Museum, 1966.

———. Review of *Genoese Baroque Drawings*. *Master Drawings* 11 (Autumn 1973): 293–94.

Bean, J., and Stampfle, F. *Drawings from New York Collections*. Vol. 1, *The Italian Renaissance*. Vol. 2, *The Seventeenth Century in Italy*. Vol. 3, *The Eighteenth Century in Italy*. New York: Metropolitan Museum of Art and Pierpont Morgan Library, 1965–71.

Benesch, O. "Marginalien zur Tiepolo-Ausstellung in Venedig." *Alte und neue Kunst* 1 (1952): 53–69.

———. *Venetian Drawings of the Eighteenth Century in America*. New York: H. Bittner, 1947.

Berenson, B. *The Drawings of the Florentine Painters*. 3 vols. Chicago and London: University of Chicago Press, 1938, 1970.

———. *Italian Pictures of the Renaissance: Venetian School*. 2 vols. London: Phaidon Press, 1957.

Bertini, A. *I Disegni italiani della Biblioteca Reale di Torino*. Rome: Istituto Poligrafico dello Stato, 1958.

Bettagno, A. *Disegni di una collezione veneziana del settecento*. Venice: Fondazione Giorgio Cini, 1966.

———. *Disegni veneti del settecento della Fondazione Giorgio Cini e delle collezioni venete*. Venice: Fondazione Giorgio Cini, 1963.

Bianchi, L. *Cento disegni della Biblioteca Comunale di Urbania*. 2d ed. Rome: Gabinetto Nazionale della stampe, 1959.

Biavati, G. "Valerio Castello: tra manierismo e rococo." *Emporium* 136 (September 1962): 98–113.

Binion, A. *Antonio and Francesco Guardi: Their Life and Milieu.* New York and London: Garland Publishing, 1976.

————. "From Schulenburg's Gallery and Records." *Burlington Magazine* 112 (May 1970): 297–303.

Bjurström, P. *Drawings from Stockholm: A Loan Exhibition from the National Museum.* New York, Boston, and Chicago: Pierpont Morgan Library, Boston Museum of Fine Arts, Art Institute of Chicago, 1969.

Blunt, A. *The Drawings of G. B. Castiglione and Stefano della Bella in the Collection of Her Majesty the Queen at Windsor Castle.* London: Phaidon Press, 1954.

————. *Handlist of the Drawings in the Witt Collection.* London: London University, Courtauld Institute of Art, 1956.

————. "A Poussin-Castiglione Problem." *Journal of the Warburg and Courtauld Institutes* 3 (1939–40): 142–47.

Blunt, A., and Cooke, H. *The Roman Drawings of the Seventeenth and Eighteenth Centuries in the Collection of Her Majesty the Queen at Windsor Castle.* London: Phaidon Press, 1960.

Blunt, A., and Croft-Murray, E. *Venetian Drawings of the Seventeenth and Eighteenth Centuries in the Collection of Her Majesty the Queen at Windsor Castle.* London: Phaidon Press, 1957.

Bodmer, H. "Drawings by the Carracci: An Aesthetic Analysis." *Old Master Drawings* 8 (March 1934): 51–66.

————. *Lodovico Carracci.* Burg b. M.: A. Hopfer, 1939.

Bora, G. *Disegni di manieristi lombardi.* Vicenza: Neri Pozza, 1971.

————. "Note cremonese, 1: Camillo Boccaccino, le proposte." *Paragone* 25 (September 1974): 40–70.

Borea, E. *Domenichino.* Milan: G. Barbéra Editore, 1965.

Brenzoni, R. *Pisanello pittore.* Florence: Leo S. Olschki, 1952.

Briganti, G. *Pietro da Cortona o della pittura barocca.* Florence: Sansoni editore, 1962.

Briquet, C. *Les Filigranes dictionnaire historique des marques du papier.* 4 vols. Facsimile of the 1907 edition with supplement. Edited by Allan Stevenson. Amsterdam: Paper Publications Society, 1968.

Broeder, F. den. *Rome in the Eighteenth Century.* Storrs, Conn.: William Benton Museum of Art, 1973.

Brown, J. *Jusepe de Ribera: Prints and Drawings.* Princeton: Princeton University Press, 1973.

Bucci, M.; Forlani, A.; Berti, L.; and Gregori, M. *Mostra del Cigoli e del suo ambiente.* San Miniato: Accademia degli Euteleti, 1959.

Byam Shaw, J. "Benedetto Carpaccio." *Old Master Drawings* 14 (June 1939): 5.

————. *The Drawings of Domenico Tiepolo.* London: Faber & Faber, 1962.

————. *The Drawings of Francesco Guardi.* London: Faber & Faber, 1951.

————. *Drawings by Old Masters at Christ Church, Oxford.* 2 vols. Oxford: Clarendon Press, 1976.

————. *Old Master Drawings from Chatsworth II.* Washington, D.C.: International Exhibitions Foundation, 1969.

————. *Old Master Drawings from Christ Church, Oxford.* Washington, D.C.: International Exhibitions Foundation, 1972.

————. "The Remaining Frescoes in the Villa Tiepolo at Zianigo." *Burlington Magazine* 101 (November 1959): 391–95.

————. "Some Venetian Draughtsmen of the Eighteenth Century." *Old Master Drawings* 7 (March 1933): 47–63.

Cailleux, J. "Les Guardi et Pietro Longhi." In *Problemi Guardeschi,* pp. 51–54. Atti del Convengo di Studi promosso dalla Mostra dei Guardi, Venice, 13–14 settembre 1965. Venice: Alfieri, 1967.

Canedy, N. "Some Preparatory Drawings by Girolamo da Carpi." *Burlington Magazine* 112 (February 1970): 86–94.

Caricature and Its Role in Graphic Satire. Providence: Art Department, Brown University and the Museum of the Rhode Island School of Design, 1971.

Catalogue of a Century of Progress Exhibition of Paintings and Sculpture Lent from American Collections. Chicago: Art Institute of Chicago, 1933.

A Catalogue of Early Italian Drawings from the Leonora Hall Gurley Memorial Collection. Chicago: Art Institute of Chicago, 1922.

Catalogue of the Carl O. Schniewind Memorial Exhibition of Prints and Drawings. Chicago: Art Institute of Chicago, 1958.

Causa, R. *L'Arte nella Certosa di San Martino a Napoli.* Naples: Di Mauro Editore, 1973.

Chiarini, M. *I Designi italiani di paesaggio dal 1600 al 1750.* Rome: Libreria Editrice Canova, 1972.

Churchill, S. "Benvenuto Cellini, the Caradossos and Other Master Craftsmen of the Guild of the Goldsmiths of Rome." *Monatshefte für Kunstwissenschaft* 1, part 2 (1908): 1092–1102.

Clark, A. "An Introduction to the Drawings of Giuseppe Cades." *Master Drawings* 2 (Spring 1964): 18–26.

————. "Roman Eighteenth-Century Drawings in the Gilmor Collection." *Baltimore Museum of Art News* 24 (1961): 5–12.

Cocke, R. "A New Light on Late Veronese." *Burlington Magazine* 116 (January 1974): 24–31.

————. *Pier Francesco Mola.* Oxford: Clarendon Press, 1972.

Constable, W. *Canaletto.* Toronto: Art Gallery of Toronto, 1964.

————. *Canaletto: Giovanni Antonio Canal, 1697–1768.* 2 vols. Oxford: Clarendon Press, 1962; 2d ed., 1976.

Cummings, F., ed. *Art in Italy, 1600–1700.* Detroit: Detroit Institute of Arts, 1965.

Davidson, B. *Mostra di disegni di Perino del Vaga e la sua cerchia.* Vol. 23. Florence: Gabinetto dei disegni e delle stampe degli Uffizi, 1966.

————. "Drawings by Perino del Vaga for the Palazzo Doria, Genoa." *Art Bulletin* 41 (December 1959): 315–26.

Degenhart, B. "Di una publicazione su Pisanello e di altri fatti (I)." *Arte Veneta* 7 (1953): 182–85.

————. *Italienische Zeichnungen 15.–18. Jahrhundert*. Munich: Staatliche graphische Sammlung München, 1967.

————. *Pisanello*. Turin: Chiantore, 1945.

Degenhart, B., and Schmitt, A. *Corpus der italienischen Zeichnungen 1300–1450*. 4 vols. to date. Berlin: Gebr. Mann Verlag, 1968–.

Le Dessin italien dans les collections hollandaises. 2 vols. Paris: Institut Néerlandais, 1962.

Dobroklonsky, M. *Drawings of the Italian School, Seventeenth–Eighteenth Centuries: A Catalog*. Leningrad: State Hermitage, 1961.

Domarus, K. von. *Pietro Bracci*. Strassburg: J. H. Ed. Heitz (Heitz & Mündel), 1915.

Drawings and Prints of the First Maniera, 1515–1535. Providence, R.I.: Department of Art, Brown University and the Museum of Art, Rhode Island School of Design, 1973.

Drawings by Old Masters from the Collection of Dr. and Mrs. Francis Springell. London: P. & D. Colnaghi, 1959.

The Eighteenth Century: One Hundred Drawings by One Hundred Artists, A Loan Exhibition. Minneapolis: University of Minnesota, University Gallery, 1961.

Emiliani, A. *Mostra di disegni del seicento emiliano nella Pinacoteca di Brera*. Milan: Palazzo di Brera, 1959.

————. *Mostra di Federico Barocci*. Bologna: Museo Civico, 1975.

Engerth, E. R. von. *Gemälde: Beschreibendes Verzeichnis* Vol. 1. Kunsthistorische Sammlungen des Allerhöchesten Kaiserhauses, Vienna: Holzhausen, 1884.

Farmer, P., ed. *The Tiepolos: Painters to Princes and Prelates*. Birmingham, Ala.: Birmingham Museum of Art, 1978.

Fasanelli, J. "Some Notes on Pisanello and the Council of Florence." *Master Drawings* 3 (Spring 1965): 36–47.

Feinblatt, E. "D. M. Canuti and Giuseppe Rolli: Further Studies for Frescoes." *Master Drawings* 7 (Summer 1969): 164–68.

————. *Old Master Drawings from American Collections*. Los Angeles: Los Angeles County Museum of Art, 1976.

————. "Some Drawings by Canuti Identified." *Art Quarterly* 24 (1961): 262–82.

Fenyö, I. *Disegni veneti del Museo di Budapest*. Venice: Fondazione Giorgio Cini, 1965.

————. *Norditalienische Handzeichnungen aus dem Museum der Bildenden Künste in Budapest*. Budapest: Corvina, 1965.

Fernandez, R. "Three Drawings by Jacopo Palma Giovane." *Museum Studies* 4 (1969): 109–15.

Ferrari, O., and Scavizzi, G. *Luca Giordano*. Vol. 3. Naples: Edizioni scientifiche italiane, 1966.

Fiocco, G. *Carpaccio*. Novara: Istituto Geografico de' Agostini, 1958.

Fischel, O. "Die Zeichnungen der Umbrer." *Jahrbuch der Königlich preussischen Kunstsammlungen* 38 (1917): 184.

Fleming, J. "Mr. Kent, Art Dealer, and the Fra Bartolommeo Drawings." *Connoisseur* 141 (June 1958): 227.

Forlani, A. *I Disegni italiani del cinquecento*. Venice: Sodalizio del Libro [1962].

————. *Mostra di disegni di Jacopo da Empoli (Jacopo Chimenti 1551–1640)*. Vol. 14. Florence: Gabinetto dei disegni e delle stampe degli Uffizi, 1962.

Fossi Todorow, M. *I Disegni del Pisanello e della sua cerchia*. Florence: Leo S. Olschki, 1966.

————. *L'Italia dalle origini a Pisanello*. I Disegni dei maestri 3. Milan: Fratelli Fabbri, 1970.

Franchini Guelfi, F. *Alessandro Magnasco*. Genoa: Cassa di Risparmio di Genova e Imperia, 1977.

Frankfurter, A. "'Il bon disegno' from Chicago." *Art News* 62 (November 1963): 28–31, 55–59.

Freedberg, S. *Painting in Italy, 1500 to 1600*. Baltimore: Penguin Books, 1971; rev. ed., 1975.

————. Review of A. E. Popham, *Catalogue of the Drawings of Parmigianino*; A. E. Popham, *Disegni di Girolamo Bedoli*. *Art Bulletin* 55 (March 1973): 148–50.

Frizzoni, G. "Miscellanea: Notizie di Germania." *L'Arte* 5 (1902): 340–46.

Fröhlich-Bum, L. "Ausstellung der Sammlung Springell bei Colnaghi, London." *Die Weltkunst* 29 (November 1959): 10.

Gamulin, G. "Due dipinti di Palma il Giovane." *Paragone* 115 (1959): 50–53.

Gavazza, E. *Lorenzo de Ferrari, 1680–1744*. Milan: Edizioni La Rete, 1965.

Gerdts, E., and Gerdts, W. *Old Master Drawings*. Newark, New Jersey: The Newark Museum, 1960.

Gere, J. "Drawings by Niccolò Martinelli, il Trometta." *Master Drawings* 1 (Winter 1963): 3–18.

————. "The Lawrence-Phillipps-Rosenbach 'Zuccaro Album.'" *Master Drawings* 8 (Summer 1970): 123–40.

————. *Il manierismo a Roma*. I Disegni dei maestri 10. Milan: Fratelli Fabbri, 1971.

————. *Taddeo Zuccaro: His Development Studied in His Drawings*. Chicago: University of Chicago Press, 1969.

Gibbons, F. *Catalogue of Italian Drawings in the Art Museum, Princeton University*. 2 vols. Princeton: Princeton University Press, 1977.

————. "Notes on Princeton Drawings I: A Sheet of Figures by Perino del Vaga." *Record of the Art Museum, Princeton University* 26 (1967): 13–18.

Göthe, G. *Notice descriptive des tableaux du Musée national de Stockholm*, part 1. 3d ed. Stockholm: Ivar Haeggström, 1910.

Grassi, L. *Il Libro dei disegni di Jacopo Palma il Giovane all'Accademia di S. Luca*. Rome: Edizione dell'Elefante, 1968.

Great Master Drawings of Seven Centuries. New York: M. Knoedler, 1959.

Griffing, R., Jr. "The Kress Collection." *Honolulu Academy of Art News Bulletin and Calendar* 16 (June 1952): 2–6.

Guerlin, H. *Au temps du Christ; Jésus, la Vierge, les Apôtres*. Tours: Alfred Mame et fils, 1921.

Hadeln, D. F. von. *Handzeichnungen von G. B. Tiepolo*. 2 vols. Florence: Pantheon, 1927.

————. *Venezianische Zeichnungen der Hochrenaissance*. Berlin: Paul Cassirer, 1925.

——. *Venezianische Zeichnungen des Quattrocento*. Berlin: Paul Cassirer, 1925.

——. *Venezianische Zeichnungen der Spätrenaissance*. Berlin: Paul Cassirer, 1926.

——. *Zeichnungen des Giacomo Tintoretto*. Berlin: Paul Cassirer, 1922.

Härth, I. "Zu Landschaftszeichnungen Fra Bartolommeos und seines Kreises." *Mitteilungen des Kunsthistorischen Institutes in Florenz* 9 (1960): 125–30.

Harris, A., and Schaar, E. *Die Handzeichnungen von Andrea Sacchi und Carlo Maratta*. Vol. 1 of *Kataloge des Kunstmuseum Düsseldorf Handzeichnungen*. Düsseldorf: Kunstmuseum Düsseldorf, 1967.

Heawood, E. *Watermarks, Mainly of the Seventeenth and Eighteenth Centuries*. Hilversum, Holland: Paper Publications Society, 1950.

Held, J., and Posner, D. *Seventeenth and Eighteenth Century Art*. New York: Harry N. Abrams, 1971.

Hesthal, W. *Painted Papers: Watercolors from Dürer to the Present*. Santa Barbara: Santa Barbara Museum of Art, 1962.

Hind, A. *Early Italian Engraving*. 7 vols. London: B. Quaritch, 1938–48.

Hurd, A. *Selections from the Collection of Esther S. and Malcolm W. Bick: Italian Drawings*. Hanover: Dartmouth College, 1971.

Inig, L. *Disegni originali di Francesco Mazzola Parte del famosa Raccolta del Sig. Co. d'Arondell, ora presso M. de Non (Denon)*. Bologna, n.d.

Italienische Handzeichnungen des Barock aus den Bestanden des Kupferstichkabinetts im Kunstmuseum Düsseldorf. Düsseldorf: Kunstmuseum Düsseldorf 1964.

Ivanoff, N. "La Flagellation de Palma le jeune au Musée des Beaux-Arts de Lyons." *Bulletin des Musées Lyonnais*, 1956, pp. 1–10.

Jaffé, M. "Rubens as a Collector of Drawings: Part Two." *Master Drawings* 3 (Spring 1965): 21–35.

Jeudwine, W. "A Volume of Landscape Drawings by Fra Bartolommeo." *Apollo* 66 (1957): 132–35.

Joachim, H. *The Helen Regenstein Collection of European Drawings*. Chicago: Art Institute of Chicago, 1974.

——. "A Late Tiepolo Drawing." *Art Institute of Chicago Quarterly* 54 (February 1960): 18–19.

——. *A Quarter Century of Collecting: Drawings Given to the Art Institute of Chicago, 1944–1970, by Margaret Day Blake*. Chicago: Art Institute of Chicago, 1970.

——. "A Tiepolo Drawing." *Art Institute of Chicago Quarterly* 53 (April 1959): 23–25.

Johnston, C. "Donato Creti." *L'Oeil* 168 (December 1968): 46.

——. *Il Seicento e il settecento a Bologna*. I Disegni dei maestri 12. Milan: Fratelli Fabbri, 1971.

Karpinski, C., ed. *Le Peintre graveur illustré*, vol. 1. University Park and London: Pennsylvania State University Press, 1971.

Kelder, D. *Drawings by the Bibiena Family*. Philadelphia: Philadelphia Museum of Art, 1968.

Kelleher, P., and Taggart, R. "The Century of Mozart." *Nelson Gallery–Atkins Museum Bulletin* 1 (1956): 1–92.

Kennedy, R. "A Landscape Drawing by Fra Bartolommeo." *Smith College Museum of Art Bulletin* 39 (1959): 1–12.

Kerber, B. "Giuseppe Bartolomeo Chiari." *Art Bulletin* 50 (March 1968): 75–86.

Knapp, F. *Fra Bartolommeo della Porta und Die Schule von San Marco*. Halle: Wilhelm Knapp, 1903.

Knox, G. *Catalogue of the Tiepolo Drawings in the Victoria and Albert Museum*. London: Her Majesty's Stationery Office, 1960.

——. "A Group of Tiepolo Drawings Owned and Engraved by Pietro Monaco." *Master Drawings* 3 (Winter 1965): 389–97.

——. "The Orloff Album of Tiepolo Drawings." *Burlington Magazine* 103 (June 1961): 269–75.

——. *Tiepolo: A Bicentenary Exhibition 1770–1970*. Cambridge, Mass.: Fogg Art Museum, Harvard University, 1970.

Koschatzky, W.; Oberhuber, K.; and Knab, E. *Italian Drawings in the Albertina*. Greenwich, Conn.: New York Graphic Society, 1971.

Kurz, O. *Bolognese Drawings of the Seventeenth and Eighteenth Centuries in the Collection of Her Majesty the Queen at Windsor Castle*. London: Phaidon Press, 1955.

Lamantia, J. *Drawings and Architecture*. New Orleans: Tulane University, 1965.

Lasareff, V. "Francesco and Antonio Guardi." *Burlington Magazine* 65 (August 1934): 53–72.

Lauts, J. *Carpaccio: Paintings and Drawings*. London: Phaidon Press, 1962.

Le Blanc, C. *Manuel de l'amateur d'estampes*. 2 vols. Amsterdam: G. W. Hissing, 1970.

Levenson, J.; Oberhuber, K.; and Sheehan, J. *Early Italian Engravings from the National Gallery of Art*. Washington, D.C.: National Gallery of Art, 1973.

Lorenzetti, G. *Mostra del Tiepolo*. Venice: Alfieri, 1951.

Lugt, F. *Les Marques de collections de dessins et d'estampes*. Amsterdam: Vereenigde Drukkerijen, 1921.

——. *Les Marques de collections de dessins et d'estampes. Supplement*. The Hague: Martinus Nijhoff, 1956.

Maffei, F. de'. "La Questione Guardi: Precisazione e aggiunte." *In Arte in Europa: Scritti di storia dell' arte in onore di Edoardo Arslan*, 1:839–67. Milan: Tipographia Artipo, 1966(?).

Mahon, D. *Il Guercino: catalogo critico dei dipinti*. Bologna: Palazzo dell'Archiginnasio, 1968.

——. *Il Guercino: catalogo critico dei disegni*. Bologna: Palazzo dell'Archiginnasio, 1969.

——. *Mostra dei Carracci: catalogo critico*. Bologna: Palazzo dell'Archiginnasio, 1956.

——. *Mostra dei Carracci: catalogo critico dei disegni*. Bologna: Palazzo dell'Archiginnasio, 1963.

——. *Omaggio al Guercino: mostra di dipinti restaurati e di disegni della Collezione Denis Mahon di Londra*. Cento: Pinacoteca comunale, 1967.

Malaguzzi-Valeri, F. "Due nuove mostre di antichi disegni." *Rassegna d'arte* 11 (1911): 18–22.

Malvasia, C. *Felsina pittrice: vite de' pittori bolognesi.* Edited by Giampietro Zanotti. 2 vols. Bologna: Tipografia Guidi all 'Ancora, 1841.

Mancigotti, M. *Simone Cantarini, il Pesarese.* Pesaro: Banca Popolare Pesarese, 1975.

Marcenaro, C. *Mostra dei pittori genovesi a Genova nel '600 e nel '700.* Genoa: Palazzo Bianco, 1969.

Martini, E. *La Pittura veneziana del settecento.* Venice: Edizioni Marciane, 1964.

Maser, E. *Gian Domenico Ferretti.* Florence: Marchi & Bertotti, 1968.

Masetti, A. *Cecco Bravo: pittore toscano del seicento.* Venice: Neri Pozza, 1962.

Massar, P. "Costume Drawings by Stefano della Bella for the Florentine Theater." *Master Drawings* 8 (Autumn 1970): 243–66.

Master Drawings from the Art Institute of Chicago. New York: Wildenstein, 1963.

Maxon, J. "A Sheet of Drawings by Carpaccio." *Art Institute of Chicago Quarterly* 56 (Winter 1962): 62–64.

McKee, W. "The Gurley Collection of Drawings." *Bulletin of the Art Institute of Chicago* 16 (March–April 1922): 25–27.

Middeldorf, U. "Three Italian Drawings in Chicago." *Art in America* 27 (1929): 11–14.

Milkovitch, M. *Sebastiano and Marco Ricci in America.* Lexington: University of Kentucky, 1966.

Moccagatta, V. "Guglielmo Caccia detto il Moncalvo: le opere di Torino e la Galleria di Carlo Emanuele I." *Arte Lombarda* 8 (1963): 185–243.

Modigliani, E. "Ancora sul 'Ridotto' di Giovanni Antonio Guardi al Museo Correr." *Dedalo* 7 (December 1926): 438–42.

Moir, A., ed. *Drawings by Seventeenth-Century Italian Masters from the Collection of Janos Scholz.* Santa Barbara: Art Galleries, University of California, 1974.

Monbeig-Goguel, C. "Giorgio Vasari et son temps." *Revue de l'Art* 14 (1971): 105–11.

———. *Vasari et son temps.* Vol. 1 of *Inventaire Général des dessins italiens.* Paris: Editions des Musées Nationaux, 1972.

Mongan, A., and Sachs, P. *Drawings in the Fogg Museum of Art.* 3 vols. Cambridge, Mass.: Harvard University Press, 1940.

Morassi, A. *A Complete Catalogue of the Paintings of G. B. Tiepolo.* London: Phaidon Press, 1962.

———. "Conclusioni su Antonio e Francesco Guardi." *Emporium* 94 (November 1951): 202.

———. *Dessins vénitiens du dix-huitième siècle de la collection du Duc de Talleyrand.* Milan: Edizioni Daria Guarnati, 1958.

———. *Guardi: Antonio e Francesco Guardi.* 2 vols. Venice: Alfieri [1973].

———. *Guardi: Tutti i disegni di Antonio, Francesco e Giacomo Guardi.* Venice: Alfieri, 1975.

———. *Mostra del Magnasco.* Genoa: Palazzo Bianco, 1949.

———. "Settecento inedito III." *Arte Veneta* 6 (1952): 85–91.

———. "A Signed Drawing by Antonio Guardi and the Problem of the Guardi Brothers." *Burlington Magazine* 95 (August 1953): 260–67.

———. "Sui disegni del Tiepolo nelle recente mostre di Cambridge, Mass. e di Stoccarda." *Arte Veneta* 24 (1970): 294–310.

Moschini, V. *Francesco Guardi.* Milan: A. Martello, 1952; 2d ed., 1956.

Mullaly, T. *Disegni veronesi del cinquecento.* Venice: Fondazione Giorgio Cini, 1971.

Muraro, M. *Carpaccio.* Florence: Edizioni d'arte Il Fiorino, 1966.

———. *Catalogo della mostra di disegni veneti della collezione Janos Scholz.* Venice: Fondazione Giorgio Cini, 1957.

———. *Mostra di disegni veneziani del sei e settecento.* Vol. 4. Florence: Gabinetto disegni e stampe degli Uffizi, 1953.

Murray, C. J. *Pierpont Morgan Collection of Drawings by the Old Masters Formed by C. Fairfax Murray.* Vol. 4. London: Privately printed, 1912.

Neilson, N. *Italian Drawings Selected from Mid-Western Collections.* Saint Louis: Saint Louis Art Museum, 1972.

Newcome, M. "The Drawings of Valerio Castello." *Master Drawings* 13 (Spring 1975): 26–40.

———. *Genoese Baroque Drawings.* Binghamton, N.Y.: University Art Gallery of the State University of New York at Binghamton, 1972.

———. "Lorenzo de Ferrari Revisited." *Paragone* 335 (January 1978): 62–79.

Newcome Schleier, M. *Maestri Genovesi dal cinque al settecento.* Biblioteca di Disegni, vol. 10. Florence: Istituto Alinari, 1977.

Nugent, M. *Alla mostra della pittura italiana del '600 e '700.* 2 vols. San Casciano, Val di Pesa: Società editrice Toscana, 1925–30.

Oberhuber, K. *Disegni di Tiziano e della sua cerchia.* Venice: Fondazione Giorgio Cini, 1976.

———. "Drawings by Artists Working in Parma in the Sixteenth Century." *Master Drawings* 8 (Autumn 1970): 276–87.

———. "Observations on Perino del Vaga as a Draughtsman." *Master Drawings* 4 (Summer 1966): 70–82.

Oberhuber, K., and Walker, D. *Sixteenth Century Italian Drawings from the Collection of Janos Scholz.* Washington, D.C.: National Gallery of Art, 1973.

Ojetti, U. *Il Settecento italiano.* 2 vols. Milan and Rome: Bestetti & Tumminelli, 1932.

Olsen, H. *Federico Barocci.* 2d ed. Copenhagen: Munksgaard, 1962.

———. "Federico Barocci: A Critical Study in Italian Cinquecento Painting." *Figura* 6 (1955): 1–228.

The Order of Saint John in Malta. Valletta, Malta: Museum of Saint John's Co-Cathedral, 1970.

Original Drawings by Old Masters of the Schools of North Italy in the Collection of J. P. Heseltine. London: Chiswick Press, 1906.

Pallucchini, R. "Altri disegni preparatori del Piazzetta." *Arte Veneta* 12–14 (1959–60): 220–22.

———. *I Disegni del Guardi al Museo Correr di Venezia*. Venice: Edizioni Daria Guarnati, 1943.

———. "Disegni veneziani del settecento in America." *Arte Veneta* 2 (1948): 157–58.

———. "Miscellanea Piazzetesca." *Arte Veneta* 22 (1968): 106–30.

———. *Mostra di Paolo Veronese*. Venice: Ca' Giustinian, 1939.

———. "Note alla Mostra dei Guardi." *Arte Veneta* 19 (1965): 223–24.

———. "Opere tarde del Piazzetta." *Arte Veneta* 1 (1947): 108–16.

———. *Piazzetta*. Milan: Aldo Martello [1956].

———. *I Teleri del Carpaccio in S. Giorgio degli Schiavone*. Milan: Rizzoli, 1961.

Parker, K. *Catalogue of the Collection of Drawings in the Ashmolean Museum*. 2 vols. Oxford: Clarendon Press, 1956.

Parker, K., and Mathey, J. *Antoine Watteau: Catalogue complet de son oeuvre dessiné*. 2 vols. Paris: F. de Nobèle, 1957–58.

La Peinture italienne au XVIII^e siècle. Paris: Petit-Palais, 1960–61.

Percy, A. *Giovanni Benedetto Castiglione, Master Draughtsman of the Italian Baroque*. Philadelphia: Philadelphia Museum of Art, 1971.

Pérez Sánchez, A. *Gli Spagnoli da El Greco a Goya*. I Disegni dei maestri 4. Milan: Fratelli Fabbri, 1970.

Perocco, G. *Carpaccio nella Scuola di San Giorgio degli Schiavoni*. Venice: Ferdinando Ongania, 1964.

Pietro, F. di. *Disegni sconosciuti e disegni finora non identificati di Federigo Barocci negli Uffizi*. Florence: Istituto micrografico italiano, 1913.

Pignatti, T. *Disegni dei Guardi*. Florence: La Nuova Italia, 1967.

———. "Disegni di G. B. Tiepolo." In G. Lorenzetti, *Mostra del Tiepolo*, pp. 175–85. Venice: Alfieri, 1951.

———. "Disegni veneti del seicento." In P. Zampetti, *La Pittura del seicento a Venezia*, pp. 155–93. Venice: Ca' Pesaro, 1959.

———. *I Disegni veneziani del settecento*. Il Disegno italiano. Treviso: Libreria Editrice Canova [1966].

———. "Un Disegno di Antonio Guardi donato al Museo Correr." *Bollettino dei Musei Civici Veneziani* 1–2 (1957): 21–32.

———. "The Exhibition of Tiepolo Drawings at Udine," *Master Drawings* 4 (Autumn 1966): 305–8.

———. *Il Museo Correr di Venezia: dipinti del XVII e XVIII secolo*. Venice: Fondazione Giorgio Cini, 1960.

———. "Nuovi disegni del Piazzetta." *Critica d'arte* 4 (September–October 1957): 395–403.

———. "Nuovi disegni di figura dei Guardi." *Critica d'arte* 11 (December 1964): 57–72.

———. Review of *Carpaccio: Paintings and Drawings* by Jan Lauts. *Master Drawings* 1 (Winter 1963): 47–53.

———. *La Scuola veneta*. I Disegni dei maestri 2. Milan: Fratelli Fabbri, 1970.

———. *Tiepolo, disegni*. Florence: La Nuova Italia, 1974.

———. "Tiepolo incisore e disegnatore." *La Fiera letteraria*, June 17, 1951, p. 11.

———. *Venetian Drawings from American Collections*. Washington, D.C.: International Exhibitions Foundation, 1974.

———. *Veronese*. 2 vols. Venice: Alfieri, 1976.

Pillsbury, E. "The Sala Grande Drawings by Vasari and His Workshop: Some Documents and New Attributions." *Master Drawings* 14 (Summer 1976): 127–46.

Pillsbury, E., and Caldwell, J. *Sixteenth Century Italian Drawings: Form and Function*. New Haven: Yale University Art Gallery, 1974.

Pillsbury, E., and Richards, L. *The Graphic Art of Federico Barocci*. New Haven: Yale University Art Gallery, 1978.

Planiczig, L., and Voss, H. *Drawings of Old Masters from the Collection of Dr. Benno Geiger*. Vienna: Amalthea, n.d.

Poensgen, T. "Some Unknown Drawings by Domenico Maria Canuti." *Master Drawings* 5 (Summer 1967): 165–68.

Pope-Hennessy, J. *The Drawings of Domenichino in the Collection of His Majesty the King at Windsor Castle*. London: Phaidon Press, 1948.

Popham, A. "The Baiardo Inventory." In J. Courtauld et al., eds., *Studies in Renaissance and Baroque Art Presented to Anthony Blunt*, pp. 26–29. London and New York: Phaidon Press, 1967.

———. *Catalogue of Drawings in the Collection Formed by Sir Thomas Phillipps, Bart., F.R.S., Now in the Possession of His Grandson T. Fitzroy Phillipps Fenwick of Thirlestaine House, Cheltenham*. London: Privately printed for T. Fitzroy Phillipps Fenwick, 1935.

———. *Catalogue of the Drawings of Parmigianino*. 3 vols. New Haven and London: Yale University Press, 1971.

———. "Dessins du Parmesan du Musée des Beaux-Arts de Budapest." *Bulletin du Musée National Hongrois des Beaux-Arts* 19 (1961): 43–58.

———. *Disegni di Girolamo Bedoli*. Viadana: Sodalizio Amici dell'Arte, 1971.

———. "The Drawings at the Burlington Fine Arts Club." *Burlington Magazine* 70 (February 1937): 87–88.

———. "The Drawings of Girolamo Bedoli." *Master Drawings* 2 (Autumn 1964): 243–67.

———. *The Drawings of Parmigianino*. New York: Beechhurst Press, 1953.

———. *Old Master Drawings from Chatsworth*. Washington, D.C.: Smithsonian Institution, 1962.

———. "Parmigianino as a Landscape Draughtsman." *Art Quarterly* 20 (Autumn 1957): 275–86.

———. "Sebastiano Resta and His Collections." *Old Master Drawings* 11 (June 1936): 1–19.

Popham, A., and Wilde, J. *The Italian Drawings of the Fifteenth and Sixteenth Centuries in the Collection of His Majesty the King at Windsor Castle*. London: Phaidon Press, 1949.

Posner, D. "The Guercino Exhibition at Bologna." *Burlington Magazine* 110 (November 1968): 596–607.

Pouncey, P., and Gere, J. *Raphael and His Circle*. Italian Drawings in the Department of Prints and Drawings in the British Museum. 2 vols. London: Trustees of the British Museum, 1962.

Precerutti-Garberi, M. *Giambattista Piazzetta e L'Accademia: Disegni*. With a Preface by R. Pallucchini. Milan: Castello Sforzesco, 1971.

Puppi, L. *Paolo Farinati (1524–1600)*. Verona: Editrice "Vita Veronese," 1965.

———. "Paolo Farinati Architetto." In *Studi di storia dell'arte in onore di Antonio Morassi*, pp. 162–71. Venice: Alfieri, 1971.

———. *Paolo Farinati: giornale (1573–1606)*. Florence: Leo S. Olschki [1965].

Ragghianti, C. *Tiepolo, 150 disegni dei Musei di Trieste*. Florence: Palazzo Strozzi, 1953.

Ragghianti Collobi, L. *Disegni della Fondazione Horne in Firenze*. Florence: Palazzo Strozzi, 1963.

Raimondi, G. "Il pittore Flaminio Torri detto Flaminio degli Ancinelli." In *Studi in onore di Matteo Marangoni*, pp. 260–66. Florence: Vallecchi Editore, 1957.

Rearick, J. *Eighteenth Century Italian Drawings: A Loan Exhibition*. Wellesley, Mass.: Jewett Arts Center, Wellesley College, 1960.

Rearick, W. "Jacopo Bassano: 1568–9." *Burlington Magazine* 104 (December 1962): 524–33.

Recent Acquisitions and Promised Gifts: Sculpture, Drawings, Prints. Washington, D.C.: National Gallery of Art, 1974.

Ricci, C. *Pinacoteca di Brera*. Bergamo: Istituto italiano d'arti grafiche, 1907.

Rich, D. "A 'Beggar Boy' by Piazzetta," *Bulletin of the Art Institute of Chicago* 26 (September–October, 1932): 55–56.

———. "A Drawing by Tiepolo." *Bulletin of the Art Institute of Chicago* 25 (October 1931): 90–91.

———. *Loan Exhibition of Paintings, Drawings and Prints by the Two Tiepolos: Giambattista and Giandomenico*. Chicago: Art Institute of Chicago, 1938.

Richards, L. "Three Early Italian Drawings." *Bulletin of the Cleveland Museum of Art* 49 (September 1962): 167–74.

Richardson, E. *Venice, 1700–1800: An Exhibition of Venice and the Eighteenth Century*. Detroit: Detroit Institute of Arts, 1952.

Ridolfi, C. *Le Maraviglie dell'arte*. Edited by D. Von Hadeln. 2 vols. Berlin: G. Grote'sche, 1924.

Rinaldi, S. "Il libro dei disegni di Palma il Giovane del British Museum." *Arte Veneta* 27 (1973): 125–43.

Rizzi, A. *Disegni del Tiepolo*. Udine: Loggia del Lionello, 1965.

Robels, H. *Drawings of the Fifteenth and Sixteenth Centuries: Wallraf-Richartz-Museum, Cologne*. Washington, D.C.: American Federation of Arts, 1964–65.

Röttgen, H. *Il Cavalier d'Arpino*. Rome: Palazzo Venezia, 1973.

Roli, R. *Donato Creti*. Milan: Mario Spagnol, 1967.

———. "Drawings by Donato Creti: Notes for a Chronology." *Master Drawings* 11 (Spring 1973): 25–32.

Rosand, D. *Veronese and His Studio in North American Collections*. Birmingham, Ala.: Birmingham Museum of Art, 1972.

Ruggeri, U. *Disegni Piazzetteschi*. Bergamo: Istituto italiano d'arti graphiche, 1968.

Russell, F. "Sassoferrato and His Sources: A Study of Seicento Allegiance." *Burlington Magazine* 119 (October 1977): 694–700.

Sack, E. *Giambattista und Domenico Tiepolo: Ihr Leben und Ihre Werke*. Hamburg: H. v. Clarmanns, 1910.

Salmina, L. *Disegni veneti del Museo di Leningrado*. Venice: Fondazione Giorgio Cini, 1964.

Schaack, E. van. "Drawings from the Art Institute of Chicago." *Arte antica e moderna* 25 (January–March 1964): 109–11.

Schniewind, C. *Drawings Old and New*. Chicago: Art Institute of Chicago, 1946.

Scholz, J. "Drawings by Alessandro Magnasco." In D. Fraser, H. Hibbard, and M. Lewine, eds., *Essays in the History of Art Presented to Rudolf Wittkower*, pp. 239–41. London: Phaidon Press, 1967.

———. *Italian Master Drawings, 1350–1800, from the Janos Scholz Collection*. New York: Dover Publications, 1976.

Schwarz, H. "Palma Giovane and His Family: Observations on Some Portrait Drawings." *Master Drawings* 3 (Summer 1965): 158–65.

———. "Portrait Drawings of Palma Giovane and His Family: A Postscript." In *Studi di storia dell'arte in onore di Antonio Morassi*, pp. 210–15. Venice: Alfieri, 1971.

Selections from the Drawing Collection of Mr. and Mrs. Julius S. Held. Binghamton, N.Y.: University Art Gallery of the State University of New York at Binghamton, 1970.

Sheard, W. *Antiquity in the Renaissance*. Northampton, Mass.: Smith College Museum of Art, 1978.

Simonson, G. "La Mascherata al Ridotto in Venezia di Francesco Guardi." *L'Arte* 10 (1907): 241–46.

Smith, G. "A Drawing for the Interior Decoration of the Casino of Pius IV." *Burlington Magazine* 112 (February 1970): 108–10.

———. "Federico Barocci at Cleveland and New Haven." *Burlington Magazine* 120 (May 1978): 330–33.

Smith, G. McKim, *Spanish Baroque Drawings in North American Collections*. Lawrence: University of Kansas Museum of Art, 1974.

Sonkes, M. *Dessins du XVe siècle: Groupe van der Weyden*. Brussels: Centre national de Recherches "Primitifs flamands," 1969.

Spear, R. "The Early Drawings of Domenichino at Windsor Castle and Some Drawings by the Carracci." *Art Bulletin* 49 (March 1967): 52–57.

Spike, J. "Mattia Preti's Passage to Malta." *Burlington Magazine* 120 (August 1978): 497–507.

Stampfle, F., and Denison, C. *Drawings from the Collection of Mr. and Mrs. Eugene V. Thaw*. New York: Pierpont Morgan Library, 1975.

Stix, A., and Fröhlich-Bum, L. *Beschreibender Katalog der Handzeichnungen in der graphischen Sammlung Albertina.* Vol. 1, *Die Zeichnungen der venezianischen Schule.* Vienna: Anton Schroll, 1926.

————. *Beschreibender Katalog der Handzeichnungen in der graphischen Sammlung Albertina.* Vol. 3, *Die Zeichnungen der toskanischen, umbrischen und römischen Schulen.* Vienna: Anton Schroll, 1932.

Stix, A., and Spitzmüller, A. *Beschreibender Katalog der Handzeichnungen in der graphischen Sammlung Albertina.* Vol. 6, *Die Schulen von Ferrara, Bologna, Parma und Modena, der Lombardei, Genuas, Neapels und Siziliens.* Vienna: Anton Schroll, 1941.

Stubbe, W. *Die italienische Graphik des Barock.* Hamburg: Kupferstich Kabinett, 1956.

Suida Manning, B., and Manning, R. *Genoese Masters: Cambiaso to Magnasco, 1550–1750.* Dayton: Dayton Art Institute, 1962.

Suida Manning, B., and Suida, W. *Luca Cambiaso: la vita e le opere.* Milan: Casa Editrice Ceschina, 1958.

Tasso, T. *Jerusalem Delivered.* Carbondale: Southern Illinois University Press, 1962.

Taubes, F. "Gaurdi and the Romantic Spirit." *American Artist* 29 (December 1957): 39.

Taylor, M. "The Pen and Wash Drawings of the Brothers Gandolfi." *Master Drawings* 14 (Summer 1976): 159–68.

Thiem, C. *Florentiner Zeichner des Frühbarock.* Munich: Bruckmann, 1977.

————. *Italienische Zeichnungen 1500–1800.* Stuttgart: Staatsgalerie Stuttgart, 1977.

Thieme, U., and Becker, F. *Allegemeines Lexicon der Bildenden Künstler.* 36 vols. Leipzig: E. A. Seemann, 1908-47.

Thomas, H. *The Drawings of Giovanni Battista Piranesi.* London: Faber & Faber, 1954.

Tiepolo et Guardi. Paris: Galerie Cailleux, 1952.

Tietze, H. *European Master Drawings in the United States.* New York: J. J. Augustin, 1947.

————. "Nuovi disegni veneti del Cinquecento in collezioni americane." *Arte Veneta* 2 (1948): 56–66.

Tietze, H., and Tietze-Conrat, E. *The Drawings of the Venetian Painters in the Fifteenth and Sixteenth Centuries.* New York: J. J. Augustin, 1944.

Tietze-Conrat, E. "Decorative Paintings of the Venetian Renaissance Reconstructed from Drawings." *Art Quarterly* 3 (1940): 15–38.

Tomory, P. *The Ellesmere Collection of Old Master Drawings.* Leicester: Museums and Art Gallery, 1954.

Treasures of Chicago Collectors. Chicago: Art Institute of Chicago, 1961.

Unbekannte Handzeichnungen alter Meister, 15.–18. Jahrhundert: Sammlung Freiherr Koenig-Fachsenfeld. Stuttgart: Staatsgalerie Graphische Sammlung, 1967.

Vasari, G. *Le Vite de' più eccellenti pittori, scultori ed architettori.* Edited by G. Milanesi. Florence: Sansoni, 1878-85; reprinted 1906.

Vaughan, H. *The Medici Popes.* London: Methuen, 1908.

de Vecchi di Val Cismon, C.; Rovere, L.; Viale, V.; and Brinckmann, A. *Filippo Juvarra,* vol. 1. Milan: Casa Editrice Oberdan Zucchi, 1937.

Venturi, A. *Pisanello.* Rome: Fratelli Palombi, 1939.

————. *Storia dell'arte italiana.* 11 vols. in 29 pts. Milan: U. Hoepli, 1901-40.

Vesme, A. *Schede Vesme: l'arte in Piemonte dal XVI al XVIII secolo,* vol. 1. Turin: Società Piemontese di Archeologia e Belle Arti, 1963.

Vey, H. "Some European Drawings at Worcester." *Worcester Art Museum Annual* 6 (1958): 9–42.

Viatte, F. *Dessins de Stefano della Bella.* Vol. 2 of *Inventaire général des dessins italiens.* Paris: Editions des Musées Nationaux, 1974.

Vickers, M. "Some Preparatory Drawings for Pisanello's Medallion of John VIII Palaeologus." *Art Bulletin* 60 (September 1978): 417–24.

Vigni, G. *Disegni del Tiepolo.* 2d ed. Trieste: La editoriale libraria, 1972.

Vitzthum, W. *Il Barocco a Napoli e nell'Italia meridionale.* I Disegni dei maestri 9. Milan: Fratelli Fabbri, 1971.

————. *Il Barocco a Roma.* I Disegni dei maestri 14. Milan: Fratelli Fabbri, 1971.

————. *Cento disegni napoletani, Sec. XVI–XVIII,* vol. 26. Florence: Gabinetto dei disegni e delle stampe degli Uffizi, 1967.

————. "Disegni di Alessandro Algardi." *Bollettino d'arte* 48 (January–June 1963): 75–98.

————. "Disegni Inediti di Ribera." *Arte illustra* 4 (January–February 1971): 74–84.

————. "Publications Received: Sebastiano and Marco Ricci in America." *Master Drawings* 4 (Summer 1966): 185.

————. *A Selection of Italian Drawings from North American Collections.* Saskatchewan: Norman Mackensie Art Gallery, 1970.

Vivant Denon, D. *Monuments des arts du dessin.* Paris: Brunet Denon, 1829.

Voss, H. *Die Malerei der Spätrenaissance in Rom und Florenz.* 2 vols. Berlin: G. Grote'sche, 1920.

————. "Studien zur venezianischen Vedutenmalerei des 18. Jahrhunderts." *Reportorium für Kunstwissenschaft* 47 (1926): 1–45.

Watrous, J. *The Craft of Old-Master Drawings.* Madison: University of Wisconsin Press, 1967.

Weigel, R. *Die Werke der Maler in ihren Handzeichnungen.* Leipzig: Rudolf Weigel, 1865.

Weiss, R. *Pisanello's Medallion of the Emperor John VIII Palaeologus.* London: Trustees of the British Museum, 1966.

Wethey, H. *The Paintings of Titian.* 3 vols. London: Phaidon Press, 1969.

White, D., and Sewter, A. *I Disegni di G. B. Piazzetta nella Biblioteca Reale di Torino.* Rome: Istituto poligraphico dello stato, Libreria dello stato, 1969.

Wick, P. "Farm Building and Pollarded Mulberry Tree

(Recto); Farmhouse and Watermill (Verso)." *Boston Museum of Fine Arts Bulletin* 56 (Autumn 1958): 106–8.

Wiles, B. "Two Parmigianino Drawings from the *Aeneid*." *Museum Studies* 1 (1966): 96–111.

Wise, S., ed. *European Portraits, 1600–1900, in the Art Institute of Chicago.* Chicago: Art Institute of Chicago, 1978.

Wittkower, R. *Art and Architecture in Italy 1600–1750.* Baltimore: Penguin Books, 1958; 3d rev. ed., 1973.

———. *The Drawings of the Carracci in the Collection of Her Majesty the Queen at Windsor Castle.* London: Phaidon Press, 1952.

Woodward, J. *Ecclesiastical Heraldry.* Edinburgh and London: W. & A. K. Johnston, 1894.

Young, N., ed., *Murray's Handbook for Rome and the Campagna.* London: Edward Stanford, 1909.

Zampetti, P. *Mostra dei Guardi.* Venice: Palazzo Grassi, 1965.

———. *Vittore Carpaccio: catalogo della mostra.* Venice: Palazzo Ducale, 1963.

Zanetti, A. *Raccolta di varie stampe a chiaroscuro tratte dai disegni originali di Francesco Mazzuola, detto il Parmigianino e d'altri insigni autori da Anton Maria Zanetti, Q. in Gir che gli stessi disegni possiede.* Venice, 1749.

Zannandreis. D. *Le Vite dei pittori, scultori e architetti veronesi.* Verona: G. Franchini, 1891.

Zugni-Tauro, A. *Gaspare Diziani.* Venice: Alfieri, 1971.

INDEX OF ARTISTS